PARIS IN JAPAN

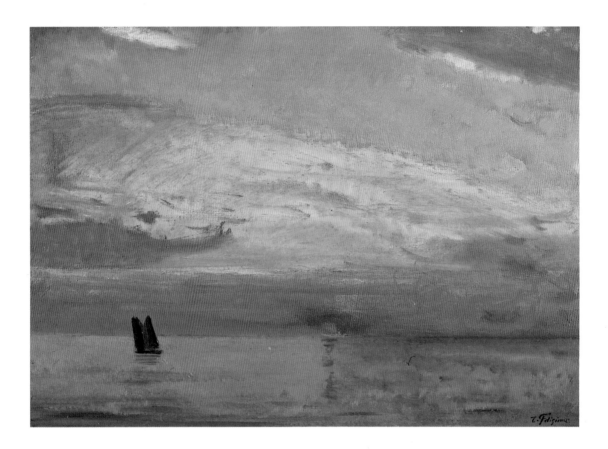

PARIS IN JAPAN

THE JAPANESE ENCOUNTER WITH EUROPEAN PAINTING

Shūji Takashina
J. Thomas Rimer
with
Gerald D. Bolas

THE JAPAN FOUNDATION, TOKYO
WASHINGTON UNIVERSITY IN ST. LOUIS
1987

Paris in Japan: The Japanese Encounter with European Painting has been organized by The Japan Foundation, Tokyo, and the Gallery of Art at Washington University in St. Louis with the cooperation of the following museums in Japan:

Bridgestone Museum of Art, Tokyo, Yasuo Kamon, Director
Mie Prefectural Art Museum, Tsu, Tetsuro Kagesato, Director
The Museum of Modern Art, Kamakura, Heihachiro Tsuruta, Director
The National Museum of Modern Art, Tokyo, Tadashi Inumaru, Director
Ohara Museum of Art, Kurashiki, Shinichiro Fujita, Director

This exhibition is supported by grants from the National Endowment for the Humanities, a federal agency. Funds provided by Anheuser-Busch Companies, Inc., St. Louis, Missouri, and the Hortense Lewin Art Fund of the Gallery of Art at Washington University in St. Louis supported the initial development of *Paris in Japan*. A grant from the Commemorative Association for the Japan World Exposition, Osaka, and contributions from Toppan Printing Company, Ltd., Tokyo, and Oji Paper Company, Ltd., Tokyo, have underwritten publication of this catalogue. The Regional Arts Commission of St. Louis, Missouri, and the Missouri Arts Council, a state agency, awarded grants for presentation of *Paris in Japan* in St. Louis.

Dates of the Exhibition:

Washington University Gallery of Art
St. Louis, Missouri
October 2–November 22, 1987

Japan House Gallery
New York, New York
December 11, 1987–February 7, 1988

Wight Art Gallery
University of California at Los Angeles
February 21–April 3, 1988

Library of Congress Catalogue Card Number 87-50582
ISBN: 0-936316-11-X
© The Washington University 1987. All rights reserved.

Cover Illustration:
UMEHARA RYŪZABURŌ, *Nude with Fans*, 1938.
Ohara Museum of Art, Kurashiki (Cat. 63).

Frontispiece:
FUJISHIMA TAKEJI, *Sunrise over the Eastern Sea*, 1932.
Bridgestone Museum of Art, Tokyo (Cat. 10).

Designed by Staples & Charles Ltd, Washington, D.C.
Typeset in Monotype Cochin and Bembo by
 VIP Systems, Alexandria, VA
Printed in Japan by Toppan Printing Company, Ltd.,
 Tokyo

TABLE OF CONTENTS

FOREWORD

Although in the past few decades exhibitions of Japanese art in the United States have been relatively frequent, almost all have focused either on traditional art from the period before the 1868 Meiji Restoration or on contemporary art from the postwar period. *Paris in Japan: The Japanese Encounter with European Painting* is the first systematic and comprehensive attempt to fill that gap. By showing side by side important works from various stages in the careers of a number of prominent artists, it will furnish a graphic illustration of the impact which the city of Paris and paintings introduced through Paris had on Japanese artists of the late nineteenth and early twentieth centuries. At the same time, it will show how traditional Japanese styles were inherited and developed in a new context.

The paintings in this exhibition have been chosen by experts in the field. The Japan Foundation is proud to have been associated with this project, and would like to thank Professors Rimer and Takashina who kindly served as guest curators, the people and organizations who gave us their support, and in particular the owners of the works for their permission to allow the works to travel outside Japan, often for the first time.

We hope that this exhibition will help promote mutual understanding between our two countries, and that it will serve as a springboard for further efforts in the field of cultural exchange.

Shoji Sato
President
The Japan Foundation

FOREWORD

Paris in Japan: The Japanese Encounter with European Painting provides one of the missing links in America's understanding of Japan: a study of several generations of Japanese artists who sought understanding of Western art in order to assimilate its principles into their own expanding aesthetic. Like artists everywhere—including American artists—who challenged established conventions, these Japanese painters occasionally encountered reprobation, disillusionment, and disappointment. At the same time they enjoyed the exhilaration of exploring and discovering new pictorial methods to express fresh ideas, and they were conscious of the fact that their efforts helped create a new cultural amalgam in Japan.

Americans should be particularly sympathetic to this enterprise, as we were dependent for so long on the culture of Europe for resources to nourish our own. Indeed, many of our own artists left home in order to learn from and eventually compete with the best artists in Paris. Today we may be intrigued to learn how painting in Japan evolved from traditions nurtured behind closed doors until the mid-nineteenth century to the position of prominence in the international arena that contemporary Japanese art enjoys today. As we encounter a chapter of Japanese cultural history that bears comparison with our own, Americans may experience a new resonance with the efforts and achievements of the Japanese artists presented in *Paris in Japan*.

The collaboration of The Japan Foundation and Washington University was undertaken with the conviction that in sharing our arts, we share our knowledge, our values, and our ideals. We are grateful to Professors Takashina and Rimer for guiding us in this endeavor, and we thank the many people and organizations that participated in its accomplishment. Some three dozen public institutions and private collectors in Japan have sent their treasures halfway around the world, and we thank them for making *Paris in Japan* a reality.

The organizers of this exhibition have enjoyed the discovery of how much the artists of both countries shared in their quests to Paris. In the process our admiration has grown for the enduring achievements that our cultural explorers created amidst the confluence of the powerful artistic currents in Paris. These pleasures will, we anticipate, be enjoyed by all who view *Paris in Japan,* which we hope will stimulate further dialogue and continued collaborations between our countries.

Gerald D. Bolas
Director
Washington University Gallery of Art

LENDERS TO THE EXHIBITION

Aichi Art Gallery, Nagoya
The Asahi Shinbun, Tokyo
Bridgestone Museum of Art, Tokyo
Fujii Gallery, Tokyo
Fukuoka Art Museum, Fukuoka
Fukushima Prefectural Museum of Art, Fukushima
Gunma Prefectural Museum of Modern Art, Takasaki
Hiroshima Museum of Art, Hiroshima
Hyogo Prefectural Museum of Modern Art, Kobe
The Ibaragi Prefectural Museum of Art, Mito
Ishibashi Museum of Art, Ishibashi Foundation, Kurume
Iwate Prefectural Museum, Morioka
Kasama Nichido Museum of Art, Kasama
Kitakyushu Municipal Museum of Art, Kitakyushu
Kume Museum of Art, Tokyo
Kyoto Institute of Technology, Kyoto
Mie Prefectural Art Museum, Tsu
The Museum of Modern Art, Kamakura
The Museum of Modern Art, Saitama
Nakamura-ya, Tokyo
The National Museum of Modern Art, Kyoto
The National Museum of Modern Art, Tokyo
Ohara Museum of Art, Kurashiki
Tamagawa Museum of Modern Art, Ehime
Tokyo Metropolitan Art Museum, Tokyo
Tokyo National Museum, Tokyo
Tokyo National Research Institute of Cultural Properties, Tokyo
Tottori Prefectural Museum, Tottori
Yamatane Museum of Art, Tokyo
Private Collections, Japan

ACKNOWLEDGEMENTS

Many people have contributed to *Paris in Japan* and we remain grateful for their efforts. The initial concept was developed with the assistance of a consulting team that included Stephen Addiss, Professor of Art History at the University of Kansas, the late Calvin French, Professor of Far Eastern Art at the University of Michigan, Charles W. Millard, Director of the Ackland Art Museum at the University of North Carolina at Chapel Hill, John Rosenfield, Abby Aldrich Rockefeller Professor of Oriental Art at Harvard University; and Joseph D. Ketner II, Curator and Registrar of the Gallery of Art, Eugene Soviak, Professor of History, and Mark S. Weil, Professor of Art History, Washington University in St. Louis. Others who have furthered the project include Tony Derham and Maryell Semal, Director and Assistant Director, respectively, of the Japan House Gallery, and Rand Castile, Director of the Asian Art Museum of San Francisco. We also thank Donald McCallum, Professor of Art History at the University of California at Los Angeles, for providing his essay for this catalogue and Ellen Conant for a number of thoughtful suggestions.

Support from the National Endowment for the Humanities at an early stage of planning *Paris in Japan* was crucial for its realization, and we have been especially aided in our planning by Steven Mansbach and Marcia Semmel of the Division of General Programs, and Gabriel Weisberg, now Professor of Art History at the University of Minnesota.

In Japan, Tadayasu Sakai, Chief Curator of The Museum of Modern Art, Kamakura, has served as coordinator of curatorial arrangements, and Emiko Yamanashi has contributed essential research for the catalog. We are also grateful to the museum curators in Japan who shared their research for the catalogue annotations. Special thanks go to Mie Kakigahara for facilitating so many arrangements in Japan, and to Mrs. Fumi Norcia, at the Library of Congress, for her research and editing contributions.

We thank the staff of The Japan Foundation for organizing the show in Japan, most especially Yoichi Shimizu of the Arts Department. We also thank Fumio Matsunaga and Hayato Ogo of the Tokyo office of The Japan Foundation, and Masayoshi Matsumura and Masao Ito, Director and Assistant Director, respectively, of the New York office of The Japan Foundation.

At Washington University in St. Louis, Sharon Bangert, Administrative Assistant of the Gallery of Art, is due our thanks, as are Regina Engelken, RoseMarie Pfaffe, Marie Roessler, Martha Scholz, Alice Sinak, Trudi Spigel, James Thompson, and Frederic Volkmann.

We are also grateful to Bruce Adaire for his assistance during the early stages of planning this exhibition.

We thank Mary Brown, Barbara Charles, and others on the staff at Staples & Charles, Washington D.C., for the design of the catalogue.

J. Thomas Rimer
Shūji Takashina

EDITORS' NOTE

In the following essays, biographies, and catalogue, the names of artists in capital letters are those included in the exhibition. Their biographies and annotations on their works in this show will be found after the essays, in two successive sections, both arranged alphabetically by the name of the artist.

Names of Japanese contributors to this publication are in Western form, with given names first. Japanese names of painters and others in the text are presented in the traditional fashion, with the family name first followed by the given name. Titles of paintings are translated from the Japanese and may vary slightly from translations provided in other publications. Dimensions of works of art are listed in centimeters followed by inches, height preceeding width. Several works have been designated Important Cultural Properties by the Japanese government; these are indicated in the headings to the annotations.

The editors are grateful to The Japan Foundation for arranging for translation of the catalogue annotations supplied by the authors listed below. The editors have generally reproduced the annotations as provided by individual authors, with adjustments exercised primarily to clarify translation. Readers interested in learning more about individual paintings are encouraged to contact the lending institutions, many of which are able to provide more complete bibliographic information. Citations included in the general bibliography are generally not duplicated in the notes for annotations.

All reproductions of works of art and photographs in this catalogue were provided by The Japan Foundation, which may be contacted for further details concerning them.

Assembly of the annotations in Japan was supervised by Tadayasu Sakai, Chief Curator of The Museum of Modern Art, Kamakura. The authors and their affiliations are as follows:

Tōru Arayashiki, Curator, Mie Prefectural Art Museum, Tsu
Hikaru Harada, Curator, The Museum of Modern Art, Kamakura
Shunrō Higashi, Curator, Mie Prefectural Art Museum, Tsu
Kenichirō Makino, Curator, Planning Office for the New Cultural Center,
 Aichi Prefectural Government
Tsutomu Mizusawa, Curator, The Museum of Modern Art, Kamakura
Atsushi Tanaka, Curator, The National Museum of Modern Art, Tokyo
Emiko Yamanashi, Researcher, Tokyo National Research Institute of Cultural
 Properties, Tokyo

Gerald D. Bolas
J. Thomas Rimer

GLOSSARY

bunjinga: Japanese literati painting, sometimes referred to as *nanga*.

Bunten: Japanese abbreviation for the *Monbushō bijutsu tenrankai*, the annual art exhibition sponsored by the Ministry of Education.

Fūzankai, or *Société du Fusain:* the Sketching Society, founded by KISHIDA RYŪSEI, SAITŌ YORI, and others in 1913 to promote the activities of new and independent artists.

Hakubakai: the White Horse Society, founded in 1896 by KURODA SEIKI, KUME KEIICHIRŌ, OKADA SABURŌSUKE, and FUJISHIMA TAKEJI, among others, to encourage Western-style painting.

Kobu bijutsu gakkō: the Technical Art School, established in 1876 at the Imperial College of Technology; closed in 1883.

Meiji bijutsukai: Meiji Fine Arts Society, organized in 1889 by ASAI CHŪ, among others. The first to promote Western-style painting in Japan, the group was dissolved in 1900.

Nihonga: Japanese-style painting created with traditional media such as ink and watercolor on silk and paper, executed from the Meiji period onward in contemporary styles related to traditional modes of Japanese painting.

Nikakai: the Second Division Group organized in 1914 by a group of artists painting in the Western style who found themselves dissatisfied with the conservative *Bunten*.

rimpa: an elegant and decorative style of painting, popular in the eighteenth century, using delicate colors and precious metals, like gold and silver, for creating designs on such objects as screens, fans, and album leaves.

Shirakaba: the White Birch Society, a literary organization founded in 1910 which published a journal of literature and the fine arts that introduced Cézanne, van Gogh, and Rodin, as well as other artists from the School of Paris, to the Japanese public.

Taiheiyō gakai: the Pacific Painting Society, sometimes translated as the Pacific Art Association, established c. 1901 by MITSUTANI KUNISHIRŌ, Yoshida Hiroshi, and Nakagawa Hachirō; it later counted KANOKOGI TAKESHIRŌ among its members.

Tokyo bijutsu gakkō: the Tokyo School of Fine Arts, established in 1887 with the encouragement of Ernest Fenollosa and Okakura Tenshin (Kakuzō) to revive traditional Japanese painting styles. A separate Western Painting Section was organized with KURODA SEIKI at its head in 1896.

ukiyo-e: literally "pictures of the floating world," a general term for Japanese woodblock prints, popular since the Tokugawa period (1600–1868).

yōga: painting executed with Western media such as oil paint on canvas support, usually in styles drawn from Europe.

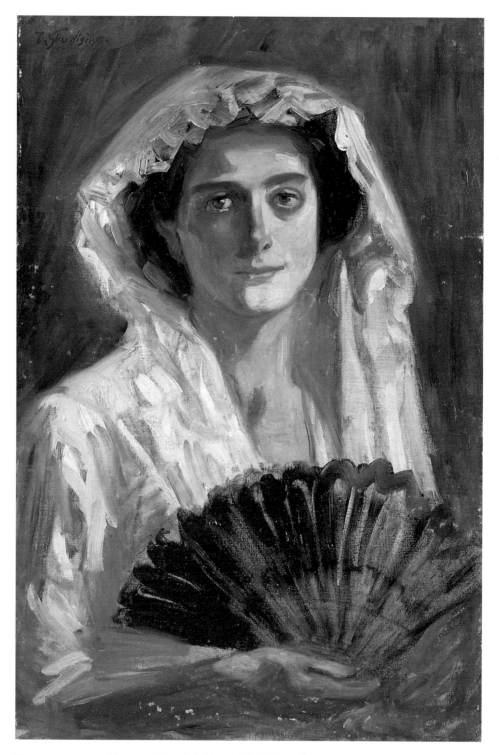

Cat. 8. FUJISHIMA TAKEJI, *The Black Fan*, 1908-1909. Oil on canvas, 64 × 41.5 cm/
25¼ × 16⅜ in. Bridgestone Museum of Art, Tokyo. *Important Cultural Property*.

AMERICAN RESPONSES TO
WESTERN-STYLE JAPANESE PAINTING

Gerald D. Bolas

America's view of the culture and people of Japan has experienced remarkable transformations since 1853 when Commodore Matthew Perry sailed into Tokyo Bay and compelled the Japanese to open their previously closed border and enter into international discourse. Still considered exotic and unknown in many ways, Japan today is also esteemed as a powerful cosmopolitan force whose intercourse with the West has achieved far-reaching dimensions. *Paris in Japan: The Japanese Encounter with European Painting* examines a component of Japanese visual art that was inspired and transformed by Western culture and offers a case study in the evolution of aesthetics through cross-cultural encounters.

The American reception of Japanese Western-style painting suggests that Americans clung tenaciously to the expectation that Japanese art remain different from and unadulterated by Western art, even while American art was being nurtured on that of Europe. Japan was seen as an ancient civilization whose longstanding traditions were threatened by Westernization, rather than the way Japan saw *itself* at the time, as a young culture, like America, in the process of inventing itself.

During the late nineteenth and early twentieth centuries, both Japanese and American artists apprenticed themselves to French masters, sharing belief in the preeminence of contemporary French art. Henry James, who chose to live abroad for many years, observed in 1887: "It sounds like a paradox, but it is a very simple truth, that when to-day we look for 'American art' we find it mainly in Paris. When we find it out of Paris, we at least find a great deal of Paris in it."[1] His assessment of the cosmopolitan character of American art confirmed that his countrymen were following the advice offered in 1864 by the American art collector and critic James Jackson Jarves:

> *If America elects to develop her art wholly out of herself, without reference to the accumulated experience of older civilizations, she will make a mistake, and protract her improvement. . . . We have not time to invent and study everything anew. . . . No one dreams of it in science, ethics, or physics. Why then propose it in art? We are a composite people. Our knowledge is eclectic. . . . To get artistic riches by virtue of assimilated examples, knowledge, and ideas, drawn from all sources, and made national and homogeneous by a solidarity of our own, is our right pathway to consummate art.*[2]

Americans' contradictory expectations of themselves and Japan are demonstrated by Jarves, who was one of the first Americans to study Japanese art. Capitalizing on the interest in Japan stimulated by her participation in the Centennial Exhibition held at Philadelphia in 1876, he published that year *A Glimpse at the Art of Japan*, a broad survey that included chapters on the psychological, religious, social, and historical origins of Japanese art. Jarves commented on a new movement in Japan:

> *Easel paintings are not found in Japan, unless we admit into this category recent attempts to imitate ours, all [of] which are striking failures, as are also our experiments in their line.*

Innovations on either side, by which the practice of the one is guided by the principles of the other, have a common result. Either system must be kept to itself, intact, or wholly abandoned. There can be no happy mixture of the antipodal elements of Oriental and European art, or subordination of one practice to the other, although we may largely gain by studying their fundamental principles and acquiring a knowledge of their materials and technical secrets.[3]

Jarves's conviction that Eastern and Western aesthetic canons were "antipodal" prevented him from recognizing the profound influence that traditional Japanese arts such as ink paintings, woodblock prints, ceramics, and lacquered objects were exerting at that moment on European, particularly French, artists. Precisely because Japanese art was recognized as an essentially different aesthetic from that of the West, it constituted a useful resource for European artists, who appropriated its stylistic solutions for their own artistic purposes. In this respect, the threat of Westernization of Japan implied the loss of welcome stimulation, especially in France, where previous generations of artists had drawn inspiration from foreign cultures through the incorporation of, for example, Chinese motifs in the seventeenth and eighteenth centuries and Near Eastern subjects in the early nineteenth century.

Turn of the century Americans craved traditional objects from and knowledge of Japan. Indeed, as Shūji Takashina explains in the essay that follows, the American Ernest Fenollosa helped convince the Japanese government in the 1880s to establish an art school to perpetuate traditional artistic values and techniques partially to counter the increasing Japanese infatuation with Western art. Extremely influential in shaping American perceptions concerning Japan, Fenollosa argued that for Americans to understand the arts of Japan they must try to see it from a Japanese perspective. Lecturing in Boston in 1892, he asserted that

the curse of western art is its hard and fast formalism by which individuality is crushed. We are so absorbed in the form and colors of things that we have no time to think of their meaning. With the Japanese artist it is widely different. Form and color he knows . . . but in every line and shade he sees the beauty of thought that lies behind. He sees the heart of things. And this is one of the lessons that we may learn from them; to drop our slavish desire to do everything as some one else has done it. . . . Art may be representative, but it must be imaginative It is the heart that gives value.[4]

In Fenollosa's view, Americans wished to learn more about the "heart" of Japanese traditional art, not how the Japanese applied the academic rules that governed Western art.

One of the ways Americans might have acquired knowledge about Western-style art in Japan was through accounts published by American artists who visited Japan in the 1880s and 90s. However, John La Farge, Robert Blum, and Theodore Wores, for instance, were silent concerning the phenomenon.[5]

One eyewitness report, not published until 1963, was that of Blondelle Malone, who spent most of 1903 in Japan. Malone, who studied at the Art Students League in New York, was friend to numerous American artists including Blum, John Twachtman, and William M. Chase. A world traveler, she toured an unidentified art school, presumably the Tokyo School of Fine Arts, where both Japanese and Western-style arts were taught:

We met the director, who spoke English. I asked if there were artists who had studied in Paris and he went for one, the instructor in oil painting. This fellow came in with Paris stamped all over him We were then taken through the school. First into the Japanese water-color department. The students . . . were copying Japanese prints. . . . The antique class came next, and they have a magnificent collection of casts. The work was as good as in the

American schools. . . . We visited the life classes next and the work was very good. . . . we met four students . . . with the studio stamped all over them—baggy-clothes, Vandyke and Rembrandt beards, and everything that goes to make an artist; that is, every superficial thing. . . . we all went upstairs to see the gallery of oil paintings. . . . The light and color seem to be better understood by the few Japanese who do go in for it than by the majority of our students. . . . each had a character of its own. I was more pleased with the exhibition than any of its size that I ever attended, that is of students' work.[6]

The Boston area was intimately involved in America's understanding of Japan through Edward Sylvester Morse (1838–1925). Morse, who first traveled in Japan from 1877 to 1880 to study and teach zoology, eventually established himself as an authority on Japanese art and aesthetics.[7] He assembled a distinguished collection of Japanese ceramics bought by the Boston Museum of Fine Arts in 1892, inspired numerous Bostonians to experience Japan, and introduced Fenollosa to the country in 1878. Fenollosa served as curator of America's first department of Japanese art at the Boston Museum of Fine Arts from 1890 to 1896, further strengthening ties to Japan.

In February of 1900 the Boston Museum of Fine Arts mounted an exhibition of Western-style watercolors and oil paintings by two young Japanese artists on their way to Europe, Yoshida Hiroshi (1876–1950) and Nakagawa Hachirō (1877–1922). Ironically, the museum where Fenollosa had served as curator presented an exhibition antithetical to his commitment to traditional Japanese values. Boston collectors and the museum itself purchased at least eighty-four of the 104 works exhibited, all of which depicted Japanese subjects such as bamboo groves, cherry blossoms, Kyoto temples, and landscapes. The *Boston Daily Advertiser* affirmed American fascination with the picturesque scenes,[8] while the *Boston Evening Transcript* commended as "modern and naturalistic" the "good drawing, good composition, and pleasant, harmonious color, combined with interesting and picturesque motives."[9] The appeal of this and subsequent shows was probably due in part to the artists' Western realism which satiated Americans' thirst for picture postcard views of the exotic foreign land.

The extraordinary success of the show led to a second exhibition mounted by the Boston Arts Club in December of 1900 that displayed some three hundred watercolors by Yoshida, Nakagawa, and four of their Japanese colleagues including KANOKOGI TAKESHIRŌ and MITSUTANI KUNISHIRŌ. The *Boston Evening Transcript* delighted in the painters' "pictorial voyage through the realms of that enchanting island" and noted a technical smoothness and sustained realism, as well as a "tendency to a rather too uniform sweetness and prettiness."[10]

The marketability of these paintings, particularly those in watercolor—which was appreciated as a traditional Japanese medium, even when handled in a Western manner—appears to have resulted in several exhibitions intended to encourage, as one catalog advised, the purchase of holiday gifts.[11] This same group of Japanese artists, who organized as the Pacific Art Association (also known as the Pacific Painting Society), had a show at the Copley Galleries in Boston in December of either 1901 or 1902. The Japanese importer and dealer Matsuki Bunkio advertised an exhibition and auction in Boston of the group in December 1901. Matsuki, who may have been the connection through which Yoshida and Nakagawa originally penetrated the Boston market, was well acquainted with Thomas E. Kirby, whose American Art Association presented shows in New York of the Japanese artists' group in November 1901 and December 1902.[12] The 1902 exhibition prompted a provocative review by the *New York Times*:

It has been the fashion to laugh at those Japanese artists who have gone to Paris to study, but they are justifying themselves. An exhibition of water colors now on view . . . shows that these men can produce work that compares favorably—very favorably—with the productions of their Occidental brothers. There is an exhibition of water colors by American artists open in Fifty-seventh Street. A visit to that show, followed by an inspection of the work of the Japanese, is likely to lead to somewhat unwelcome reflections—to an American.

It would be instructive to place one of the pictures by, for instance, Winslow Homer, which are shown in Fifty-seventh Street, beside, for instance, the "Misty Morning," by Hiroshi Yoshida. . . . In the one is an absolute lack of poetic feeling, color that is strong but unpleasing, drawing that is very clever but unrefined. In the other one finds a subject of the simplest character treated in a manner which exhibits the truest poetic instinct, subdued color which nevertheless has the qualities of a gem, drawing in which every line is subtle and full of meaning.[13]

The exhibit to which the reviewer alluded, that of the New York Water Color Club, honored Winslow Homer in 1902 with a special showing of eighteen watercolors, most of which had been executed in Bermuda. Homer's quickly-worked, vividly-colored sketches represented an extreme contrast to the muted tonalities and explicit realism of the Japanese artists; even in their own country they were conservative as compared with their colleagues who employed the Impressionist-influenced palette taught by KURODA SEIKI. The *New York Times* review of the New York Water Color Club exhibition implied the context in which cultural sensibilities were exchanged; it noted that *The Rain* by Charles Courtney Curran depicted a "nude, treated in Japanese style, exquisite in color and in line, and charming in sentiment," and then singled out for praise seven watercolors by the Japanese Yeto Genjirō, "in which the best traditions of the Japanese school of flower painting are followed."[14] Thus at the turn of the century, both the traditional and radical elements of Japanese art confronted one another in New York City, while American artists revealed the influence of Japanese art in their own work.

The St. Louis World's Fair of 1904 presented the most comprehensive display of Western-style Japanese art in the United States to date. In the Fair's Art Palace the Japanese government presented some ninety-one works organized into a "Japanese School" and a "European School." The latter section comprised twenty-six oil paintings and watercolors by eighteen painters, including OKADA SABURŌSUKE. Artists of the Japanese school took the lion's share of the thirty-five prizes awarded by the international jury; three of the lowest rank went to the European School painters Yoshida, MITSUTANI, and Wada Eisaku. It is significant that although all four of the Japanese artists mentioned above had by now been to Europe, they presented in St. Louis only Japanese figure, genre and landscape subjects.[15] Their work was generally overlooked by critics, most of whom lavished praise on the Japanese-style painters. For example, the American artist Will Low, who had studied in Paris with Jean-Leon Gérôme and Carolus-Duran, found "the only regrettable feature of the exhibit . . . was a small collection of works by Japanese artists trained in Western schools and painting in accordance with our methods."[16] Charles Caffin argued that the Japanese oil painter had

separated himself from the motives as well as from the methods of his own art. For the motive of Japanese painting is not one of representation, as ours is, but of suggestion. . . . It has grown out of and conformed itself to the preference which the Japanese have for the abstract over the concrete.[17]

In such judgments these critics upheld the position of Fenollosa and his Japanese colleague, Okakura Kakuzō, who, as the first director of the Tokyo School of Fine Arts in 1887, had organized the curriculum to revive the teaching and appreciation of native traditions. In 1904 Okakura presented a paper on "Modern Problems in Painting" at the Congress of Art and Science convened at the St. Louis World's Fair. Alerting his audience to the "onslaught of Western art on our national painting," he reported that "a great battle is raging among us in the contest for supremacy between Eastern and Western ideals."[18] Okakura also cautioned that

> *our national painting seems not to have been grasped by the general Western public. Our painting is still known to you through the color-prints of the popular school, and the flower and bird pictures which represent the prettiness, not the seriousness of our artistic efforts.*[19]

His admonition that Occidentals were confused in their judgments of the genuine qualities of Japanese art strikes at the heart of the problem concerning the identification of authentic national sensibilities. Even when looking at the Western-style art of Japan, Americans wanted to see, as did Maude Oliver visiting the Art Palace at the St. Louis World's Fair, "something of the dainty simplicity" that Japan "stamps . . . upon even the oil paintings of her artists."[20]

In 1903 Sadakichi Hartmann published *Japanese Art*, the first study in English to include a detailed chapter on the modern movements. Hartmann, born in Nagasaki to a Korean mother and German father, delineated a cosmopolitan perspective on the issues, reporting that the Western-style "radicals" had "found the classical [Japanese] styles unequal to the expression of the new ideas, and largely unintelligible to a modern public."[21] Briefly recounting the career of KURODA, he offered an assessment that differentiated between the artist's academic history paintings and his landscapes:

> *The Radicals never convince us when they attempt elaborate compositions. Kouroda's [sic] most important picture [Telling an Ancient Romance, (Fig. 3)] . . . is not even as interesting as Alma Tadema, while his views of Fusiyama [Mount Fuji] and river scenes, bearing all the characteristics of Japanese composition, are exquisite creations. They are vibrant with light and warmth, and show keen observation of nature in the Western sense.*
> *The Radical school seems to have no future. It will never become national.*[22]

During the 1910s Japanese art historians and critics published in English a number of accounts of contemporary Japanese painting that discussed the Western movement as seen from within Japan. For example, Harada Jirō in 1910 informed readers that "it is the general opinion among our own art critics that our oil paintings show a more marked advancement than do our native paintings."[23] In a comprehensive survey of the movement, Harada affirmed that

> *those Japanese artists who have adopted the European method of expression have done much for the advancement of art in general. If in nought else, at least by their boldness and freedom of expression they have pointed out new possibilities and given a fresh stimulus to those of our artists who have shown more or less inclination towards conventionality.*[24]

While the Western-painting movement received increasing coverage in the art magazines, the number of exhibitions of Japanese Western-style paintings declined. In contrast, during the 1920s and 30s the Boston Museum of Fine Arts, Pennsylvania Academy of Fine Arts, and Toledo Museum of Art, among others, mounted shows of contemporary

Japanese-style painting and woodblock printing.

At the same time growing numbers of aspiring Japanese artists arrived in the United States, often fresh from art school in Tokyo. Many went to New York where they enrolled at one or more of its art schools. For example, between 1902 and 1918 no fewer than sixty-seven students at the National Academy of Design in New York listed their birthplace as Japan.[25] Many Japanese set Paris as their goal, with America a halfway step where they might improve their skills and raise money through sales of their work.[26] The most accomplished almost inevitably went on to the French capital. Ogiwara Morie (1879–1910) and Yanagi Keisuke (1881–1923) studied at both the National Academy and the Art Students League in 1904 and 1905, respectively, before going to Paris. Kawashima Riichirō (1886–1971), who worked at the National Academy after graduating in 1910 from the Corcoran School of Art, in Washington, D.C., and Tōyama Gorō (1888–1928), who attended the National Academy in 1919, also went to Paris. The Académie Julian in Paris, which attracted numerous Japanese students during the first two decades of the century, reported in its journal that there were many Japanese studying Western art in San Francisco, evidence of the rapport between French and American art centers during the period.[27]

The art school at Washington University in St. Louis publicized with pride the accomplishments of one of its students, Date Kotarō (1878–1964), a native of Japan. Date arrived in St. Louis via Seattle at the behest of Kajiwara Takuma (1876–1960), a Japanese photographer and portrait painter. Graduating in 1907, Date worked at the Art Students League for two years before returning to St. Louis, where he painted an unlocated mural for a local high school. He returned to Japan with the ambition of establishing his own art school in order to lead his countrymen "to a right conception of artistic principles . . . to help wean Japan from the artistic methods that have so long obtained there."[28]

American responses to the Western-painting movement of Japan disclose some of the presumptions, as well as enthusiasms, that shaped Western opinions concerning Japanese art of the period. On the one hand, Americans welcomed Japanese artists to the United States, bought their work, and offered training in Western painting methods, while on the other hand, Americans criticized their efforts as unworthy of Japan's great artistic traditions. Today, in attempting to see Western art through Japanese eyes, Americans may gain a fuller understanding of Japanese culture. Further, viewers of *Paris in Japan* may judge for themselves the extent to which these painters fulfill or redefine expectations concerning Japanese artistic sensibilities. As earlier in the century, there remain competing perceptions regarding the cultural values expressed by these artists. Yet equipped with the advantage of hindsight and knowledge of contemporary Japan, Americans today may enjoy learning how and why Japan sought inspiration from the West and discovering how much we have shared with Japan in the quest to articulate cultural values through the visual arts.

Notes:

1. Henry James, "John S. Sargent," *Harper's New Monthly Magazine*, 75 (October 1887): 683.
2. James Jackson Jarves, *The Art-Idea* (1864; reprint ed., Cambridge, Massachusetts: Harvard University Press, 1960), pp. 166–67.
3. James Jackson Jarves, *A Glimpse at the Art of Japan* (1876; reprint ed., Rutland, Vermont: Tuttle, 1984), p. 184.
4. Ernest Fenollosa's remarks were cited and reviewed in "A Lecture on 'Japanese Art,'" *Studio* n.s. 7 (27 February 1892): 118.
5. See for example John La Farge, *An Artist's Letters from Japan* (1897; reprint ed., New York: Hippocrene Books, 1986); Robert Blum, "An Artist in Japan," *Scribner's Magazine* 13 (May 1893): 624–636; (June 1893):

729–749; Theodore Wores, "An American Artist in Japan," *Century* 38, n.s. 16 (September 1889): 670–686.

6. Louise Jones Dubose, *Enigma: The Career of Blondelle Malone in Art and Society, 1879–1951 . . . As Told in Her Letters and Diaries* (Columbia, South Carolina: University of South Carolina Press, 1963), pp. 30–31. I am grateful to William H. Gerdts for bringing this account to my attention.

7. Most notable among Morse's studies of Japanese culture was *Japanese Homes and Their Surroundings* (1885; reprint ed., New York: Dover, 1961).

8. "Japanese Artists' Work," *Boston Daily Advertiser*, 13 February 1900, p. 8.

9. "Japanese Pictures at the Museum of Fine Arts," *Boston Evening Transcript*, 10 February 1900, p. 10.

10. "Exhibition of Japanese Watercolors at the Boston Art Club," *Boston Evening Transcript*, 17 December 1900, p. 16.

11. I thank Emiko Yamanashi for generously sharing her research on the subject of American perceptions of Japanese art, particularly regarding this point.

12. Matsuki frequently assembled and sent collections of Oriental objects to the American Art Association. In 1906 he consigned seventy oil paintings and watercolors by the same group of Western-style Japanese artists, an indication of continued demand for their work. In addition to Japanese genre and landscape subjects, the sale included *Dawn in New England* and *Dusk in May* painted in the Berkshires by Yoshida. For a review of the work see "By Japanese Artists. Paintings and Water Colors at the American Art Gallery," *New York Times*, 11 April 1906, p. 5.

13. "Japanese Water Colors," *New York Times*, 10 December 1902, p. 8.

14. "The Water Color Exhibition," *New York Times*, 27 November 1902, p. 9.

15. Perhaps equally significant is the fact that one of the Japanese-style painters, Takashima Hokkai, exhibited two watercolor and ink paintings of the Rocky Mountains. The choices of subjects exhibited by each faction may disclose Japanese opinions concerning American taste and expectations. The oil painters may have avoided direct comparison with American and European landscape painters by offering only Japanese subjects.

16. Will H. Low, "The Field of Art: St. Louis," *Scribner's Magazine* 37 (June 1905): 767.

17. Charles H. Caffin, "The Exhibit of Pictures and Sculpture," *World's Work* 8 (August 1904): 5183.

18. Kakuzō Okakura, "Modern Problems in Painting," in *Congress of Arts and Science: Universal Exposition, St. Louis, 1904*, vol. 3, ed. Howard J. Rogers (Boston: Houghton, Mifflin and Company, 1906), p. 674.

19. Ibid., p. 675.

20. Maude I. G. Oliver, "Japanese Art at the St. Louis Exhibition," *International Studio* 25 (1905): 250.

21. Sadakichi Hartmann, *Japanese Art* (Boston: L. C. Page, 1903; reprint ed., New York: Horizon Press, 1971), p. 258. For another early view of contemporary Japanese painting see Kakasu [Kakuzō] Okakura, *The Ideals of the East with Special Reference to the Art of Japan* (New York: Dutton, 1903).

22. Hartmann, pp. 261–262.

23. Jirō Harada, "Japanese Art and Artists of To-day. I. Painting," *Studio* 50 (1910): 120.

24. Jirō Harada, "The Modern Development of Oil Painting in Japan," *International Studio* 55 (1915): 277. See also Jirō Harada, "The Old and New Schools of Japanese Painting," *Studio* 57 (January 1913): 231–236; "Japanese Painters Owe Debt to West," *New York Times*, 14 January 1913, p. 8; and Yone Noguchi, *The Spirit of Japanese Art* (New York: Dutton, 1915), pp. 100–114.

25. I am indebted to Abigail Gerdts for facilitating access to registration records at the National Academy of Design and for providing information on Date Kotarō.

26. Masanori Ichikawa confirms that at the time "the image of America as a money tree was widespread throughout Japan." See "A Study on Yasuo Kuniyoshi and the Problems of the Japanese-American Painters," in *Japanese Artists Who Studied in U.S.A. and the American Scene* (Tokyo: National Museum of Modern Art, 1982), pp. 174-175.

27. Serph Dumagnon [A. de Talmours], "Note," *L'Académie Julian* 12th year (November 1912): 5. Many Japanese studied in Jean-Paul Laurens's atelier at the Académie Julian; see "Les Japonais à l'Académie Julian," *L'Académie Julian* 4th year (November 1904): 2. The December 1906 issue of the school journal featured KANOKOGI TAKESHIRŌ on its cover; see "M. T. Kanokogui," *L'Académie Julian* 7th year (December 1906): 1–2. YASUI SŌTARŌ was featured in the December 1909 issue; see "Note," *L'Académie Julian* 9th year (December 1909): 4. I am indebted to Catherine Fehrer for insight into the history and organization of the Académie Julian and its journal.

28. "A St. Louis Student to Revolutionize Japanese Art," *St. Louis Globe-Democrat*, 2 April 1905, p. 23. After arriving in Tokyo in 1920, Date returned, following the great earthquake of 1923, to his native province where he finished his life as an artist in and around Kagoshima.

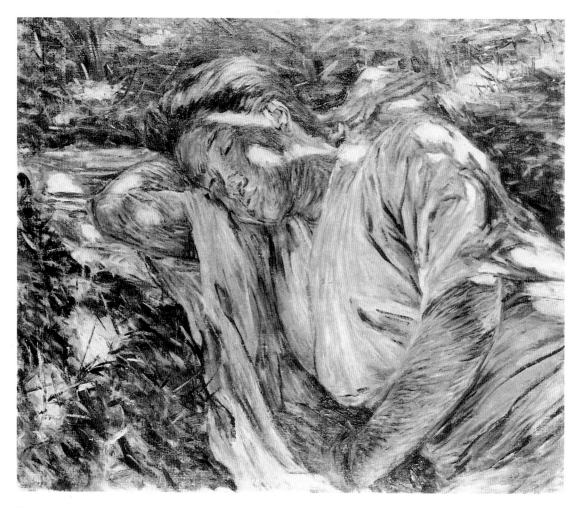

Fig. 1. KURODA SEIKI, *Siesta,* 1894. Oil on canvas, 49.8 x 61 cm/19⅝ x 24 in.
Tokyo National Research Institute of Cultural Properties, Tokyo.

EASTERN AND WESTERN DYNAMICS IN THE DEVELOPMENT OF WESTERN-STYLE OIL PAINTING DURING THE MEIJI ERA

Shūji Takashina

Paris does not emerge as a force in the history of modern Japanese art until after 1896, the year that KURODA SEIKI (1866–1924), still fresh from a decade of study in France, was appointed director of the Tokyo School of Fine Arts' Western Painting Section. KURODA was by no means the first Japanese artist to study painting in France during the Meiji era (1868–1912). Yamamoto Hōsui (1850–1906) arrived in Paris in 1878, Goseda Yoshimatsu (1855–1915) followed in 1880, and these were joined by men like Hyakutake Kenkō (1842–87), Kawamura Kiyo-o (1852–1934), Gōda Kiyoshi (1862–1938), and Fuji Masazō (1853–1916). Some of these artists remained abroad longer than others, but all applied themselves diligently to the mastery of Western painting technique during their stay. Indeed, Goseda and Fuji were rewarded in their efforts by the considerable honor of having their works accepted for exhibition by the French government-sponsored Salon, an accomplishment even for a French artist.[1] With the exception of Fuji Masazō, who later traveled to the United States and remained there throughout his life, all the aforementioned painters returned to Japan with their new skills in the 1880s, considerably before KURODA arrived on the scene. Yet their impact on Japanese art was limited. There are two major reasons for this. One is that these artists had studied with such conservative French academicians as Jean-Leon Gérôme and Léon Bonnat, and the styles they brought home with them consequently lacked freshness and vitality. A more fundamental reason is that just when they were returning to Japan, the fortunes of Western-style oil painting, or *yōga*, as it was called, happened to be at a low ebb; a campaign to revive traditional Japanese styles was in full swing, and *yōga* had been eliminated from official art curricula and denied official exhibition space. Western-style painters returning from study in Europe—not only in France but in Germany, Italy, and England as well—were denied an outlet for their skills.

Seen from this perspective, KURODA was doubly fortunate to have arrived in Paris a few years behind the rest. First, he was able to study with Raphaël Collin (1850–1916), who, academician though he was, represented a younger generation of artists that had come under the influence of the Impressionists. Second, he returned to Japan just as the government authorities had begun to revise their thinking and restore *yōga* to a position of respect. Another point in KURODA's favor was his family background. He belonged to the influential Satsuma clan, and his uncle and adoptive father, Kuroda Kiyotsuna, had played an important role in the Meiji Restoration and later risen to a high position in the government. Blessed with unusual talents in addition to such social status, KURODA had scarcely returned from Paris when he found himself at the center of the Japanese art world. He was to remain a leader in that world for many years to come.

To properly assess KURODA's impact on modern Japanese art it is necessary to survey the processes and underlying concepts according to which Western art styles were imported into Japan during the first three decades of the Meiji era, before KURODA's debut.

I. The Technical Art School and the Drive for Westernization

The history of art during the first two-thirds of the Meiji era, from 1868 to 1896, can be divided broadly into two periods. The first, from 1868 to 1882, was a period of thoroughgoing Westernization, dominated by the government's commitment to what it termed *bunmei kaika* (civilization and enlightenment). Traditional Japanese values were challenged, and Western art was held up as the definitive model. The succeeding period saw an abrupt about-face as the nation reacted against the blind Westernization of the preceding decades and sought a revival of Japanese tradition. *Nihonga*, or traditional Japanese-style painting, was given the official stamp of approval, and *yōga* was discouraged. Standing as symbols of the diametrically opposing trends of these two periods—one a headlong rush toward Westernization and the other an equally extreme traditionalist reaction—are two major art-historical events: the founding of the *Kōbu bijutsu gakkō* (Technical Art School) in the first period and the opening of the *Tokyo bijutsu gakkō* (Tokyo School of Fine Arts) in the second.

The Technical Art School was set up on the campus of the Imperial College of Technology, in Tokyo's Toranomon district on November 6, 1876. The event is recorded in the *Kōbu enkaku hōkoku* (Report on the Development of the Ministry of Industry and Technology) as follows:

> *The Technical Art School was established on November 6 as part of the main college. Its curriculum is to consist of painting and sculpture, painting involving instruction in drawing and oil painting, and sculpture involving instruction in the techniques for modeling the forms of various objects in plaster. Three Italians were enlisted as instructors, and the school regulations were drawn up.*

This, then, was Japan's first official art school. It might be noted that the first government-sponsored music school, the *Ongaku torishirabe-gakari* (Music Study Committee), which was later renamed the *Tokyo ongaku gakkō* (Tokyo Music School), was not launched until three years later, in 1879, and it was not until the following year that Luther Whiting Mason and three other American musicians arrived from Boston to teach at the school. Since the Italian art instructors mentioned in the record cited above began to teach classes as soon as the school was established, the Technical Art School had a head start of four years. This is not because the Meiji government somehow judged the plastic arts more noble than music, but because in the first part of the Meiji era, Western-style drawing, painting, and sculpture were viewed more in technical than in aesthetic terms. In fact, the regulations of the Technical Art School stated clearly that the facility was established "to improve various crafts by promoting the application of modern European techniques to traditional Japanese methods."

That the concept behind the establishment of these two schools differed fundamentally is apparent from the fact that the Music Study Committee was under the jurisdiction of the Ministry of Education, while the Technical Art School was established as part of the Imperial College of Technology, which was under the *Kōbushō* (Ministry of Industry and Technology), an affiliation virtually spelled out in the name of the art school. The Imperial College of Technology itself, established with the objective of "promoting the development of industry to the full," covered in its curriculum practically every field of practical value, including civil engineering, mechanics, electronics, architecture, chemistry, and mining. It was established, in other words, to import the Western technology needed to fur-

ther the national goals embodied in such official slogans as "civilization and enlighten-
ment" and "foster industry, promote production." Art was simply given a supporting role
in the importation of Western technological civilization.

Considered in this context, it is hardly surprising that the Technical Art School dis-
played an uncompromising Western orientation from its inception. Whereas the Music
Study Committee at least included a *hōgaku* (Japanese music) as well as *yōgaku* (Western
music) department, the Technical Art School consisted of a painting department and sculp-
ture department, both of which were concerned exclusively with Western styles and tech-
niques. Traditional Japanese art was ignored entirely.

This was not so much a conscious decision as an inevitability. Doubtless it never oc-
curred to the Minister of Industry and Technology, Itō Hirobumi, and the others who had
conceived of the Technical Art School, that the traditional styles and techniques of Kanō
school painting or of Buddhist sculpture, for example, should be included under the rubric
of "art," itself an imported concept.[2] The uncompromising Europeanizing orientation of
the Technical Art School can be inferred from two provisions in the original school regu-
lations: "Only Westerners shall be appointed as instructors," and "Within the school both
staff and students shall adopt the Western mode in all things relating to clothing, meals,
and living quarters." As one might well imagine, the latter rule proved somewhat imprac-
tical in a country that had first opened its doors to the outside world only some twenty
years earlier, and it was abandoned in the revised regulations that were later adopted. Such
dizzying developments and abrupt turnabouts are vivid testimony to the sense of urgency
with which the leaders of Meiji Japan drove the county on toward their goal of Westerni-
zation and modernization. More than anything, the Technical Art School was a product of
the utilitarian, Westernizing ideals that motivated the builders of early Meiji Japan.

Actually, the tendency to view painting solely in terms of technique had already taken
hold among the small circle of Japanese painters who had begun to devote themselves to
the study of Westen art during the late Edo period (1615–1869). The Tokugawa Shogunate's
long-held isolation policy notwithstanding, a limited amount of trade was conducted with
the West, primarily Holland, and the exotic Western civilization that filtered into Japan
through the port of Nagasaki, especially during the second half of the eighteenth century,
had a profound influence on the more advanced Japanese intellectuals of the day. A land-
mark in the pursuit of Western learning during this period was the publication in 1774 of
Kaitai shinsho (New Book of Anatomy), translated from the Dutch edition of a German
medical book.

In the area of art, the vast majority of Western works imported into Japan were either
copperplate prints or book illustrations, but even these were sufficient to give Japanese
painters a sense of the vast gulf between Western and Japanese painting. What stirred their
admiration was a drawing technique whereby the visible world could be reproduced with
astonishing accuracy. One such admirer was Satake Shozan (1748–85), the daimyō of the
Akita clan, whose retainer Odano Naotake (1749–80), drew the illustrations for *Kaitai
shinsho*. A talented painter in his own right, Shozan pointed out in his 1778 essay *Gahō
kōryō* (Art of Painting) that traditional Japanese painting methods did not allow one to dis-
tinguish between a circle and sphere or indicate whether a boat floating on a river was near
or far away. But by using the Western techniques he had mastered, Shozan boasted,
all such distinctions could be clearly expressed. Similar ideas are put forth somewhat later in
the *Seiyōgadan* (Discussion of Western Painting), written in 1799 by the renowned pioneer
of Western art and science, Shiba Kōkan (1747?–1818):

It is impossible to depict reality using Chinese and Japanese drawing techniques. The reason is that when depicting a spherical object [using these techniques] one simply draws a circle and calls it a sphere. There is no method for dealing with convexity. When depicting the front view of a human face, likewise, one is unable to describe the prominence of the nose. [Western] painting emerges not from the delineation [of objects] but from [their modeling in] light and shade.

As this passage makes clear, the author believes that the purpose of painting is to "depict reality," and that as a means to this end, Western art technique is superior to that of Japan or China. This thinking continued in an unbroken line from people like Shozan and Kōkan to the prominent late-Edo and early-Meiji *yōga* painter Takahashi Yuichi (1828–94) and to the students of the Technical Art School. The notion profoundly influenced the subsequent development of *yōga* by encouraging Japanese painters studying Western painting to focus on techniques for rendering three-dimensional effects, such as spatial depth and solidity. Such pictorial techniques, devised during the Renaissance, enabled artists to attain visual realism through perspective drawing, modeling, and chiaroscuro. Of course, in the West these techniques were grounded in classical aesthetic principles. But Japan's *yōga* movement displayed no interest in the aesthetic underpinnings of Western art; it focused only on the techniques to which those principles had given rise. To be sure, Antonio Fontanesi (1818–82), one of the Italian artists who had been invited to teach at the Technical Art School, discussed aesthetics in his lectures, but his Japanese students failed to absorb such concepts—or, more accurately, they failed to understand them. To these students, Western painting was nothing more or less than a set of techniques for the realistic representation of the visible world.

The utilitarian, art-as-technology approach of Japan's first official art school in large measure determined the course of Western-style painting in Japan, with both negative and positive results. On the one hand, it was this very utilitarian emphasis that led to the summoning of European instructors to provide formal Western art training less than a decade into the Meiji era. Had such steps not been taken, *yōga* would have continued to grope in the darkness for years to come. On the other hand, the overwhelming emphasis on technical and utilitarian values made it difficult for *yōga* to achieve artistic independence and maturity, which in turn hindered the development of supporting aesthetic principles. As a consequence, when the American Ernest Fenollosa came wielding his own brand of aesthetics, and delivered a blistering attack on *yōga* in the late 1870s, the Technical Art School, with its grounding in utilitarian values, could muster neither the aesthetic principles nor the artistic concepts to withstand the onslaught and crumpled under the assault.

II. The Tokyo School of Fine Arts and the Traditionalist Revival

Whereas it was three Italian instructors, brought to Japan with the cooperation of the Italian government, who enabled the Japanese government to open the Technical Art School, it was a single American with a passion for Japanese art who provided the main impetus behind the establishment of the Tokyo School of Fine Arts. Ernest Fenollosa (1853–1908), a graduate of Harvard University, arrived in Japan in 1878 to assume a teaching post at Tokyo University. At the time Fontanesi had just returned to Italy after two years in Japan, so that by pure happenstance Fenollosa appeared on the scene as if to take his place.

Although invited to Japan to teach political economy, Fenollosa was also an art aficionado and had studied drawing and oil painting in Boston. When he first arrived in Japan,

however, he knew almost nothing about Japanese art and, in fact, actually conferred with artists like Takahashi Yuichi on ways to foster Western-style art in Japan. According to records left by Yuichi, around 1880 the two became friendly and made plans to hold lectures and similar activities to promote "the expansion of *yōga*," but the plan was never realized. Fenollosa switched course and began to espouse the cause of *Nihonga* instead.[3]

Beginning in 1880, Fenollosa made frequent trips to Nara and Kyoto, where he found to his surprise that ancient Japanese art was not only surpassingly beautiful but also possessed stylistic elements that could be traced back to the so-called Greco-Buddhist, or Gandharan, art of Northern India and Pakistan—and, by extension, to the art of ancient Greece and Rome—a discovery that led him to the theory that ancient Japanese art is a distant heir to the classicism of ancient Greece.[4] Working from this theory, he singled out for praise the languishing Kanō school of painting as the most orthodox and legitimate heir to the ancient legacy of classicism and thenceforth bent his energies to the revival of that school.

Hence, Fenollosa's appreciation of Japanese art was not an indiscriminate infatuation with the exotic. It was, rather, a considered evaluation based on his own distinct interpretation of history. In fact, Fenollosa was sharply critical of other contemporary currents in Japanese painting, most notably *bunjinga*, a school based on the style of Chinese literati painting that enjoyed considerable favor at the time. In a famous lecture delivered in 1882, Fenollosa went so far as to declare that in Japan "true painting" was being crushed to death between *bunjinga* and *yōga*.

In 1884, Fenollosa began to apply himself in earnest to the revival of what he called "true painting," holding exhibitions of and lectures on old paintings, and forming the *Kangakai* (Painting Appreciation Society) to discuss and appraise such works. In addition, he actively encouraged and assisted contemporary *Nihonga* painters, including the Kanō school artists Kanō Hōgai (1828–88) and Hashimoto Gahō (1835–1908). In his campaign to revive traditional styles he found an ally in his protégé and colleague Okakura Kakuzō (1862–1913), more commonly known as Okakura Tenshin, and their efforts bore fruit in the founding of the Tokyo School of Fine Arts in 1887.

The Technical Art School, meanwhile, had been closed down in 1883, a victim of the Meiji government's abrupt shift in policy concerning art education. This new policy was to be embodied in the Tokyo School of Fine Arts, whose *raison d'être* was the revival of Japanese traditions—the direct antithesis of the Technical Art School's Westernizing mission. To prepare for the founding of the new school, Fenollosa and Okakura traveled abroad and toured the art facilities of major European countries. Their conclusion, however, was that there was "nothing at all there that Japan should adopt."

Thus it was, when the school's three departments of painting, sculpture, and crafts were established, that the curriculum of each was designed with a view only to traditional Japanese techniques; such Western media as oil painting and pencil drawing had no place in the school. The classrooms were equipped with neither easels nor chairs, as students were expected to work on tatami mats, sitting with their legs tucked under them in the Japanese manner. The uniforms worn by the faculty and students were personally designed by Okakura in imitation of the official attire of the Nara period (710–794). Only eleven years after the Technical Art School had adopted its almost absurdly Europeanizing regulations, the government had embraced the opposite extreme of traditionalism as the cornerstone of its policy on the fine arts.

It should be noted, however, that the traditionalism of the Tokyo School of Fine Arts

aimed not simply at the revival of old styles but at the creation of a new school of Japanese-style painting. Fenollosa, who had glimpsed the heritage of Greek classicism in ancient Japanese art, hoped to witness the birth of a modern Japanese painting idiom informed with that same spirit. Okakura, who was even more international in his outlook than Fenollosa, went further, arguing for the incorporation into *Nihonga* of Western techniques for suggesting spatial depth and rendering light and shadow. Okakura's protégés, artists like Yokoyama Taikan (1868–1958), Hishida Shunsō (1874–1911), and Shimomura Kanzan (1873–1930), responded by boldly forging modes of expression previously unknown in Japanese painting, and as a result found themselves locked in bitter confrontation with the more conservative *Nihonga* painters.

These were dark days for Japan's *yōga* artists, pushed into obscurity by the momentum of the traditionalist revival. No official facility for the study of Western art techniques arose to take the place of the now defunct Technological Art School, and the enrollment of private art classes run by *yōga* painters dwindled until most of them, too, were forced to close down. In 1882 *yōga* works were banned from the National Competitive Painting Exhibition held by the government for the promotion of art. The persecution to which *yōga* was subjected during this time is reminiscent of the desperate measures that the Tokugawa Shogunate took to rout the foreign traders who were attempting to open the country to the West in the early nineteenth century. A number of *yōga* painters recorded ruefully that in those days, anyone attempting to work in the Western style was viewed as a traitor.

To form a united front capable of standing up to this persecution, a group of artists led by ASAI CHŪ (1856–1907) and Koyama Shōtarō (1857–1916), both former students of Fontanesi, banded together in 1889 to form the *Meiji bijutsukai* (Meiji Fine Arts Society). Thereafter the government gradually began to permit *yōga* painters to participate again in official exhibitions. But it was not until KURODA'S advent that the *yōga* movement was able to regain its former momentum.

III. *Kuroda Seiki and the New School*

KURODA returned to Japan in 1893 after nine years in France. Three years later he was appointed director of the newly established Western Painting Section of the Tokyo School of Fine Arts. In the same year he withdrew from the Meiji Fine Arts Society, in which he had participated since his return, and, together with KUME KEIICHIRŌ (1866–1934), whom he had met in Paris, founded a new association of *yōga* painters called the *Hakubakai* (White Horse Society), which held its first exhibition that year. Thus KURODA launched a brilliant career that spanned both the public and private spheres. KURODA'S reasons for leaving the Meiji Fine Arts Society and establishing an independent group related to major differences between the bright-colored, Impressionist-influenced painting style he had learned in Paris and the style preferred by the majority of the Society's members, who traced their artistic lineage back to Fontanesi. KURODA'S teacher in Paris, Raphaël Collin, while himself an academician, had borrowed a number of stylistic elements from the Impressionists, including the use of informal compositions and a preference for bright colors, creating a style that might be termed "Impressionistic Academism." KURODA perpetuated this style, and to those accustomed to the murky painting of the Meiji Fine Arts Society, his works must have appeared shockingly out of the ordinary. In fact, when KURODA showed his painting *Siesta* (Fig. 1), painted the year after he returned to Japan, in

the Society's sixth art exhibition, the work elicited these scathing comments by Takayama Chogyū in a review published in the March 1896 issue of the magazine *Taiyō*:

> There are fine parallel brushstrokes of yellow, red, blue, violet, and other colors adorning the faces, hands, and feet, so that at first glance it is difficult to discern whether in fact this is a human figure or not. However beautiful his Southern-school cronies may have found the painting, the Society members, their general enthusiasm for painting notwithstanding, could only stare at one another in blank amazement.

In view of this type of reaction, it is not surprising that KURODA felt the need to part ways with his fellow *yōga* painters in the Meiji Fine Arts Society and establish a new direction for *yōga* by forming an independent association of his own. From 1896 on, the history of Meiji *yōga* is dominated by the competitive relationship between the "new school," represented by the White Horse Society, and the "old school," represented by the Meiji Fine Arts Society and its later incarnation, the *Taiheiyō gakai* (Pacific Painting Society).[5] Even within lay circles attention was focused on the rivalry between the old and new schools of Western-style painting, which came to be known also by such sobriquets as the "resin school" and the "purple school," or, as in the passage quoted above, the Northern and Southern schools, respectively.

This split continued beyond Japan's borders, moreover, manifesting itself in the type of training Japanese artists received in Paris. While many artists of the White Horse Society, including OKADA SABURŌSUKE (1869–1939) and Wada Eisaku (1874–1959), followed in the footsteps of KURODA and KUME by studying under Raphaël Collin, most of the more prominent members of the Meiji Fine Arts Society and the Pacific Painting Society, including MITSUTANI KUNISHIRŌ and Nakamura Fusetsu (1866–1943), chose instead to work in the atelier of one of the most conservative painters associated with the French Academy, Jean-Paul Laurens. In other words the dichotomy between the old and new schools within Japanese *yōga* paralleled the situation within the Paris art world itself, a correlation that attests to the close connections between the Paris and Japanese art worlds during this period.

At about the same time, moreover, *Nihonga* had likewise split into two opposing camps, consisting on the one hand of the more conservative Japanese-style painters and, on the other hand, of Okakura Tenshin's protégés at the *Nihon bijutsuin* (Japan Fine Arts Academy), founded in 1898, who had forged a bold "new *Nihonga*" by incorporating Western modes of expression. Thus the dynamics of the Meiji art scene shifted in the 1890s from the confrontation between *yōga* and *Nihonga* to that between conservative and progressive forces in both schools. The old-new split overshadowed the East-West split to the extent that on occasion the *Nihonga* progressives and the *yōga* progressives found themselves on the same side of the fence. Okakura, the foremost advocate of the "new *Nihonga*," was himself relatively receptive to the new *yōga* of KURODA and KUME; in fact, the first exhibition of the White Horse Society was held jointly with a group consisting primarily of Okakura's pupils, the *Nihon kaiga kyōkai* (Japanese Painting Society).

IV. Toward a New Aesthetic Foundation

KURODA'S impact on Western-style painting in Japan went far beyond the introduction of techniques for suggesting the play of light through the use of bright colors. KURODA wished not only to propagate the Impressionist-influenced style of Collin but also to transplant in Japanese soil the underlying artistic principles of European academism. These prin-

ciples, collectively referred to as the *ut pictura poesis* aesthetic, revolved around the notion that the purpose of painting is not simply to represent the visual world but to convey some story, idea, or philosophy. This aesthetic, as embodied in the concept of classicism, had crystallized in the Renaissance and prevailed through the first half of the nineteenth century. Within the framework of European academic art theory, it meant that "history painting" (in its broad sense embracing religious, allegorical, and literary subjects) was at the top of the painting hierarchy.[6]

That KURODA had grasped the aesthetic principles of academic painting while studying in Paris is apparent from a letter to his father dated April 17, 1890. In it KURODA conveyed his realization that the function of painting is not the representation of the outward form of nature but the expression of inner thoughts and ideas.

> *Here [in France] the human figure is used to present a given idea. In a painting of my teacher's titled* Spring, *for example, a plump, beautiful woman is depicted lying down in a meadow full of flowers, casually chewing on a blade of grass. . . . Ignorant people viewing this painting of a beautiful woman, which my teacher had titled* Spring, *would think it nothing but a picture of a naked woman lying in the grass. . . . They would subject it to absurd criticisms, arguing that in Europe women do not really lie naked in meadows, and so forth. My teacher, however, in order to represent the feeling of spring, borrowed the figure of a woman as lovely as a flower beginning to bloom. In other words, this spring is a spring that exists only within the human heart. Anyone possessed of the same sensibility as my teacher will be filled with inexpressible joy upon viewing this work.*

The work that KURODA refers to in this passage is probably Collin's well-known painting *Floréal* (Fig. 2) which should accordingly be considered an allegorical painting. After his return home, KURODA tried his own hand at historical and allegorical subjects—producing such works as *Telling an Ancient Romance* (Fig. 3), *Wisdom, Impression, and Sentiment* (Fig. 4) and *Flowering Field* (Cat. 37)—hoping to introduce this genre into Japan. The enthusiasm with which various other *yōga* painters applied themselves to historical painting during the last decade of the Meiji era is largely owing to KURODA's influence. One of the finest products of this phase of *yōga* is *Palace under the Sea* (Cat. 2) by AOKI SHIGERU (1882–1911), an active participant in the White Horse Society exhibitions.

Nonetheless, history painting as KURODA conceived of it—that is, painting that communicates an idea or principle—never really developed to maturity in Japan. This is no doubt partly because Japanese painters found it difficult to shake free from the emphasis on representation of the visual world that characterized *yōga* in its early phases, and partly because KURODA himself, despite his superb expressive technique, lacked the imagination to produce great historical painting. But most decisive was the fact that in the late nineteenth century European academism itself was in the midst of a major upheaval. In Paris, by then the center of the art world, while academic styles were still prominent, the spotlight had shifted to the more progressive plein-air artists, Manet, the Impressionists, and the Post-Impressionists. These artists rejected the *ut pictura poesis* aesthetic, declared history painting passé, and set about forging a new mode of artistic expression for the twentieth century. KURODA attempted to transmit the concepts underlying the long tradition of Western academism to Japan just as that tradition was breathing its last gasp in Europe.

Moreover, as the work of Collin demonstrates, academic painting itself was undergoing major transformations. Works like *Floréal* and *Three Women in a Green Field* (Fig. 5) show Impressionist influence not only in their use of color but also in their composition,

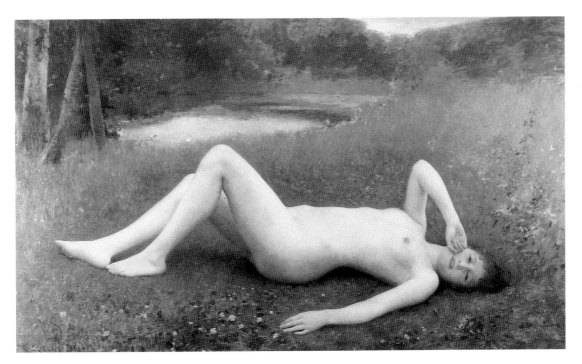

Fig. 2. Raphaël Collin, *Floréal,* 1886. Oil on canvas, 110.5 x 191 cm/43½ x 75³/₁₆ in.
Museum of Fine Arts, Palais Saint-Vaast, Arras.

Fig. 3. KURODA SEIKI, *Telling an Ancient Romance,* 1898. Oil on canvas,
189 x 307 cm/74⅜ x 120⅞ in. Original destroyed.

Fig. 4: Kuroda Seiki, *Wisdom, Impression, and Sentiment(from right)*, 1899. Oil on canvas, each panel 180.6 x 99.8 cm/71⅛ x 39⁵⁄₁₆ in. Tokyo National Research Institute of Cultural Properties, Tokyo.

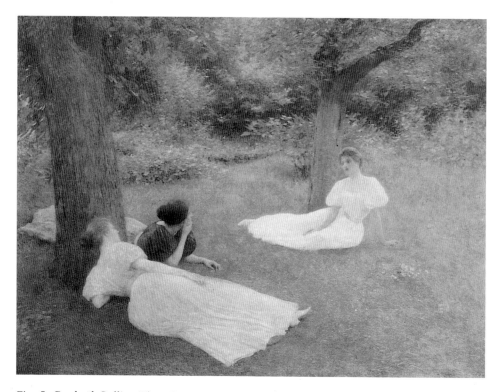

Fig. 5: Raphaël Collin, *Three Women in a Green Field,* 1895. Oil on canvas, 143 x 196 cm / 56½ x 77⅙ in. Private collection, Tokyo.

with their elevated viewpoint and high horizon. These devices, favored by Gauguin and the Nabis, represented marked departures from standard compositional formulas, widely observed since the Renaissance, of locating the viewpoint at human eye level. By minimizing the effect of spatial depth, this type of composition opened the way to a new emphasis on the picture surface. It is of considerable interest to note that many of the distinctive features of the new style, including the high horizon and the preference for bright colors, were inspired by Japanese art of the Edo period, woodblock prints in particular. In *Siesta* and *Flowering Field*, KURODA faithfully incorporates these stylistic features as he learned them from Collin. Thus, while he himself was doubtless unaware of it, his art represents the reimportation into Japan of those distinctive elements of Japanese art that crossed over to Europe on the slightly earlier wave of nineteenth-century *Japonisme*.

Within a half-century after the Tokugawa Shogunate had opened the country's doors to the West in 1854, the distance between Japan and Europe had shrunk to the point where stylistic interchanges and mutual influences were possible. As the Meiji era gave way to the Taishō period (1912–1925), this distance telescoped even further. New art movements, especially those originating in the artistic capital of Paris, elicited immediate reactions from artists in Japan and acted as vital catalysts in the development of modern Japanese painting.

Notes:

1. Goseda Yoshimatsu had paintings selected for Salons in 1881, 1882, and 1883; Fuji Masazō's work was exhibited by the Salon des Artistes Français in 1888.

2. The term *bijutsu* was coined in the 1860s, when it was used to designate the arts in general, including music and literature. By the 1870s, its meaning had altered to embrace the English term "fine arts" or the French "beaux-arts," including architecture. Since the 1880s, the meaning of *bijutsu* has narrowed in general usage to refer only to the plastic arts (painting and sculpture). The concept of art in general came to be conveyed by a latter neologism, *geijutsu*.

3. The following passage appears in the *Takahashi Yuichi abura-e shiryō*, a record in the possession of the Tokyo University of Fine Arts and Music: "In Meiji 13, Mr. Fenollosa, an American in the employ of the Ministry of Education, appeared at my residence, the Tenkai gakusha. He spoke about promoting the spread of *yōga* and conferred with me about the possibility of visiting my school from time to time and delivering lectures on *yōga* and the history of Western art for the painting students and general listeners. I was happy to oblige and promised to call on him to lecture. Later I visited Mr. Fenollosa occasionally at his residence in Hongō, where he showed me some oil paintings of his own creation and he eventually gave me one, a landscape. Thereafter we grew closer as we continued to exchange thoughts on the subject of *yōga*, but . . . [ultimately] the agreement we made was dissolved, for Mr. Fenollosa had converted to the cause of promoting *Nihonga*."

4. The chapter on the Nara and Heian periods in Fenollosa's posthumously published book *Epochs of Chinese and Japanese Art* is titled "Greco-Buddhist Art in Japan."

5. In 1900 the Meiji Fine Arts Society, its influence eclipsed by that of the White Horse Society, was dissolved, and in the next year the Pacific Painting Society was organized by a group of artists centering on such students of Koyama Shōtarō as MITSUTANI KUNISHIRŌ, Yoshida Hiroshi (1876–1950), and Nakagawa Hachirō (1877–1922). Painters who joined the Society later included KANOKOGI TAKESHIRŌ and Nakamura Fusetsu.

6. Articulated by Horace in his *Ars poetica, ut pictura poesis* was interpreted in the Renaissance to mean "as is poetry so is painting." According to this principle, it was the purpose of painting to express universal human experience and truth through the depiction of instructive episodes from classical or biblical history. Perpetuated in the academic manner of teaching, the aesthetic resulted in a hierarchy that ranked history painting, since it fulfilled the classical mandate to both instruct and please, above portrait, landscape, and still life painting. See Rensselaer W. Lee's *Ut Pictura Poesis: The Humanistic Theory of Painting* (New York: Norton, 1967).

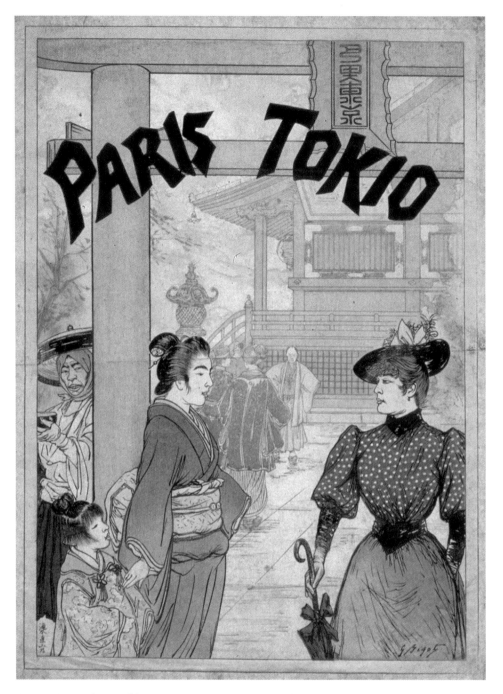

Fig. 6. Poster designed by George Bigot (1860–1927) for the 1900 Paris Exposition
Universelle. Woodblock print, 32 x 24.5 cm/12⅝ x 9⅝ in.

TOKYO IN PARIS/PARIS IN TOKYO

J. Thomas Rimer

Prologue: The Context for Japanese Interest in Western Art

By the late nineteenth century, Paris had become the center of the artistic world. Artists from the Americas, the rest of Europe, and from many parts of Asia were flocking to live, observe, study and create in an atmosphere of intellectual exhilaration and aesthetic accomplishment. The sense that by living in Paris they were at the center of the excitement, part of an artistic society within a society, helped sustain several generations in their quest for a new and authentic means of artistic expression. The interchange between Paris and Berlin, Vienna, London, and New York have been much studied and commented upon, and more recently the travels of Scandinavian, eastern European, and Russian artists to Paris have come to be documented as well. The exhibition, however, sets out to explore the equally evocative links between Paris and Japan in that formative period from 1890 to 1930 when the traditions of modern Japanese art were being established. *Japonisme*, the effect of Japanese art on the French, is a well-known phenomenon, but the reciprocal and equally important effect of French art on the Japanese is the story that this exhibit will, at least in part, reveal. What follows here is a general sketch of the artistic activities of this period that focus on the significance of the French experience, and the French example, in the development of modern Japanese art. There were other European influences as well during the period; in particular, some Japanese artists were inspired by the example of German, English, and Spanish painters. The main focus of artistic relationships from 1890 to 1930, however, was that established between Paris and Tokyo.

In order to create a context for understanding the significance of this link, a number of topics are dealt with here in order to provide some overall sense of the complexities, both in the world of art and in the larger cultural aspects of Japanese society. It is our hope to raise here a number of provocative questions and issues, even if, at this stage of research on the period, they cannot all be responded to fully. In order to help readers new to the subject of modern Japanese art, certain points are raised in differing contexts, which accounts for some occasional repetitions.

Until the latter part of the nineteenth century the traditions and techniques of older Japanese art were consonant with those originally inspired by the Chinese model. Centuries of interplay between Chinese ideals and Japanese sensibilities created the great traditions of Japanese painting which encompass many modes. By the Tokugawa period (1600–1868), these possibilities ranged from works drawing on predominantly Japanese styles, such as screens by Ogata Kōrin (1658–1716) (Fig. 7), to the literati painting (*bunjinga*) of the eighteenth and nineteenth century (Fig. 8), which reassembled elements of classical Chinese painting according to Japanese sensibilities of color, line, and subject matter.

In the development of these traditional Japanese styles and techniques, a significant element of self-consciousness was present. Individual artists had as a part of their artistic and philosophical grounding the skills needed to assess, and therefore manipulate, both Japanese and Chinese painting styles of any period. It is this quality of self-awareness, this implicit understanding of art as conscious creation, as a theme and variations, that gives so

Above: Fig. 7. Ogata Kōrin, *Iris,* early eighteenth century. Folding screen, colors on paper, each panel 151.2 x 360.7 cm/59½ x 142 in. Nezu Art Museum, Tokyo.

Left: Fig. 8. Yosa Buson, *Black Kites and Crows,* 1778–1783. Hanging pair of scrolls, ink and colors on paper, 133.3 x 54.4 cm/ 52⅜ x 21½ in. Private collection.

much of traditional Japanese painting that quality that might be defined as a controlled and highly creative eclecticism. Indeed, it might be noted that the developments in Western art in our own century, with its own restless reworking of styles, has allowed the modern public in Europe and America to appreciate these virtues in traditional Japanese art, as viewers have become increasingly familiar with the various elements that go to make up the Chinese and Japanese vocabulary of style.

However powerful the influence of Chinese painting had been on the traditional arts of Japan, knowledge and appreciation of Western art began with the coming of the Europeans, many of them Catholic

Fig. 9. Anonymous, *Foreign Princes on Horseback,* about 1590. Detail of four-panel screen, colors on paper, 166.2 x 468 cm/65½ x 184¼ in. Kobe Municipal Museum of Nanban Art, Kobe.

missionaries, in the 1500s to create what has been dubbed "Japan's Christian century." The Europeans brought with them objects and art works that were avidly studied by Japanese artists and patrons. Certain maps and other works painted by the Japanese at that time in imitation of Western styles, although scarcely of the highest level of accomplishment, show the existence of a lively curiosity and a satisfactory grasp of new and fundamental Western techniques, such as shading and perspective (Fig. 9).

These tentative experiments might well have become traditions in their own right had not the Tokugawa Shogunate, shortly after consolidating its power in 1600, decided for political reasons to virtually cut off all contact between Japan and the nations of Europe. Only the protestant Dutch were permitted to continue their trade with the Japanese through the southern port of Nagasaki. They were seldom allowed to travel to the great cities of Kyoto, the imperial capital, Osaka, the center of merchant culture, or Edo (now Tokyo), the administrative capital of the Shogunate. It was through the tiny aperture of Nagasaki, itself a distant and provincial milieu for the Japanese, that information on all subjects Western, including Western art, was permitted to filter into Japan.

Japanese curiosity about Western art, however, continued to produce a series of remarkable and sometimes aesthetically accomplished experiments using Western artistic techniques as a means of recording the sights of the physical world, a desire that in itself reflects the burgeoning of a scientific spirit. Western art came to be seen, from the limited amount of evidence available, as an effective means to record the realities of the physical world, both in terms of space, through the use of perspective, and the choice of subject matter. By the late eighteenth and early nineteenth centuries, such artists as Shiba Kōkan (1747–1818) (Fig. 10), Aōdō Denzen (1748–1822) (Fig. 11), and Watanabe Kazan (1793–1841) (Fig. 12), had not only produced accomplished works, based on what they were able to learn, but had managed to stimulate curiosity in artistic circles generally about the vocabulary of Western art. On the whole, it might be said that those artists used what they knew about Western art in the same way their predecessors employed elements in Chinese art. In both cases these imported styles were mixed and blended with elements in the Japanese tradition so as to produce a synthesis that manifested, through juxtaposition and combination, the power of their own individual artistic personalities.

35

Above: Fig. 10. Shiba Kōkan, *Shichirigahama,* 1798.
Colors on paper, 49.5 x 71.2 cm/19½ x 28 in.

Below: Fig. 11. Aōdō Denzen, *Outside Edo Castle,* undated.
Colors on paper, 35 x 68 cm/13¾ x 26¾ in.
Tokyo University of Fine Arts, Tokyo.

Right: Fig. 12. Watanabe Kazan, *Portrait of Ichikawa Beian,*
1837. Hanging scroll, ink and colors on silk, 129.5 x 59 cm/
51 x 23¼ in. Agency for Cultural Affairs, Tokyo.

Fig. 13. Antonio Fontanesi, *Tranquillity*, 1860. Oil on canvas, 82 x 120 cm/32¼ x 47¼ in. Municipal Museum of Modern Art, Turin.

In 1868, the Emperor Meiji took the political power from a defeated Shogunate and, in a reversal of the long traditional policy, opened the country directly to outside influences. The famous "Charter Oath" of 1868 exhorted the nation's youth: "Knowledge shall be sought throughout the world so as to strengthen the foundation of imperial rule." Within a few years, Japanese were abroad studying everything from police management and banking systems to Western hygiene and railroad design. There were some among them, of course, who also went to study art and literature. It was the work of that first generation which, taking Japan out of her isolation, was able to set the stage for the initial period of creativity in the arts that was to materialize before the turn of the century.

Relatively few, of course, could make the expensive, lengthy, and difficult trip to Europe. Many, however, endeavored to learn what they could, even if they had to remain in Japan. Fortunately for those interested in Western-style painting, certain opportunities soon became available in Tokyo. As in other areas of intellectual and scientific life at the time, the government made the decision to bring to Japan foreign teachers who would work directly with large numbers of students, drawn from around the country. Given the pragmatic atmosphere of the day, it may seem remarkable that precious funds were provided for training in such an obscure discipline as oil painting, but at that time, the Meiji officials chose to regard Western art as a "scientific" discipline that the Japanese, like the Americans and the Europeans, should possess in order to make possible an accurate rendering of space and form. In that spirit, an official art school, the Technical Art School, was opened in 1876. The first artist imported to teach painting came from Italy. Antonio Fontanesi (1818–1882) was a highly respected painter in Europe during the period, known primarily for his Barbizon-style rustic landscapes, often painted with thick pigments in dark and romantic tones (Fig. 13). Fontanesi had been appointed professor of landscape painting at the Turin Academy some years before his arrival in Japan, so he was already a practiced teacher of theory and technique. His students found him a charismatic figure. Fontanesi only remained in Japan for two years, when he had to return to Italy because of illness. Fontanesi's time in Japan was short, but he brought the traditions of nineteenth-century realistic European painting to his eager and often gifted students, many of whom

in turn conveyed to their own younger disciples what they had learned from their revered Italian master. Some Japanese at the time, notably the enormously gifted Takahashi Yuichi (1828–1894) (Fig. 14) had learned to master the art of oil painting from books and lithographs. Now such young men as ASAI CHŪ and Yamamoto Hōsui (1850–1906) could learn directly such important Western techniques as mixing oil colors, perspective, modeling, and other fundamentals never part of traditional Japanese art training.

The very accomplishments of these young artists, however, crystallized a number of basic problems that every Japanese painter—indeed any creative person in Japan during the period—would have to face in some fashion or other. The fundamental questions they found themselves posing were: what should be the relationship between the ideas provided them by their Tokugawa background and the example of the new knowledge gained from Europe? What should and could be retained of the older habits and heretofore accepted traditions? In the field of art, Japanese painters had long combined customary perceptions and techniques in a synthetic vocabulary capable of a wide range of expressiveness. In the decade of the 1880s, Western painting seemed to have so little in common with these oriental traditions that no expressive amalgam seemed appropriate, even possible.

Moreover, there were ideological implications involved as well. In 1864, Sakuma Shōzan (1811–1864), a retainer to an important feudal lord and a supporter of the internationalization of Japan at

Above: Fig. 14. Takahashi Yuichi, *Salmon,* 1877. Oil on paper, 135 x 44.5 cm/53⅛ x 17½ in. Tokyo University of Fine Arts, Tokyo.

Below: Fig. 15. Yokoyama Taikan, *Cherries at Night,* 1929. Six-panel screen, colors on paper, each panel 177.5 x 375 cm/69⅞ x 147⅝ in. Ōkura Cultural Foundation, Tokyo.

a time when the Shogun's policy was one of strong isolation, coined the telling phrase, "Eastern ethics and Western science," voicing thereby the hope that one half of the equation need not unduly influence the other. A number of historians have viewed the history of Japan since 1868 as a test of the possibilities and dangers inherent in Shōzan's celebrated and often-repeated dictum.

Could Western methods be absorbed, leaving the indigenous value system, the native soul untouched? For some in the world of the arts, the adoption of Western artistic values and techniques amounted to an abdication of a great tradition. The introduction of Western painting, so different in its methods and aims from the traditional canons of taste and value, served in turn as a stimulus to bring about a counter-reaction, a new definition and a renewed appreciation of older Japanese ideals and methods. Caution against abandoning the great traditions was expressed by such an important figure as Okakura Tenshin (1862–1913), who, along with his American colleague Ernest Fenollosa (1853–1908), warned that a true contemporary Japanese art should carry on earlier traditions, mixing with them only the most sympathetic elements from the Western example. Okakura, who with Fenollosa helped build the great collections now housed in the Boston Museum, spoke both as a modern man and as a Japanese patriot. The art that he and his disciples fostered at the Tokyo School of Fine Arts drew on classical Japanese examples, often using water soluble pigments rather than oils. This style of modern painting "in the Japanese style," now referred to as *Nihonga*, has been adopted by a number of artists much revered in Japan, notably Yokoyama Taikan (1868–1958) (Fig. 15). These methods have not, however, at least in the eyes of most foreign students of modern Japanese art, produced a tradition capable of sustaining admiration outside of Japan. Like the traditional *haiku* and *waka* poetry written since the 1880s, *Nihonga* seems all too often turned in on itself, settling for the sentimental rather than risking bold innovation. Still, the *Nihonga* style remained, and still remains, a viable alternative to the path of a wholesale adoption of Western techniques. A number of painters in this exhibition, notably KISHIDA RYŪSEI, KOIDE NARASHIGE, and YOROZU TETSUGORŌ, experimented with such traditional styles of painting at one time or other in their careers as a means to search out the contrasting facets of their developing artistic personalities.

As in so many areas of cultural activity in Japan during the late nineteenth and early twentieth century, the government played a seminal role in initially fostering the study of Western art. Such support was crucial for both the teaching and the public presentation of new Japanese art, both at home and abroad. What is more, the directions and limitations of that assistance helped establish a climate of official opinion and set in motion as well the development of a resistance to those opinions. In effect, and through no conscious set of decisions on the part of the bureaucrats concerned, these government-sponsored art projects, as in France, came to provide support for basically conservative forces in terms of Western styles that were encouraged and propagated. The individuals and groups working independently of government support were on the whole more adventuresome and creative. The pattern of French official patronage in the nineteenth century was thus to repeat itself several decades later in Japan. Still, without such support in the first place, Western painting and sculpture might never have been taught systematically until decades later.

The activities of the Japanese government in the Meiji period were visible in three distinct areas. The first involved the teaching of the techniques of painting. As was mentioned above, an official school was first set up in 1876, attached to the Imperial College of Technology (Fig. 16). It was here that Fontanesi taught his pupils. This experiment, how-

ever, although judged a success in some quarters, was terminated in 1883, partially for want of properly trained faculty. In 1887, the Tokyo School of Fine Arts was opened, under the guidance of Okakura Tenshin and Ernest Fenollosa. As the philosophy of the school stressed the bolstering of traditional techniques, Western-style painting was provided no support until, as a result of continuing pressures from those students who wished to study the medium of oil painting, a section for Western painting was finally established nine years later in 1896. The Western Painting Section provided a focus for students from

Fig. 16. An early photograph of the Technical Art School, Tokyo.

all over Japan and soon had so many applicants that a gifted young painter like KOIDE NARASHIGE had to console himself with entry into the Japanese Painting Section while waiting for entry into the more popular Western department. Many of the finest painters during the period, from KURODA SEIKI and KUME KEIICHIRŌ to YASUI SŌTARŌ and UMEHARA RYŪZABURŌ, provided instruction there at one time or another, and a significant number of the most accomplished painters in Japan during these decades had at least some training at the Tokyo School of Fine Arts.

Secondly, the government set up a system for exhibiting contemporary Japanese art in Tokyo and elsewhere in the country. The yearly Ministry of Education Art Exhibition, the *Monbushō bijutsu tenrankai*, shortened in popular reference to *Bunten*, was inaugurated in 1907. The effort was popular from the beginning. The initial exhibition attracted almost 44,000 people, and by 1912, the number had risen to over 160,000. *Bunten* has continued on, weathering a number of changes in name, size, and purpose, down to the present day. The *Bunten* functioned somewhat along the lines of the French Salon, upon which it was partially modeled. Pictures were submitted each year to a group of judges appointed by the government, a large number of selected pictures were hung, and prizes were awarded. In the first year of the exhibition, for example, a total of eighty-three paintings in the Western style were chosen for display from 329 submissions, while eighty-nine out of 635 *Nihonga* were hung. Success in such a national exhibition meant favorable publicity and considerable attention from a growing urban public eager to learn about contemporary art. The exhibition brought needed public attention to Western-style art, a great deal of genuine excitement to those who actually saw the pictures, and, occasionally, the advent of a scandal that could generate even more publicity. Many private methods of exhibiting art were to develop as well, including the concept, so novel to American visitors in Japan, of art exhibits in department stores, but the government's *Bunten* provided the first and most influential model.

Thirdly, officials in the government became convinced that the vitality of art, as an artifact of culture, could indeed serve as an index to the health and progress of the nation. One important way that Japan could demonstrate the force of her modernizing thrust was to participate in the international fairs that served in much of the period as a potent means to illustrate the progress of various nations around the world.[1] In terms of international recognition, Japan, unlike China, was little known and appreciated in the West before the Meiji Restoration of 1868; her long seclusion had rendered her mysterious and remote.

The Shogunate in its final days had provided materials for a small exhibit at the Paris World's Fair of 1867, which included some woodblock prints by then-contemporary artists in the traditional styles. These and later exhibits of prints, such as those shown at the 1873 Universal Exposition in Vienna, did much to stimulate interest in the "exoticism" of Japanese art; as late as 1876, the Japanese pavilion at the Centennial Exposition at Philadelphia showed the traditional work of ink painters and craftsmen like Shibata Zeshin (1807–1891) (Fig. 17), whose drawings of landscapes and other traditional subjects suggested nothing of the growing interest among young Japanese concerning Western art. By the time of the famous 1893 World Columbian Exposition held in Chicago, however, Japanese officials began to make more strenuous efforts to show the world something of modernizing Japan, providing information and exhibits on railway lines, telegraph systems, and schools. The arts, however, continued to present a reflection of traditional values. The Japanese pavilion was constructed in a fashion to illustrate the building techniques used in various periods of Japanese architecture, and few new paintings or works of sculpture were shown, none in Western style.

The Exposition Universelle held in Paris in 1900, however, provided Japanese Western-style painters with their first real opportunity to have their works shown officially abroad. By then, some Japanese painters, such as KURODA SEIKI, were already known in France, and more and more young Japanese painters resident in Paris were attempting to win a place in the Salon. French interest in Japanese traditional art often extended to friendly curiosity about contemporary Japanese attempts to paint in the European style, and the time seemed ripe for a display of what the Japanese government committee took to be representative of the best work then being done by their artists. Paintings by KUME, KURODA, OKADA, FUJISHIMA, and ASAI CHŪ were included, as well as works by some thirty-odd others. The Japanese artists were thrilled to be displayed in Paris, and they seemed content enough with the friendly reception their work received.

The 1904 Louisiana Purchase Exposition in St. Louis provided the next significant

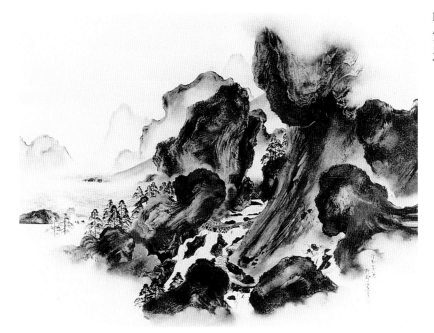

Fig. 17. Shibata Zeshin, *Plank Road in the Mountains,* 1877. Colors on panel, 38.5 x 51 cm/15⅛ x 20 in.

forum for the display of a modernizing Japanese state. The Japanese pavilion was planned so that the public might be convinced of the reality of the new Japan, to show how well she had adjusted her politics, economy, and military structures to the needs of modern life. In the sections that dealt with art, Western-style oil paintings were shown as in Paris, among them works by OKADA SABURŌSUKE and a dozen others; and although some commentators bemoaned the fact that the Japanese were becoming less exotic, the Japanese organizers felt that these contemporary works of art could enhance the image set forth by the government of a nation abreast of world developments, cultural and political.

The Japanese government, like many others, continued to use the mechanism of the international exposition to show her progress. By the time of World War I, however, alternate channels of information made this special and expensive vehicle less useful. Still, many Japanese painters had their first important foreign exposure on such occasions. UMEHARA, ARISHIMA IKUMA, YAMASHITA SHINTARŌ, and YASUI, among others, were doubtless given their first American showings in the Japanese pavilion at the 1939 New York World's Fair, and the prestige of inclusion in such an international show was significant in Japan in terms of the domestic career of any artist.

At the same time, however, the activities of the government stimulated independent responses, and, on occasion, counter movements. In the area of teaching, for example, a number of painters set up their own studios, painting and teaching privately. KURODA himself, who at a later point in his career did teach at the Tokyo School of Fine Arts, established in 1894 his own atelier, the *Tenshin dōjō* (which might be paraphrased to mean, appropriately enough, "a seminary for the intuitive understanding of nature") where he worked with a number of talented students, including FUJISHIMA TAKEJI. ASAI CHŪ, after returning from Europe, preferred to teach in Kyoto, where he organized a private art academy. KOIDE NARASHIGE worked with private students in Osaka. By the 1920s, the growing interest in various styles and possibilities made the relatively narrow curriculum of the Tokyo School of Fine Arts seem old-fashioned in somewhat the same way that the ateliers of the academic painters and the studios of the École des Beaux-Arts had come to seem out of date in France a generation or more before.

A parallel situation existed with the government-sponsored art exhibits. With the influx of contemporary ideas new to Japan that came in from Paris between 1905 and 1910 as UMEHARA and others returned to Tokyo, younger painters began to group themselves together in order to create associations that could support their enthusiasms. A bewildering array of these organizations rose up only to disappear. Many of the prominent artists showed their work in the government-sponsored exhibitions as well, but these private groups, which will be discussed in detail later in this essay, provided the kind of spiritual and occasional financial support that eschewed the tastes of official government sponsors.

In an usually unarticulated but significant way, then, these various government activities performed an important function in the development of a genuine tradition of modern painting in Japan. By serving as a source of training, power, and prestige, the government established a status quo against which newer artists could profitably react. By 1910, the existence of a conservative "school" of skillfully executed Western-style oil painting centering around the Tokyo School of Fine Arts began to provide the same kind of foil for adventuresome younger Japanese artists that the École des Beaux-Arts had provided in France for young French painters in the later nineteenth century. This dialectic of movement and counter movement not only spurred on the development of modern Japanese painting but made it possible for artists to react and respond to new artistic challenges even

without making the costly trip to France. Without the settled traditions of an accomplished ASAI CHŪ or KURODA SEIKI against which to rebel, however implicitly, it would be hard to imagine the independent accomplishment of artists like YOROZU TETSUGORŌ or KISHIDA RYŪSEI.

I. Painting in the Context of France and Japan: 1890–1930

The general sharp contagion of Paris . . . youth in the air, and a multitudinous newness, for ever reviving, the diffusion of a hundred talents, ingenuities, and experiments. . . .

—Henry James, The Tragic Muse (1890)

If you ask of what the artistic life consists, the answer is not difficult to give. The artist creates his own group, apart from society, and neglects everything else. From morning to night, he does nothing but look at art, hear about art, talk about art, as though art were all the life he knew. You might think that this could be done in London or New York, but it cannot be . . . for the best artistic minds, Paris alone has the right feel, the proper atmosphere.

—Iwamura Tōru, Parii no bijutsu gakusei (The Art Students of Paris), 1902

By the close of the nineteenth century, most countries in Europe, indeed most countries around the world, regarded Paris as the center of civilization and the arts, particularly in the visual arts and literature. Not everyone approved of that dominance; in the United States, for example, Edith Wharton and Henry James may have applauded the fact, but Mark Twain made fun of the whole affair in his *Innocents Abroad*. Still, all acknowledged it. Germans, Austrians, Czechs, and Spaniards found themselves as attracted as was the Russian Turgenev, and, in later generations, such diverse figures as Rainer Maria Rilke, Gertrude Stein, and Heitor Villa-Lobos would be.

The same attraction held true for the Japanese. France began to attract a number of the most gifted writers and artists from the 1880s onwards. The great novelist Shimazaki Tōson (1872–1943) went to France in 1913 and remained for five years, using his experience there as the basis for his classic novel *Shinsei* (New Life), in which his protagonist comes to a new vision of himself through his contact with France. Nishiwaki Junzaburō (1894–1982), one of the most revered of modern Japanese poets, who knew Ezra Pound and T.S. Eliot and who composed poetry in French, English, and Japanese, wrote that as a young man he was a "beggar for Europe" and sought out Paris as his spiritual home. Yokomitsu Riichi (1898–1947), arguably the most accomplished novelist of his generation, wrote his most ambitious and philosophical work *Ryoshū* (The Sadness of Travel) based on his troubled interior life during the time he spent in France in the 1930s.

Through the works of similar artists in virtually every country, the general educated public around the world began to partake of the "myth of Paris," and to make the assumption, implicit in the myth, that only the atmosphere, values, and training available in Paris could support and sustain the real creative work of the artist.

In the case of Japan, the writer who possibly did more to create and sustain the "myth of Paris" than any other was the novelist Nagai Kafū (1879–1959), one of the most gifted writers of his generation to go abroad. Kafū went to the United States for several years, then managed to get to France, his real goal, for only a short time, from 1907 to 1908. He tried to experience as much as possible, visiting galleries, going to concerts, travelling into

the countryside, and making notes for cultural comparisons with Japan. On his return to Tokyo, he published his *Furansu monogatari* (Tales of France), in which he fictionalized his various encounters with the French and French culture. He wrote as well a number of essays and other short pieces in which he used his knowledge of the accomplishments of French civilization as a standard, a measuring rod to point out the shortcomings of his own. In Kafū's view, there was a wholeness, a comprehensiveness to French civilization that could give resonance to the simplest activities of daily life; and while Japan might have possessed a similar wholeness up until the fall of the Tokugawa Shogunate in 1868, he felt that her rush to amalgamate Eastern and Western experiences had brought spiritual poverty to the fabric of daily life. Kafū often used the example of art or architecture to provide his most trenchant examples. In a 1910 novel, his protagonist explains the pattern.

> *The first suspicion of this new mood came one day when he was walking through Shiba Park. He could see nothing in the bronze statue of Count Gōtō that struck him in any way beautiful, but asleep behind it, solitary and forgotten, lay the mortuary shrines of the Shoguns. He stepped into the grounds and his astonishment grew. The memory had quite faded of days when his parents had brought him to this same park to see the cherry blossoms, and the surprise, as he found in a corner of the vulgar, ugly, accursed city a place reserved for art, was as if he had unearthed Pompeii. . . . the design, in sum, was to raise to the highest possible intensity the sense of reverence and worshipfulness. It succeeded magnificently, the place was a masterpiece. As he sought to compare the complex with Parisian buildings he had believed to be the supreme aesthetic experiences of his life, he felt that the Shiba mausoleum, whether their superior or not, was in no way their inferior. Just as the acute angles of Gothic architecture communicated perfectly the spirit of the people who had created it, he thought in the intensity of his delight, so the rectangular lines of this shrine and the richness of its colors gave perfect expression to the proud and lonely and aloofly aristocratic bent of the East. . . .*[2]

Kafū went on to become a highly original novelist and a brilliant translator into Japanese of such great French poets as Mallarmé, Verlaine, and Baudelaire. Through the influence of Kafū and others like him, the stature of the arts in France rose higher and higher among an increasingly educated and curious Japanese public.

All of this enthusiasm brought results. An increasing number of Japanese now wanted to experience France for themselves. The trip, first by ship, usually from Yokohama through the Suez Canal to Marseilles, then to Paris by train, was slow and, for most Japanese at the period, prohibitively expensive. The psychic costs were high as well. Tōson and other travellers at the time wrote eloquently of their sense of loneliness and isolation in Paris. Most found difficulties in learning to speak French with fluency, and Tōson in particular seems to have been made uncomfortable, understandably, when he was stared at, or identified as a Chinese. Nevertheless, a trip to France was the premier intellectual and spiritual adventure of the period. Hagiwara Sakutarō (1886–1942), the most gifted poet of his generation, wrote wryly in one of his celebrated poems:

> *I wish I could go to France,*
> *But France is too far away;*
> *I will go at least on a wayward journey*
> *In a new suit*
> *And when the train climbs a mountain path*
> *I will dream of pleasant things, this and that. . . .*[3]

Painters in particular were much encouraged by the high success, both in France and in Japan, of KURODA SEIKI, who had indeed mastered the French language, met important painters in Paris, and found his work admired there. They were informed as well by the example of Iwamura Tōru (1870–1917) who went to France during the same period in order to study painting and art history, met KURODA, and published in 1902 his account *The Art Students of Paris*, which enjoyed wide circulation. In the book, Iwamura, who had worked at the Académie Julian, described the teachers, how the students worked, and the kind of free society in which these young people lived, both idealistic and raucous, a *vie de bohême* calculated to excite and cajole his readers. The kind of environment Iwamura suggested seemed, in the context of the constraints of Japanese society, irresistably attractive.

Iwamura did not fail to point out that Japanese art students would need to find a better means to develop their skills in speaking French in order to mix with their continental colleagues, but by the same token he made it clear that, in the atmosphere of Paris, talent, not nationality, provided the means of entry and the road to ultimate success. He and his contemporaries could in principle join in that society; and they should be able to accomplish their own goals, since they could share the values of their European friends.

The gifted poet and translator Ueda Bin (1874–1916), in France from 1908 to 1912, amplified Iwamura's convictions. Japan was to have a new age of creativity, brought about through her contact with European culture.

> *Ours is a time that encompasses the pains of a new birth, and so for that very reason it is a period of great confusion. On the surface it seems difficult to know what to do. Yet is there no way to overcome that feeling? Our time is special, because we can criticize, we can overthrow the rules and standards established by former generations. To borrow the words of the German philosophers, ours is a time when we can recast the old means of expression. For those old ways of expression are useless to us. And what is useless is detrimental. It is we who now must rewrite, recast those old attitudes, in the arts, in morality, in the customs that have come down to us, even in terms of philosophical discourse.*[4]

The intellectual and artistic community in Japan took this challenge seriously and was quick to provide encouragement to Japanese painters, who, after all, seemed to visualize the new in a fashion clear to anyone who saw their work. Natsume Sōseki (1867–1917), the premier novelist and one of the most perceptive critics of his day, wrote articles on contemporary Japanese art and artists, and, during the years from 1909 to 1912, published a column on the arts in the leading newspaper of the day, the *Asahi Shinbun*. Mori Ōgai (1862–1922), another great writer of the period, had lived in Germany; his continuing interest in European aesthetic theory made him a powerful exponent in Tokyo for the values and ideals of new movements in art, theatre, and literature.

Perhaps the most diligent of the intellectuals in this regard was Soseki's younger colleague Kinoshita Mokutarō (1885–1945). Like Ōgai, Kinoshita's formal training was in the field of medicine, but his cultural interests were wide and he wrote perceptively of topics ranging from the theatre and literary criticism to painting and aesthetics. Kinoshita wrote a number of highly influential articles and reviews, and his stature as a distinguished man of culture lent considerable weight to his enthusiasms. He soon became aware of the fact that the Japanese public had no intellectual and historical framework on which to base their judgements concerning the Western-style paintings created in Japan. His translation into Japanese of a well-respected work on nineteenth-century French art written in 1901 by the German scholar Richard Muther, *Ein Jahrhundert Französischer Malerei* (A Hundred Years of

French Painting), published in Tokyo in 1919, was Kinoshita's contribution towards creating a proper context of understanding.

Others took up the torch. By 1910 there were a number of groups expressing their enthusiasm for a Western art movement in Japan. Some members of these groups were themselves artists returned from France. Others were men of letters who found themselves inspired by what they took to be the heroic role of the European artist in his society, and therefore viewed such figures as Cézanne and van Gogh as the sort of paragons that would be needed in Japan if she were to develop her own authentically modern culture. The most important of these groups was doubtless the *Shirakaba* (White Birch Society), whose members virtually dominated the arts and literature during the second decade of the century.

The Society was particularly important because of the journal that its members sponsored and published. The first issue appeared in April 1910 and publication was only terminated in 1923 when the devastating earthquake in Tokyo destroyed the magazine's printing facilities. The journal demonstrated a remarkable and sustained interest in European culture. Article after article on the great European writers, musicians, and artists appeared. Many younger Japanese have written that their first contact with the names of such figures as Beethoven, Rodin, and Tolstoy came from this magazine, which enjoyed a nationwide circulation. The journal included reproductions of art works, sometimes in color, which provided, in the phrase of André Malraux, "museums without walls" for a whole generation with no direct access to such masterpieces without a visit to Europe.

Among the most important articles published in the journal were those written by modern Japanese artists on the European art that inspired them. ARISHIMA IKUMA wrote a particularly influential piece in 1910 describing his excitement at seeing the work of Cézanne in the famous 1907 retrospective.

During the time I was in Japan, and in fact even after I came to Europe, I heard and thought virtually nothing about Cézanne. After I became a student in Paris, I visited many museums, particularly the Musée du Luxembourg, where I practically memorized the Impressionist paintings hung in the small room where the Caillebotte bequest was displayed. Even then I only came across two small samples of Cézanne's work. I probably thought, like all those who had read their Baedekers, that his efforts were no more than some sort of childish scribbling. In the fall of 1907, however, the Salon d'automne *included a retrospective of his work, over two hundred works of art, displayed in two galleries. It was then for the first time that my eyes were opened, that my soul was moved, and that I learned of a new way in which the great garden of art might be cultivated. And I also found myself in the tide of change concerning the popular appreciation of his work.*[5]

ARISHIMA provided in his article, for the first time in Japanese, a clear outline of Cézanne's life and accomplishments. He reminded his readers that Cézanne was difficult for much of the French public as well, because of the newness of his vision. ARISHIMA went on to suggest that even though the Japanese public might not as yet know the history of Western art in depth, they could find in Cézanne's work a "world element," as he put it, that could transcend a particular culture and so speak directly to any true believer in art, whatever his or her particular background. ARISHIMA's own dictums on Cézanne indicate a good deal about the ardor of the Japanese for European art during this period, and something as well about the way in which more traditional Japanese attitudes concerning the role of the artist remained latent but alive even in the face of these modern enthusiasms. "Most of all," ARISHIMA wrote, "We must admire Cézanne's eye, which has the

freshness of a child's, and his purity of heart." The artist's sincerity, the nobility of his intentions, had always been put forth as cardinal virtues in traditional Japanese artistic canons. ARISHIMA thus began to lay the foundation for a new cult stressing the importance of the painter's motivation. Other artists too used the journal as a forum for their enthusiasms. UMEHARA RYŪZABURŌ wrote on Renoir, KISHIDA RYŪSEI on the art of the future, and the sculptor and great poet Takamura Kōtarō (1883–1956) published there an account he had written in 1908, during his stay in Paris, in which he described the effect on him of the art of Matisse:

> Charm, lightness, freshness, sensations that change just as soon as you think you have grasped them. Painting with a clear palette of color![6]

There were other influential journals too, some of them more specialized, that published reviews, articles on Western painters, discussions of questions of aesthetics, and interviews with Japanese artists. Read together, such magazines and journals as *Hōsun* ("An Inch Square") (Fig. 18), *Mizue* (literally, "Watercolor," but in fact a review of all the visual arts (Fig. 19), *Chūō bijutsu* (Central Review of Art) (Fig. 20), *Bijutsu shinpō* (Art News) (Fig. 21), *Seikatsu to geijitsu* (Arts and Life), and a half-dozen others provide a fulsome guide to the various new movements in the arts of the period. Newspapers and large circulation magazines, too, saw contemporary art as a national cultural asset and helped publicize, and indeed sponsor, art exhibitions both in Tokyo and elsewhere.

Many of these writers and artists identified two tasks they saw as linked and intertwined in terms of the public they attempted to reach, educate, and hopefully inspire. The first, that of promoting the work of Japanese artists, was not so difficult, but the second, that of showing real European works of art to the public, proved much more difficult. Before the turn of the century, some contemporary painting had been seen, albeit briefly, in Tokyo, notably in 1890, when the Japanese art dealer and friend of the brothers Goncourt, Hayashi Tadamasa (1853–1906), then resident in Paris, arranged for a showing at the Third National Industrial Fair of works by Degas, Rousseau, Millet, Daubigny, and others. Such a brief glimpse, however, could not provide any sustained basis either for study by artists or understanding by the public. Most European art, classic or contemporary, was only known in photographic reproduction.

As more and more Japanese artists went to Europe, however, it became clear to them that reproductions could inspire but not truly educate the eye. The White Birch Society in particular tried to organize an exhibit of Western art in 1921, with the idea of encouraging interest in creating a public museum, and indeed the group had previously attempted to mount public showings of Western art using reproductons. With advice from the British potter Bernard Leach, then in Japan, by purchasing a few items, and by drawing on the generosity of some private lenders, they hoped to show a Cézanne, a Dürer etching, some sketches of Puvis de Chavannes, an oil of van Gogh, some small Rodin sculptures, and a number of other important items. Despite their various negotiations, however, the project never came to fulfillment. When the earthquake struck in 1923, the group's resources were annihilated and their experiments finished.

Around this time, however, other possibilities for seeing Western art in Japan became apparent. As fascination with Western art spread, so did an interest in collecting Western works. By the 1920s, collections of artistic merit were beginning to be assembled. The first among them was the so-called Matsukata collection, assembled for Matsukata Kōjirō (1869–1950), a prominent figure in government and financial circles. Among those who

Above left: Fig. 18. *Hōsun,* August 1909 (front cover). *Above right:* Fig. 19. *Mizue,* July 1905 (front cover). *Below left:* Fig. 20. *Chūō bijutsu,* October 1915 (front cover). *Below right:* Fig. 21. *Bijutsu shinpō,* May 1911 (front cover).

helped him was Frank William Brangwyn
(1869–1956). Brangwyn had studied with
William Morris and became well known
both in England and on the continent as a
highly accomplished painter and etcher.
Matsukata so admired Brangwyn's work
that he bought over seventy paintings and,
after meeting the artist, engaged him to pre-
pare plans and drawings for Matsukata's
dream, a museum of Western art he hoped
to build in Tokyo (Fig. 22). The coming
of the depression, unfortunately, destroyed
Matsukata's hope. In the early 1920s, some
of the paintings Matsukata collected were
brought to Japan and shown in Tokyo. (His

Fig. 22. F. W. Brangwyn's drawing for Matsukata
Kōjirō's proposed museum of Western art in Tokyo,
c. 1920.

collection was eventually presented to the Japanese government in 1959 and now forms the
basis of the collections of the National Museum of Western Art in Tokyo's Ueno Park).[7] In
1921, Ōhara Magosaburō (1880–1943), a wealthy businessman living in the city of Kurashiki,
west of Osaka, first put his collection of French art on view, allowing the public to study
at leisure works by Matisse, Renoir, Maurice Denis, Odilon Redon, Monet, Marquet, and
Cézanne. Ōhara eventually built a museum in Kurashiki to house the paintings, where
they have been on public display since the 1930s.

The French themselves were also helpful in encouraging Japanese aspirations to see
original European works of art. Excited by this interest, Paul Claudel (1888–1955), the
famous poet and dramatist who arrived in Tokyo as France's ambassador to Japan in 1921,
helped arrange in that year an exhibition held in Tokyo that displayed works by a number
of modern French masters, including Cézanne, Renoir, Signac, Bonnard, Denis, Vlaminck,
Rodin, and Bourdelle, among others.

By the mid-twenties, then, it had become possible for both the public and the artists
alike to come in contact with real European works of art, both classic and contemporary.
"It might somehow be possible," ASAI CHŪ had once written to his brother, "to catch up
after all." Now a guide and some standards had been established.

The flowering of styles and talents that took place in Japan during the period from
1910 to 1930 was of course only possible, ultimately, because of the real talents of the
artists at work during the time. Still, those men were able to develop their talents because
the generations before them had learned the skills, and prepared the environment, for the
experiments of those two decades. The exhibitions of Western art, the articles, the transla-
tions, the travellers' accounts, all confirmed the greatness of the European tradition as well
as the prominence of the French school since the middle of the nineteenth century. For a
Japanese artist working in the second decade of this century, the French example and
French standards provided the ultimate point of repair.

The French example provided many ideas and buttressed many convictions among the
Japanese artists of the period. First among them was the fact that the teaching of painting
could be made available to the public, through government support. In this regard, the
École des Beaux-Arts and the official French Salons served as particularly important exam-
ples. Many of the training mechanisms developed in Paris—methodical sketching, ad-
vancement from drawing to painting, student exhibitions, and promotions to official

status, were emulated when the curriculum of the Tokyo School of Fine Arts was established. That school, like the École des Beaux-Arts, trained students in the rules, so that they could then, if they chose, break them. Without these institutions, a progressive movement in Japan, such as that seen between 1910 and 1930, would be hard to imagine.

In nineteenth-century France, the École des Beaux-Arts served as a model for smaller, private studios, where painters, some rejected by the official school, some with more progressive ideas, could learn their craft in a freer and less bureaucratic atmosphere. These schools and ateliers were open to all, and it was through this means that most of the Japanese painters who managed to get to France were able to develop their basic skills.

On the whole, Japanese students worked with well-known, able, and conservative French painters. Such connections were perhaps inevitable. Progressive painters whom the Japanese came to admire—Degas, Monet, van Gogh—seldom if ever took students. Cézanne, who after 1907 became the idol of many Japanese artists, was still alive when the first generation of Japanese painters arrived in Paris in the 1880s and 1890s, but he lived most of every year in Provence as a recluse and his work was unknown to them, as to all but a few enthusiasts even in France. Aside from UMEHARA RYŪZABURŌ, who worked with Renoir, virtually all the Japanese painters could only learn from those French artists whose careers involved more teaching than independent creation. In, say, 1890, when divergences between traditional and avant-garde art were not so great, the pupils were well-enough served by their teachers; by the time of World War I, however, after the advent of Cézanne, Matisse, and Picasso, virtually every instructor available seemed conservative. The situation created a particularly poignant situation for those Japanese painters who were still in the process of learning the technical skills their craft required. Some Japanese painters, despairing the formal instruction available to them in France, felt compelled to work altogether on their own.

Most of the painters included in this exhibition who went to France studied with four teachers, all of them well-versed in the academic French tradition: Raphaël Collin, Jean-Paul Laurens, Fernand Cormon, and Carolus-Duran.

The first, Raphaël Collin (1850–1916), was famous as a painter of nudes in a delicate, airy style that owed something to his relationship with certain of the Impressionist painters (see Takashina, Fig. 2). By 1873, he had begun to win prizes in the Salon; before long he was receiving commissions to do large-scale murals for public buildings in Paris, among them an allegory on poetry for the Hôtel de Ville, the ceiling for the Théatre de l'Odéon (replaced in recent years by a new Chagall commission), and a ceiling for the Opéra Comique. In 1902 he was made a professor at the École des Beaux-Arts. For some years before this, Collin had taken on private students. After he accepted KURODA SEIKI as a student in 1886, the young Japanese painter began to encourage other of his countrymen, providing Collin with a number of gifted Japanese students until his death in 1916. Through KURODA's introduction, OKADA SABURŌSUKE, KUME KEIICHIRŌ, YAMASHITA SHINTARŌ, and a number of others worked with the French master. By Collin's death during World War I, however, his style had come to be regarded as old-fashioned, and his great public reputation throughout Europe quickly faded.

Jean-Paul Laurens (1838–1921) taught fewer Japanese students but was a more successful artist than Collin and one of the most gifted painters of historical subjects in his period (Fig. 23). A man with a strong personality and a tenacious spirit, Laurens had difficulties establishing himself in Paris, but by 1869 he had won a prize in the Salon, and a first prize there in 1872. By 1878, he was accorded a first retrospective. From 1898 to 1918, Laurens

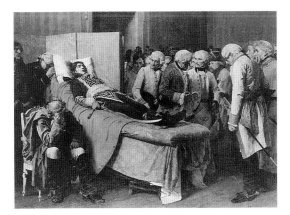

Fig. 23. Jean-Paul Laurens, *Austrian Officers before the Body of General Marceau*, 1877. Oil on canvas, 210 x 300 cm/82¾ x 118⅛ in. Private collection.

Fig. 24. Fernand Cormon, *Return from the Chase*, 1882. Oil on canvas, 150 x 200 cm/59 x 78¾ in. Museum of Fine Arts, Carcassonne.

taught painting at the Académie Julian, where his twice-weekly visits to examine the work of his students became the stuff of legend among his admirers. Among his Japanese students were KANOKOGI TAKESHIRŌ, MITSUTANI KUNISHIRŌ, and, finally, YASUI SŌTARŌ. YASUI, who arrived in 1907, began working with Laurens, but was so impressed by the Cézanne retrospective that he abandoned his interest in academic training. Later YASUI was to define the 1907 Cézanne retrospective as heralding the end of one era and the beginning of another.

Fernand Cormon (1845–1924), like Laurens, painted historical subjects but he chose to attempt canvases that focused on evoking an imaginary archaic past, producing works that conveyed what might be described as a kind of poetic anthropology (Fig. 24). His skill and energy were rewarded by important commissions, among them one of the ceilings of the Petit Palais. He was a highly respected teacher and numbered among his pupils such famous artists as Toulouse-Lautrec and, briefly, Matisse. In 1898, he replaced the well-respected painter Gustave Moreau as Professor at the École des Beaux-Arts. FUJISHIMA TAKEJI worked with him there in 1905.

It was thanks to the help of Cormon that FUJISHIMA was also able to work in Italy with the director of the French Academy in Rome, Charles Émile Augustus Carolus-Duran (1837–1917), one of the great portrait painters of his period. Carolus-Duran admired such Spanish painters as Velazquez, and many of his students, including the American painter John Singer Sargent, reveal the influence of that enthusiasm (Fig. 25). Painters like ARISHIMA IKUMA and FUJISHIMA learned much from Carolus-Duran, and in particular, the landscapes and portraits that FUJISHIMA produced during his two years with the French master in Italy are among his most felicitous compositions.

Schools, academies, and teachers were an important element in the training of Japanese artists, but for many, the exposure to the great works of art in the museums of Paris remained the most important influence on their work. Virtually every Japanese painter coming to Paris before 1900 was prepared, intellectually and psychologically, to look at and study only contemporary painting, particularly the pictures displayed at the Musée du Luxembourg, which functioned since the mid-nineteenth century until 1939 (when its collections were incorporated into those of the Musée d'Art Moderne) as a museum of contemporary French and European painting. The pictures hung there were chosen

Fig. 25. Carolus-Duran, *Portrait of Mme. Feydeau,* 1897. Oil on canvas, 190.5 x 127.8 cm/75 x 50⅜ in. National Museum of Western Art, Tokyo.

by juries for purchase by the French government, and so represented more the established view than that of the avant-garde; still, fine representative works by both French and foreign artists could easily be seen there, and many young Japanese painters such as UMEHARA RYŪZABURŌ and ASAI CHŪ worked at the museum, studying and copying the paintings they found in these galleries.

A number of Japanese artists have written of their difficulties in developing first a knowledge, then a sympathy, for the diversity of styles that go to make up the long traditions of Western art. UMEHARA wrote that, while he found an immediate attraction to the work of Renoir, "other paintings I saw at the same time, with the exception of those by Cézanne, Degas, and two or three of the Impressionists, seemed to me of no significance; some struck me as altogether unpleasant. It was considerably later that I came to appreciate the works of art I found hanging in the Louvre." Indeed, it was Renoir himself who stimulated in his Japanese pupil the desire to know more of older Western art. "He singled out Titian and Velazquez for special praise," UMEHARA wrote, who remembered as well Renoir's excitement at seeing the Titian portrait of Ariosto during a visit to the National Gallery in London. "Ah, the beauty of those rich swellings in the robes," Renoir told UMEHARA, continuing, "and did you see the Holbein portrait of Queen Christina . . . and those beautiful rows of trees by Hobbema!"[8]

The 1900 Exposition Universelle in Paris provided the Japanese artists living in or visiting Paris at the time, such as OKADA and ASAI CHŪ, a special opportunity to learn something of the history of French nineteenth-century art because of an important retrospective assembled for the fair. On the whole, however, Japanese painters visiting France sought out the contemporary.

Of those painters who went to France, a number of them left Paris and the ateliers of their teachers in order to work directly from nature. KURODA SEIKI and ASAI CHŪ made Grez-sur-Loing, near Paris, well known to those who saw their work, and SAEKI YŪZŌ created a number of his most effective experiments in various spots in the Île-de-France and Normandy. FUJISHIMA ranged widest of all; through his contacts with the French Academy in Rome, he was able to create a number of his most striking paintings in Rome, Pompeii, Venice and elsewhere in Italy.

In sum, it might be said that the role of the Parisian teacher and the Japanese student was considerably altered between the 1880s, when the first students arrived, and the end of World War I. As the academic styles available in France fell increasingly into disrepute on

52

the continent, the Japanese artists, like all the other younger painters in Paris, by about 1915 were thrown on their own resources, with little tradition to fall back upon. The situation was to continue on for several decades. As new waves of artists returned to Japan from Europe, each brought a new source of stimulus and a new layer of dilemma, both for the artists and for the art-loving public in Tokyo and elsewhere. By 1915, KURODA's work was regarded virtually as old-fashioned among progressive circles in Tokyo, just as that of his mentor Collin had come to be seen in Paris. Time, and shifting styles, moved too quickly to permit any sense of equilibrium.

II. Learning to be a Painter

By the turn of the century it was possible for young Japanese to learn in Japan the basic skills of Western painting. A number of artists who had studied in Europe, notably ASAI CHŪ and KURODA SEIKI, were giving lessons and had opened private ateliers both in Tokyo and in the Kyoto-Osaka area. Most important of all were classes given at the Tokyo School of Fine Arts, which, since making Western-style oil painting a part of the curriculum in 1896, provided several generations of aspiring artists talented enough to pass the entrance examination with the skills required to master the basic techniques involved. The sequence of courses offered was an amalgam based on the experiences of KURODA and KUME KEIICHIRŌ, who had studied in Europe and examined various academies and schools in Paris before setting up their own private atelier in Tokyo after the pair returned from France in 1893. The resulting course of study was both thorough and rigorous, in the traditional academic mould. In the first year, students learned to sketch from plaster models. In the second year of instruction, they sketched living models using charcoal. In the third year, students were shown the techniques of using oil paints and made copies of other works. It was only in the fourth and final year that they were allowed to proceed with their own original work. KURODA's private students followed him to the Tokyo School of Fine Arts when the new course was opened in 1896, so that the Western Painting Section became almost immediately a thriving institution.

Many, if not most, of the painters who were to assume major roles in the development of Japanese modern art attended this school. Most learned the basis of their craft during those years; their own personal responses as artists to this academic tradition, more often than not, matured later in their careers. Student paintings, often the obligatory self-portraits by many of the artists in this exhibition, still remain and can illustrate this early phase in their careers. A number of these works reveal skill and talent, but, as might be expected, comparatively few show many elements of the kind of personal style that most artists would show in their mature work. In this regard, the traditional master-disciple relationship that involved learning by copying, so much a part of the teaching of art in Japan for so many centuries, still continued on in this new guise of a Western academy. Beginners spent considerable time copying the works and techniques of their masters, until the time when they might begin, perhaps at first unwittingly, to introduce into the system they had already internalized certain individual qualities expressive of their particular personalities. In the case of Western-style painting, the technical knowledge of sketching, design, and the use of oil pigments was new and only available to beginners through the teaching of those who had learned their skills in Europe, at first hand. It was no wonder that students copied carefully. There was no tradition at large to which to turn for knowledge.

Some students, however, eventually came to realize the nature of the complex interplay

between the assumptions taught in class and the evidence of their own eyes. While studying at the Tokyo School of Fine Arts, for example, KOIDE NARASHIGE was often told by his teacher KURODA that "the shadows cast by objects, because of the nature or the lines of light involved, appear purple." Unable to locate any such color with his own eyes, KOIDE felt KURODA'S statement represented not an observed truth but merely a subtle artistic and technical convention, so that, as the younger painter put it, "I may have to paint something I cannot see. I came to realize that I was being asked to paint purple shadows in a fashion that I could not myself visualize." On the whole, however, such independent eyes were likely to develop later, after the experience of the academy, and often out of the country, in France. As time went on, and alternative techniques and styles became available to young artists in Japan with the return of such painters from France as UMEHARA, YASUI, and SAKAMOTO HANJIRŌ, the precepts of the academy were challenged almost as soon as they were put in place. Iwamura Tōru celebrated the freedom of artistic inquiry he found in Paris as early as 1902, and by 1910, the kinds of work shown by the younger painters back from France seemed to prove his point. Even a painter like KURODA, at the height of his career, began to risk looking old-fashioned as an artist and out of date as a teacher. The traditional relationship of master and pupil, both in Europe and in Japan, seemed to be breaking down rapidly.

The level of art instruction in Japan, reinforced by basic training in drawing and sketching in the secondary schools, slowly began to assure an acceptance of artistic expression consonant with more realistic Western modes of expression. In terms of subject matter, Western-style landscape, still lifes, seascapes, and scenes of city life found echoes and sanctions, in terms of the subjects considered appropriate in traditional Japanese art. Portraiture, although not an active genre in earlier centuries, did possess a certain lineage in the older traditions, which now could be adapted. Much more problematic were two categories of subject matter that, although of central importance before World War I in European academic painting, found little sympathetic response among Japanese artists.

The first of these was history painting. Nineteenth-century French and other European art was filled with examples of vast, complex works, based either on ancient history and mythology, such as those created by artists like Gustave Moreau or Puvis de Chavannes, or actual events in European history, a speciality of such artists as Carolus-Duran or Ernest Meissonier. Towards the end of the century, the earlier generation of Japanese Western-style painters, having observed such continental models, made some attempt to treat similar types of subjects in Japanese terms. Yet efforts to show ancient mythological themes concerning the origins of Japan taken from the *Kojiki* chronicles, or historical themes from the much loved medieval tale of the 1185 civil wars between the great clans of Japan, *Tales of the Heike,* proved generally unappealing to the public (Fig. 26). One problem may have been that traditional styles of Japanese painting did not generally encompass such subject matter; and even when historical subjects were involved, the approach used in ink or scroll painting tended toward the anecdotal or lyrical rather than the purely historical. Ancient *shintō* myth in particular had developed very little in the way of a fixed imagery or iconography to provide examples of figures visualized anthropomorphically. Trying to picture them at the end of the nineteenth century seemed to reduce their mythic and sacred status to that of actors in some historical pageant, in which modern men and women adorned themselves in arbitrarily borrowed plumage.

Then too, the kinds of historical encounters and clashes between cultures that produced a tradition of historical painting in Europe, the battles chronicled by Velazquez, Rubens,

Fig. 26. Nakamura Fusetsu, *Founding of the Nation,* 1907. Oil on canvas, 157.5 x 215.5 cm/62 x 84⅞ in.

and David, did not take place in Japan, which with its long, isolated history could offer little in the way of overwhelming historical grandeur. It is no wonder that Japanese viewing early attempts at historical painting by KURODA and others often took them to be some form of realistic genre painting, rather than as instructive historical works.

The difference inherent in fostering the development of historical styles in the modern tradition can easily be seen in the series of commissions made for the 1926 Memorial Picture Gallery for the Emperor Meiji, begun after his death in 1912 in the Outer Gardens of the Meiji Shrine, to house paintings illustrating famous incidents in the life of the ruler who modernized Japan. Forty artists in the modern Japanese or *Nihonga* style were involved, as well as an equal number in the Western style, among them five artists represented in the present exhibition, FUJISHIMA, MITSUTANI, KANAYAMA, YAMASHITA, and KANOKOGI (Figs. 27, 28). As visitors to the Gallery will quickly realize, the lack of tradition for depicting the military and ceremonial subject matter made artistic success difficult. Ironically, the *Nihonga* artists, drawing on the medieval scroll traditions, were able to render their commissions more persuasively than did the Western-style painters, whose attempts centered on capturing mood, personality, and setting (Fig. 29).

Equally problematic for Japanese artists at the end of the nineteenth century was the representation of the nude human figure. The work of such later artists as OKADA SABURŌSUKE, KOIDE NARASHIGE, or MAETA KANJI shows how diverse their respective skills had become in representing the undraped female body, yet even by the 1920s the possibility of painting such subject matter was a relatively new one. In the West, the painting of nude figures doubtless had its roots in the anthropomorphic sculpture of Greece and Rome, but the human body, male or female, as an object of artistic veneration had never been part of the Japanese aesthetic. Traditionally, when figures were sculpted or painted they were idealized, as in statues of Buddha, or at least generalized within the context of the figure being represented, as in portraits of Buddhist monks or court poets. In virtually all cases, they were clothed.

When KURODA went to Paris in 1884, he apprenticed himself to a wholly different set

Above left: Fig. 27. YAMASHITA SHINTARŌ, *Poetry Party at the Imperial Palace,* 1926. Oil on canvas, 273 x 242 cm/107½ x 95¼ in. Memorial Picture Gallery, Meiji Outer Shrine, Tokyo.

Above right: Fig. 28: KANOKOGI TAKESHIRŌ, *The Battle of Mukden,* 1926. Oil on canvas, 273 x 212 cm/ 107½ x 83½ in. Memorial Picture Gallery, Meiji Outer Shrine, Tokyo.

Left: Fig. 29. Morimura Gitō (1871–1938), *The Emperor Viewing the Rice Harvest,* 1926. Colors on paper, 300 x 270 cm/118⅛ x 106⅜ in. Memorial Picture Gallery, Meiji Outer Shrine, Tokyo.

Left: Fig. 30. YASUI SŌTARŌ, Untitled sketch, c. 1907–10. Chalk on paper, 62.5 x 48 cm/24⅝ x 18⅞ in. Tokyo University of Fine Arts, Tokyo.

Center: Fig. 31. KURODA SEIKI, Untitled sketch, 1889. Chalk on paper, 62.5 x 47 cm/24⅝ x 18½ in. Tokyo National Research Institute of Cultural Properties, Tokyo.

Right: Fig. 32. KUME KEIICHIRŌ, Untitled sketch, 1887. Chalk on paper, 62 x 47.5 cm/24⅜ x 18¾ in. Kume Museum of Art, Tokyo.

of artistic principles. The student sketches of nude figures he and his generation produced often show a wonderful skill and a high degree of finish, but the young artists who created them did not consider them as works of art but as exercises (Figs. 30, 31, 32). Certainly the Japanese public at that time would not have considered them as finished works in any sense. After returning to Japan in 1893, KURODA displayed his prize-winning painting *Morning Toilette* and caused an enormous uproar (Fig. 33). Some critics found it pornographic, some found it unbecoming, some found it daring. Few found it beautiful. The debates in print over the propriety, artistic and moral, of representing the naked body continued on and off for some years (Fig. 34). By the second decade of the century, the concept of the female nude had become domesticated as a possible subject, at least in the kind of lyrical, academic, and slightly arcadian guise that a painter like OKADA could provide. Yet harsher experiments, such as YOROZU'S *Nude with a Parasol* (Cat. 76) or his experimental Cubist figure studies, continued to shock the Japanese public. Changes in Western art were forcing an acknowledgement of new categories for potential beauty. The Japanese public, art lovers and intellectuals alike, often found themselves affronted by such shifting definitions. Western audiences, too, found themselves shocked by changes in Europe. But there were certain differences. A Picasso cubist nude might offend the bourgeoise, but the lineage of such subject matter itself stretched back from Manet to Ingres, Goya, Rubens, indeed all the way to Botticelli, and ultimately to antiquity. Picasso and Matisse were doing variations, admittedly sometimes shocking ones, on a revered theme. In Japan, there were no such reassuring precedents.

For an artist to learn more and to grow beyond the confines of the academy, a trip to France seemed inevitable. Yet not everyone could afford to go. Some, to move beyond their training, left the cities for the countryside. YOROZU TETSUGORŌ, for example, aban-

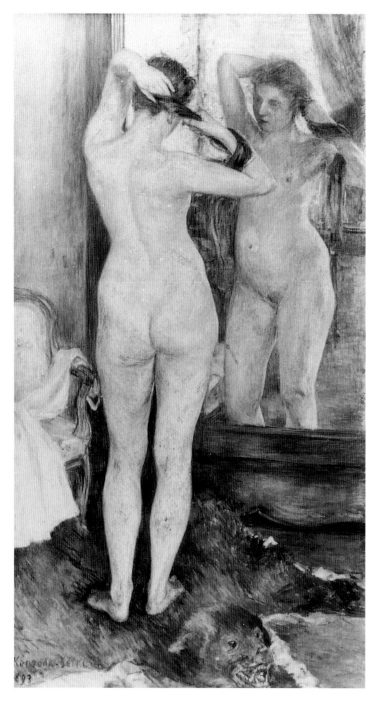

Fig. 34. An 1895 caricature of Japanese spectators viewing KURODA'S *Morning Toilette* by the French artist and satirist Georges Bigot, resident in Japan when the work was first publicly exhibited.

Fig. 33. KURODA SEIKI, *Morning Toilette*, 1893. Oil on canvas, 178.5 x 98 cm/70¼ x 38⅝ in. Destroyed by fire during World War II.

58

doned Tokyo and withdrew to the north of Japan, where, after a series of restless experiments, he succeeded in creating a personal version of Cubism. KISHIDA RYŪSEI followed somewhat the same pattern when he created his remarkable still lifes that show his homage to Dürer and other older German Renaissance masters he had discovered through reproductions. KISHIDA's work was all done in Japan, yet even he felt the call of France and attempted, toward the end of his life, to raise the funds needed to make the long and expensive trip. Even in the case of those artists who did not go to Europe, their artistic development would be hard to posit without the continuous stimulus of European art that arrived in Japan, either as reproductions or for increasingly frequent exhibitions. The European influence was exerted indirectly as well through the work of those Japanese painters who had made the trip to France and were now exhibiting their work back in Tokyo.

For the painters, some of the reasons for going to Paris were practical, some were spiritual. For an artist like KANOKOGI, who himself made three trips to France, training in Western technique was crucial. He wrote that he felt that his generation should sacrifice itself for the sake of those to follow. In his view, fifteen years of effort would be needed to assimilate styles and attitudes concerning Western art.

Others expressed a more poetic vision. Possibly the most eloquent verbal exponent of the French experience was the poet and sculptor Takamura Kōtarō, who although he did little painting, managed through his poetry and essays to serve as an artistic spokesman for his generation. Takamura spent only a brief time in Paris, in 1908, where he had a decisive encounter with the work of Rodin. His experience was an intense one. A well-known poem concerning his response to Paris runs in part:

> Notre-Dame, Notre-Dame,
> rock-like, mountain-like, eagle-like, crouching-lion-like cathedral,
> reef sunk in vast air,
> square pillar of Paris,
> sealed by the blinding splatters of rain,
> taking the slapping wind head-on,
> O soaring in front, Notre-Dame de Paris,
> it's me, looking up at you.
> It's that Japanese.
> My heart trembles now that I see you.
> Looking at your form like a tragedy,
> a young man from a far distant country is moved.
> Not knowing for what reason, my heart pounds
> in unison with the screams in the air, resounds as if terrified.[9]

For Takamura, Paris gave him the opportunity, both as an individual and as a Japanese, to participate in the creation of a new internationalized Japanese art and literature. He was to write eloquently of these matters after his return to Tokyo in 1909. His essays, often bristling with new and foreign terms—*motiv, persönlichkeit, eigenheit*—dazzled and excited his readers when they appeared in the *Shirakaba* magazine and elsewhere.

Perhaps the most influential of all his essays, "The Green Sun," appeared in 1910, in which he raised the crucial question that was to trouble artists of his generation and after: What is, what should be, "Japanese" about modern Japanese painting? For Takamura, the artist's individual self was crucial. Nationality, he was convinced, was of no ultimate consequence in terms of any enduring artistic achievement.

I was born as a Japanese; and as a fish cannot leave the water to make his life, I will always be a Japanese, whether I acknowledge that fact to myself or not. And, by the same token, just as a fish has no consciousness that it is wet with water, there are times when I take no notice of the fact that I am Japanese. In fact, those moments predominate. In ordinary social dealings, of course, I am quite conscious of the fact that I am Japanese. When I am involved in nature, however, I take little cognizance of the fact. And indeed, when I am conscious of myself at all, it is within my own personal sphere. When my own sense of self is submerged in the object of my attention, there is no reason for such thoughts to occur to me.[10]

For Takamura, creativity must spring from a unique and personal relationship with the physical world.

At such times, I never think of Japan. I proceed without hesitation, in terms of what I think and feel. Seen later, perhaps the work I have created may have something "Japanese" about it, for all I know. Or then again, perhaps not. To me, as an artist, it makes no difference at all.[11]

Takamura considered the individual inner creative impulse all important; for him it represented the basic temperament of the artist. The kind of "realistic local color" sought by artists such as KURODA, Takamura insisted, risked being applied from the outside and did not spring from the authentic personality of the artist. For Takamura, a Japanese artist who purposefully seeks native local color ignores his unique individual potential. "A Japanese artist is Japanese, and what he creates will be Japanese," Takamura insisted, just as Gauguin's pictures of the South Seas are altogether French.

What is more, Takamura continued, the spectator, while not creating the work of art, will instinctively respond to that authenticity conveyed by the artist. What is sought is not "exotic" or "representative" in terms of Japan, but that which is genuine.

If another man paints a picture of a green sun, I have no intention to say that I will deny him. For it may be that I will see it that way myself. Nor can I merely continue on, missing the value of the painting just because "the sun is green." For the quality of the work will not depend on whether the sun depicted is either green or red. What I wish to experience, to savor, as I said before, is the flavor of work in which the sun is green.[12]

Takamura Kōtarō's manifesto did much to define, then glorify, the idea of the individual artist, whose skills were used in order to best express his interior, instinctive responses to his subject matter. Other artists were to pick up this romantic concept as well. "I never think what others may see in my work," YOROZU wrote at one point, "I only paint in terms of what I feel myself." Freed from tradition, and stimulated by Western example, young artists could now seek themselves.

Such attitudes developed important intellectual support in Japan. Certainly the writers and artists who contributed to the *Shirakaba* magazine and other artistic periodicals espoused such attitudes. A Western artist like the famed potter Bernard Leach (1887–1979), who during his intermittent stays in Japan from 1909 to 1920 had become a friend and confidant of KISHIDA RYŪSEI, expressed the same hopes, stressing the possibility of personal development that might come from the encounter with Western art.

It is always a matter of curiosity to nine Europeans out of ten that the Japanese should be influenced by European aesthetics, and it is an additional surprise that the most modern work has the greatest influence. Japanese thought is chiefly engaged with problems that have arisen from recent intercourse with the West. New ideas from Europe strike root very easily—so

much so that the present movement has been accepted sooner and more rapidly in Japan than in America. A few square apples of Cézanne's; the flames of van Gogh; strange Tahitian women by Gauguin; together with magazine articles were sufficient to sow the seed. Artists were first attracted and certain of them, before long, formed the Société du Fusain *for the encouragement of such art in Tokyo, and have recently been holding their second exhibition. It contained many superficial works but some which showed real insight, notably pictures by Mr. Ryūsei Kishida.*[13]

The view of the artist as independent creator was also prevalent in the foreign books that young Japanese artists most enjoyed reading. According to Leach and others at the time, for example, a book by the English critic and journalist Charles Lewis Hind, *The Post Impressionists*, written in 1911, provided a particularly powerful appeal, and Hind's convictions gave support and nourishment to a group of artists struggling to express, and in a still partially unfamiliar idiom, what they took to be themselves. Like Takamura Kōtarō, Hind insisted that individual expression, not worldly success, must always represent the hallmark of the true artistic spirit.

We are all too apt to regard art as a sort of solemn affair of wealth and connoisseurship, much too portentous to be part of humble daily life. We suffer not only from tyranny of exhibitions, but also from the tyranny of the masterpiece. Cézanne, van Gogh, and Gauguin were disdainful of exhibitions and masterpieces. They expressed themselves on canvas, and when they had said all they had to say, sometimes they left their canvases in the fields, or tossed them into a corner of the studio. They painted for themselves, not for exhibition. They lived to paint, not to exhibit.[14]

The artist's experience, the energy with which he approaches his task, conveys his authenticity to his viewers.

Art is but an episode of life. The artist's life is but a part of the whole. To be effective he must express himself. Having expressed himself his business ends. He has thrown his piece of creation into the pond of Time. The ever-widening ripples and circles are his communication to us, the diary of his adventures. We read the diary. We are comforted, stimulated, consoled, edified, helped to live according to the degree of life-force in the diary, and the idea behind it.[15]

Along with a thirst for what Hind called the need for a "synthesis in the soul of man and in the substance of things," however, came the need for Japanese artists to enter into their own conversations with the Western art of the past, to engage in a dialogue with previous generations of artists who created the European tradition. In this regard, a striking paradox developed. Those Japanese artists who went to France and apprenticed themselves to the master painters they encountered there did manage to learn something of that tradition. Yet many of them, in taking on the weight of those historical precedents, found their own developing individuality subsumed. For every FUJISHIMA, who could remain creative and himself within the stimulus provided him by the beaux-arts tradition, there were many like OKADA, YAMASHITA, and countless other less gifted painters who never were able to rise above producing smooth, even sentimental versions of the traditions they had so painstakingly studied, to which they added from time to time what Takamura would have sardonically called the requisite "local color." Artists who did not travel to Europe, however, and who could only learn of Western art from a distance, as Prof. McCallum points out in his essay, had a special opportunity. More or less divorced from

an accurate understanding of European historical and artistic relationships as they had developed, they often found themselves engaged in a naive yet powerful encounter with certain European artists who moved them personally. Many of these artists represented older European traditions, yet they seemed fresh and provocative to the eyes of the Japanese. NAKAMURA TSUNE, for example, when he discovered Rembrandt in reproduction, had relatively little sense of the Dutch artist's place in the history of Western art. His response was powerful and genuine. KISHIDA RYŪSEI'S encounters with reproductions of Western art in the *Shirakaba* magazine and elsewhere brought him an enormous sense of excitement, so that he found himself in a continuous state of inspiration.

> *We were so thrilled that we almost wept; rather than sensing the art in its period, we came to look on what we saw as virtually a model. . . . I would talk together excitedly with my friends. For me, who had not had such opportunities before, the experience was as strong as though I had been given a second birth.*[16]

Much of the finest painting done in the second and third decades of the century was inspired by the visceral stimulation gained from seeing reproductions of Western art, not from any real knowledge about its history. It would be safe to say that few if any of the artists in the present exhibition possessed the kind of disciplined understanding of Western art history expected of European, or even of American artists of the period, who, in such institutions as the École des Beaux-Arts, were required to pass an examination on the history of European art in order to enter. Often, conflicting inspirations can be seen from picture to picture as the more imaginative artists wrestled with creating styles in which they could realize themselves in the fashion that a Takamura Kōtarō had demanded. Sometimes the restlessness was powerful and moving, sometimes awkward, even disturbing.

III. The Public and a Growing Knowledge of Art: Scholars and Journalists

If artists found difficulty in constructing a mental historical framework to inform their perceptions of Western painting, the Japanese art-loving public had an equal if not greater difficulty in doing so. The intelligentsia, of course, had the same access to reproductions of European art as did the artists themselves, and a steady progression of exhibitions of the work of contemporary Japanese artists newly returned from Europe helped to develop the public's sensibilities. Then too, by the 1920s, a certain number of useful, indeed important, exhibitions of Western modern art were held in Tokyo and elsewhere. Still, there were no large public museums for Western art even in the major cities, and with the floundering of the Matsukata fortune at the end of the 1920s, plans for a national museum of Western art had to be scrapped. Only the Ōhara collections in Kurashiki, rather difficult to visit even from Osaka, provided a group of Western works of high value that were permanently on display from 1930 onwards. The wholesale importation of Western art for the Japanese public was not to occur until after World War II. The true connoisseur's eye, therefore, could only be developed in Europe. A profound appreciation of Western art might be a goal for many, but resources to turn aspiration into knowledge were scarce.

Those writers and intellectuals who were able to travel, however, wrote accounts of their personal responses to what they saw, so transmitting their enthusiasm to the reading public. Many of these writers were not trained at all in Western art. The eminent novelist Shimazaki Tōson wrote enthusiastically of the ferment in the arts and literature in Paris just before World War I, but sprinkled among his observations are candid admissions that

the meaning and significance of much that was new partially escaped him. Nevertheless, his enthusiasms, given his cultural pedigree, helped spread a high level of interest among the Japanese reading public for all that was new in France. Litterateurs and cultural philosophers such as Abe Jirō (1863–1959) and Watsuji Tetsurō (1889–1960) also wrote of their European travels, in which their observations on art and architecture helped them to come to grips with the significance of Japan's cultural past in its relation to a rapidly changing present. Watsuji, for example, was able through his knowledge of Western art to make provocative comparisons between the cultures of Europe and Japan.

> *I found myself in front of the Tōshōdaiji temple in Nara [established in 759 a.d.] and spent a few minutes of happy contemplation. A clump of pine trees surrounding the temple gave me an ineffable feeling of intimacy. Between the pine-grove and this monument of ancient architecture there is certainly an affinity both intimate and ineffable. I do not think a piece of Western architecture, of whatever kind or style, would match so well with the sentiments aroused at the sight of the pine-grove. To encircle the Parthenon with a clump of pine trees would be unthinkable. Nor can we, by the furthest stretch of the imagination, conceive that a Gothic cathedral would in any way match with the gently sloping curves of these graceful pine branches. Such buildings have to be contemplated in conjunction with the towns and cities, forests and fields of their respective lands . . . just as do our Buddhist temples have something intimately connected with and inseparable from the characteristic features of our native shores. If there are to be found some traces of the Northern forest in Gothic architecture, can we not say with equally good reason that there are in our Buddhist temples some traces of the Japanese pine and cypress forests?*[17]

Watsuji's generation was virtually the first that could make such comparisons on a firsthand basis, and his words carried both appeal and authority.

In this context, Western art provided the educated Japanese public a stimulus for a move toward cultural self-definition. By the 1930s, for example, powerful cultural critics such as Kobayashi Hideo (1902–1983) were writing with superb insight on such European figures as Cézanne and van Gogh in a broad and vivid manner. The art scholar Yashiro Yukio (1890–1975), a friend and colleague of Bernard Berenson, by 1925 had produced a world-famous monograph on Botticelli. These books, and many others like them, were widely read and appreciated by the general Japanese public.

On the whole, Japanese scholarship on Western art between the two world wars helped fix an historical and stylistic chronology in the minds of serious readers and students. Few scholars, on the other hand, wrote for the general public on contemporary or avant-garde art, either European or Japanese. This area was seen rather as the province of the journalists. As a result, there remains virtually nothing in the way of any synthetic analysis of modern Japanese art between the wars. In many ways, this lack is not surprising. The teaching of art history in the universities in Japan was based, as in many other countries, on the German model, which tended to stress classical principles rather than modern trends.

In Japan, the teaching of art history moved in two parallel courses, which sometimes intertwined. The first of these involved the study of aesthetics as a field in philosophy. Translations of writings on Western aesthetics were made as early as the 1870s, and by 1899, the novelist Mori Ōgai had made known to Japanese readers important works by the neo-Kantian philosopher Eduard von Hartmann (1842–1906), which did much to lay the ground for the teaching and development of aesthetic theory in Japanese academic circles. Later scholars went on to translate and teach important texts by such central figures

in the history of aesthetics as Hegel, Wilhelm Dilthey, and Theodor Lipps. Japanese professors and students of aesthetics, however, were mostly concerned with attempting to construct systems that could accommodate the cultural facts of their own classical tradition. Thus their connections with the actual progress of modern Japanese art were indirect and slight. The training their discipline provided, however, did help to raise a number of questions about the function of art in society and the relationship between art and ideas that, through the more general writings contributed by the Japanese academic world to the press and popular magazines, helped inform the public about the possibilities of art as a means of informing life.

The second involved the study of the history of the evolving styles of Western art, in the sense of art history as now generally understood. The first lectures on the aesthetics of Western art history were doubtless those given by the American Ernest Fenollosa in 1881 at Tokyo University. Fenollosa, with his philosophical background in Hegel and Spencer, helped suggest the kind of international philosophical framework by which to interpret Western art as well as traditional Japanese and Chinese art, an area of inquiry which came to dominate Fenollosa's own distinguished career and concluded with his curatorship at Boston's Museum of Fine Arts. The German philosopher Raphael von Koeber (1848–1923), who made such a profound contribution to the teaching of philosophy and aesthetics during his long sojourn at Tokyo University from 1893 until virtually the end of his life, introduced in his lectures a number of specific examples of Western art from various periods. It was not until 1919, when Sawaki Yomokichi began his classes at Tokyo University, however, that any systematic attempt at teaching the history of art objects, as distinct from general aesthetic theory, was undertaken. Sawaki was a specialist of Greek sculpture, and his introduction of the writings of the German critic Heinrich Wöfflin, still widely considered important methodological texts, provided a particularly vital contribution. Dan Inō, who replaced him in 1923, had done graduate work at Harvard, as well as in London and Lyons, and brought a wide range of interests to his teaching, ranging from the art of Greece and Rome to Gothic architecture, the Italian renaissance, and nineteenth-century painting. But it was not until the mid-1930s that students could work with a teacher such as Kojima Kikuo, who combined his studies of general history and theory with the practical understanding he had gained as an editor of *Shirakaba* magazine twenty years before. It was with the placement of scholars like these in such an influential academic milieu as Tokyo University that the study of Western art could begin to integrate itself to some extent with contemporary creative Japanese concerns. During virtually the whole period before the end of World War II, however, the public for art worked more from intuition, sharpened by journalistic accounts, than from any body of assimilated knowledge. That their interest remained as intense and as sustained as it did, tells much both about the depth of artistic inclinations in Japanese culture generally and the powerful pull of Western art and culture.

IV. The Japanese Experience in France

In one sense, the experiences of Japanese artists in France during the period were as various as the temperaments of the individual painters themselves. Most went first to learn their craft, then to put themselves in the capital of the arts, to transcend their own provincialism. The contemporary cultural critic Kato Shūichi has remarked that many artists went, and still go, to Paris ". . . to escape the 'village' that is the world of art in Tokyo. 'In

Paris,' one artist told me, 'it's ability that counts. However famous a man, nobody bothers about him unless he's turning out good stuff. That's the only way to produce really good work.'"[18]

Most of the painters envisioned their stay in Paris as a period of training. They looked on the work they produced there as experimental. When they returned to Japan, most would go on to develop and adapt their still-evolving styles to suit the tastes of the Japanese public with which, however tacitly, they were engaged in a continuing dialogue concerning the nature of the modern artistic experience. Most painters therefore found their time in France well spent. A few, particularly by the 1920s and after, felt, like KOIDE NARASHIGE, that they had little to learn from Europe, since French academic models had themselves become discredited.

There are two ways, however, in which the experiences of these painters might be categorized, thereby revealing certain implications. The first might be organized according to generations, not in terms of the actual ages of the artists involved, but rather with regard to the time of their French experience. The second might be characterized according to paradigms of responses to the French experience. In terms of generation, the first group, beginning with KURODA and ending with FUJISHIMA, found itself at the end of the nineteenth century still closely linked with elements of the French academic tradition and so tended to evaluate the Paris experience in terms of training in subject matter, style, and technique. As precursors, they consciously attempted to bring back to Japan a codified body of skills that could be transmitted to younger Japanese, who in turn could be taught to "compete" with Western artists, based on mutually accepted perceptions of international standards. In this phase, the contributions of the individual artists and their own developing talents were regulated by the academic framework of their studies, which supplied uniform standards applicable to all. It is not therefore suprising that, given the abilities of a number of these artists, they should win the approbation of their French colleagues, both in the Salon (as did KURODA), or within those groups designed to function in some consonance with the philosophy of the academy, such as Jean-Paul Lauren's Académie Julian, which awarded prizes to KANOKOGI, YASUI, and others during the early years of the century.

A second generation of painters, beginning with SAKAMOTO, YASUI, and UMEHARA, from early in the century until the advent of World War I, experienced both the sense of excitement and of dislocation as new styles of French painting began to challenge, replace, and eventually destroy previously agreed-upon academic standards. Japanese painters inevitably found themselves becoming somewhat more experimental. Some, like UMEHARA, were lucky enough to attach themselves to masters like Renoir, who encouraged the individual aspects of his talent. Virtually all of these Japanese painters reacted with shock, surprise, and delight to the newly-visible work of the Post-Impressionists. In that regard, the 1907 Cézanne retrospective was as powerful an impetus to Japanese painters as it was to younger French artists. Those in this second generation, most of whom returned to Japan by 1914, because of the coming of the war, regarded the French experience as one of expanding possibilities rather than of codified rules. The freshness and sense of individual personality shown in the pictures brought back from France by YASUI, SAKAMOTO, and UMEHARA had as profound an effect on Japanese taste as the work of their mentors—Renoir, van Gogh, and Cézanne—had on the still conservative French public.

Members of a third generation, however, found it necessary to respond to a more complex environment when they arrived in France after World War I. All commonality had seemingly disappeared, to be replaced by a welter of conflicting artistic styles and phil-

Fig. 35. FUJITA TSUGUJI, *The Virgin Mary,* 1966. Fresco.
Chapel of Our Lady of Peace, Reims.

osophical obligations, some now as much political as aesthetic. This period was the most difficult for the Japanese artists. Styles were changing so rapidly that it no longer seemed possible for an artist to place himself in a learning role in order to find his way towards mastering any given set of techniques. Now he was to create his own style, and found himself sometimes compelled to change it from picture to picture. The fecundity of a Picasso or a Matisse made them cruel models for a generation of artists who were still, as a group, grappling with their attempt to understand the Western tradition, and just at the time when contemporary European artists were in full rebellion against it.

Japanese artists at this stage were still seeking models which they could safely emulate as learning devices. Thus, while the work of the Japanese painters during this period is remarkably varied, and often quite accomplished, the paintings of individual artists reveal that, spiritually if not literally, they were still approaching their work as a craft, a series of lessons to be learned, from whatever European painter they chose to regard as a possible mentor. A certain amount of their painting thus seems to function as a kind of cultural mirror, reflecting the predilections of their chosen Western model. SAEKI YŪZŌ thus shows resemblances to Vlaminck and Utrillo, MAETA KANJI echoes elements in André Derain, and YOROZU TETSUGORŌ, whose European travels were only in his head, tried to assimilate the concepts of the Cubists. Earlier painters like KURODA had managed to make individual statements that were acknowledged within the European tradition. Now, the burden of proof concerning artistic authenticity and individuality was placed squarely on the shoulders of the individual artists. For newcomers to the game, it was an extremely difficult challenge.

In addition to the generational analysis, there is a second means to categorize the re-

Fig. 36. Umehara Ryūzaburō, *Peking,* 1942.
Oil on canvas, 88.5 x 72.5 cm/34⅞ x 28½ in.
The National Museum of Modern Art, Tokyo.

Fig. 37. Umehara Ryūzaburō, *Venice,* 1959.
Oil on canvas, 61 x 50 cm/24 x 19¾ in.

sponses of these Japanese artists, one that involves the nature and extent of their personal involvement with France. On one end was the possibility of assimilation; on the other, rejection. Most of those artists who went to France responded somewhere in between these two polarities, often in complex ways only half-understood or articulated, even to themselves.

At one extreme is situated a figure like Fujita Tsuguji, the only Japanese painter of the period to earn his major, and considerable, reputation in France. Soon after his arrival in Paris in 1913, Fujita found both a personal and artistic niche, one that he never really abandoned, despite the fact that he spent the war years back in Japan.

The best of Fujita's works are looked on as belonging in the École de Paris and were, for the most part, painted in and remain in France. Baptized a Catholic late in life, he died after decorating a chapel in Reims (Fig. 35). In a sense, Fujita became an emblem for the open, cosmopolitan side of French culture, which beckons and sustains men of talent. For this assimilation he paid a correspondingly high price in Japanese art circles, where Fujita has often been regarded as a kind of artistic opportunist who, in abandoning his own culture, lost his personal integrity. The fact that few·other Japanese painters from the period are known in France itself is perhaps less a commentary on their talents than on the fact that such painters as Fujishima, Yasui, and Sakamoto, to mention only three, saw themselves as altogether Japanese. For them, as for most of the others, a career in any country other than Japan would have probably been unthinkable.

Midway on the continuum are the painters, doubtless best exemplified by Umehara, who were able to bridge both worlds through the quality of their talents and personalities, moving back and forth between the cultures in a largely self-invigorating way. Umehara,

more than any other figure in his generation living in Japan, continued warm and close contacts in France, largely through the agency of his mentor Renoir and his family. He continued to travel back and forth between Europe and the Far East, seeking and incorporating a wide variety of stylistic influences that made him able to paint with equal skill and panache a scene in Peking (Fig. 36) and a canal in Venice (Fig. 37). He usually succeeded in combining a Japanese sense of color and design with a genial variety of subject matter. UMEHARA never saw himself as French, but he believed in, and lived out, his version of cultural synthesis.

At the other extreme were those crushed by the tensions they felt between the worlds they found themselves forced to bridge. Of all the artists shown in the present exhibition, no one gives greater testimony to this anguish than SAEKI YŪZŌ, who committed suicide in Paris in 1928. SAEKI came to France in 1924, like so many other gifted young painters, with an idea of liberating his talents, the next appropriate stage after his academic training in Tokyo with FUJISHIMA, himself a distinguished representative of the established academic style of painting as taught in Japan. It became clear to SAEKI after his arrival in Paris, however, that the older virtues as taught at the Tokyo School of Fine Arts no longer applied. For SAEKI, the moment of truth came in the summer of 1924 when a painter he much admired, Maurice de Vlaminck, looking at the young Japanese painter's work, told him that in order to develop his own talents, he must abandon all the academic styles that he had been taught in order to truly find his own unique voice. SAEKI took up the challenge, and abandoned the idea of learning from others. He attempted to pull everything from within himself and virtually exhausted himself in the process. To locate the self and to cast it up on the canvas without any cultural supports proved an effort that eventually consumed him. The works he painted reveal that journey toward self-destruction, and the best of them chronicle his battle with astonishing poignancy. SAEKI is admired in Japan, often for extra-artistic reasons. He is seen as a handsome and romantic figure. The message he bore, that of the struggle between disparate cultures, implicit in so many of the works produced in the arts during the period, was brought to the surface in his struggle toward authenticity. For many, the death of SAEKI was seen as a requiem for the agonies of a generation.

These artists, then, caught on one side within the confines of the training given them in Japan before going to France, and on the other side with an expanding and changing vision of the nature of contemporary European art, faced a peculiar challenge. Their accomplishments, and their limitations, may ultimately be a result of their individual talents, but the circumstances in which each found himself were shared, and difficult for all. Few other artists living outside the European orbit even dared the attempt at all.

V. Back Home Again: The Painters in their Larger Careers

With the exception of FUJITA, the experience in France was most often a relatively brief one for the artists in the present show. For the majority of them, it was an opportunity that came relatively early in their careers. To the extent that they made a success of that learning experience in Paris, they found on return a need to adjust their skills, expectations, even the strategies used to develop their maturing talents, to the realities of Japan, in terms of society, environment, and reward. Many, especially those who returned to Japan from Europe with advanced stylistic commitments, found this period of adjustment an awkward, painful and a sometimes surprisingly protracted one.

For some, questions as basic as the climate came to the fore. UMEHARA and others complained that the moist atmosphere of Japan softened the contrasts in the natural shapes they had learned to paint in the clear light of France, rendering their palettes inaccurate. Others complained that the best paints, brushes, and other materials were not available to them, or could only be found at prices so high they could not afford them. Some felt a sense of visual stagnation. YASUI SŌTARŌ later wrote that after his return, he continued to feel a sense of malaise and artistic uncertainty for virtually a decade. Many, outside of the heady atmosphere of Paris, questioned their own talent.

It was not, however, that the metropolitan areas of Japan, notably Tokyo and Kyoto, did not provide support to these returning artists. Most of them were given "homecoming exhibitions" under a variety of sponsors, to show off the new skills they had acquired in Europe. The public enjoyed seeing these shows, not only as a means to evaluate recognized talent but as a way to find out something of the newest developments in Europe, presumably mirrored in the work of those just returned.

This kind of exhibition might offer one kind of success, but having one's work seen continuously was quite another. Indeed, launching a real career was a complex undertaking altogether. The first step was to have one's work shown under friendly circumstances. The yearly government-sponsored exhibition put on by the Ministry of Education, the *Bunten*, functioned as a kind of Salon open to most. Reorganized in 1919 as *Teiten* (the Imperial Art Academy Exhibition), it has continued on until the present under the current name *Nitten* (Japan Art Exhibition). *Bunten* represented the largest, best publicized, and most professionally attractive opportunity, since the greatest number of potential patrons, private and public, were likely to see the show. If *Bunten* had the virtues of its largely French model, however, it also possessed some of its precursor's faults. Many of the more progressive painters found the *Bunten* judges far too conservative and academic. Success in the exhibition did bring a level of public prestige that helped with commissions, teaching opportunities, and patronage. But for many, such success, when it came, seemed purchased at too high a cost in terms of a sacrifice in stylistic experimentation. Still, *Bunten* did bring important benefits to the world of contemporary art. The very importance of the exhibition, which invariably drew huge crowds, helped create a need for higher standards of journalism concerning art. Editors of newspapers and magazines, those burgeoning organs of the new mass media that were to transform the possibilities of learning about the visual arts, were anxious to report on new artistic developments. A painter who succeeded in the *Bunten* thus became a part of a whole cultural system.

On the other hand, independent artists could also use elements in that same cultural system to show a wider range of their work. The novelist Natsume Sōseki, whose occasional newspaper pieces on modern Japanese painting remain particularly evocative, stressed in 1912 the need for a Tokyo *salon des refusés*. If a Japanese Cézanne were to appear, Sōseki felt, some mechanism must be in place to provide him with the chance to be seen. From the turn of the century onwards, a whole plethora of small sponsoring groups sprang up, often for brief periods, which had for their purpose the creation of a series of occasions when the work of various like-minded artists might be viewed. As journals and newspapers continued to write about these exhibitions, and so publicize the groups and their artists, some semblance of a public for new and as yet uncertified art began to grow.

Many of the artists in the present exhibition helped found such independent organizations. In retrospect, a number of these groups appear to have been very important histori-

Fig. 38. Poster advertising the seventh exhibition of the *Sōdosha*, 1919.

Fig. 39. Poster advertising the first exhibition of the *Shun'yōkai*, 1923.

Fig. 40. Photograph of members of the *1930 kai* taken on the occasion of their first group exhibition in 1926. From left, SAEKI YŪZŌ, Kojima Zentarō, Satomi Katsuzō, Kinoshita Takanori, MAETA KANJI.

cally, but during their often brief and fitful lifetimes, they must have served as frail vessels indeed. KURODA, along with KUME, FUJISHIMA, OKADA, and others, formed the first important such group, the *Hakubakai* (White Horse Society) in order to plan for more comprehensive exhibitions of Western-style oil painting. From 1896 until its dissolution in 1911, the group introduced to the public many of the works now regarded as the most representative successes of Meiji Western-style painting. In the brief span of the *Fusainkai* (The Sketching Society), from 1912 to 1913, KISHIDA RYŪSEI, SAITŌ YORI, YOROZU TETSUGORŌ, and thirty-odd others managed to assemble the first Post-Impressionist group of Japanese artists, who, in the face of conservative disapproval, managed to mount two exhibitions that helped introduce to the Japanese public examples of a fresher Japanese painting more in consonance with the newest developments in France. Others followed. In 1914, a collection of younger painters, among them ARISHIMA, YAMASHITA, YASUI, and UMEHARA, decided to create an organization they termed the *Nikakai* (Second Division Group) to oppose the *Bunten*. The group began holding a series of exhibitions in Tokyo's Ueno Park. With some modifications, the group still continues on today. In 1915, KISHIDA decided to gather around him a group of like-minded artists to found the *Sōdosha* (Grass and Earth Society) (Fig. 38) which managed to present yearly exhibitions until 1922, when KISHIDA decided to participate in another group, the *Shun'yōkai* (Spring Season Society) (Fig. 39) which attempted to go beyond manifestos, ideologies, and fixed styles in order to create a free and open association of painters. KISHIDA was joined by MORITA TSUNETOMO, UMEHARA, YOROZU, and a half-dozen others. In 1926, SAEKI YŪZŌ, MAETA KANJI, and several others founded the *1930 kai* (1930 Society) (Fig. 40), choosing their name in honor of the coming hundreth anniversary of the generation of French painters they much admired, the so-called French "School of 1830," in particular Corot and Millet. The society was formed as a means to show their own work and that of others, so startlingly different from the Impressionist and Post-Impressionist paintings by now familiar to the Japanese public.

Some of these many groups were able to adapt themselves to changing circumstances and continued on into the post-World War II period. Some died out quickly. Some issued manifestos, while others saw their function to serve more as fraternal groups in support of fellow artists. All of these groups tried to forge some kind of useful connection between the artist and his possible public. The avant-garde playwright and artist Murayama Tomoyoshi (1901–1977), who undertook his studies not in France but in Weimar Germany, began a campaign after his return to Tokyo in 1923, and with some success, to place paintings in cafes, coffee houses, and small local galleries, "where the people could see them."

Seeing the pictures was one thing; buying them was another. Few Japanese homes of the period had Western-style walls on which oil paintings could be comfortably hung (Fig. 41). Some wealthy Japanese had begun to add Western-style rooms to their traditional homes, but relatively few of them collected art, and among those who did, expensive imported works took pride of place. The government bought a certain amount of art for use in public buildings, embassies, and the like, but the works chosen, as might be expected, were by conservative and academic painters. By the 1950s, private Japanese collectors were buying Japanese art of the prewar period with increasing discrimination, and at rapidly escalating prices, but in 1915 or 1930 there were few patrons with the space, or the eye, to keep these Japanese artists financially independent. Oil painting did not therefore gain significance for the public as a collectable commodity; it remained something which at its best could be spiritual and moving, but which was to be observed, not possessed.

Fig. 41. Photograph of the interior of KURODA SEIKI'S Japanese-style house. Western-style paintings are of necessity hung above the sliding doors, virtually out of sight.

Fig. 42. An illustration by KOIDE NARASHIGE for "Husband and Wife," a work by Murō Saisei published in 1926.

Many painters after their return to Japan turned to teaching as a means of support. Some, such as ASAI, YASUI, and KOIDE, opened their own studios. There they were able to train others while they made a reasonable livelihood. Some of the best painters in the earlier years of the century, FUJISHIMA and KURODA, for example, felt comfortable teaching at the Tokyo School of Fine Arts, but by the 1920s, many of the younger artists, even if they were lucky enough to gain admission in order to undergo their training there, did not wish to work as mature artists in an atmosphere they felt confining. A certain number of painters continued doggedly to support themselves as artists, even though the financial difficulties involved were tremendous. Many, such as YOROZU, SAKAMOTO, NAKAMURA, and KISHIDA, spent time working far from Tokyo as they wrestled with the development of their own vision. A few, like UMEHARA, had both commercial success and some independent wealth. But with the exception of FUJITA, who lived and sold his pictures in France, few of these artists, even though they may have been the object of wide admiration at some point in their lifetimes, could support themselves altogether through their art.

Artists often assumed other related careers, which were helpful to them not only financially but psychologically. Some functioned as journalists, writing about art exhibitions in Tokyo and elsewhere, or on new developments in European art and related, more general topics. A certain number spent time as commercial illustrators. During the career of ASAI CHŪ, for example, it was still possible to do drawings for newspapers on current events, such as the Sino-Japanese and Russo-Japanese Wars. In later decades, however, photography had effectively replaced the function of the artist-journalist, so others turned to book and magazine illustration. Most successful in this category among the artists represented in the present exhibition was KOIDE NARASHIGE, whose drawings for the work of such prominent writers as Tanizaki Jun'ichirō (1886–1965) and Murō Saisei (1889–1962) were particularly successful (Fig. 42). In fact, the prominent novelist Uno Kōji (1891–1961) was so struck by the power of a painting by KOIDE, *Landscape with Dead Trees* (see McCallum, Fig. 56), that he used the image as a kind of motif in one of his most successful novels, to which he gave the same title.

72

Above left: Fig. 43. YOROZU TETSUGORŌ, *Riverside District,* undated. Colors on paper, 77.0 x 34.4 cm/30¼ x 13⅝ in. Iwate Educational Committee, Iwate Prefecture.

Above center: Fig. 44. Tani Bunchō, *Landscape,* 1793. Colors on silk, 66.5 x 28.0 cm/26⅛ x 11 in. Tokyo National Museum, Tokyo.

Above right: Fig. 45. Uragami Gyokudō, *Frozen Clouds Sifting Powdered Snow,* c. 1810. Hanging scroll, colors on paper, 133.2 x 56.6 cm/52½ x 22¼ in. Private collection.

Lower left: Fig. 46. ASAI CHŪ, *Landscape,* 1897. Scroll, colors on silk, 117.8 x 53.3 cm/46⅜ x 21 in.

Lower right: Fig. 47. KISHIDA RYŪSEI, *Eggplant,* 1924. Scroll, colors on paper, 35.8 x 26.8 cm/14¼ x 10½ in.

73

Despite the diversity of artistic commitment made by the Japanese artists, virtually all of them would have agreed, as their writings make clear, that the French experience taught them one essential thing: the need for an inner, personal integrity. By the 1920s, training and self expression had moved from the exterior to the interior. Thus even those who did not visit France or Europe learned the same, often painful, lessons. This search for that inner integrity of purpose made many of the artists extremely high-minded. After all, they had been forced to sacrifice much, both psychologically and financially, to undertake their chosen careers.

A number of painters, having studied and absorbed modern European styles, later looked back at the traditional Japanese arts with a new and sharpened eye, incorporating elements that seemed potentially expressive within the purview of their own vision. Some of YOROZU'S work (Fig. 43) shows his fascination with such Tokugawa literati painters as Tani Bunchō (1769–1840) (Fig. 44) and Uragami Gyokudō (1745–1820) (Fig. 45). ASAI (Fig. 46) and KISHIDA (Fig. 47) made similar attempts to use the art of the Tokugawa period. UMEHARA studied the work of such traditional artists as Ogata Kōrin (1658–1716) (Fig. 7) and Tomioka Tessai (1836–1924) as a means of absorbing their congenial sense of design. Much of this work was intended to be private and experimental, representing attempts by thoroughly modern artists to explore their own cultural past in a new way.

Of all the artists in the present exhibition, however, perhaps none labored so long or so carefully to reach a real synthesis of styles as SAKAMOTO HANJIRŌ, who withdrew from the Tokyo art world shortly after his return from France in 1921. On the southern island of Kyushu he spent his long and quiet career in an attempt to use the techniques he had mastered in Europe to manifest the individual and the essential Japanese spirit he felt within himself. For many Western viewers, a first experience with the paintings of SAKAMOTO may suggest a statement of the problem rather than its solution. They often reveal abstract forms and pale colors that may seem at first glance lacking in definition and theatricality. For many Japanese, however, SAKAMOTO'S succeeded best of all in amalgamating his French experience into his life-long experience as a Japanese artist. Those who admire SAKAMOTO'S work feel that, for him, the excitement of a new tradition was successfully absorbed, then distilled, into an art at once tactile and spiritual.

VI. Japanese Values and Modern Japanese Art

Virtually all of the assumptions on which Japanese culture had been based were called into question during the period from 1890 to 1930. Some of those assumptions underwent radical shifts, and in some areas, notably political, some dangerous dislocations. Having removed themselves from the Chinese cultural orbit, the Japanese found that the establishment of new European perspectives cut not only ties with mainland Asia but with much of the Japanese past. Some merely found the past outmoded, while others tried to reformulate elements from past Japanese experience to make them more modern, and thus implicitly more closely oriented toward Western values. This movement back and forth from the past to the present applied in virtually every field of conceptual and practical endeavor, from politics and military strategy to scientific inquiry, literature and philosophy. In the case of the arts, this struggle was often seen as a brave one between different and conflicting patterns of allegiance.

Stepping back from the accomplishments of the individual artists presented in *Paris in Japan*, certain issues emerge in terms of the developing internationalization of modern art.

These issues in turn suggest a framework within which to judge what Paris could at best have provided for these men, and, possibly, what it could not.

The first of these issues centers on problems of assimilation and creativity. In terms of our contemporary perceptions of achievement in art, the authentic individual statement has come to stand for the only true hallmark of success. To simplify and so perhaps to parody our contemporary sensibility, a painter's potential genius must seem to lie in his *difference* from others. Such attitudes may seem self-evident today, yet not only would such assumptions concerning the nature of art have been virtually unintelligible in the late Tokugawa artistic circles of early nineteenth-century Japan, but they would have been questioned as well, say, in the same period in France, when painters there were still expected to master a specific set of technical skills and attitudes about the purpose of art. That painterly skills could be taught and objective standards applied were assumptions known in both cultures.

When Japanese artists began to work in the Western mode in the latter part of the nineteenth century, they did so in a Parisian climate that still paid homage to transpersonal European standards. Once a painter like KURODA, for example, had mastered these skills, he was as "acceptable" an artist in the academic tradition as a French painter, since both were competing for favorable judgement in terms of the same criteria. Assimilation could still be rewarded. After the arrival in Japan of more modern Western values in artistic creation, however, a kind of individualism was called for that posed a peculiarly difficult test for the Japanese painters, who, a mere two or three decades after Western techniques and ideas on art had been introduced, were now being asked to rebel against them. In this regard, Japanese painters had a more difficult task to face than, say, the American painters of the same generation, since they were already a part of the European tradition. Those Americans who wished to rebel knew, as it were, who the enemy was. For the Japanese, their necessary course of action seemed far less certain. Whatever the nature of the individual accomplishments of the artists included in this exhibition, the changes in attitude from men like ASAI and KURODA to the generations of FUJITA and MAETA show an enormous expansion in the understanding of the art of Europe, past and present. As a group, these artists reveal in their work a genuine attempt to come to terms both with the nature of their own talent and with that larger world in which they found themselves. KURODA had created a modern tradition of Western-style painting within Japanese culture itself; by the time of SAEKI and YOROZU, only fifteen or twenty years later, a certain number of artists felt confident enough to go beyond it. Once a dialogue could take place, not only exclusively between France and Japan, but within Japan itself, then creative energies could be generated. Looking at the art of this period in terms of our contemporary concern for high individual differentiation may, therefore, cloud over the nature of the real success obtained— that of establishing, both in terms of individual artistic growth and audience receptivity, the basis for further creativity. Without this achievement, the postwar development of contemporary art in Japan as part of an international milieu would be unthinkable. Without the record of individual achievement from 1890 to the onset of World War II, younger artists in later decades would have found themselves lacking the kinds of role models who, even if their earlier accomplishments may have been only tacitly acknowledged, could provide a positive concept for the variety of roles that a modern artist can play.

The paradigm of the artist of one generation serving as a role model for artists in the succeeding generation was perhaps the most tenacious psychological legacy left to the modern period by traditional Japanese art. There, the master-disciple relationship had al-

ways served most effectively as a means to pass on traditional skills from one generation to the next. In the context of the avant-garde, however, the disciple was in effect forbidden to copy the master's work in and of itself. What the younger artist *could* still copy, however, was his master's attitude, his stance vis-à-vis his art and society. So it was, perhaps, that the best of the prewar artists came to be looked on as cultural heroes, both to younger painters and to the public at large. They were romantic figures who seemed in their careers to encapsulate strategies for maintaining their cultural force outside the confines of a polite middle-class society that could aptly be characterized as a Japanese version of the Victorian bourgeois. In Europe, the idea of the creative artist as a person outside society, a romantic rebel, was championed by the time of Baudelaire. Indeed, in the West, the popular nineteenth-century ideal of the romantic artist-as-Bohemian-hero still seems attractive and plausible enough. In particular, the example of Cézanne made a profound impression on the crucial generation of young Japanese painters that took spiritual sustenance from the trenchant example of this particular artist who, in their view, retreated from society in order to carry on a struggle with his own creative potential. The critical difference, and one that seems to have gone largely unperceived in Japan during this period, was the fact that Cézanne was struggling *against* established ways of "seeing" in order to put down what he saw himself. The Japanese painters, on the whole, had already set aside the ways of "seeing" inherent in their older art altogether. In this sense, *all* of Western art came to serve as their avant-garde. Thus, when the European traditions began to crumble, they faced not a struggle against an older vision but a void.

For many Japanese the angst of this creative struggle was perceived in and of itself as an act of merit. These attitudes were reinforced by a whole panoply of writers and intellectuals. Arishima Takeo, (1878–1923), for example, one of the leading novelists of the period and the older brother of ARISHIMA IKUMA, created as his protagonist in his celebrated 1918 novel *Umareizuru nayami* (The Agony of Coming into the World) a young man who struggles against the terrible difficulty of his life in a crude Hokkaido fishing village as he tries to become an artist. When the narrator of the story first sees the sketches and oils brought to him by the aspiring painter, he professes himself astounded:

> *It is true, they showed that you had not yet gone through any disciplined artistic training, and they were quite immature in technique. But some mysterious power seemed to be stored up in them, and this struck me the very instant that I glanced at them. I could not repress an irresistible impulse to take my eyes off them and have another look at you.*[19]

The quick identification between perhaps imperfect works of art and an artist ennobled by the quality of his struggle demonstrates Arishima's own impulse to merge intention with accomplishment. That process suggests one of the real dangers that the Japanese public faced, and, to a real extent, still faces in their desire to judge the value of a work of art by the intentions of the artist. However inevitable those attitudes may be, given the cultural matrix in which they developed, they have possibly rendered a disservice to the creation of a greater understanding of the real accomplishments of the Japanese painters in this present exhibition. Perhaps the brunt of popular displeasure has been born by FUJITA, who through his painterly skills and personality was able to propel himself into a prominent place in the École de Paris. For many Japanese, FUJITA was seen as an opportunist, who appropriated techniques, "tricks" if you like, from the traditional Japanese arts—(flat surfaces, black outlines, juxtaposed textures)—to achieve an inferior goal, that of worldly success. Thus, the argument goes, FUJITA was not avant-garde enough; he accepted, rather

76

than rejected, the society around him. SAEKI YŪZŌ, on the other hand, remains for the Japanese a figure of heroic proportions because he suffered from the dislocations he experienced between the two cultures. He lost his life trying to synthesize styles (and cultures) through the kind of internal struggle that a painter like FUJITA was seen to have set out to sidestep altogether.

For a Western viewer, unburdened by such cultural and biographical background, both painters show creative and expressive strengths. Without recourse to romantic legend, we may be able to judge these painters in a more "objective," perhaps harsher light than the Japanese. We may not wish to adopt the same cultural assumptions that the Japanese have made, yet *Paris in Japan* can, one hopes, point out just how conditioned by cultural contexts our own responses to art may remain.

Although in the largest perspective the painters in this exhibition can be seen as precursors to contemporary Japanese artists now at work within the international style, it must be noted that there came a certain break in the development of modern Japanese tradition in the mid-1930s, when the rise to power of the militaristic government inhibited the development of any avant-garde. The imposition of a nationalistic and traditionalist spirit on art circles, as on all areas of Japanese intellectual and cultural life, dampened free and adventuresome spirits. Any art with leftist political or proletarian leanings was specifically suppressed. New Cubist and Surrealist experiments, cut off from a free exchange with Europe, suffocated for lack of support. Younger painters experienced greater difficulties travelling to Europe, while many already in France and elsewhere were forced home. Older painters, such as SAKAMOTO HANJIRŌ, either remained in relative obscurity, or found themselves facing the necessity to take up themes of "national significance," employing styles deemed "appropriate" to the patriotic nation-state. Japan is an island country, and no refugee routes were available. Artists had either to concur, unwillingly or willingly, as FUJITA evidently did during his temporary residence in the late 1930s and 40s, or to retire to teaching and the freedom of a private atelier.

VII. *Some Final Remarks*

We who see the work of these Japanese painters from the vantage point of the 1980s may find a number of opportunities to gain a new appreciation of the dynamics of the fascinating Tokyo/Paris connection during those years. To observe the Japanese sensibility experienced through the medium of Western oil painting may help us revise our understanding of Japanese culture at large. These early twentieth-century works, however similar to European painting in general technique and subject matter they may be, demonstrate that the Japanese painters of this period developed a set of attitudes about the role and goals of painting that are at least as different from their composite European models as those of, say, the American Impressionists. At the same time, the issues raised by the work of these artists for contemporary viewers are complex. The present exhibition, which can only serve as an introduction to the subject, cannot provide sufficient data to come to terms with all the questions that a thoughtful student of the subject might raise.

One of the most pertinent of these issues lies in the difficulties encountered in attempting to locate, in this period when Western modalities had already been adopted, the distinction between individual talents and Japanese sensibility. Whatever the range of personal expressions involved, there may remain certain qualities held in common that, to our eyes, set these works off from those of their European mentors. Careful and continued observa-

Fig. 48. Koga Harue, *The Sea,* 1930. Oil on canvas, 128.5 x 160.5 cm/50⅝ x 63¼ in. The National Museum of Modern Art, Tokyo.

Fig. 49. Fukuzawa Ichirō, *The Good Cook,* 1930. Oil on canvas, 81.6 x 115.6 cm/32¼ x 45½ in. The Museum of Modern Art, Kamakura.

tion of modern Japanese art may reveal the elements of a perhaps unarticulated yet powerful national sensibility, based on centuries of accumulated visual memories, that surface in some fashion in these pictures. In some way, their most appealing qualities may lie less in the area of individual statement than in a recasting of Japanese conceptions of time, light, space, surface, pattern, distance, color and design, into a new Western medium, one already familiar to us. To locate and appreciate a national sensibility in a category of painting that Westerners want to judge in terms of a fashionable demand for individual statement requires an adjustment of preconceptions. Such an effort will be worthwhile, however, if it can help the real beauty of these works to emerge.

The question of national sensibility may also help to explain why certain trends in European art—Cubism, Surrealism, Futurism, Dadaism, among others, seem to have been less attractive to the Japanese than Impressionism and Post-Impressionism. After all, those two styles remained for many decades the preferred point of access to Western art not only for the educated Japanese public but for many of the artists themselves.

Further, those European styles show a reciprocal exchange with Japanese art through the importation into France of woodblock prints and Japanese *objets d'art.* There was, in other words, a natural congruence of taste between the two cultures; each borrowed from the other in this particular phase of their respective artistic development. It might be possible also to argue that the traditional Japanese love of design, color, and pattern made the appeal of Cubism and other later developments less intrinsically appealing. There were, of course, a number of important Japanese experiments with Cubism, Surrealism, and socially-conscious proletarian art. The later and somewhat fitful experiments in more avant-garde forms need to be studied, observed, and judged in the contexts established by the painters under study here. The fact that later experiments with advanced European styles remained tentative, however, suggests that, even discounting the effect of the dour atmosphere created by the military in the 1930s, those particular movements lacked sufficient resonances within Japanese cultural sensibility. Distinguished artists such as Koga Harue (1895–1933) and Fukuzawa Ichirō (b. 1898), who created works in such genres (Figs. 48, 49), represent individual talents that lie somewhat outside the mainstream of modern Japanese art.

Finally, it should be said that many of the questions raised by the development of modern painting in Japan remain to be fully addressed in Japan itself. The kind of data necessary to come to a fuller understanding of what might be termed the sociology of modern Japanese art is only now being systematically collected. The powerful prestige of Western art for both Japanese scholars and the Japanese public has meant that until recently, fewer studies have been undertaken concerning the way in which the work done by Japanese artists early in the century was received in Japanese society. Biographies of individual artists, usually portrayed as cultural heroes, often appear, but a serious examination of the documents of the period, for example, is just now beginning. The word "hero," too, suggests another problem so far largely ignored. Why were there no women painters? Or, if there were, why have their reputations not been sustained?

Now that the Japanese art world itself has begun to examine this justly-admired national heritage in the spirit of friendly objectivity, it will become more possible to create a full-fledged appraisal of what has been accomplished. For the visual record of those years shows that, in our century, cultures have had the ability, at their best, to grow together yet retain their own authenticity.

Notes:

1. For useful information on Japanese participation at such international expositions, see the essay by Neil Harris, "All the World a Melting Pot? Japan at American Fairs, 1876-1904" in Akira Iriye, ed. *Mutual Images, Essays in American-Japanese Relations* (Cambridge, Massachusetts: Harvard University Press, 1975).

2. Quoted in Edward Seidensticker, *Kafū the Scribbler* (Palo Alto: Stanford University Press, 1965), p. 19.

3. For a translation of the full poem, see Ichiro Kōno and Rikutaro Fukuda, *An Anthology of Modern Japanese Poetry* (Tokyo: Kenkyusha, 1957), p. 20.

4. Ueda Bin, quoted in Noda Utarō, *Nihon tanbiha no tanjō* (Tokyo: Kawade Shobō, 1975), p. 10.

5. Arishima Ikuma, *Hitotsu no yogen* (Tokyo: Keishōsha, 1979), pp. 18–19.

6. Takamura Kōtarō, "Garon, Henri Matisse," *Takamura Kōtarō zenshū* (Tokyo: Chikuma shobō, 1957–8), Vol. 17, p. 201.

7. For additional details, see various entries in Haru Matsukata Reischauer, *Samurai and Silk* (Cambridge, Massachusetts: Harvard University Press, 1986).

8. Umehara Ryūzaburō, *Runowaru no tsuioku* (Tokyo: Yōtokusha, 1944), p. 33.

9. For the complete text of the poem, see Hiroaki Sato and Burton Watson, ed., *From the Country of Eight Islands* (New York: Doubleday, 1981), pp. 464–467.

10. Takamura Kōtarō, *Geijutsuronshū* (Tokyo: Iwanami bunko, 1982), p. 81.

11. *Ibid.*

12. *Ibid.*, p. 82.

13. The quotation is taken from Bernard Leach, *Between East and West: Memoirs, Portraits and Essays* (New York: Watson-Guptill Publications, 1978), p. 123.

14. Charles Lewis Hind, *The Post Impressionists* (Freeport, New York: Books for Libraries Press, 1969), pp. 27–28.

15. *Ibid.*, p.6.

16. Cited in Azuma Tamaki, *Shirakabaha to kindai bijutsu* (Tokyo: Azuma shuppan, 1980), p. 26.

17. Watsuji Tetsurō, tr. Geoffrey Bownas, *Climate and Culture* (Tokyo: Hokuseido Press, 1961), pp. 212–213.

18. Kato Shūichi, *Form, Style, and Tradition: Reflections on Japanese Art and Society* (Berkeley: University of California Press, 1971), pp. 32–33.

19. Arishima Takeo, tr. Fujita Seiji, *The Agony of Coming into the World* (Tokyo: Hokuseio Press, 1955), p. 3.

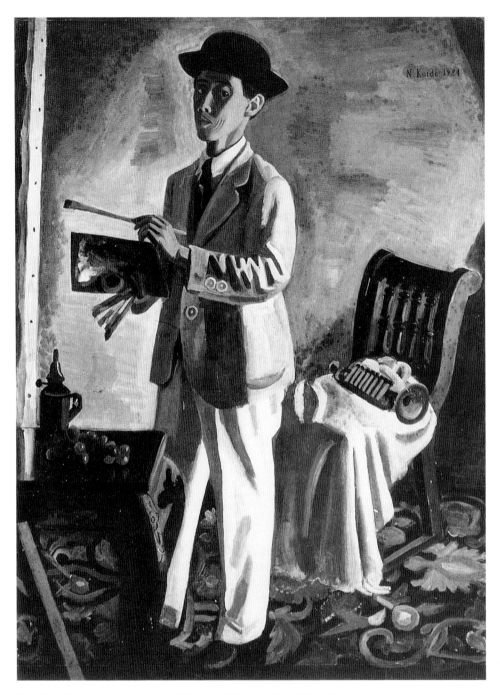

Fig. 50. KOIDE NARASHIGE, *Self Portrait Wearing Hat,* 1924. Oil on canvas, 126 x 91 cm/49⅝ x 35¾ in. Bridgestone Museum of Art, Tokyo.

THREE TAISHŌ ARTISTS:
YOROZU TETSUGORŌ, KOIDE NARASHIGE,
AND KISHIDA RYŪSEI

Donald F. McCallum

Introduction

The Meiji period (1868–1912) was the time during which Japan transformed herself from a traditional society to a modern state. Pioneers of oil painting, men such as KURODA SEIKI and ASAI CHŪ, were products of the Meiji experience, and can be linked with the general social and cultural circumstances of Japan during the later nineteenth century. In this essay I would like to consider several artists who might be thought to exemplify the characteristics of the succeeding Taishō period (1912–1926). Contrasting with Meiji, which combined dynamic energy and an authoritarian political structure, Taishō seems both less active and less repressive. During Taishō more attention was paid to the individual, which led, not surprisingly, to significant new developments in literature and art.

The three painters to be discussed here—Yorozu Tetsugorō, Koide Narashige, and Kishida Ryūsei—were born, respectively, in 1885, 1887, and 1891, that is, in the middle Meiji period. They were students during the first decade of the twentieth century and each began his professional career early in the second decade, almost exactly conforming to the beginning of the Taishō era. Their lives ended in 1927, 1931, and 1929, again almost exactly equivalent to the end of Taishō. In order not to be bound by rigid periodization, and also for the sake of convenience, I propose to treat the Taishō experience in this essay in terms of the two decades from around 1910 until 1930. Japanese of the Taishō period, or at least the educated urban classes, saw these years as a time of increased freedom. The goals of the Meiji Restoration were largely accomplished, and it was no longer necessary for the individual to sublimate his desires to the greater good of society. As a modern, prosperous state, Japan was thought to have resources adequate to allow the individual the option of self-cultivation through intellectual and cultural pursuits. More and more people received a higher education, leading to a great expansion in the number of bureaucrats, business executives, and professionals of all categories, and it was these people, and especially those who catered to their artistic and intellectual needs, who formed Taishō culture. Yorozu, Koide, and Kishida are all fascinating examples of the complexity of Taishō culture but, more importantly, each was an outstanding artist.

The lives of these three artists were contemporaneous, but there is another feature that they have in common that is even more significant, particularly in light of the dominant theme addressed in this exhibition. Yorozu and Kishida never visited Europe, and while Koide made a short trip to France in late 1921 and early 1922, it was at a stage when he was already a mature artist. I would suggest that this differentiates them very importantly from other painters featured in this exhibition, including predecessors such as KURODA SEIKI, FUJISHIMA TAKEJI, and OKADA SABURŌSUKE, or contemporaries like SAKAMOTO HANJIRŌ, YASUI SŌTARŌ, UMEHARA RYŪZABURŌ, and FUJITA TSUGUJI, all of whom spent substantial periods of time studying and working in France. The ways in which a

European experience, or the lack thereof, affected Japanese painters of this period seems to have been quite an important factor not only for Yorozu and Kishida, but also for a number of other excellent painters including AOKI SHIGERU, MURAYAMA KAITA, SEKINE SHŌJI, and NAKAMURA TSUNE.

Another trait that Yorozu, Koide, and Kishida have in common is their tragically short life spans, living to the ages (respectively) of 42, 44, and 38. And yet within these rather truncated careers each was able to produce substantial oeuvres marked by high quality and considerable variety. It is interesting to consider that those artists just cited as having studied in Europe all lived normal life spans, while some of them, such as SAKAMOTO, UMEHARA, and FUJITA, attained very advanced ages. Concomitantly, those mentioned above who did not go abroad all died quite young, SEKINE and MURAYAMA both in their early twenties. In terms of painters represented in the present exhibition, only SAEKI YŪZŌ does not fit this paradigm, for he both worked in Europe *and* died young, although as a result of suicide. In the conclusion we shall return to the question of *yōsetsu* (premature death) as a phenomenon among modern Japanese artists.

With this brief introduction as background, it is now time to present a careful analysis of representative works by Yorozu, Koide, and Kishida. These analyses will be formalistic in nature, attempting to isolate the most salient characteristics of each artist's painting.

YOROZU TETSUGORŌ (1885–1927)

The oldest of the three artists to be dealt with in this essay was, somewhat surprisingly, particularly radical in terms of his aesthetic intentions. Moreover, he hailed from the far north, traditionally one of the most conservative regions of the country. Why, given this background, Yorozu developed into the leading Japanese avant-gardist is a subject that will have to be elucidated. Interestingly, he was among the first Japanese artists to explore such new stylistic traditions as Expressionism and Cubism. In this respect it is important to note that other artists included in the exhibition, such as KURODA SEIKI, FUJISHIMA TAKEJI, and SAKAMOTO HANJIRŌ, all of whom had lengthy periods of study in Europe, tended to paint in rather old-fashioned modes, apparently ignoring the more up to date developments actually occurring while they were in Europe. Yorozu, through his study of books and periodicals, grasped the expressive possibilities of the newest styles, rapidly incorporating them into his own work. Compared with his more cautious predecessors and contemporaries, Yorozu seems to be the most adventurous painter of his era, always willing to experiment with something new.

Yorozu received a conventional, academic education in art school, and his early sketches and paintings amply demonstrate his mastery of conventional pictorial techniques such as modeling and perspective. In contrast to such traditional works, one of the two paintings that he submitted as a graduation requirement—*Nude Beauty* of 1912—(Fig. 51) comes as a tremendous shock. This large-scale canvas is undoubtedly Yorozu's best known and admired work, as well as being one of the most significant documents of early twentieth-century painting in Japan. There are preliminary drawings and oil sketches for the composition which show that the young artist moved gradually from a relatively realistic depiction of the model to the expressive distortions which characterize the finished work. It must have been a truly surprising painting when first shown, with its intense color contrasts and rather crudely executed line. The element of deformity seen in the woman's body is obviously intentional, and it is apparent throughout the composition that

Yorozu was striving for extreme effects. *Nude Beauty* is normally discussed in terms of Fauve influence, especially as Yorozu spoke of the significance of that French movement for his art, but I believe that the work has an expressionistic content which is more closely related to German than to French art.

Although *Nude Beauty* is the most well known of Yorozu's early works, I would suggest that in some ways *Self Portrait with Red Eyes* (Cat. 74), also of 1912, is of equally high significance. In certain respects it follows the style of the preceding work, although it is far more startling in effect. Compared to his earlier academic style this work shows great freedom in color and very strong brush work, and it is safe to say that *Self Portrait with Red Eyes* would have been considered a "shocking" painting in 1912 in virtually any part of the world. Certainly the Cubists were more advanced in formal terms at this time, but their paintings are more subdued and neutral in emotion. It is the intense, expressionistic quality of Yorozu's work that is most evident, and it seems clear to me that this quality cannot be related to Fauvism. What French painting displays the strong forms with jagged contours and the exceedingly jarring color scheme seen here? I am convinced that *Self*

Fig. 51. Yorozu Tetsugorō, *Nude Beauty,* 1912. Oil on canvas, 160 x 97.5 cm/63 x 38⅜ in. The National Museum of Modern Art, Tokyo.

Portrait with Red Eyes must be related to German Expressionism, perhaps to the work of Kirchner or Schmidt-Rottluff. The strangely morbid characterization seen in this work has gone far beyond standard late Meiji-Taishō introspection, and Yorozu appears to be investigating deeper psychological states than simple artistic alienation.

A quite different mood can be seen in *Woman with a Boa* of 1912 (Cat. 75), a representation of the artist's wife. In contrast to the expressive intensity of *Self Portrait with Red Eyes*, this painting has a rather gentle, affectionate character. Nevertheless, the woman sits in a strictly frontal, symmetrical pose, and stares out directly at the viewer, as does Yorozu in his self portrait. There is a similar range of hues in *Woman with a Boa*, although they tend to be less strident, even somewhat lyrical in certain areas. In looking at the actual painting, one is struck by the loveliness of the execution of the surface, a fact that reminds one of the essential complexity of Yorozu's aesthetic aims. *Nude with a Parasol* of 1913 (Cat. 76), is a rather peculiar painting, representing a woman seated on a low stool holding an opened umbrella over her right shoulder. A striking feature of the nude is her somewhat awkward, ungainly body, especially the way in which the breasts have been depicted. In its total impact, this work is somewhat troubling, apparently representing cer-

tain attitudes, perhaps subconscious, that Yorozu had toward the subject.

The three representations of women from Yorozu's early mature period—*Nude Beauty, Woman with a Boa*, and *Nude with a Parasol*—provide one with varied and interesting material for an analysis of his artistic intentions. While *Nude Beauty* is executed in a distinctly expressionistic style and seems suffused with some sort of primitive energy, *Woman with a Boa* is a quiet and delicate work, depicting the artist's wife in her "Sunday Best." (The wearing of a fur boa with traditional Japanese kimono strikes the Westerner as incongruous, but it is a standard component and thus its appearance here should not be thought of as an idiosyncrasy of Yorozu.) As just noted, *Nude with a Parasol* is a slightly strange representation of a nude woman, presumably a model, under an umbrella. It might be instructive to compare this painting with Kirchner's *Girl under Japanese Umbrella* of c. 1908 in terms of both subject matter and mood.

Yorozu did a number of interesting landscapes during these early years. *Rural Landscape* of c. 1912 (Cat. 73) gives a good idea of his development in this genre. It depicts a broad area of green fields, occupying about half of the composition, with a large, centrally placed tree dominating the upper half, placed against a pink sky. Throughout the work one is particularly conscious of the broad, heavy application of paint in large daubs which creates an insistent rhythm somewhat independent of the representational issues. Other early landscapes, such as *Cornfield under the Sun* of 1913, are more intensely expressionistic in style, and in that respect similar to *Self Portrait with Red Eyes*.

Yorozu's art reached a sort of early peak during this period of frenzied creative energy in 1912 and 1913. Although he had just graduated from art school, he was 27 years old, roughly the same age that Picasso was when he did some of his most startlingly innovative works. If Yorozu had not painted after 1913 I suspect that he would still be remembered as one of the most significant painters of his time. The next few years, from 1914 until 1917, do not appear to be marked by the same degree of spontaneous creativity as seen in 1912–1913; instead, one notes a gradual maturation with many works having a decidedly lyrical quality. In addition, there is a long series of probing self portraits.

The next burst of intense productivity occurred in 1917 when Yorozu moved from his earlier coloristic experimentation into new directions, particularly an exploration of Cubism. A work that is almost as well known as the 1912 *Nude Beauty* is *Leaning Figure* of 1917 (Fig. 52), a very large painting (162.5 x 112.5 cm) that is Yorozu's major Cubist effort. Perhaps the first thing that one notes about *Leaning Figure* is its strongly expressionistic content. As has been frequently noted, expressive distortions in true Cubism normally serve specific formal ends, as the artist takes apart and then reassembles the various components of his composition. It is difficult to interpret Yorozu's painting in these terms, since the distortions of the nude woman's body seem to relate to expressionistic rather than formal interests. In this respect, it might be noted here that Yorozu is following the same path taken by most of the minor Cubists who, by and large, employed distortion for immediate emotional ends rather than as one device among several utilized to create a new pictorial world. Consequently, it might be argued that *Leaning Figure* relates to a general expressionistic current in Yorozu's art that stands above and beyond the conventional labels of "Fauvism" and "Cubism." Moreover, the color scheme of *Leaning Figure* does not follow the usual practice of Cubist painting.

Although this is not yet the place to attempt a synthetic interpretation of Yorozu nudes, it seems evident that *Leaning Figure*, despite its Cubist trappings, must be considered in the broader framework of the significance of this subject matter for the artist. While the present

Left: Fig. 52. YOROZU TETSUGORŌ, *Leaning Figure,* 1917. Oil on canvas, 162.5 x 112.5 cm/64 x 44¼ in. The National Museum of Modern Art, Tokyo.

Above: Fig. 53. YOROZU TETSUGORŌ, *Still Life with Tea Implements,* 1918. Oil on canvas, 53 x 73 cm/21 x 28¾ in. Iwate Educational Committee, Iwate Prefecture.

work differs substantially from *Nude Beauty*, it will be recalled that distorted forms were seen in that work as well. Certainly the violent attack on the female body perceived in *Leaning Figure* is different, but it is a difference in degree rather than kind.

Yorozu did a number of impressive still lifes during these years, including *Still Life with Tea Implements* of 1918 (Fig. 53). In this work monochromy produces the basic effect, with a very dark table cloth and subdued brown in the wall behind. The only strong contrast to the over-all color effect is the intense brick-red of the tea cup at lower left. Throughout this composition the artist has emphasized distortion in the forms, especially in the shape of the pot at upper right. As a whole, this is a particularly beautiful work, demonstrating Yorozu's mastery of the genre. It is interesting to note that all three of the artists considered in this essay executed very fine still lifes. Since this genre seems not to have received a great deal of critical attention in Japan, I will make an effort later to elucidate its overall significance within Taishō painting.

In this discussion of Yorozu's oeuvre we have had occasion to consider several of his female nudes, including his graduation presentation—*Nude Beauty*—and *Leaning Figure* of 1917. I would like to conclude with a brief analysis of an example from his later career, *Reclining Nude* of 1923 (Cat. 77). This work seems somewhat uncharacteristic of Yorozu in several respects. The broad planes of flat color for the wall and mattress are unusual in his works; the overall mood seems different. Something of the frenzy of many of his earlier paintings is gone. The mood now seems quiet and calm.

Yorozu Tetsugorō was open to a broad range of stylistic possibilities, from Expressionism and Cubism to the lyrical and decorative. He was an explorer and innovator, seldom content to remain with any mode for a substantial length of time. This tendency gives his

work a somewhat unfocused quality, as he tries first this and then that style without a long-term commitment to any single one. And yet there is an intensity to his practice that imbues individual works with great power, suggesting that his constant changing should not be seen as weakness, but rather as one of the sources of his artistic strength.

KOIDE NARASHIGE (1887–1931)

Yorozu was a man of the Tohoku region, the distant north; in contrast, Koide Narashige was from Kansai, the traditional heartland of Japanese culture. He came not from Kyoto, however, but from Osaka, which makes a difference because the inhabitants of the Osaka area are known more for their commercial astuteness than for aesthetic pursuits. Koide was born October 13, 1887 in the heart of Osaka to a merchant family which dealt in pharmaceuticals. As was the case with Yorozu, Koide's family was prosperous, a typical pattern for individuals who became painters in early twentieth century Japan. Koide himself began manifesting a strong interest in art from around the age of ten, and by the time he graduated from Middle School had decided to become an artist.

Although Koide Narashige emerged as one of the major painters in Japan during the 1920s, he got off to a rather slow start. He began his studies in the Japanese section of the Tokyo School of Fine Arts in 1907 because he failed to gain admission to the Western Painting Section. A number of Koide's *Nihonga* productions are still extant, mostly copies of famous Chinese and Japanese works. While they display a high level of technical facility, they are difficult to judge in terms of expression since they are fundamentally derivative in character. After a period in the Japanese section, Koide was able to transfer to the Western Painting Section.

A *Self Portrait* in oils of 1912 (Fig. 54) is a typical example of this genre as practiced by Japanese artists at the end of the Meiji and during the Taishō period. The somewhat self-conscious, introspective expression that it exemplifies can also be seen in the self portraits of Yorozu Tetsugorō, and in the next section we shall see related works by Kishida Ryūsei. It seems clear that the concern with self-identity and individual expression which characterized the Taishō intellectual are reflected in all of these self portraits.

Koide did not produce especially interesting work during the early years of his career; in this sense he is quite different from Yorozu. There are a few landscapes which are in no sense distinguished, and it is obvious that Koide was still struggling with basic issues at this stage. These were years of learning rather than years of solid accomplishment.

Perhaps the first really important painting by Koide is the portrait of his wife, *Portrait of Mrs. N*, dated March 1918 (Cat. 25). Koide married Wada Shigeko in June 1917 and their son was born on April 13, 1918, so this work represents Mrs. Koide in the final stages of her pregnancy. Certainly the facial expression and the general mood of the work can be understood partially in terms of maternal feelings. It is with this work and others done at about the same period that one begins to see the strong impact of Northern Renaissance painting on Koide. The rich, glowing colors and the sense for solid forms and tangible textures are all qualities that are related to his study of Northern painting. Particularly important is the fact that Kishida Ryūsei was also influenced by Northern painting in these years and thus both artists were moving deep into the European past for their inspiration, rather than drawing on the somewhat academic Impressionism which had been popularized by KURODA SEIKI, ASAI CHŪ, and their disciples. It might be argued that the course followed by Kishida and Koide had the effect of strengthening the development of

86

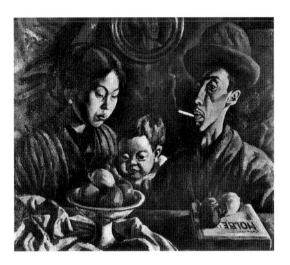

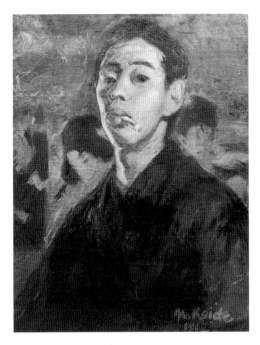

Left: Fig. 54. KOIDE NARASHIGE, *Self Portrait,* 1912. Oil on canvas, 60 x 45.5 cm/23⅝ x 18 in.

Above: Fig. 55. KOIDE NARASHIGE, *The Family of N,* 1919. Oil on canvas, 78.8 x 91 cm/31 x 35¾ in. Ohara Museum of Art, Kurashiki.

oil painting in Japan, since the two artists moved away from the somewhat facile styles practiced by many of their contemporaries.

The issues investigated in *Portrait of Mrs. N* are further pursued in *The Family of N* of 1919 (Fig. 55), Koide's first clear masterpiece. In this case the Northern Renaissance source is specifically acknowledged in the form of a volume entitled "Holbein" which lies on the table in front of the artist. The characteristics noted in *Portrait of Mrs. N* are brought to a fuller stage of development in the present work, and one is especially conscious of the expressiveness of the light as it sweeps in from the right, modeling the various forms. As in the earlier painting, here too Koide allows richly glowing forms to emerge out of the dark ground, thus enlivening the picture plane. The execution of the surface is in terms of a heavy build-up of texture, creating an impasto effect in many areas.

The period up through 1921 were years of gradual maturation and some real accomplishment, although as yet Koide was not widely recognized. In September of that year he sailed for France, arriving in Paris in October. He spent a short time in that city, and then travelled to the south of France, before embarking on the return voyage to Japan in February 1922. Koide's stay abroad was short, and it is difficult to assess the impact of this experience on his art. However, it would appear that his brushwork loosened up substantially and he more or less abandoned the heavy impasto of his earlier style.

Two of the works executed in France are views seen through the windows from Koide's lodgings, one in Paris (Cat. 26), the other painted in the south of France. While this is a relatively standard theme in French painting, it is perhaps significant that Koide was drawn to a theme that allowed him to work within the security of his own room, an outsider looking at an alien world. The Parisian window scene evokes the mood of the city at the approach of winter, since most of the colors are somewhat somber. Particularly striking in this work is the looseness and freedom of the brushwork, and one wonders what sort of art works Koide had been looking at to produce this change in style. Additionally, there seems to be a greater concern with abstract compositional effects than is

generally seen in the earlier work. *The Window* of 1922, which was painted in Cannes, has the bright light and color of the south of France, in that sense quite distinct in style from the work executed in Paris. Nevertheless, it still manifests something of the alienation of the earlier work, as one imagines Koide gazing out at the world around him.

Any attempt at deeper understanding of Koide as a mature artistic personality should undoubtedly begin with an analysis of his *Self Portrait Wearing Hat* of 1924 (Fig. 50), certainly one of the most interesting depictions of painter as painter in twentieth-century art. The artist stands in the center of his studio, incongruously wearing a black hat and an impeccable white suit. He holds his palette and several brushes in his right hand while the brush he is painting with at the moment is held in his left hand, ready to touch the canvas. However, Koide looks out at the spectator rather than at the canvas, although it is possible that he is looking at a mirror that reflects his image. In any case, one is most struck by the self-consciousness of the representation of the artist, and it seems certain that Koide was striving to create an image adequate to project what he perceived to be the essence of his own personality. We know from photographs that Koide was somewhat of a dandy, an aspect of his character which is clearly visible in this painting. The light illuminating the room sweeps in from the right and it is interesting to note that while the left side of the artist's head is brightly lit, practically all of his face is deeply shadowed. Koide occasionally employs this device in representations of nudes and one must assume that it was intended, perhaps subconsciously, to veil somewhat the personality of the individual depicted. Certainly in the present work considerable emphasis is placed on the artist's hat, suit, and painting tools, with relatively less focus on his facial features. Nevertheless, one still receives a vivid impression of Koide's character from the work.

After returning from Europe Koide concentrated on still life and nudes, although he continued to do the type of figural work that we have just analyzed, as well as landscape. Before considering his most significant achievement between 1925 and 1930—the nudes— it might be useful to study one of the still lifes. I commented above on the beauty of some of Yorozu's works in this genre and later we shall look at Kishida Ryūsei's even greater accomplishment. It is my impression that the Taishō still life tradition has not yet received the recognition that it so fully deserves, and it is in this context that I am considering those done by Yorozu, Koide, and Kishida.

Still Life with Globe of 1925 (Cat. 28) is one of Koide's masterpieces and is certainly among the finest paintings that he had done by the mid-twenties. The gray of the wall is painted in an extremely free and spontaneous manner, while the dark tones of the table seem to produce a field against which the various elements glow. Beautiful yellow-greens for the pears, darker greens for the grapes, and a red-brown for the pomegranate, create a delicious quality to the fruit. Equally beautifully painted are the inanimate objects, especially the glass pieces. The globe is blue with a brown frame, and the same colors— in the opposite proportions—can be seen in the book at the lower left corner of the table.

Of the major artists active in the Taishō period and early years of the Shōwa period, Koide devoted the most attention to the nude, and it seems fair to say that he achieved the greatest success in this genre. In a sense these paintings should be regarded as a series related to Kishida's Reiko portraits even though they represent several different models, since Koide's concentration on the specific theme of the nude woman seems to have enabled him to produce major works.

In the course of his studies at the Tokyo School of Fine Arts, Koide executed numerous drawings of the nude which display the precise technique universal in productions of

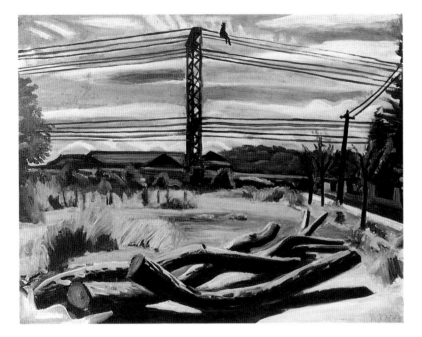

Fig. 56. KOIDE NARASHIGE,
Landscape with Dead Trees,
1930. Oil on canvas,
72 x 90 cm/28⅜ x 35½ in.

the academy, and a strange lifelessness that hardly prepares one for his later achievements. Nevertheless, it was probably through these exercises that the artist gained his initial insights into the nude as a theme. Paintings of the nude were done during the later teens and early 1920s, but it was not until the second half of the 20s that the artist succeeded in producing one masterpiece after another in a breathtaking series.

A brilliant example of the mature work is *Reclining Nude* of 1928 (Cat. 30). This work utilizes a pose seen in many of the paintings of this group. As is normally the case with Koide's reclining nudes, the figure stretches from one edge of the picture to the other, thus dominating the composition. It is important to recognize that the nude is not a traditional category of Japanese painting. When introduced by the Meiji pioneers it was usually in the form of a Western woman which seemed, somehow, to make it acceptable. However, in Koide's nudes we see an intense concentration on the characteristic facial features and body structure of the Japanese woman; the nude, as genre, was naturalized. A lusty eroticism pervades the present work as well as most of his other paintings of the female nude, and it must be acknowledged that we are offered a rather blatant example of the depiction of woman as sex object.

Koide's last great painting is *Landscape with Dead Trees* of 1930 (Fig. 56), a composition which shows a view out of the window of the artist's studio, including the distinctive feature of the wires over the Hanshin Railroad tracks. It is a very focused and intense painting, with an open composition and a light atmosphere. The sky is beautifully painted, with an alternation of blue and white bands, while the railroad wires provide an articulating accent. Significant, perhaps, is the fact that the main tower supporting the wires is rather close to the central axis of the composition. Just to the right of this tower one can see an enigmatic black figure seated on the uppermost wires. Given the general character of Koide's art, this Surrealist touch is very startling, although it must be acknowledged that the figure is effectively integrated into the composition. A second strange element in the picture is the group of oddly shaped logs in the foreground. Since these are mentioned

in the title, they must have had importance to the artist; certainly in color and form the dead trees create an ominous, even frightening mood, and they seem to work with the figure perching on the wires to produce an eerie effect in the whole picture. The symbolism of this painting remains to be elucidated, although it seems clear that it was profoundly meaningful to Koide as an artist and individual.

Kishida Ryūsei (1891–1929)

While our first two artists were both natives of places far from Tokyo, only coming there for art school, Kishida Ryūsei was born in the very center of the city—Ginza—on June 23, 1891. Thus it is not surprising that he was exposed to rather advanced ideas at an earlier age than were Yorozu and Koide. Around 1912 Kishida discovered the Post-Impressionist masters Cézanne and van Gogh, and began to incorporate their styles into his work. The Cézannesque element in Kishida's painting can be seen well in the portrait of the English potter Bernard Leach (Cat. 19). However, Kishida did not linger long with the Post-Impressionist styles, as he soon began working in a mode that derived from Northern Renaissance and Baroque painting. We have already seen this concern in the art of Koide Narashige, although it would appear that Kishida, the younger artist, was the first to go back to the earlier European styles. As was mentioned above, the concern that Koide and Kishida showed for northern artists such as Holbein and Dürer was contrary to the major currents in late Meiji and Taishō painting, which tended to reflect the influence of later nineteenth century developments in France. In the case of Kishida, the impact of early northern European painting is seen particularly in his numerous portraits and self portraits.

Kishida is especially well known for his very extensive series of self portraits. In them one is conscious of the constant self observation of the Taishō intellectual; seemingly gazing outward, it can be suspected that he is really looking inward at his own soul. For this reason, I would suggest that the self portrait as practiced by the present three artists, and several others as well, is of key importance to a broader understanding of Taishō culture.

The *Self Portrait* in the exhibition (Cat. 20) shows the face turned slightly to the right. The field shows the ochre hues typical of the entire series, and Kishida wears a dark kimono. His face is articulated in darker ochres and browns, the pigments applied rather thickly in order to build up a rough, textured surface. From behind his metal rimmed glasses, the artist gazes out in a solemn, stern manner, a mood that characterizes all of the works in the series.

One of Kishida's most beautiful paintings is *Portrait of the Artist's Wife* of 1915 (Fig. 57). In style it relates to the self portraits that he had been working on for several years and in subject matter it reflects a concern for the individual, in this case his wife, Shigeru. Particularly important is the way she is treated as a real person, rather than being idealized as was normally the case in pre-modern Japanese portraiture. Shigeru has a solemn, somewhat pensive expression as she gazes to the left; significant in terms of realism is the bump at the bridge of her nose, a detail that would probably have been eliminated in a more idealized depiction, but which is utilized here to intensify the sense of veracity. Alert eyes, full lips with a rich red hue, and splendidly modeled cheeks complete the portrayal. Kishida successfully combines psychological penetration with a stunningly beautiful color scheme of restrained deep blues and reds harmonizing with the flesh tones and the white of the scarf.

We have considered Kishida's very impressive accomplishments in portraiture, and we

shall return to this theme presently in the discussion of the Reiko series. However, it would be a mistake to create the impression that Kishida was fundamentally a portraitist since he, like Yorozu and Koide, achieved great success in a variety of genres, including landscape and still life.

Let us look first at a landscape which is generally considered to be Kishida's finest work in this genre, as well as one of the masterpieces of Taishō painting, *Sketch of a Road Cut Through a Hill* of 1915 (Fig. 58). The work depicts the area around Yoyogi, in Tokyo, still very undeveloped in the early Taishō period. Kishida employs a dramatic perspective scheme which leads the viewer's eyes up the steep incline of the road, which then seems to disappear into infinity. This effect is enhanced by the intense, supernatural blue of the sky, which is only interrupted by a few wispy clouds; the ochres and browns of the road contrast vividly with the intense blues of the sky. The extremely strong recession of the wall at left tends to propel the gaze into the distance, thus reinforcing the effect created by the road. There is a certain vagueness at the point where the

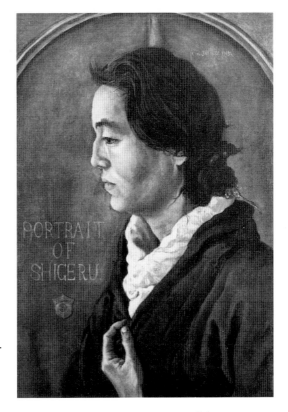

Fig. 57. KISHIDA RYŪSEI, *Portrait of the Artist's Wife*, 1915. Oil on canvas, 58.5 x 40.5 cm/ 23 x 16 in. Ohara Museum of Art, Kurashiki.

base of the wall abuts the top of the road, as if the artist did not know how to handle this area. Or perhaps he did, and was trying to achieve a mysterious, somewhat troubling quality. In the context of the northern European influence discussed above, in the present work one can observe a great amount of precise detail in the weeds on the road at left forefront, in the texture of the earth, and on the rocks at the lower part of the wall. Perhaps the most dramatic accent in the painting consists of the dark, horizontal lines produced by the shadows of the electricity pole; to my eyes these are perhaps the strongest lines in Japanese art with the possible exception of the "irrational line" in Sesshū's *Winter Landscape*.

Repeatedly in this essay I have stressed the importance of Taishō still life, and I think it is no exaggeration to assert that Kishida's achievements in this genre were the highest of any Japanese artist. In the course of his relatively short career he was able to produce a number of masterpieces which are among the finest of all modern Japanese oil paintings. One of the best examples is *Still Life (Three Red Apples, Cup, Can, Spoon)* of 1920 (Cat. 22). Despite the length of its title, the composition manifests a sparseness seen in most of Kishida's still lifes; instead of packing the picture plane full of elements, as Koide frequently did, Kishida spreads his relatively few elements laterally across the surface. In studying the present painting, one cannot help but be impressed by the magnificent control of brushwork that he achieves in the varied grays of the walls. These, combined with the rich, dark brown of the table, provide an effective contrast for the more intense hues of fruit and the other objects. Koide's still life exhibits comparable contrast between subdued ground and

Fig. 58. KISHIDA RYŪSEI, *Sketch of a Road Cut Through a Hill,* 1915. Oil on canvas, 58.3 x 54.4 cm/ 23 x 21⅜ in. The National Museum of Modern Art, Tokyo.

intense motifs, but whereas Koide's paint is lush and fluid, Kishida's seems more controlled and austere. In overall impact, Kishida's still lifes seem decidedly mysterious, almost as if the various elements were meant to have a profound metaphysical significance.

Undoubtedly most people interested in modern art in Japan would consider Kishida's series of portraits of his daughter Reiko to be his supreme achievement. Reiko was born on April 10, 1914—the third year of Taishō—and the first portrait of her, *Reiko at the Age of Five,* was finished on October 8, 1918 (Fig. 59). It is unlikely that when Kishida executed this work he realized that it was going to be the initial step in an extraordinarily successful series of portraits; however, in the course of the next few years he painted masterpiece after masterpiece chronicling the early years of his daughter. In format, the first Reiko portrait relates closely to the portrait of his wife done a few years earlier, particularly in the depiction of a frame at top and the inclusion of an inscription within the picture. As is usual in Kishida's portraits, the figure is placed against a flat plane, in this case a beautiful blue-green field. Reiko is in a frontal pose, the head inclined slightly as she gazes out to the left. She has the solemn expression that we have noticed in several other works. Reiko wears a beautiful yukata of dark blue fabric with varied patterns in white, and she grasps a small thistle blossom, a motif derived from Dürer that Kishida frequently utilized.

A little more than two years later is *Reiko with a Woolen Shawl* of 1920 (Cat. 21). Here Kishida has eschewed the depicted frame, simply placing his daughter against a neutral dark background, gazing to the right. She wears a kimono with an orange-red obi, over which is draped the shawl which gives the painting its name. The texture of this woolen shawl is brilliantly delineated, with the individual colors brightly rendered. Reiko's face reflects her increased maturity, seemingly less babylike than the earlier version. Only her right hand is visible, grasping a single white flower, the same motif that we saw in the initial portrait.

Kishida did numerous other versions of Reiko, some full length portraits, one even including two representations of his daughter. The most unusual work in the series, *Country Girl* of 1922 (Cat. 23), may not be a specific representation of Reiko although it is certainly Kishida's most striking, even bizarre "portrait," for he has taken the facial expression from a Chinese Yuan Dynasty depiction of Han-Shan and Shih-Te by Yen Hui and transposed it to the standard representation of Reiko. Thick heavy hair flies out at either side, giving the girl a rather spooky quality, while the intensely bright light illuminating the face enhances the precisely modeled features to create the full sense of possession. The weird expression of the eyes and the maniacal grin of the unnaturally wide mouth enhance the grotesque mood of the work.

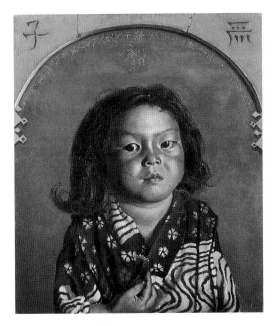

Fig. 59. KISHIDA RYŪSEI, *Reiko at the Age of Five,*
1918. Oil on canvas, 45.3 x 38 cm/17¾ x 15 in.
The National Museum of Modern Art, Tokyo.

Fig. 60. KISHIDA RYŪSEI,, *White Gourd,* 1927.
Oil on canvas, 37.5 x 45 cm/14¾ x 17¾ in.
The National Museum of Modern Art, Tokyo.

There are several other important portraits in the mid-1920s, of which one of the best
is *Portrait of Dr. Kondō* of 1925 (Cat. 24). Here we see the subject in a standard pose, gaz-
ing off to the right, and holding a small sprig of purple flowers in his right hand. The
deep brown field and Dr. Kondō's black suit produce an overall dark tonality, broken only
by the white collar of his shirt. Dr. Kondō's face has a rather oily, somewhat unpleasant
quality, while to the modern viewer his mustache seems rather humorous. Nevertheless,
the overall expression is exceedingly serious and stern.

I would like to discuss at least one painting in order to give a general sense of Kishida's
later style in oil painting. (It is necessary to specify material since much of the artist's later
work is *Nihonga.*) For this purpose I have selected *White Gourd* of 1927 (Fig. 60), a repre-
sentative example of his later still lifes. At first glance a painting such as this may seem
excessively simple, even simple-minded, but closer inspection suggests that Kishida was
striving to produce a mysterious, hypnotic image utilizing minimal means. When we
looked at his glorious still life of 1920, we were struck by its austerity, but in contrast to
White Gourd the earlier work seems positively packed with detail.

Conclusion

A general sense of artistic practice can be derived from the paintings discussed above, and
it might be helpful now to consider briefly the artists' similarities and differences. Most
immediately apparent is Yorozu's position as an avant-gardist, in contrast to the more con-
servative and traditional styles utilized by Koide and Kishida. While it would be unfair, at
a deeper level, to suggest that the latter two were less imaginative than Yorozu, the fact
remains that throughout his career Yorozu was extremely sensitive to innovations in picto-
rial art whereas Koide and Kishida seem to have pursued more self-contained, internal sty-

listic developments. This distinction being made, one feature that all three have in common is their intense dedication to self portraiture. These artists were clearly fascinated with the issue of representing their own features and, in a more profound sense, each was deeply concerned with making a statement as to who he was and what position he occupied in the modern world. Consequently, there is a probing, self-conscious quality to these works as we see the artists returning again and again to the investigation of themselves.

Yorozu and Koide both did a large number of female nudes, particularly Koide, whereas this subject is very rare in Kishida's oeuvre. Most of Yorozu's nudes fit within avant-garde stylistic categories, and the majority emphasize strong expressive distortions in the depiction of the model. In distinction to this, the nudes painted by Koide are characterized by an immediate sensuosity and eroticism that seems less troubled than that of Yorozu.

In terms of figural art in general—excluding the nude—one sees relatively few examples in Yorozu's oeuvre, a few more in Koide, and the largest number in Kishida's painting. Perhaps as an avant-gardist, Yorozu was rather uninterested in conventional portrayals of people. Koide did representations of his family and of a few other people, but he certainly did not concentrate on the genre. Only Kishida, of our three artists, devoted a great deal of attention to figural art. In addition to the numerous self portraits which have already been mentioned, he did a large number of portraits of friends and relatives, most importantly the extensive Reiko series. It seems clear that Kishida was particularly sensitive to the expressive possibilities of figural art, especially portraiture, and thus expended a lot of energy in this genre.

In addition to figural works of various types, our artists also painted highly successful landscapes and still lifes. It seems to me that the still life category has been somewhat neglected in discussions of modern Japanese art, and I would suggest that further study is essential. As far as Yorozu, Koide, and Kishida are concerned, each produced extremely interesting still lifes throughout their careers. Not surprisingly, Yorozu's still lifes tend to have specifically modernistic traits. Those of Koide are usually somewhat dark in hue, but packed with rich, glowing forms. Kishida did a series of hauntingly beautiful still lifes with a few discrete elements isolated within a broader environment. While each artist's still lifes obviously relate to his individual stylistic predilections, taken as a group these paintings tell us a lot about Taishō art. It would appear that the very limitations of still life allowed the artists to concentrate on essential factors, with the result that their works in this genre are singularly intense in expression. At times the still lifes of our artists have a sad, melancholy aspect which may bear a metaphorical relationship to the feelings of isolation experienced by the artist himself. While I do not wish to overinterpret these paintings, I do believe that more attention should be paid to them in the analysis of the spiritual currents of Taishō art.

One of the most important factors underlying the very impressive bodies of work produced by our three artists—perhaps the single most important—is the total lack of direct European experience on the parts of Yorozu and Kishida, and the very short stay in France by Koide. Most of the artists surveyed in this exhibition spent substantial periods of time in Europe, usually in France, and their work tends to be strongly aligned with the stylistic lineages that they studied while abroad. Although there is nothing strange about this, it is a little surprising that by and large those artists who studied in Europe tended to ignore the more up-to-date developments, instead drawing on stylistic currents of the preceding decades. The paradigm for this phenomenon is the academic Impressionism learned and practiced by such notables as KURODA, ASAI, FUJISHIMA, as well as many others. Trans-

planted to Japan, it became the orthodox mode of painting, even though European artists had long been working in various Post-Impressionist modes, while the more adventurous were about to venture into the Fauvist and Cubist styles. Seen from an international perspective, much of late Meiji and early Taishō painting seems quite conventional and rather timid. It would appear that many of the Japanese who studied abroad were overwhelmed by the richness of contemporary European painting, and thus concentrated their efforts on easily learned, unthreatening styles such as academic Impressionism.

While the three artists dealt with in this essay were all familiar with the dominant late Meiji style, none chose to linger with it for long. Yorozu—without European experience—worked in new styles, especially Expressionism and Cubism, while Koide and Kishida anchored their painting in much earlier European modes. Clearly all three were dissatisfied with the relatively superficial style that constituted the mainstream of early twentieth century painting in Japan. I would like to suggest here that their very lack of sustained experience in Europe may have been a positive rather than negative factor for our artists, since this "lack" may have prevented them from succumbing to the dominant academic currents seen in the works of many of their contemporaries.

A final issue to be considered is a highly complex and controversial matter. As mentioned above, our three artists, and a number of other impressive painters as well, died at relatively young ages. It was also pointed out that there seems to be a correlation between premature death and lack of European experience. How are we to explain this? Living and studying in Europe for an artist pursuing oil painting as a career tended to be a validating experience, enabling him to assume a well defined role upon returning to Japan. The vast majority of artists who became "establishment" figures had a European pedigree, and most of them lived long lives. On the other hand, those artists who did not get to Europe—even though they desperately wished to—experienced greater difficulties in establishing themselves. There seem to have been two results for the latter group. First, their art is in many ways more resonant and powerful, reflecting quite directly intense personal struggles. Second, the very difficulties under which they labored must have worn them down, leading at times to profound discouragement. Is it too much to suggest that both the roots of their creative activity *and* the source of their early death are linked to one and the same factor? The implications of this hypothesis are more tragic than romantic, for it suggests that a very high price was paid by our artists for their success. It is thus incumbent on us to approach their works with a deep awareness of the context within which they were created, keeping in mind the essential seriousness of Yorozu, Koide, and Kishida.

ARTISTS' BIOGRAPHIES

J. Thomas Rimer

青木繁
AOKI SHIGERU
1882–1911

Aoki, whose romantic fervor encountered many obstacles in the practical world of Meiji Japan, became for a growing body of admirers an early model of the artist as a figure of high romance. His posthumous fame stands in striking opposition to the relative neglect he suffered during his brief lifetime.

Born in Kurume, on Kyushu Island in the same place and year as his friend SAKAMOTO HANJIRŌ, Aoki's early interest in art, opposed by his family, eventually led him to pursue his studies in Tokyo. There he worked under Koyama Shōtarō (1857–1916), a pupil of Fontanesi who also taught, among others, SAKAMOTO, KANOKOGI, MITSUTANI, and MORITA. In 1890, Aoki managed to win a place at the Tokyo School of Fine Arts, where he studied Western painting under KURODA.

Aoki was a brilliant, if eccentric, young man. His studies sometimes took him out of the atelier and into the libraries, where he pursued his growing fascination with Japanese and Indian mythology. In seeking out a personal style with which to express his romantic visions, he developed a palette and an imagery redolent of the English Pre-Raphaelites.

On sketching trips to the country with colleagues such as MORITA and SAKAMOTO, Aoki developed his ability to draw and paint natural scenery. At the same time he composed scenes from Japanese mythology that owed more to his fertile imagination than to any desire for realistic historical reconstruction. As a poetic vision of Japanese antiquity these paintings remain unparalleled in modern Japanese art.

Although Aoki's romantic style differed from the more naturalistic style of KURODA and his circle, the young artist did find a certain number of admirers, among them the well-known poet Kanbara Ariake (1876–1947), who, like Aoki, was deeply inspired by contact with Western romanticism through his reading of Keats, Byron and Shakespeare. Kanbara also used ancient Japanese myth as a fundamental element in his poetry, and his interest in the British poet and painter Dante Gabriel Rossetti echoed Aoki's interest in the Pre-Raphaelites. When Kanbara first saw one of Aoki's paintings shortly after the artist's graduation from the Tokyo School of Fine Arts in 1904, he felt that he had found a soul-mate. Kanbara wrote poetry based on his responses to Aoki's paintings, and Aoki did the frontispiece and illustrations for one of Kanbara's poetry anthologies.

Despite the admiration that a discriminating few showed for Aoki's work, he had difficulty supporting himself. Eventually, he abandoned Tokyo for his native Kyushu where he roamed feverishly from place to place, attempting both to paint and to teach, until his death in a Fukuoka hospital in 1911. Virtually forgotten then, Aoki is now regarded, despite the relatively few paintings that he was able to create during his short life, as one of the early seminal masters of Japanese oil painting.

有島生馬
ARISHIMA IKUMA
1882–1974

Arishima came from a family of distinguished creative talents. His older brother, Arishima Takeo (1878–1923), was one of the most famous novelists of modern Japan, and his younger brother, Satomi Ton (1888–1983), was also a noted writer. Arishima Ikuma's own essays on art rank in importance with his painting.

Arishima studied Italian during his early years, but a growing interest in art led him to study with FUJISHIMA TAKEJI, who would later, like Arishima, go to both Italy and France. In 1905 Arishima went to Rome, where he worked briefly with Carolus-Duran at the French Academy in Rome. (A year later FUJISHIMA arrived to study with the French master.) In 1906, Arishima was joined by his elder brother Takeo, who had arrived from the United States. They toured Italy, Germany, and finally arrived in Paris in 1907, where Arishima resumed his study of painting with Raphaël Collin, by now revered in Japan as the teacher of KURODA SEIKI. During that year, Arishima went to see the 1907 retrospective of Cézanne, an experience that changed his artistic perceptions, as well as those of many others who saw the exhibition. Arishima's response was particularly significant, not only because of the effect it had on his own work, but because after his return to Japan in 1910 he wrote a series of influential articles on Cézanne that introduced the name and philosophy of the great French master to the Japanese art world. Arishima's commitment to Cézanne remained strong. In 1920, he translated into Japanese Émile Bernard's seminal 1912 *Souvenirs sur Paul Cézanne.*

Arishima made a number of good friends among the Japanese artists then resident in Paris. His later writing in support of such men as his former teacher

FUJISHIMA, the sculptor Ogiwara Morie (1879–1910), the sculptor and poet Takamura Kōtarō (1883–1956), and the painters UMEHARA RYŪZABURŌ and YAMASHITA SHINTARŌ proved important to their careers and reputations.

Subsequent to his return to Japan in 1910, Arishima continued his painting while writing on art for the *Shirakaba* (White Birch Society) magazine. His creative energies diversified; he wrote short stories and novelettes, and even designed stage scenery for a production of Mascagni's "Japanese" opera *Iris.*

Arishima continued both writing and painting until the end of his long career. His perceptive eye and his writings on painting and sculpture established him as a figure of great importance to the modern art movement in Japan.

浅井忠
ASAI CHŪ
1856–1907

Asai, along with his friend and colleague KURODA SEIKI, was a distinguished predecessor of the majority of the painters treated in this exhibition. Like KURODA, Asai perfected his art in Paris. As a teacher he guided the talents of numerous younger painters, including two of the most accomplished artists of the interwar period, YASUI and UMEHARA.

Asai was a child when the Tokugawa regime fell and the Emperor Meiji took over the reins of power in 1868, and his early artistic training was solely in traditional Japanese ink painting styles. In 1872 he was sent to Tokyo by his family to pursue what was then termed Western learning, which for Asai included the techniques of Western painting. His first teacher, Kunisawa Shinkurō (1847–1876), who had studied briefly in England, introduced Asai in 1876

to Antonio Fontanesi, who taught him a number of basic skills. After the Italian master's return to Italy because of illness in 1878, Asai worked on alone.

In 1889, Western-style painting in Japan was given fresh impetus by the formation of the Meiji Art Society, which sponsored exhibitions of contemporary Japanese painters. Asai had considerable success with the group in its early phases. But the return of KURODA in 1893 signaled the introduction to Japan of the plein-air style which tended to eclipse the more academic work of Asai and his colleagues.

During the first year of the Russo-Japanese War (1894–1895), Asai volunteered to go with the Japanese troops to the mainland front. His sketches and paintings, like those of KURODA who went along as well, provide a striking visual account of this crucial conflict in modern Japanese history.

In 1899, Asai was sent to France by the Ministry of Education for further study and enrichment. Already a mature and respected artist of forty-three, Asai still found, after his arrival in Paris, that he had much to learn. Befriended by younger Japanese artists such as OKADA and KUME, many of whom were in Paris for the 1900 Paris Exposition Universelle, Asai had one of his own works displayed in the Japanese exhibition of painting shown at the Paris fair. He spent considerable time studying the exhibitions prepared by the French government for the occasion, including a one-hundred-year retrospective of French painting. He visited the Louvre and Musée du Luxembourg, expanding his vision still further, and he wrote that he was finding himself filled with a new excitement and enthusiasm.

Remembering KURODA's enthusiasm for the beauties of a suburb of Paris, Grez-sur-Loing, Asai moved there for several months to paint and sketch. In Grez he lightened his palette considerably and created a series of plein-air works that, when he returned to Japan, helped transmit a fresh wave of inspiration to younger Japanese painters. In this respect, it might be said that Asai made the same discoveries as KURODA, almost a decade later.

When Asai returned to Japan in 1902 he decided to teach in Kyoto. His newer style, filled with light and subjective renderings of nature, was quite different from his earlier work, based on the more conservative nineteenth-century style imported by Fontanesi. Journalists had set up Asai and KURODA as opposites, but now the differences were difficult to define. Whatever the variations in their styles, however, the two artists remained colleagues and friends, sometimes painting and sketching together.

A teacher until his death, Asai was an important conduit for new ideas which enriched both oil painting and understanding of modern Western art in Japan.

藤島武二

FUJISHIMA TAKEJI
1867–1943

Born in Kagoshima, in the southernmost area of Japan, Fujishima was brought up in a colorful, semitropical atmosphere that some critics feel influenced his bold sense of texture and color. As a boy, Fujishima was orphaned by the age of eleven; supported by relatives, he studied art and began to show talent first in traditional Japanese-style painting, then in Western oil painting-style techniques. The great novelist and critic Mori Ōgai (1862–1922) praised an early effort, which encouraged Fujishima to continue painting despite difficult financial circumstances.

At the age of twenty-nine Fujishima was chosen by KURODA SEIKI, the most influential man in the Japanese art world at that time, to teach in the new Western Painting Section of the Tokyo School of Fine Arts.

In 1900, he joined Myōjō (Venus), a leading intellectual magazine of its day in the field of art, poetry, and literature. Fujishima designed many of the most striking covers for the publication which, together with a series of romantic paintings shown in Tokyo art exhibitions, won him an award from the Japanese Ministry of Education to study abroad.

With KURODA's encouragement, Fujishima went to France in 1905, already a mature artist of thirty-eight. He was to remain in Europe for five years. KURODA had urged his younger colleague to study with his own teacher, Raphaël Collin, but Fujishima, excited by the newer developments of Post-Impressionist painting, rejected the academic style of Collin's studio and chose instead to work with Fernand Cormon at the Académie de la Grande Chaumière; at the same time Fujishima took great delight in sketching and painting out-of-doors.

Like so many other Japanese painters of the period, Fujishima's greatest discovery in Paris was

Cézanne; his reaction to the great 1907 retrospective of the painter—finally acknowledged as a master in France—was as profound as that of ARISHIMA IKUMA. Anxious to further his studies in light and landscape, Fujishima sought out an intense southern light similar to Cézanne's and made arrangements to study at the French Academy in Rome. There, the Director of the Academy, Charles E. A. Carolus-Duran, himself a painter of some distinction and the teacher of John Singer Sargent, brought Fujishima's work to full maturity.

On his return to Japan in 1910, Fujishima's work both as a painter and as an illustrator was widely admired. Kinoshita Mokutarō (1885–1945), one of the leading writers and critics of the period, found himself moved by "a glitter of light and a technique of brushwork that could only have been learned in France." "No Japanese painter," he continued, "had ever managed such a thing before."

In Fujishima's mature years Cézanne remained a major inspiration, especially in the Japanese painter's landscapes. In retrospect, Fujishima wrote:

Cézanne resembles the stillness of the East. Yet to make such an extreme statement suggests in fact that there is some reason to seek a differentiation between East and West. While it seems that there may exist some difference in artistic spirit between the two, what is needed to penetrate into the roots of any art is a profound sense of responsibility about the purposes of art itself. Within this responsibility, this conscience, lies a spirit of tradition. Thus, even when Cézanne as a young man made copies of classic works of art, what he felt in them was their spirit. Art is said to concern itself with nature and tradition, but in the end, it concerns itself with the spirit of man.

Fujishima insisted as well on the integrity of the artistic traditions and attitudes of the East, which aim at "simplicity and silence." "One line," he wrote, "can show all the selflessness of great art." By learning patiently to copy nature, Fujishima felt, a mature artist can eventually learn to simplify what he sees so that a deeper truth can emerge.

Fujishima's work was first seen in the United States at the art exhibition held in conjunction with the 1939 New York World's Fair. By the end of his life, Fujishima had served as an example, and as an inspiration, for the majority of the Western-style painters who worked during the entire prewar period. ▨

藤田嗣治

FUJITA TSUGUJI (TSUGUHARU)
1886–1968

Of all the painters included in the present exhibition, Fujita became the most fully assimilated into the Parisian art scene. Indeed, after World War II he returned to France where he took citizenship and worked under both of the names Leonard and Tsuguharu Foujita. Several of his works hang today in the Museum of Modern Art in Paris, as well as other institutions in France and the U.S.

Only after some persuasion did Fujita's father, an army doctor, permit his son to study Western painting with KURODA SEIKI at the Tokyo School of Fine Arts. After Fujita's graduation in 1910, he continued his studies with the gifted painter Wada Eisaku (1874–1959), who had studied from 1899 to 1903 in France with Raphaël Collin. In 1913, Fujita left for Paris with the encouragement of Mori Ōgai, the novelist and writer on aesthetics, who as Surgeon General of the Japanese army, convinced Fujita's father of the need for such a trip. Fujita took to the trappings of French artistic life at once, soon becoming a fixture at the Montparnasse cafe, La Rotonde, frequented by so many of the important artistic figures of the period. Yet Fujita found himself totally unprepared for the French art world. His prior notion of contemporary Western painting had comprised a vague form of Impressionism; now the Cubist experiments confronted him at a time when, as he wrote, "I didn't even know of the existence of Cézanne."

After a series of struggles, both artistic and financial, he began to find his way, and by 1918 started to sell his work with a certain amount of success, partly because of the efforts of his first wife, Fernande Vallé, an important art dealer who helped guide his taste and talent. By 1920, Fujita had developed his "trademark" style, paintings elegant in design, often

of women, in which their flesh was painted as an undulating surface outlined in black, providing a combination of linear clarity and sensuous tactility unusual in French art of the time.

Fujita's originality resulted, at least in part, from his successful juxtaposing of Eastern and Western techniques and media. For example, his application of semi-transparent Western oil pigments in light washes is redolent of oriental ink and watercolor painting techniques.

Fujita's cosmopolitan life continued; he replaced Fernande with a stunning Frenchwoman he called "Youki," who, after she left him, became the mistress of the well-known French poet Robert Desnos. Fujita travelled in Europe and, later with a new admirer, Madeleine Lequeux, in South America, becoming both the most successful and the most worldly of the Japanese artists of his generation. In 1933, for a number of reasons, some of them obscure, he returned to Japan where he remained, except for a brief visit to France between 1939 and 1940, until 1950. When Fujita finally returned to France (after World War II), this time with a Japanese wife, he painted a number of works based on Christian themes, which constitute another phase of his work.

Despite Fujita's popularity in France and elsewhere, his reputation in Japan has remained ambiguous. Some Japanese critics find him an opportunist who sought worldly success rather than giving himself over to the kind of inner struggle typical of the romantic figures of the period such as YOROZU TETSUGORŌ or KISHIDA RYŪSEI. He painted and sold a large number of works, some of them of indifferent quality. Yet at his best, Fujita exhibits an assurance and a charm that can appeal to both Eastern and Western tastes. ▨

金山平三
KANAYAMA HEIZŌ
1883–1964

Kanayama was born in Kobe and remains the favored son among Western-style painters from that cosmopolitan city. He left at the age of twenty to enter the Tokyo School of Fine Arts, where he not only studied painting but began to learn French as well, with the hope that he might visit Paris, a wish that was fulfilled in 1912. Kanayama travelled extensively, visiting museums in Paris, including the Louvre, to sketch and paint after the masters. He continued painting feverishly during the first days of World War I, until compelled to return to Kobe in 1915.

Kanayama enjoyed early success in Japan with a number of works he had painted while in Paris, and the still lifes and landscapes he continued to paint in Japan won a number of important prizes. Active until his death at 81, Kanayama's skill and attractive subject matter won him an appreciative public not only in the Osaka-Kobe area but throughout the country. He returned to Paris in 1961 and produced there a group of works among the most important of his later career. Kanayama's sketches and pastels, particularly a noted series on the *kabuki* theater, are also highly regarded. ▨

鹿子木孟郎
KANOKOGI TAKESHIRŌ
1874–1941

Kanokogi was born in Okayama Prefecture in central Japan. Like MORITA, AOKI, MITSUTANI, and others, Kanokogi undertook his first serious training with Koyama Shōtarō (1857–1916), who had worked with Fontanesi to develop the academic style of Western painting in Japan. Successful as a student, Kanokogi became a secondary school teacher of art. In 1900, he arrived in France, where he met ASAI CHŪ, who encouraged him to study with Jean-Paul Laurens at the Académie Julian. During three years at the Académie Kanokogi was stimulated by Laurens' historical painting style, a mode rapidly being eclipsed by Impressionist and Post-Impressionist tendencies.

When Kanokogi returned to Japan in 1904, he joined ASAI CHŪ in the Kyoto area as a teacher. Kanokogi was soon befriended by a prominent industrialist from the Sumitomo family, who, recognizing his talent, sent him back to France on two later occasions to continue his studies with Laurens.

Kanokogi continued to paint in an academic style modeled on Laurens and was a well-respected teacher in the Kyoto and Osaka area during the 1920s and 1930s. He was decorated by the French government in 1932 with the *Légion d'honneur*. A less adventuresome painter than some of his contemporaries, Kanokogi held to the ideals of his French mentor and produced works that, although conservative, were beautifully accomplished.

岸田劉生
KISHIDA RYŪSEI
1891–1929

An original and ardent spirit, Kishida underwent a number of indirect European influences, although he never visited Paris as he wished. Kishida was brought up in an educated milieu in Tokyo and was encouraged in his artistic pursuits by his family. Much of his formal study was undertaken with KURODA SEIKI, and Kishida was successfully entering national exhibitions by the time he was twenty.

Around 1910 Kishida discovered two powerful forces that marked his future development. The first was the new humanism of the White Birch Society. Kishida found in Takamura Kōtarō's 1910 manifesto, "A Green Sun," both a challenge and a release from tradition. At the same time that Kishida embraced Takamura's profound faith in the power of art, he was drawn strongly to Christianity; art, in his view, could provide the means for realizing his spiritual commitments. Although Kishida's religious flirtation was relatively brief, his conviction that art could serve as a road to personal salvation never left him.

These attitudes led Kishida in turn to the conviction that he should be a painter in the modern, Western style, not because it constituted the prevalent contemporary aesthetic in Japan but because Western-style oil painting seemed to provide the best means to follow his own inner demands. Kishida was willing to break with his generation if necessary, just as his heroes van Gogh and Cézanne had broken with theirs. Ultimately, Kishida felt his work might not resemble that of his spiritual mentors at all, but he would be following their highest example by seeking out his own way. On the basis of this conviction, Kishida began to study nature directly. Kishida had little money for models and so painted the scenes and people he knew. His continued association with the thinkers and writers of the White Birch

Society helped expand his artistic vocabulary, as did the reproductions included in the group's magazine of Dürer, Rembrandt, and other northern Renaissance artists not widely known in Japan until that time.

In 1914, Kishida formed an artistic society, the *Sōdosha*, to sponsor art exhibitions, which continued until 1922. In the meantime, Kishida had retired to the country and began a series of still lifes which represent for many his most sustained successes. On one of these paintings, he wrote the following poem.

> *The great mystery of what exists, there:*
> *Should I kneel down, worship it?*
> *All I can do is paint, paint,*
> *Until I have understood what exists, there.*

During the course of the *Sōdosha* exhibitions, Kishida initiated a series of paintings of his young daughter, Reiko, in which he evoked the inner beauty of the girl. This series of pictures has remained among the most popular of any works by any artist in modern Japan.

One of Kishida's most important encounters was with the English potter Bernard Leach, whose portrait he painted. Leach's interest in Asian art and culture led Kishida to re-evaluate his own traditions. Leach also taught Kishida the technique of etching. Kishida learned from him to simplify, rather than merely to copy, nature.

After the 1923 Tokyo earthquake destroyed his home, Kishida moved to Kyoto, where for the first time in his life he found himself steeped in the atmosphere of the past instead of the present. Kishida began to collect Asian art and experimented with painting in the traditional Japanese style, as his friend YOROZU TETSUGORŌ had done several years earlier.

In 1929, still hoping to go to Europe, as he told one of his drinking partners, in order "to teach *them* art," Kishida died of a sudden illness. His stylistic evolution reveals a powerful spiritual impulse to go beneath the surface of things seen in order to express a personal vision that may, perhaps, be considered a religious one. ▨

小出楢重
KOIDE NARASHIGE
1887–1931

Of the painters in the present exhibition who visited Paris, Koide's trip was the shortest, and, on the surface, the most disappointing. He wrote to his wife in Tokyo that after half an hour in the Salon he felt compelled to flee the galleries, for they held nothing of interest to him. Yet no artist's style changed more than Koide's during his six-month stay in France, and few developed such a powerful self-knowledge in so short a time.

Koide was born and brought up in Osaka, where he experienced the vitality, and the occasional vulgarity, of the Osaka merchant culture. His love of commonplace surroundings and belief in the tactile power of the most ordinary objects remained constant throughout his career.

Koide entered the Tokyo School of Fine Arts in 1907, first gaining entrance in the section devoted to Japanese-style painting. Only two years later was he able to transfer to the Western Painting Section to pursue the training he sought. There he came under the tutelage of such experienced older painters as KURODA SEIKI and FUJISHIMA TAKEJI. Unlike his fellow student YOROZU TETSUGORŌ, Koide took little interest in such imported contemporary French experiments as Fauvism; he continued to paint in a sturdy, conservative, and somewhat unremarkable fashion.

After graduation in 1914, Koide returned to the Osaka area, where he continued during a period of four or five years to seek out his own personal style, painting from nature both in the countryside around Osaka and in the old capital of Nara. Relatively little work from these years remains. In 1919 he entered several of his increasingly accomplished pictures in the *Nikakai* exhibition, where his work was now singled out for special praise. At this point in Koide's

career, his paintings were still heavy, thickly painted, and quite powerful in their focus.

Spurred on by his success, Koide decided to visit Europe, particularly to discover the relationship between Western-style painting and the cultures that produced it, especially France. Koide found himself uninspired both by the art and the art world of Paris and produced only a few sketches there.

After some weeks in the French capital, Koide tried the countryside; when he arrived at Cannes, on the French Riviera, he felt himself rejuvenated. He wrote his wife:

> *Ever since I left home, I have thought that I would*
> *not be able to paint one picture, but the scenery here*
> *is so beautiful that there is no way for me to resist.*
> *So I will be able to hang up Cannes on my wall!*
> *The light showers down on my back. I really feel as*
> *though I can accomplish something.*

Defrauded in Paris of much of his remaining funds, Koide returned to Japan in 1922. Although his trip was not a happy one, Koide did feel that he had begun to grasp the relationships between European culture and its art. "In Western painting," he later wrote, "there is something immovable, heavy, a kind of inviolability that seems a property of the oil paints themselves," while Japanese art "shows in general a quality reminiscent of the delicacy of paper, of sliding doors, a kind of fleeting softness, quite insubstantial." He continued, with an ever lighter palette, to pursue his new sense of those differences.

During the last decade of Koide's life, he opened an important art school in Osaka and collaborated as illustrator with such important novelists as Tanizaki Jun'ichirō. In his paintings Koide concentrated on still lifes and nudes, working and reworking the same elements in order to achieve the strength and solidity that he felt the medium of oils demanded. In 1931, Koide painted several landscapes of scenery near his home that had a strangely troubled, disquieting air about them, a new quality in his work. Only a few months later he was dead of diabetes.

France had proved for Koide not a source for any new personal style, but rather helped him integrate his still-developing philosophy and artistic technique. In his final, mature period, Koide's powerful brushstroke, unique tonality, and compositional strength distinguished him as an original and influential Master.

児島虎次郎
KOJIMA TORAJIRŌ
1881–1929

Kojima holds a special place in the history of modern Japanese art, not so much for his talent as a painter as for the fact that he made two trips to France after his initial voyage in 1908 in order to help assemble the pieces of Western art that formed the basis of the famed Ōhara collection in Kurashiki.

Kojima was born in Okayama Prefecture, where he established important ties to the Kurashiki industrialist Ōhara Magosaburō. Kojima studied at the Tokyo School of Fine Arts under KURODA, KUME, and FUJISHIMA; after his graduation in 1904, he began to exhibit some of his work and was highly regarded as a promising young painter. When Ōhara saw Kojima's work, he was impressed by the young man's talent and helped arrange for the artist's first trip to Europe in 1908, just as he would help the young Okayama artist MITSUTANI several years later. KURODA hoped that his student would study with Raphaël Collin, but Kojima abandoned the project within a week, deciding that he preferred to visit scenic spots with fellow painters and work directly from nature. Of all the painters whose works he studied, Kojima was most impressed with Jean François Millet. In 1912 Kojima studied briefly with the academic painter Edmond-François Aman-Jean, then continued his European travels until his return to Japan later the same year.

In 1919, with funds from Ōhara, Kojima returned to France, both to paint and to seek out possible works of value to purchase for Ōhara's newest enthusiasm, a collection of Western art that could be shared with the Japanese public. Kojima called on Monet and Matisse in their ateliers and bought important works that were sent off to Kurashiki. To these he added significant works by Pierre-Albert Marquet, Maurice Denis, Aman-Jean, and more than

a dozen others. After Kojima's return in 1921, Ōhara arranged to borrow a local school building and presented there an exhibition that included the twenty-seven works Kojima had purchased, as well as forty-seven paintings done in Europe by Kojima himself.

Encouraged by the success of the exhibition, which was shown again in 1922, Ōhara sent Kojima back to Paris, where he purchased works by El Greco, Millet, Ferdinand Hodler, and Gauguin, among others, returning to Japan with a remarkable group of paintings in 1923. Ōhara mounted a third exhibit, this time with a total of fifty-six works, for which he received enormous acclaim from the Japanese public for this act of cultural generosity. Kojima continued painting successfully and entered his compositions in a number of exhibitions. His travels to China in 1926 were also reflected in his broadening sources of subject matter. Illness, however, brought his career to a close three years later. ▨

1900 Paris Exposition Universelle, however, he had virtually stopped painting. Although one of his pictures won a prize at the Paris exposition, he increasingly occupied himself with administration and teaching at the Tokyo School of Fine Arts. KURODA urged his friend to continue painting, but Kume produced little after this period. Kume lived on for more than a decade after KURODA's death, during which he continued to promote KURODA's stylistic commitment to plein-air painting.

Kume's contemporaries considered his painting more delicate in palette and, in the strict sense of the word, more Impressionistic than that of KURODA. One Japanese writer suggested that if KURODA could be compared to Manet, Kume might be likened to Pissarro. Despite his small oeuvre, Kume has retained his reputation as a gifted painter active at a crucial juncture in the development of modern Japanese art. ▨

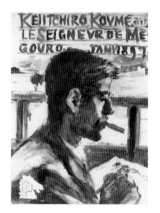

久米桂一郎
KUME KEIICHIRŌ
1866–1934

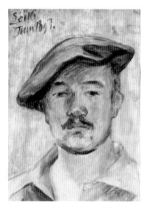

黒田清輝
KURODA SEIKI
1866–1924

Kume began his studies in Japan in 1884 with Fuji Masazō (1853–1916), who had studied with Fontanesi. Fuji went to France the following year and took up his own studies in Paris with Raphaël Collin. When Kume arrived in Paris in 1886, he met KURODA SEIKI and subsequently all three worked with Collin. KURODA and Kume shared living quarters in Paris and painted together in Grez-sur-Loing, where they experimented with the plein-air landscape painting styles. When the pair returned to Tokyo in 1893 they opened a private art school. Both soon were chosen to teach at the Tokyo School of Fine Arts.

By the time Kume returned to France for the

Like his slightly older colleague ASAI CHŪ, Kuroda helped initiate the movement toward a viable position for Western oil painting in Japan, and his accomplishments served as an inspiration and point of departure for many important artists. In particular, Kuroda taught a wide range of talented painters including AOKI SHIGERU, OKADA SABURŌSUKE, KISHIDA RYŪSEI, NAKAMURA TSUNE, and KOIDE NARASHIGE.

Kuroda did not set out to become a painter. Born into a wealthy family, he studied French as a young man in Tokyo and was sent to Paris in 1884 to study law. One of his friends, the young and tal-

ented painter Fuji Masazō (1853–1916), hoped to study with Raphaël Collin but, diffident about speaking French, asked Kuroda's assistance as interpreter. Kuroda's long-standing interest in art, spurred on by these contacts, eventually led him to abandon his law studies and take up painting himself.

Collin had Kuroda begin by making charcoal sketches of classical sculptures in the Louvre; Kuroda soon mastered various elements of design and began painting in earnest. Kuroda and his friend, KUME KEIICHIRŌ, with Collin's urging, moved to Grez-sur-Loing, near Paris, in order to paint directly from nature. During their two-year sojourn in the country Kuroda did some of his very best work.

Shortly before his return to Japan in 1893, Kuroda spent considerable time on a painting called *Morning Toilette* (see Rimer, Fig. 33), the study of the back of a nude woman looking into a mirror while arranging her hair. The picture was highly praised by Collin as well as by Puvis de Chavannes, whom Collin had invited to see it. Kuroda had every reason to feel proud of his rapidly developing skills. When the picture was shown publicly in Tokyo, in 1894, the work caused an enormous stir because of its supposedly immodest subject matter. The painting, one of the most controversial of its time, was destroyed during World War II.

Kuroda brought back from France a lighter palette and a freer style than his contemporaries in Tokyo were familiar with. Even as fine a painter as ASAI CHŪ, for example, was still working in the earlier, more conservative academic manner taught by Fontanesi. Kuroda opened a painting school with KUME and later took up a position as teacher of Western painting at the Tokyo School of Fine Arts. His influence remained enormous, and by his death in 1924, he was universally regarded as the Grand Old Man of Western painting in Japan. 🕸

前田寛治
MAETA KANJI
1896–1930

Born in Tottori Prefecture, in a fairly remote area near the Sea of Japan, Maeta demonstrated a marked talent for drawing as a child. In 1914, when he was eighteen, he failed the difficult examinations for admission to Higher School (then roughly equivalent to a French Lycée) and, freed from this obligation, decided to pursue his artistic talents in earnest. Working with a local teacher trained at the Tokyo School of Fine Arts, he improved his techniques to a level that enabled him a year later to enroll directly in the Tokyo School of Fine Arts, where he studied with the well-known painter FUJISHIMA TAKEJI. By this point in time interest in KURODA's plein-air style was eclipsed by fascination with the work of Matisse and the Fauves, as evident in Maeta's student work of the period.

During his Tokyo years, Maeta developed a strong spiritual faith. Like so many young idealistic Japanese, his first attraction was to Christianity; later, he applied the same ardor to socialism.

When Maeta graduated from the Tokyo School of Fine Arts in 1921 he returned to Tottori, where he purposely put himself close to nature, painting and writing poetry out of doors. A small circle of enthusiastic admirers supported him, and he submitted his pictures, sometimes successfully, for national exhibitions such as the Imperial Art Academy exhibition and the *Nikakai*.

In 1922, Maeta saw in Kurashiki the Ōhara collection of Western paintings exhibited for the first time in Japan. He was overwhelmed by his first exposure to original works of Matisse, Renoir, Maurice Denis, Marquet, and Cézanne. He wrote to a friend that, "I was exhausted for a whole day and could not sleep. I felt a kind of pressure on me from the paintings, and I was awake almost twenty hours by

the end of the evening yesterday."

This personal glimpse of modern European art inspired Maeta to visit France; with the financial help of his friends, he left for Paris in November. On the ship to Marseilles, Maeta met a number of distinguished passengers, among them Albert Einstein, of whom Maeta made an admirable sketch.

Once in Paris, Maeta quickly established himself with other Japanese artists and musicians in residence there and began his systematic examination of the modern European masters. Cézanne impressed him most of all, and Maeta was determined to learn how to apply the French painter's "laws" of nature with the kind of humanism Maeta had long before admired in Courbet. While in Paris Maeta deepened his friendship with an old acquaintance, the prominent socialist thinker Fukumoto Kazuo (1894–1983), who, after his own return to Japan, was to become a leading theoretician of the Japanese Communist party later in the decade. Fukumoto's idealistic vision of an egalitarian society led Maeta to a shift of conviction and, in his art, to a more realistic, and occasionally, a more proletarian subject matter.

Back in Japan in 1925, Maeta helped found the influential *1930 kai* (1930 Society), along with SAEKI YŪZŌ and others, and many of Maeta's works were shown under the auspices of that group.

Maeta's experiences in Europe made him conscious of his ability to serve the Japanese public as a critic of art, and his writings, particularly on Courbet, were highly stimulating to his generation. For Maeta's contemporaries, his painting, while concerned with objective reality, was understood to have sought and, at its best, found, a personal poetry within it. ▨

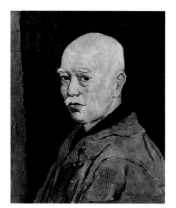

満谷国四郎

MITSUTANI KUNISHIRŌ
1874–1936

In many ways, Mitsutani's career paralleled that of his colleague from Okayama Prefecture, KANOKOGI TAKESHIRŌ. Both went to Tokyo for early training with Fontanesi's student Koyama Shōtarō, found early success in their work, and went to Paris in 1900, on the occasion of the Exposition Universelle, there to work with Jean-Paul Laurens.

Mitsutani returned to Japan, like KANOKOGI, having perfected the conservative academic figure-painting style espoused by Laurens. Mitsutani's continued success won him the interest and support of the important local industrialist Ōhara Magosaburō (1880–1943), who would later, with the help of KOJIMA TORAJIRŌ, assemble his famous collection of Western painting at the Ohara Museum in Kurashiki. Ōhara underwrote Mitsutani's return to France where, from 1911 to 1913, the artist, while continuing his work with Laurens, came to develop a more personal, decorative flat style based on his study of Cézanne and Matisse.

Mitsutani went on to a satisfying career as a painter and remained much appreciated during his life. His work, while not of the most individual quality, nevertheless shows a fluency and skill that have maintained his reputation as an important figure of his period. ▨

森田恒友
MORITA TSUNETOMO
1881–1933

村山槐多
MURAYAMA KAITA
1896–1919

Born in Saitama Prefecture, Morita graduated from the Tokyo School of Fine Arts in 1906. He also took private instruction from Koyama Shōtarō (1857–1916), a distinguished teacher who had worked with Fontanesi and provided lessons to a number of Morita's contemporaries, among them Aoki Shigeru, Mitsutani Kunishirō, Sakamoto Hanjirō, and Kanokogi Takeshirō. Soon after leaving art school, Morita joined the famous literary Salon founded in 1908, *Pan no kai* (Circle of Pan), presided over by the critic Kinoshita Mokutarō and the modernist poet Kitahara Hakushū. The group did much to introduce European romantic ideals of literature and art to Japanese intellectual circles during its short but intense lifetime.

Morita's mature style developed during the time he spent in Paris from 1914 to 1915. Like many other painters, Morita found inspiration and sustenance in his encounter with the work of Cézanne. Many Japanese artists saw the French master as a spiritual model but did not directly emulate his stylistic approach. Morita, however, studied his work closely and attempted to apply Cézanne's methods of spatial organization in his own painting.

After his return to Japan, Morita participated in joint exhibitions with Umehara Ryūzaburō, Kishida Ryūsei, and others. Like Kishida, Morita also began to experiment with traditional Asian styles of art, particularly ink painting. Not a major master, Morita nevertheless perpetuated the influence of Cézanne in Japan and earned the respect of his generation. 🔳

Murayama played a role in his culture comparable to that played by Byron and Rimbaud in theirs. Brought up in Kyoto, his talents as a painter were discovered by his cousin, the painter and print-maker Yamamoto Kanae (1882–1946), one of the editors of the influential art journal *Hōsun*. Inspired by the example of that magazine, Murayama and a group of friends published a student journal which he filled with his precocious plays, poetry, and essays. Murayama sent some of his drawings and paintings to Yamamoto, then in Paris, who, struck with their excellence, showed them to his friend Kosugi Hōan (1881–1964), another well-respected Japanese painter. Kosugi's response testifies to the rapport between Japanese and French art circles; he refused to believe them the work of a student and remarked, "They have a Western odor; they suit an atelier rented in Paris. They are so fresh; they seem to speak French all by themselves!"

During his middle school years, Murayama plunged himself into reading the poetry of Baudelaire, Edgar Allen Poe, and Mallarmé. By the time he had left his home to study in Tokyo, at the age of eighteen, he had formed an intensely erotic (but evidently unconsummated) relationship with a young man he referred to as "Y." To him, Murayama sent the following message on a postcard when he left for Tokyo:

Go to the future! To the future! There will be shame in the future, misery in the future, and failure, and pain. But there will be life. Go to that life! Burst into that rose garden of life, and report on the flowers!

In Tokyo, Murayama was given lodgings by Kosugi, now back in Japan, and the younger artist

threw himself into a fiercely creative and highly decadent life. He wrote poetry, painted, made furious trips all over Japan, and sustained an intense love affair with Otama, one of his female models. His paintings started to win prizes, and Yamamoto, Kosugi, and others began to help promote his career. Suddenly, in 1922, he was struck with a lung disorder. His illness did little to stop his drinking and his outrageous behavior. Murayama wandered through the streets of central Tokyo, dressed in outlandish clothing, or, on other occasions, wearing very little at all. Such clowning, his friends felt, was the technique he employed to ward off death. After a last frantic burst of activity, he was gone at twenty-three years of age. Murayama's painting, like his poetry, shows great vitality and often a quiet intensity as provocative as it is disturbing. ▨

中村彝

NAKAMURA TSUNE
1887–1924

One of the most appreciated painters of his period, Nakamura, like YOROZU TETSUGORŌ and KISHIDA RYŪSEI, could only learn of Western art from reproductions. Nakamura's oeuvre resembles a map of exploration, in which he experiments with style after style in order to locate a vehicle for expressing his own artistic personality. Despite stylistic changes from picture to picture, the *persona* of the artist remains consistent, appealing, and powerful.

Nakamura was born in Mito and was destined for a military career, but ill-health from tuberculosis and an interest in Western art led him to Tokyo at the age of nineteen, where he took up studies with KURODA SEIKI. One of his close friends, the sculptor Nakahara Teijirō (1888–1921), described Nakamura

as a man who "possessed an enormous objectivity," for although his daily life was poor and miserable, "the impression he gave, one of freshness and brightness, was altogether the opposite." Like MAETA KANJI, Nakamura became a Christian, evidence of his youthful, idealistic nature.

As with his contemporaries, many of whom were influenced by the White Birch Society, Nakamura tried to merge his art with his life. Unable to afford a trip abroad, he poured over reproductions and art books. At one point he spent a great portion of his meager resources on a book on Rembrandt, which, he said, helped him to "find his way." A remarkable self portrait in a Rembrandtesque style now at the Bridgestone Museum in Tokyo testifies to his love of the Dutch master's achievements. Nakamura was also particularly impressed by Rodin's concept of art as an expression of an inner force, a notion introduced to the Japanese by the gifted young sculptor Ogiwara Morie (1879–1910), who had known both Rodin and Bourdelle in Paris before his return to Tokyo in 1908.

In 1911 Nakamura was befriended by a couple who arranged for him to live in Ogiwara's studio after the young sculptor's death. Despite their affection and care, however, Nakamura's health did not improve. He collected a number of people around him in a kind of informal Salon, where Nakamura and his friends discussed art and literature. He occasionally painted members of the group, including his portrait of the blind Russian poet Eroshenko, a painting that later earned Nakamura considerable fame.

In 1920, Nakamura saw some works of Renoir owned by the art collector Imamura Shigezō. Nakamura's encounter with these works stimulated a new atmosphere in his last landscapes and still lifes, in which he used a lighter and more fanciful palette.

Nakamura's joy at the growing appreciation of his work could not stop the illness that cut him down at age thirty-seven. Nakamura's sickness and his determined struggle to develop his own style cast him in the role of a romantic figure in the history of modern Japanese art. A poem he once wrote is often quoted as a sign of his ardent spirit:

He who knows the blessings of health
Is not the healthy man
But the sick one.
He who knows the beauty of the sun
Is not the man of the south,
But the man of the north, wrapped in mist.

In the midst of Rembrandt,
I see beauteous light;
In the midst of Renoir, ill with palsy,
I sense the happy pulsations of health. ▨

岡田三郎助
OKADA SABURŌSUKE
1869–1939

Born in Saga Prefecture, Okada grew up in both Tokyo and Osaka, where he was exposed to Western-style art as a child. His serious study of painting began at eighteen and, by the time he was twenty-one, he was entering pictures in the exhibitions of the Meiji Art Society, founded by ASAI CHŪ. In 1892, Okada was tremendously excited by his first glimpse of some of the paintings of KURODA SEIKI, done while that painter was in France. The following year he came to know KUME KEIICHIRŌ, himself just returned from Paris, who introduced him to KURODA. Both KUME and KURODA subsequently served as mentors to this gifted young man.

In 1897, Okada was sent by the Japanese Ministry of Education to Paris for further study; through KURODA's introduction, Okada was able to arrange to study with Raphaël Collin. By then several Japanese painters had already settled in Paris, and the number swelled in 1900, at the time of the Paris Exposition Universelle. Okada joined with a group of Japanese artists who assembled a small show of their work at that time in Paris.

Back in Japan in 1902, Okada secured a job teaching at the Tokyo School of Fine Arts. He entered a number of his pictures in the White Horse Society exhibitions and was delighted when two of his pictures were chosen to be shown in the Japanese art section of the 1904 St. Louis World Exposition.

In 1906 Okada married Okada Yachiyo, a well-respected novelist whose brother, Osanai Kaoru (1881–1928), began the modern theater movement in Japan with the formation of the *Jiyū gekijō* (Free Theater), which served as a rallying point for young avant-garde intellectuals of Tokyo. Okada, excited by his new connection, did some posters for the group and helped prepare the scenery for Osanai's opening production in 1909 of a version of Henrik Ibsen's *John Gabriel Borkman* translated by the novelist Mori Ōgai.

In 1912, Okada, now a considerable success, set up his own teaching studio, working with his colleague FUJISHIMA TAKEJI. During his mature years Okada became a highly respected member of the Japanese art establishment, exhibiting his fluent and elegant canvases at important national exhibitions until the late 1930s. Okada sustained in his slightly old-fashioned lyrical paintings of women and landscapes a freshness and gentle eroticism that has long made him a popular favorite of Japanese.

佐伯祐三
SAEKI YŪZŌ
1898–1928

Saeki Yūzō remains one of the most fascinating personalities among those Japanese artists who ventured to Paris between the wars. His art was born of an inner anguish, and the tension he sensed between the two disparate cultures in which he lived undoubtedly caused his suicide. A romantic figure since his death, Saeki continues to stand as a symbol of the challenge and the pain involved in the creation of an authentic modern Japanese art.

Saeki was born in Osaka; by twenty he was in Tokyo, studying with FUJISHIMA TAKEJI at the Tokyo School of Fine Arts. Upon graduation in 1923 Saeki took his family to France where he soon found himself sketching, as had his teacher FUJISHIMA two decades before, at the Académie de la Grande Chaumière. During that time Saeki made friends with several Japanese painters including MAETA KANJI and Satomi Katsuzō (1895–1981).

Judging from the few paintings of this period that remain, his work was heavily influenced by the work of Cézanne.

Satomi, who admired Saeki's work, took him to meet Maurice de Vlaminck, who characterized the young painter's work as academic. He urged Saeki to find and develop his own personal style. Shocked by this challenge, which seemed to nullify all that he had learned, Saeki abandoned his teachers and began to paint alone, both in Paris and in the surrounding countryside. He found the emotional cost enormous; the tensions arising from his search began to spill over into the images he painted, imbuing his pictures with a highly-charged, expressionistic quality, particularly in the cityscapes of the poor streets of Paris near his small apartment studio.

In 1925 Saeki had two pictures accepted in the *Salon d'automne*, which were much admired by those who saw them. The following year he returned to Japan with his family, still somewhat nervous and distressed.

Back in Tokyo, Saeki formed a group with MAETA and Satomi to exhibit their paintings called the *1930 kai* (1930 Society). Although some viewers were intrigued by Saeki's new works painted in Japan, he seemed unable to incorporate Japanese light and landscape within his own style. Saeki spent his small savings and returned to Paris with his family.

On the surface of his life, everything seemed to be going well. Saeki had mastered a number of technical problems and patrons were interested in buying his paintings. Yet his work became obsessive and his wife was unable to prevent a suicide attempt which resulted in the artist's death in a Paris hospital.

Saeki's widow returned to Japan with her husband's pictures, where she found that he was rapidly becoming a cult figure. His work began to bring significant prices, and eventually he was cast in the role of a Japanese van Gogh, a figure of high romance and tragedy. Despite an occasional surface resemblance to certain strategies of Utrillo, whose work Saeki was coming to know by the end of his life, his pictures express a hard-won personal vision and broad cultural significance.

For some painters, such as Saeki and YOROZU, the creation of an authentic modern Japanese tradition of oil painting represented a struggle as much for the creator's soul as for the artist's mind and brush. Hence, Japanese critics have seen Saeki's oeuvre as representing an "art of pathos." Saeki's art continues to be highly admired in Japan because of his witness to the lonely struggle of an artist attempting to make an alien tradition his own. ▨

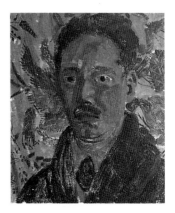

斎藤与里

SAITŌ YORI
1885–1959

Like UMEHARA and YASUI, Saitō was a student of ASAI CHŪ, who encouraged the young painter to go to France. Saitō remained in Paris from 1906 to 1909, studying under Jean-Paul Laurens. When Saitō returned to Japan, he organized, along with the poet and sculptor Takamura Kōtarō, KISHIDA RYŪSEI, and others, the *Fusainkai* (Sketching Society) in order to find a means to promote newer and fresher styles of painting. His work was later shown both in the *Bunten* and *Shun'yōkai* exhibitions, occasionally winning prizes of distinction.

Much impressed by the Fauves and Maurice Denis during his years in Paris, Saitō often made use in his paintings of motifs and colors he had observed in their work. He wrote vividly on both French and Japanese artists and was an important figure in the organization of art exhibitions and other activities during his long career. A man of commitment and sensibility, he did much to encourage the development of modern Japanese art. ▨

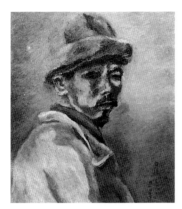

坂本繁二郎

SAKAMOTO HANJIRŌ
1882–1969

Elevated to the status of a popular and highly respected painter in the postwar period, Sakamoto did little to further his ever-growing fame. Painting became for him a mystical experience having little relevance to the world of galleries, admirers, journalists, museums, and patrons. Even during his stay in France, from 1921 to 1924, Sakamoto yearned for the quiet of the Japanese countryside, and as soon as he was back in Japan he returned to his home town of Kurume in Kyushu, where he spent virtually the rest of his life.

Sakamoto's first encouragement came from AOKI SHIGERU who had gone to Tokyo to study Western painting, then returned to Kyushu. AOKI's excitement over Sakamoto's early work gave the young painter the courage to go to Tokyo to study formally. Inspired by the new wave of influences brought back from Paris to Japan by UMEHARA RYŪZABURŌ, YASUI SŌTARŌ, and others, Sakamoto joined in the formation in 1914 of a group called the *Nikakai*, which gave support to those interested in employing newer Western styles in their work.

Sakamoto went to Paris in 1921 as a mature artist entering his forties. After a brief apprenticeship he decided to work by himself. By now, virtually the whole range of what was called the "École de Paris" was available to him for reflection and study. Cézanne, hero of the last generation of Japanese painters, now seemed too "logical" to Sakamoto, although he recorded finding something "Asian" in the color of the Master's light. Corot remained his favorite landscape painter.

Back in Tokyo, Sakamoto mounted a successful show of works he had painted in France; a contemporary critic wrote that he had "transcended the '-isms'"

and was able to express his own personality.

Soon, however, Sakamoto was back in Kurume, painting the countryside he loved so well, as well as what was to become perhaps his most representative subject, horses. Later he began to concentrate on grave, small still-life paintings as deceptively simple as those of the modern Italian painter Morandi; toward the end of his life, Sakamoto began to include such Japanese objects as *nō* masks in his configurations of boxes, vases, and bowls.

Sakamoto's palette remained austere and his subject matter ever more tightly controlled, yet many Japanese viewers found, and continue to find, a quiet and searching authenticity in his work that places him at the forefront of the modern Japanese masters.

関根正二

SEKINE SHŌJI
1899–1919

Like his contemporary MURAYAMA KAITA, Sekine lived a short and intense life, died early of illness, and left behind the image of the artist as hero, struggling against obscurity and indifference, that contributed so much to popular notions of the romantic role of the artist in modern Japanese society.

Born into a large, poor family in Fukushima Prefecture, Sekine struggled against hardships almost from the beginning of his life. He showed an early aptitude for art, and by 1914, when he was still in his mid-teens, he had given up school to become an apprentice in the printing business while continuing to practice and study Western painting in his few spare hours. He also became an avid reader of Western literature, devouring Wilde and Nietzsche in translation. The noted printmaker and painter in the Japanese style, Itō Shinsui (1898–1972), seeing some

of Sekine's work, took a strong interest in the preco-
cious artist and began to introduce him in Tokyo
artistic circles.

In 1915, on a trip into the mountains of Nagano,
Sekine met another aspiring painter, who showed
him for the first time reproductions of Dürer,
Leonardo da Vinci, and other Renaissance masters.
This discovery, plus an opportunity the same year to
see an important exhibition held in Tokyo of the
paintings done in France by YASUI SŌTARŌ, re-
newed Sekine's sense of vocation, and he plunged
into further studies of Western painting.

By 1917 Sekine had made great progress, but his
overexertion and frail health were already curbing his
energies. Still, he lived a somewhat bohemian life; he
and his friends established themselves at their "Café
de Paris," drinking and playing the mandolin.
Around this time he met the well-known novelist
and playwright Kume Masao (1891–1952), who was
then involved with a number of prominent figures in
the literary world. Kume, impressed with his talent,
wanted to help the career of this artist now called by
many "that mad young painter," but it was too late.
By 1919, Sekine had died.

"When I first knew him," Kume wrote of Sekine
in 1920, "his pictures resembled Cézanne's, in the
good sense of the word . . . but his real genius devel-
oped into his own kind of true art that was later at a
considerable distance from that model; from the time
he found himself, his art showed with a flourish his
own true genius." Only a handful of Sekine's pictures
remain, but his work, and his example, have assured
him a place among modern Japanese masters. 🖾

梅原龍三郎
UMEHARA RYŪZABURŌ
1888–1986

Umehara Ryūzaburō, only recently deceased, has
consistently held a reputation as the leader of the
Japanese artists painting in the Western style during
the interwar period and into the postwar years.
There is, in fact, an entire room dedicated to his
work in the Museum of Modern Art in Tokyo; he is
the only artist so honored. During his long and pro-
ductive life, he managed to blend his own personal
perceptions with canons of taste appealing to both
Japanese and Western values. At his best, he achieved
a synthesis appropriate to both, and his large, ele-
gant, and satisfying canvases can be seen in most
Japanese museums that include twentieth-century
Japanese oil paintings.

Umehara took up his formal studies in 1906 with
ASAI CHŪ in Kyoto. Two years later, when he was
twenty, he went to France with the idea of some-
how meeting Renoir and studying with him. He vis-
ited the French painter at his home in the south of
France; delighted with the talents of the young
Japanese painter, Renoir took him on as a student.
By 1911, Umehara had met Picasso and, at his sug-
gestion, toured Spain to experience other landscapes
under different light. Back in Paris in 1912, he took
an apartment near Notre Dame (which figures in
some of his paintings from this period) and travelled
to various sites in Italy as well. The following year
he bid Renoir adieu, returned to Japan by trans-
Siberian railway, and arrived back in Kyoto, where
he held his first exhibit.

Umehara's family had connections with the silk
weaving industry in Kyoto. The artist's childhood
exposure to traditional Japanese methods of design,
plus his work with Renoir and understanding of the
Fauves, gave Umehara a comfortable, distinctive
style that bridged the enthusiasms of the French and

Japanese publics alike. Umehara developed flat, clearly delineated decorative patterns that he filled in with brilliantly nuanced colors to create a strong emotional effect. The color harmonies he evolved bear recognizable relationships to his subject matter, yet also serve as satisfying abstract juxtapositions of shades and hues. In this way Umehara's pictures expressed the freedom of Western painting while retaining a control of color worthy of the great Japanese woodblock artists of the past.

Umehara was most successful in Japan, and he soon found himself a relatively popular figure, with disciples and students. When he learned of the death of Renoir in 1919, he interrupted his work to travel back to France, where he visited the artist's family, with whom he had become quite close.

Subsequently, Umehara applied his skill to a wider range of subject matter. He travelled extensively in Japan and was particularly impressed by the semi-tropical scenery of southern Kyushu; in particular, his paintings executed in the Kagoshima area suggest that he, at least, found certain affinities between that scenery and the south of France. In 1939 he made a visit to China, where he painted the streets and temples of Peking with the same freshness that he had brought to European and Japanese subjects.

After the war, Umehara returned several times to France, often with his children and grandchildren. His later, looser style, replete with thick paint surfaces, seems especially appropriate for his scenes of Venice. Umehara continued until his death to move between the two worlds of France and Japan as though he belonged in them both in the most natural sort of way.

山下新太郎
YAMASHITA SHINTARŌ
1881–1966

Yamashita was brought up in Tokyo, where he began serious study of Western painting at the Tokyo School of Fine arts with FUJISHIMA and KURODA. By this time KURODA was long returned from France, but FUJISHIMA did not travel to Paris until 1905, a year after Yamashita himself had left for Europe. In Paris, Yamashita, like so many others, approached first Raphaël Collin, then Fernand Cormon. The latter, sufficiently impressed with the young Japanese painter's talents, arranged for him to audit classes at the École des Beaux-Arts, where Yamashita eventually enrolled as a full-time student. Yamashita was a talented and diligent worker, attending classes, making sketches in the Louvre, and studying older art in the Paris museums. Like UMEHARA RYŪZABURŌ, he admired the work of Renoir and was able to meet the master briefly in 1909.

In 1914, Yamashita, along with ARISHIMA IKUMA, YASUI SŌTARŌ, UMEHARA RYŪZABURŌ, and others of his generation who brought new influences from Europe, established the *Nikakai*, which broke away from government sponsorship in order to show directly to the public their more experimental works. The group, although later reorganized, has continued to the present.

Yamashita's early promise was never entirely fulfilled, but he made a real contribution in his efforts to introduce new styles and techniques from France. His later interest in the restoration of paintings helped alert professionals and art collectors alike to the challenges involved in this neglected aspect of art collecting in modern Japan. Yamashita was awarded the *Légion d'honneur* by the French Government in 1939 for his services in introducing the ideals of French art into Japan.

安井曾太郎
YASUI SŌTARŌ
1888–1955

Along with his friend and colleague UMEHARA RYŪZABURŌ, Yasui has continued to share pride of place in the Japanese public eye. Yasui had a long and distinguished career, and his continuing attempts to find a way to simplify nature within a context of realism won him admirers throughout his lifetime.

Like UMEHARA, Yasui was brought up in Kyoto and so as a child knew something of the great artistic traditions of an older Japan. Both studied with the renowned painter ASAI CHŪ during his residency in Kyoto; after ASAI's death in 1907, Yasui left for Paris, where he remained until 1914, when the war forced him back to Japan. Like many of his compatriots, Yasui chose to study with Jean-Paul Laurens at the Académie Julian, where he was considered a particularly brilliant student and won many prizes in the school's monthly competitions. Yasui began going to the countryside to paint as well, and eventually he abandoned academic training in order to develop a more individual style. For Yasui, the greatest artistic experience of his years in France remained the 1907 Cézanne retrospective, which taught him, as he later wrote, "to see nature through the Master's eyes."

Back in Japan, Yasui's works painted in France were displayed in a "homecoming show" that had an enormous impact on his fellow artists and on the general public. His work demonstrated just how accomplished the new generation of Japanese painters could become when freed from the earlier academic training still prevalent in Japanese teaching circles.

After this initial success, however, Yasui plunged into a decade of furious and not always successful activity, attempting to accommodate what he had learned in France to his own temperament and to his new environment. The quality of light, he came to realize, was sufficiently different in Japan from the fabled luminosity of France that it was necessary to create new techniques to render it. Further, some of the painting materials available in Japan did not produce the same effects as those the painter had used in France. In Yasui's view, it was not until 1929 that he found himself again.

In Yasui's major period, which began in the decade of the 1930s and continued until his death, he created work after work that his public felt represented a truly contemporary and authentically Japanese vision. His colors were dynamic, and his ability to portray psychological elements of his portrait sitters was highly developed. Then too, his growing ability to simplify forms and take delight in flat and abstract shapes represented for many a resurgence of a truly Japanese quality in his art. Some critics traced these accomplishments, as they did those of UMEHARA, to their Kyoto background.

During the 30s, 40s, and 50s, the world of Western painting in Japan was dominated by YASUI and UMEHARA. Despite the differences in their individual styles, both showed a love of color, pattern, and surface richness that gave their works a sense of relaxed beauty and an amiability rare at a time when so many artists continued to reveal in their work the difficulties of striking a balance between their French models, Japanese traditions, and personal expectations. Yasui's pictures, like those of UMEHARA, are easy to look at, but behind the pleasure lies the achievement of a delicate rapprochement between a variety of contending artistic impulses. ▨

万鉄五郎

YOROZU TETSUGORŌ
1885–1927

Yorozu was one of the most imaginative and daring of all the artists of his generation. Of himself, he once jotted on a scrap of paper:

I am a kind of walking aborigine. We don't need to know anything. We see what we see, hear what we hear, eat what we eat—it is enough to walk, sleep, and paint.

In painting after painting, Yorozu tested himself by penetrating one style after another: Post-Impressionism, Fauvism, and Cubism, all experienced through reproductions observed and studied in Japan. Yorozu, like his friend KISHIDA RYŪSEI, also experimented with traditional Japanese styles such as decorative Tokugawa *rimpa* painting.

As a child he experimented both with Western watercolor and with traditional Japanese ink painting. When he finished middle school, Yorozu was anxious to see the world, and managed, by means of a Buddhist religious group to which he belonged, to visit the United States, where he worked briefly as a houseboy.

By 1907 Yorozu was back in Tokyo, studying design and determined to become an artist. He saw the paintings of FUJISHIMA TAKEJI on display shortly after his return from Paris in 1910, and this event convinced Yorozu to abandon the academic Western painting style then being taught in Tokyo. As a result he and KISHIDA RYŪSEI, along with several others, founded the *Fusainkai* in 1912, a group dedicated to promoting Fauvist styles. Yorozu was particularly excited by reproductions he had seen of van Gogh and Matisse. His own pictures from the period, created in a Fauvist mode, confused and occasionally baffled their first Japanese viewers.

The well-known painter Kimura Shōhachi (1893–1958) described a visit to Yorozu's studio:

Starting to climb up to the second floor, I saw a baby carriage in the hallway, filled with charcoal. Yorozu had gotten it from his home village out in the country and had carried it up for use at home, I learned later. Climbing to the top of the rickety stairs, I found a couple of chairs; it was this area that constituted Yorozu's "studio." Looking around, I saw heaps of canvases, one after the other, all piled everywhere in great confusion, so many that there was nowhere to sit. Across from the table and chairs was the pale and (at that period of his life) emaciated face of Yorozu himself, with his startlingly thick moustache, his throat all wrapped up in a high black woolen jacket. The incandescent gas lamps were burning, their mantles glowing, and they gave off an unsteady light. Standing in the midst of what must have been a hundred exercises for his graduation picture, was his remarkable "nude." I was virtually speechless.

Yorozu restlessly began in 1912 a series of landscapes, self portraits, and still lifes, many of them in Cubist monochrome, and all quite different from his earlier Fauvist works. By 1917, some of these paintings began to find favor with the public.

In 1919, his nerves weakened by sustained exertion, Yorozu retired to the countryside. Away from the art centers in Tokyo, he, as would KISHIDA RYŪSEI a few years later, worked to combine elements from all his styles into works that continued to challenge his viewers. At the same time he went on to explore traditional styles.

Yorozu has come to be appreciated as one of the most gifted and challenging artists of his period. The European influences upon him, as with KISHIDA, were indirect, and his search for mastery grew not out of any attempt to please his public or sell his pictures but from his personal standards. For that reason Yorozu's art represents for many the record of an inner life that can serve as an emblem for the ideals and the tensions of the entire Taishō period.

AOKI SHIGERU
The Sea 1904
Oil on canvas, 36.5 x 72.8 cm/14⅜ x 28⅝ in
Fujii Gallery, Tokyo

In the summer of 1904, after graduating from the Tokyo School of Fine Arts, Aoki Shigeru, along with his painter friends SAKAMOTO HANJIRŌ, MORITA TSUNETOMO, and Fukuda Tane, went for two months to Chiba Prefecture, north of Tokyo, where they spent time sketching in and around the Mera area. According to his friends, Aoki produced there a considerable number of sketches from nature that were of the highest quality.

The painter Masamune Tokusaburō, who later commented on his friend Aoki's seascapes drawn during the trip, pointed out that, while the artist's pictures dealing with mythological or religious subject matter record the influence on him of the English painters of the Victorian period, in particular the Pre-Raphaelites, Aoki's seascapes testify to his admiration for French Impressionism. Although Aoki himself did not regard these works as his most important ones, Masamune indicated that the works remain fresh and vivid and the undulating sea they record "grasp a real part of nature."

The poet Kanbara Ariake, who admired Aoki and came to own *The Sea*, observed that the painting is more than a mere seascape, suggesting rather a romantic attitude toward nature held by the artist.

This picture of the sea was created by a kind of magician. It could not have been painted by merely following the principles of the color spectrum. A vision such as this does not come from merely mixing paints. At the time when Mr. Aoki produced this painting, his perceptions of nature were straightforward, yet he possessed a symbolic understanding so individual, so unique, that the work takes on a mystic quality. How did he seize that strong sunshine and compress it into the picture? In the midst of the uproar of the raging sea, we find the painter's soul. In this work, Mr. Aoki carries out his own Impressionism, one that is unique, free, and bold.[1]

Yashiro Yukio, the distinguished Japanese historian of Western art, commenting on Kanbara's analysis, goes further to claim that Aoki holds a special position in the history of modern Japanese art.

Aoki was a genius who caught objects in a manner full of poetic sentiment and imagination. Accordingly, even when he presented Nature as he found it, his art was woven from emotions hard to describe. Any banality was overcome. I like his seascapes very much . . . in many of these works, the sea itself seems to be swelling up, overwhelming us with its grandeur. Some of these paintings depict waves and rocks in a Pointillist fashion, yet Aoki never uses a mere mechanical application of Impressionist theory in order to create them. Rather, he records what he sees in accordance with the movement of his own sensations. These works are thus full of his own true feelings. They are very powerful.[2]

Incidentally, this painting, first owned by Kanbara Ariake, later came into the collection of Kawabata Yasunari, the renowned Japanese novelist who was awarded a Nobel Prize in 1968.

Tōru Arayashiki

Notes:

1. Kanbara Ariake, *Hiunshō*, Shomotsutenbōsha, 1938.
2. Yashiro Yukio, *Kindai qaka gun*, Shinchōsha, 1955.

116

AOKI SHIGERU
The Sea 1904

AOKI SHIGERU
Palace under the Sea 1907
Oil on canvas, 181.5 x 70 cm/71½ x 27⅝ in
Ishibashi Museum of Art, Ishibashi Foundation,
 Kurume
Important Cultural Property

When the legendary Prince Fire-fade lost his older brother Fire-shine's fishhook in the sea, the younger Prince is said to have dived into the water after it. In those depths he visited the palace of the God of the Sea. There he met and talked with the daughter of the God of the Sea, who fell in love with him. Aoki's painting takes its subject from this ancient Japanese myth recorded in the *Kojiki*.[1] Fortunately, the artist left a detailed account of his motives in creating this particular work. While the painting was on display in a 1907 exposition, where it won third prize, Aoki wrote a newspaper article in which he related the following:

> *Indeed, I spent three full years planning this picture. Yet once I actually began to put paint to canvas, the finished work was only three months in the making. The year before last, an event truly etched my impressions of the bottom of the sea into my head and my heart. I took a sketching trip to a summer resort . . . to avoid the heat of the city. And one day, I was actually able to enjoy myself in the billowing waves with a pair of diving goggles.*

Such was evidently Aoki's first view of the beauty of the sea floor. On this occasion he did little more than create study sketches of underwater scenes, although, as he wrote, he was able to "harmonize color and tone with the sorts of deformations that can be seen in the shape of the human body under the sea." It was not until the next summer that he had the idea to combine these observations with figures from classical Japanese mythology. Subsequently he travelled south to Nagasaki and actually donned a diving suit and helmet in order to descend to the sea floor. According to his own testimony, this experience allowed him to complete the basic conception for the composition of the piece.

The final work was painted between January and March 1907 in a farmhouse near the home of a woman he much loved, Fukuda Tane. She and a neighborhood farm girl were pressed into service as his models.

When the painting was hung, some found it successful, others wrote that it lacked the kind of technical power shown in another work on display that took its subject from ancient mythology, *Founding of the Nation* by Nakamura Fusetsu (see Rimer, Fig. 26).

Natsume Sōseki, the great novelist of the period, visited the exhibition, and a mention of Aoki's painting found its way into his 1909 novel *Sore kara*. The protagonist, named Daisuke, is in fact much moved by the painting.

> *Some fellow named Aoki had painted a picture of a long-figured woman standing on the bottom of the ocean. The painting had been shown at an exhibition once. Of all the various works he had seen there, Daisuke felt it was the only one he could truly like. He so wished that he too could give a gentle sigh, and feel the same tranquility that he sensed from the canvas.*

Some critics see certain influences from the British Pre-Raphaelites in Aoki's painting, and indeed, the artist himself wrote of his interest in the decorative compositions of Sir Edward Burne-Jones, which he knew from reproductions.[2] Whatever the apparent influences, *Palace under the Sea* is a rare and important example of a "history painting" in the Western sense, one that presents a noble hero of Japanese myth enacting virtuous deeds.

Kenichirō Makino

Notes:

1. For a translation of the tale, see Donald Keene, ed., *Anthology of Japanese Literature from the Earliest Era to the Mid-nineteenth Century* (New York: Grove Press, 1955), pp. 54-58.
2. For details concerning these influences see the Bridgestone Museum catalogue *Shigeru Aoki and the Late Victorian Art*, published in 1983, which has useful essays in both English and Japanese.

AOKI SHIGERU
Palace under the Sea 1907

ARISHIMA IKUMA
Man Smoking a Pipe 1908
Oil on canvas, 73 x 59 cm/28¾ x 23¼ in
Private collection

In an essay of 1909, the celebrated novelist Shimazaki Tōson, who would travel to France himself in 1913, first introduced his readers to Arishima Ikuma, then studying painting in Paris:

> I had not heard from Mr. Arishima for some time until my friend [the poet] Ueda Bin, recently returned home from abroad, brought me a photograph of an oil painting depicting a vase filled with flowers. This photograph was sent to me by Mr. Arishima as a present. It is a work of Cézanne. And although the picture itself shows only a vase and flowers, it puts me in touch with the contemporary sentiment of France. Mr. Arishima attached the following commentary on Cézanne. "Although this painter may not match an art student in empty skill, in temperament he is unparalleled throughout the ages, a master who never wearies of the love of life. It was to him that some of Zola's letters were addressed. The painter who serves as the chief character in Zola's novel L'Oeuvre is said to have been modelled on him."

Arishima first visited Shimazaki Tōson in Komoro, Nagano Prefecture in 1903. At that point in his career, Arishima had attempted to compose poetry in the style of the new experimental Western-style verse so successfully created by Shimazaki himself. At their meeting, Shimazaki showed Arishima a reproduction of a work by Pissarro that so impressed the young man that he decided to take up painting. Arishima later recalled the moment:

> Until that moment, I had never seen an Impressionist picture. The dream of a profound, a remote world emerging from that painting fascinated me so powerfully that my heart almost stopped beating. The instant in which that picture was impressed on my very soul was the most significant, the most moving of my whole youth. The events of that precious day determined the course of my life.

The following year, immediately after graduating from the Department of Italian at the Tokyo School of Foreign Languages, Arishima began to study oil painting under the guidance of FUJISHIMA TAKEJI. In 1905, Arishima left for Italy, where he studied first at the French Academy in Rome, then at the national school of fine arts in that city. By 1907 he was settled in Paris, where he worked with Raphaël Collin and others at the Académie de la Grande Chaumière. It was in the autumn of that year that he visited the Cézanne retrospective and, as he put it, "found a new way that leads to a frontier of art I never dreamt of."

When Shimazaki Tōson mentioned Arishima's letter and the photograph of a painting of Cézanne in his essay, his text took on a historic significance, for it represented the first introduction, however fragmentary, of the name and work of Cézanne into Japan.

Arishima's painting *Man Smoking a Pipe*, created some six months after the Japanese painter discovered Cézanne, suggests his profound admiration for his reclusive hero. The painting was later shown in Tokyo, in an exhibition in 1910 sponsored by the *Shirakaba* magazine editors. At the show Arishima displayed some seventy works of art he had produced in Europe. According to various accounts, the exhibition attracted many of the important men of letters and intellectuals of the day. Even a half-century later, the celebrated sculptor and poet Takamura Kōtarō recalled that Arishima's works were especially fresh and truly excellent in form and color. After his return to Japan, Arishima was tireless in his efforts to introduce the work and ideals of Cézanne to Japan. In his own work, Arishima did not wish to copy the French painter's style, but to follow his ideal in spirit, and thereby convey something of it to the Japanese public.

Kenichirō Makino

120

ARISHIMA IKUMA
Man Smoking a Pipe 1908

ARISHIMA IKUMA
Mosquito Net 1917
Oil on canvas, 95.5 x 111.7 cm/37⅝ x 44 in
Tokyo Metropolitan Art Museum, Tokyo

This work was exhibited at the fourth *Nikakai* exhibition, held in 1917, along with three other pieces by Arishima. The artist created *Mosquito Net* during the summer of 1917, but in the midst of finishing the composition his health failed him, possibly because of the recent death of his father. Whatever the reason, the painter was not satisfied with his work.

> *Perhaps it was because of the blistering heat that I had been battling since July; I don't know why, but I was physically exhausted. . . . It was as if the pictures were looking towards me, talking to me even when I was lying on my bed on the floor. My head was filled with the constant rustling of their voices, and even my short pauses for rest brought me no refreshment. As a result, I was able to make no personal judgements about my paintings. . . . My feelings, my spiritual powers were entirely spent. My paintings were leaning against the wall, and the last thing I felt like doing was to turn them face out into the room. As I stood there, looking at the blank backs of my works, I was confronted, for the first time in my life, with the spectre of a psychological breakdown. When the frame for* Mosquito Net *was delivered from the dealer, I immediately put the picture into it to see how it would look. All its defects seemed to stand out quite distinctly, yet I did not have the strength to undertake any repair of them at that time.*[1]

Mosquito Net is the largest of Arishima's works created at this period in his life. He had evidently worked on the composition for some time, yet as is clear from the sentiments expressed above, he never found himself satisfied with the outcome.

At this time in Japan, the image of a young woman reclining under a mosquito net was a common sight of a summer evening in virtually every household in the country. According to the daughter of the artist, Arishima Akiko, the model for the picture was the mistress of the noted author Satō Haruo (1892–1964), then an up-and-coming novelist who wrote in a highly refined and aesthetic style.

Arishima himself took very seriously his mission as an artist, maintaining his support for the *Nikakai*, of which he had been perhaps the most important founding member. In 1917, the year he created *Mosquito Net*, the painter wrote an article stressing the group's commitment to creative individuality as a first priority; for the artists in this group, he insisted, the effectiveness or ineffectiveness of the works they created was a matter of only secondary concern. Arishima's emphasis on artistic freedom and respect for the individual allowed the *Nikakai* to support a steady stream of inspired and individualistic painters, among them KISHIDA RYŪSEI, Tōgō Seiji, SEKINE SHŌJI, Hayashi Shizue, and KOIDE NARASHIGE. Arishima's efforts were not in vain, and his *Mosquito Net* remains a captivating expression of the artist's personal vision.

Kenichirō Makino

Notes:

1. *Shinchō*, November 1917.

ARISHIMA IKUMA
Mosquito Net 1917

ASAI CHŪ
Fields in Spring 1888
Oil on canvas, 56 x 74 cm/22 x 29⅛ in
Tokyo National Museum, Tokyo
Important Cultural Property

One hundred years ago Tokyo was filled with fields like this one, which have long since been engulfed in the downtown area of the capital. In his book on Asai Chū, published in 1929, the painter Ishii Hakutei surmised that a number of Asai's paintings created during the period may have represented scenes the painter witnessed in the Kanasugi area, near present-day Ueno Station, where such fields still existed as late as the turn of the century. Asai moved there in 1889; thus the present picture, finished the year before, may show the fields around Ushigome, near the present-day Ichigaya, also in the center of Tokyo.

The picture is redolent of the season it depicts, that of early spring. Against a low, dark sky illuminated by weak, soft sunlight, such seasonal sensations as the smell of damp, chilly air and the feel of moist, black earth are suggested. In the painting, rape plants bear yellow flowers, and the plum trees are in bloom. In Tokyo, these flowers blossom in March, and are thus considered heralds of spring. Plums, which bloom despite the cold, have long been given an important place in the subject matter considered appropriate to the Chinese and Japanese traditions, and plum trees have appeared for many centuries in literati paintings.

Before Asai studied Western painting, he spent ten years studying Japanese ink drawing, a skill traditionally appreciated by the samurai class. The concepts he cultivated through this study were thus deeply implanted in his Western painting. Most of his works display the daily life of the farmers. Traditionally, such subjects might have depicted the gaiety and joy of such men and women, in consonance with traditional precepts, but Asai has chosen to suggest rather their honesty and steadfastness. In the Meiji period, Asai saw the farmers changing very slowly, while the city dwellers and upper classes experienced drastic changes in the rapid transition of their society.

We can also recognize in *Fields in Spring* the influence of Fontanesi, Asai's instructor at the Technical Art School and, through him, of the Barbizon School, which the Italian painter introduced into Japan. In the history of Japanese painting, attempts to present realistic scenery originated as early as the eighteenth century, although usually only those places were depicted that had previously been assigned some poetic significance. Asai's choice suggests a certain continuity with the spirit of that tradition. Although greatly interested in photography, Asai never merely copied from photographs. For him, Western painting meant much more than merely reproducing what was seen by the eye.

After studying abroad, KURODA SEIKI and his colleagues took pains to introduce academic Western concepts into the new painting of Japan. In this effort, they praised nudes and what they called "conceptual paintings." Asai also attempted "conceptual paintings," but these works are crude in expression and deficient in sentiment. His artistic talents were most fully revealed when he painted landscapes and the people he saw there. In the West, as the academic style was itself depreciated at the end of the nineteenth century, landscape painting rose in importance and aesthetic appeal. Asai's works, being relatively free from Western academic painting styles, remain fresh and attractive today.

Emiko Yamanashi

124

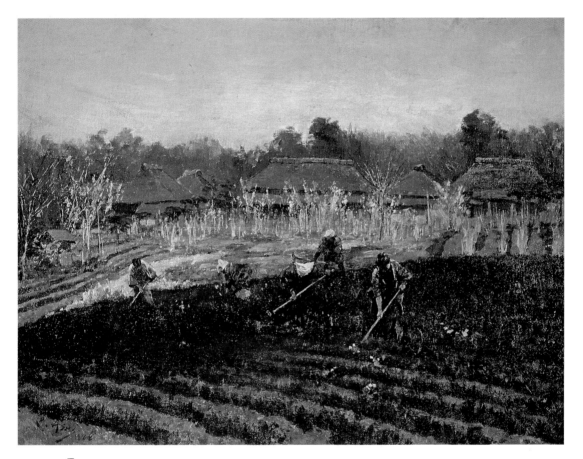

ASAI CHŪ
Fields in Spring 1888

ASAI CHŪ
Washing Place in Grez-sur-Loing 1901
Oil on canvas, 33 x 45.5 cm/13 x 18 in
Bridgestone Museum of Art, Tokyo

When this picture was repaired, a penciled note, "Grez Octobre 1901" was discovered on the lower left-hand corner of the canvas where it had been folded under the frame. This fact indicates that the work was finished during the last of the four visits the painter made to Grez-sur-Loing during his stay in France. At that period, Asai shared lodgings with another gifted oil painter, Wada Eisaku (1874–1959). Together, they kept a diary which provides useful documentation on their experiences in France.

The first entry is dated October 1, 1901. Leaving Paris at noon, they arrived in Grez, which lies to the south of Paris, at about two o'clock. During the afternoon Asai wrote, "the scenery is unexpectedly blue, very different in hue from the autumnal tints now seen in Paris." They did not go sketching the first day; on the second, they were kept inside by light rain in the morning and could not go out of doors until the afternoon. "We began sketching on a riverside. There are cattle in a meadow. Women are washing clothes at the river. The foliage is still green, and the scenery, even at this season, remains quite pleasant," Asai wrote.

Asai repeatedly returned to the riverside to make sketches. He produced a number of pictures of the river, bridges, and other scenes he saw in the surrounding countryside. More problems with weather sent the painters back to Paris, but they were to return again after October 10.

Asai's study in France brought about great progress in his artistic development. The changes are particularly remarkable in his watercolors. In order to investigate methods of recording different impressions in both transparent and opaque colors, he depicted some scenes twice, using the same configurations. Upon comparing the artist's work before and after his sojourn in France, it is clear that the watercolor techniques he learned were of use in the creation of his later oil paintings. *Washing Place in Grez-sur-Loing* has a transparency found nowhere in *Fields in Spring* (Cat. 5) or *Harvest,* two important pictures he created prior to his departure for Europe. Its bluish tones are completely different from the brown tints of his earlier paintings. The space of the picture, closed as it is in the background, is shallow yet suggest capaciousness.

Asai began his work in Japan by depicting simple scenes. During his stay in France he avoided popular and spectacular places but rather chose as his subject matter fields, beaches, and such places where nature remained close at hand. When he did portray human figures, he chose those who were at work. Such choices were conscious ones on the artist's part. He had little fascination for the exotic. He remained, as always, an accurate and often affectionate observer of what he saw.

In January 1891, members of the Meiji Fine Arts Society discussed the topic "Do Nude Paintings and Sculpture Do Harm to the Manners and Customs of the Nation?" On this occasion, Asai pointed out that, in his view, Japanese artists were still unskillful and were not yet able to paint nude figures with assurance, concluding that, "for at least thirty years or so, until our skills attain maturity, we should refrain from producing nudes. Besides, there are many other suitable subjects to choose." In agreement with these sentiments, he never produced a nude throughout his career.

Emiko Yamanashi

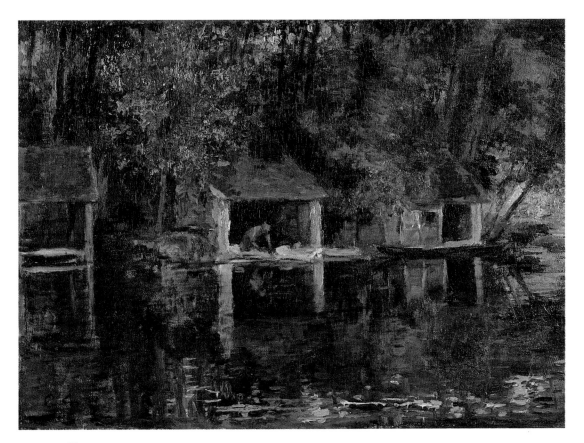

ASAI CHŪ
Washing Place in Grez-sur-Loing 1901

FUJISHIMA TAKEJI
Cypresses 1908–1909
Oil on canvas, 40 x 37 cm/15¾ x 14⅝ in
Bridgestone Museum of Art, Tokyo

For four years from the end of 1905, Fujishima studied in France and Italy as a government-sponsored overseas student. He was already thirty-nine years old and for the previous ten years had been assistant professor at the Tokyo School of Fine Arts. He had established a solid reputation for himself in the Japanese art world through the submission to the White Horse Society of works painted in a new idiom which offered a premonition of Japanese romanticism. Fujishima explained his reasons for going abroad as follows:

> The path which I have been following hitherto and shall continue to follow in the future is that of painting in the decorative style. Such was my aspiration right from the outset. All my landscapes and portraits were painted as preparations for decorative art. Neither of my teachers abroad, Fernand Cormon and Carolus-Duran, was especially strong in the field of decorative painting. I felt particularly attracted to the work of artists such as Puvis de Chavannes, from the first time I saw such art in photographs. I chose Cormon and Duran as my teachers because I wanted to learn about completely different aspects of painting.

What Fujishima meant by decorative painting are murals which form a unity with the surrounding architecture, works which enable the depiction of total, idealistic concepts and include a sense of historical perspective through the incorporation of Japanese myths and legends. A code of beliefs capable of forming the content of such paintings was missing from Japanese art. Fujishima regarded the purpose of his period of study in Europe as an attempt to find the means to acquire the technique and conceptual ability necessary to paint pictures imbued with such a code of beliefs, in other words, decorative painting. What he had in mind, presumably, were the colossal murals painted by nineteenth-century French academicians, his admiration for which was the motivating factor behind these remarks.

Fujishima spent the first two years of his stay abroad in Paris, absorbed in learning traditional techniques from Fernand Cormon at that bastion of academicism, the École des Beaux-Arts. This was the time at which the work of Cézanne and van Gogh achieved general recognition and the Fauvist movement was getting under way. Fujishima nevertheless remained untouched by such innovations and left Paris for Italy. He spent the remaining two years of his overseas study acquiring greater technical proficiency under the supervision of Carolus-Duran, director of the French Academy in Rome. Fujishima found himself engrossed in his Italian surroundings and Renaissance painting.

The purpose of Fujishima's study with Cormon and Duran was to learn to paint large murals with an idealistic content. The techniques of portraiture and landscape painting which he acquired from them were supposed to be no more than an initial preparation for the creation of such murals. However, Fujishima never actually managed to realize the kind of paintings which he had set up as his ideal. He was unable to implant such idealism, already a thing of the past in Europe, in a Japanese setting.

Cypresses, painted during Fujishima's residence in Italy, depicts the garden of the Villa Falconieri in Frascati to the south of Rome. The view of tall cypresses reflected on the surface of a pond is depicted powerfully within a simple compositional framework. Fujishima's principal gain from study in Europe was perhaps his acquisition of the technique employed in this painting, a technique of refined expression which permitted him to simplify the composition of a painting, work quickly with fluid brush strokes, and incorporate coloring in a well-balanced manner. During his two years in Italy Fujishima painted many landscapes in the environs of Rome and Rivoli, and in the course of travel to Naples, Pompeii, Venice and Switzerland. Each of these works is in a gently Impressionistic style, expressive of the artist's intimate feelings as he faced the landscape floating over the surface of the picture.

Although it many well have been Fujishima's aim to combine portraiture and landscape and to portray human ideals in his work, this landscape, *Cypresses*, serves by its own merits to give authentic expression to the artist's sensibilities. Landscape painting was to take on increasing importance for Fujishima and to become the central aspect of his creative work.

Hikaru Harada

FUJISHIMA TAKEJI
Cypresses 1908–1909

FUJISHIMA TAKEJI
The Black Fan 1908–1909
Oil on canvas, 64 x 41.5 cm/25¼ x 16⅜ in
Bridgestone Museum of Art, Tokyo
Important Cultural Property

This work was painted during the artist's stay in Rome and is perhaps the most accomplished product of his period of overseas study. Traces of fleeting brush strokes remain above the black fan, blurring the oil colors, and this blurred effect creates a perfect sense of the motion of the fan, gently wavering in the model's hand, as well as a somewhat translucent texture. The color contrast between the black fan and the white veil, and the correspondence with the jet black hair, show the skill with which the picture is structured in terms of color. The picture as a whole is given cohesiveness through its bold expression employing strong brush strokes, a sense of vital motion making itself felt within an atmosphere of tranquillity.

During his stay in Rome, Fujishima learned from his teacher Carolus-Duran that:

When painting a picture, it is essential to acquire beforehand the required knowledge, and then face the canvas with heightened sensibility and paint without hesitation in a single creative spurt. Vacillation when applying the paint must be avoided at all costs.

In *The Black Fan* it would seem that the lesson of Carolus-Duran's has been well digested, as can be seen from Fujishima's purposeful brush strokes as he attempts to grasp the subject in a single concentrated effort. Carolus-Duran was a painter who specialized in portraits, especially of women, and it was under his influence that Fujishima suddenly acquired his technique of portrait painting. The elegant, brilliant and somehow coldhearted aristocratic sense which can be felt in *The Black Fan* was perhaps also an acquisition from Carolus-Duran.

Fujishima painted five portraits of women during his two-year stay in Italy. These five works can be placed in chronological order on the basis of the stylistic change they evidence. Commencing from an orthodox, academic technique, he gradually moved away from an attempt to depict his models as faithfully and thoroughly as possible to a style in which the subject's features are painted concisely with rapid brushstrokes in an impressionistic form of expression which attempts to portray the effects of light and wavering of the air. Bearing in mind that another pupil of Carolus-Duran's, John Singer Sargent, while remaining faithful to his master, came close to the style of the Impressionists through effective use of smooth and rapid brushstrokes, it is clear that Fujishima too, was caught up in the trend of the times.

As mentioned in the comments on *Cypresses* (Cat. 7), the original purpose of Fujishima's study in Europe was to look into styles of conceptual art that attempted to convey a philosophical message, as typified by the work of Puvis de Chavannes and Gustave Moreau. He intended to make a start by acquiring, through Fernand Cormon and Carolus-Duran, the necessary academic techniques. However, his idealized vision of grand nineteenth-century murals, what he himself referred to as "decorative painting," seems to have gradually faded away after he actually went to Europe and began to study academic technique. Fujishima became a landscape and figure painter for whom the power of painting lay in gazing dispassionately at landscapes and people and transferring them to the canvas in a simple compositional framework.

In *The Black Fan*, although the subject is realistically depicted, the picture has little sense of volume and tends to be two-dimensional. This feature applies also to *Cypresses*. One of the characteristics of Fujishima's style is the pursuit of a taut sense of balance in coloring and perspective with emphasis on two-dimensionality. This characteristic can be seen perhaps in its first tentative manifestation in *The Black Fan*.

Hikaru Harada

130

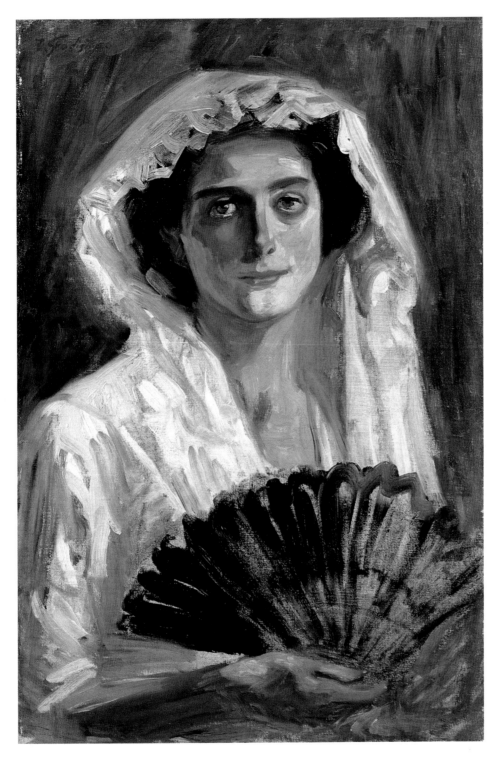

FUJISHIMA TAKEJI
The Black Fan 1908–1909

FUJISHIMA TAKEJI
Reverie 1913
Oil on canvas, 64 x 51 cm/25¼ x 20⅛ in
The National Museum of Modern Art, Tokyo

Fujishima had the following to say about this work:

> *For the first time since coming back to Japan I sub-*
> *mitted to the seventh* Bunten *exhibition a picture*
> *painted after my return. It was entitled* Reverie,
> *and was an attempt to represent a phantasmal frame*
> *of mind through the depiction of a young woman re-*
> *clining on a cushion, wearing an ancient Japanese*
> *embroidered costume. I gave the painting this title*
> *for no other reason than that I was attracted by the*
> *rapt expression of the model as she lay by the win-*
> *dow bathed in the gentle sunlight. As far as I re-*
> *member it was awarded third prize at the*
> *exhibition.*[1]

Fujishima returned to Japan in 1910 after four
years of overseas study. While he was out of the
country, the Ministry of Education Art Exhibition
(popularly referred to as the *Bunten*) had been insti-
tuted in 1907 and was receiving submissions from an
enormous number of artists. This was the first offi-
cially sponsored large scale exhibition to be held in
Japan and was created on the model of the *Salon
d'automne* held every year in Paris. Fujishima began
to submit works to the *Bunten* the year after return-
ing to Japan. These works were paintings either exe-
cuted during his stay in Europe or produced in Japan
on the basis of motifs gathered during his residence
overseas. *Reverie* was the first work in which, some
three years after his return to Japan, he at last began
to render motifs taken from his own immediate
environment.

A noticeable feature of this painting is its deliber-
ately two-dimensional surface. It is not the artist's in-
tention here to produce a realistic portrait, providing
a faithful depiction of its subject. The use of the
brush and of light and shade is not aimed at recreat-
ing the subject but is directed exclusively by compo-
sitional necessity. Fujishima is moving in this paint-
ing toward the omission of complex points of detail;
and although he does not divorce himself completely
from his subject, he is clearly attempting to use
brush strokes and coloring for direct expressive ef-
fect. The way in which the work is composed has
thus to a considerable extent been decided by the ar-
tist himself. During his years of overseas study, Fuji-
shima did his best to learn academic technique from
Fernand Cormon and Carolus-Duran, but what he

actually acquired in Europe was the ability to express
the autonomous beauty inherent in painting through
the free treatment of line and color as the will of the
artist dictates. In *Reverie*, Fujishima broke out of the
shackles imposed by his long experience as a painter
and embarked upon a new artistic experiment. This
is the cause of the apparent two-dimensionality of
this painting. However, Fujishima spent the ten
years after his return to Japan groping, struggling,
and occasionally losing his bearings in an attempt to
realize an art in painting conceived in two-dimen-
sional terms with a sense of visual autonomy. His
artistic experiments moved him away from the aca-
demic use of depth and volume for the purpose of
penetrating more deeply into his subject. As a result
of his experiments, he veered in a direction linked
with Japanese traditional painting and two-dimen-
sional painting of types which make bold use of line
and color. During these ten years of experimentation
after his return to Japan, Fujishima thus took on the
problem of how oil paint could be used to portray
Japanese nature and people.

Hikaru Harada

Notes:

1. *Bijutsu shinron*, vol. 5, no. 4, vol. 5, no. 5, April, May, 1930.

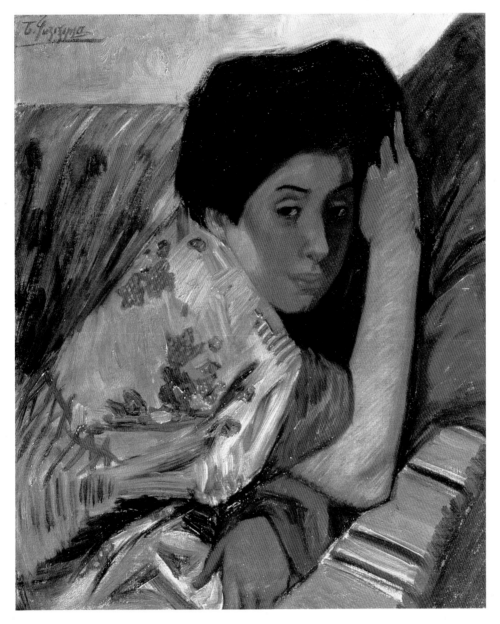

FUJISHIMA TAKEJI
Reverie 1913

FUJISHIMA TAKEJI
Sunrise over the Eastern Sea 1932
Oil on canvas, 65 x 91 cm/25⅝ x 35⅞ in
Bridgestone Museum of Art, Tokyo

Nineteen hundred twenty six was the year in which the Taishō period ended and the Shōwa period began, marking the ascension of a new Emperor. Fujishima was commissioned to do an oil painting celebrating the ascension as a decoration for the Emperor's living quarters. The theme which Fujishima conceived as being appropriate for this commission was the rising sun.

The rising sun is often used as a symbol of Japan. In search of a scene worthy of a painting on such a theme, Fujishima spent ten years after receiving the commission travelling the length and breadth of Japan to view the sea and mountains. He travelled out of the country to Taiwan, and even journeyed as far as Inner Mongolia. Painting continuously on his travels, the work which best realized his intentions portrays the sun rising at Dorn Nuur in Inner Mongolia, with a small camel moving through the vast expanse of the desert. That picture was painted in 1937. He also created many other landscapes during this period, when the style to which he had been aspiring came to greater maturity, now manifested to the fullest in these landscapes.

Sunrise over the Eastern Sea is a landscape from this period. It is said to have been painted in the course of the painter's travels through Japan's Inland Sea district, but the exact basis of its composition is not known. A small sailing vessel crosses the peaceful, becalmed sea at the break of day. The morning sun, just appearing from beneath the low horizon, scatters golden rays of light over the vast sky. The sea and the sky harmonize in a band of color, and the sense of boundless space changes into a vivid color symphony. It is not clear whether this is a realistic portrayal or a symbolic expression. Fujishima once stated as follows:

> I believe that the most important thing in the art of painting is simplicity. Complex scenes should be simplified. The first priority for an artist when deciding upon the layout of a painting is how to use his powers to simplify complexity, as if he were unravelling a twisted string.

Structural simplification is here carried out in a thorough manner. This simplification has been arrived at by a process of conceiving the picture in two dimensions and adopting a thoroughly two-dimensional approach to pictorial representation. As a result, the basic element in this picture is not its representation of external reality, but the intermingling harmonies of color. The picture achieves its identity almost exclusively through the use of color. This is the revolutionary element in Fujishima's artistic sensibility.

Speaking subjectively, this picture may also have another meaning. Green and orange, the two main colors used in the picture, have traditionally been favorites among the Japanese people and are considered to be the representative colors of Japan. Japanese people customarily feel a sense of religious awe at the rising of the sun out of the sea and from behind the mountains, the picture becomes pervaded with a sense of nationalistic romanticism and seems to portray a mythical spatial expanse. Although there is no evidence that such was Fujishima's deliberate intention when creating this picture, it is safe to say that the work makes a link with ancient tradition and with the Japanese sensibility nurtured within the bounds of tradition. The year 1932 belongs to an age when Japanese nationalism was on the rise within Japan, and this picture might well be considered as an expression of this nationalism in painting.

Sunrise over the Eastern Sea was exhibited at the New York World's Fair in 1939.

Hikaru Harada

Notes:

1. Iwasa Shin. "Fujishima Takeji," *Seikatsu bijutsu*, June 1943.

FUJISHIMA TAKEJI
Sunrise over the Eastern Sea 1932

FUJISHIMA TAKEJI
Surging Waves at Daio Point 1932
Oil on canvas, 73 x 100.3 cm/28¾ x 39½ in
Private collection, on deposit at Tokyo
 National Museum, Tokyo

Fujishima travelled the length and breadth of Japan in search of daybreak motifs. His visit in 1930 to Toba in Mie Prefecture was made for the same reason. Cape Daio is situated in this area, at the tip of the Shima peninsula looking out on the Pacific Ocean. This work was in fact painted two years after he first gained inspiration from his visit to the cape.

Standing on the tip of a rock at Cape Daio, Fujishima portrayed from a high vantage point the waves billowing beneath him. The artist is said to have viewed this scene just before the break of day, when a streak of purple cloud could be seen on the horizon. Above this in the picture is a gleaming golden cloud that heralds the sun which is about to emerge from beneath the horizon.

The artist's intention here is to create a simple and plain structure. The cliffs rising up in a "V" shape on both sides of the picture are the supports for the painting's composition. The section of the cliff on the right side is depicted in an abbreviated form through an approximate assemblage of colors, with the undulations of the rock being represented in a simple manner. A pine tree grows at the center of the cliff and a boat can be seen at the left tip of the horizon extending leftwards from this tree. The small images of the pine tree and the boat correspond one to another and serve as a consciously conceived accent in the pictorial composition. Two reefs can be observed in the sea, which seems to be engulfed in the "V" shape of the cliffs, and the depiction of the waves slamming with gushes of white spray against these reefs constitutes the focal point of the picture.

The depiction of the waves is in fact more a representation of a decorative pattern. All the compositional resources of *Surging Waves at Daio Point*, including the simplistic depiction of the rocks, are utilized in order to create a sensation of the slow rhythmic motion of the waves, whose unusual form suggests the stylized aesthetic of traditional Japanese art. The artist's brush flows smoothly as he paints these waves. The movement of the brush within the painting seems to have given the work a sense of slow movement and rhythm. The real waves of the Pacific as they roll in with mighty force are translated into the terms of a refined formalized aesthetic.

The essential point when painting the sea and waves is to remain aware of their tempo. Gazing at the sea, one notices water rising up ever so slowly over a wide flat expanse. This slow build up reaches its peak and all of a sudden the wave loses its equilibrium, striking against objects or buttressed by the wind. Its flat surface disintegrates to assume solid form. At a rapid tempo the wave becomes dynamic and breaks up. Sudden two-dimensional stillness changes into sudden three-dimensional dynamism. This is the rapid tempo of stillness and dynamism. Infinite pains are needed but infinite stimulation is also provided by the expression of such a phenomenon in terms of the visual arts.[1]

These are Fujishima's feelings expressed in connection with another of his works depicting the sea, but they apply just as well to *Surging Waves at Daio Point*. The artist senses the waves as movement, and attempts to translate this movement in pictorial terms. A representational approach to nature will never succeed in coming to terms with nature in movement; thus the artistic expedient which Fujishima employs in his attempt to visualize such movement involves leaving nimble, clear brush strokes within a plain, simple and quiet structure, thereby creating a gentle sense of rapture and providing movement in the composition of the painting as a whole.

A preliminary study for this work is in the collection of the Hiroshima Museum of Art. The composition is the same but there are differences in detail, indicating that strenuous effort was required before Fujishima was able to produce the definitive version.

Hikaru Harada

Notes:

 1. *Bijutsu shinron*, vol. 6, no. 8, August 1931.

136

FUJISHIMA TAKEJI
Surging Waves at Daio Point 1932

FUJITA TSUGUJI
Two Female Nudes 1930
Oil on canvas, 142 x 124.5 cm/55⅞ x 49 in
The Museum of Modern Art, Kamakura

Fujita returned to Japan in September 1929, seventeen years after he left to study painting in Paris. There, having developed a unique style of finely drawn lines of constant width on a milky white foundation, he had come to enjoy great popularity. Thus his homecoming to Japan was triumphant. A one-man exhibition held in Tokyo the month after his return drew so many spectators that the jostling crowd broke down a fence placed to protect the pictures.

Fujita's work was first introduced to the Japanese public in 1922, when he had already developed his hallmark style, the so-called *grand fond blanc*. It was not until 1929 that the works that would identify Fujita as "a painter of cats and nudes" were shown in Japan. The painter and critic Kimura Shōhachi, who saw the Fujitas on display expressed enormous admiration.

> *I give my heartfelt approval and respect to Fujita. I understand that oil paintings by Mr. Fujita are called not* tableaux *[paintings], in the manner of Matisse, but* dessins *[drawings]. Certainly when I think of Fujita's* My Studio, *or his* Self Portrait, *and of many of the other works on display in Tokyo at this time they do not appear to be* tableaux *at all. If* dessin *seems not to be an appropriate appellation, they nevertheless do represent a kind of style that is most effectively rendered in the Fujita manner.*

Kimura was convinced that "as long as they are seen as a certain kind of picture created in the artist's own personal mode, they surely excel all other works on display at this year's *Teiten* [the name for the national yearly exhibit referred to as *Bunten* until 1919]. They suggest a serene individuality," Kimura concluded, "that is impressive in its dignity, one that could not be perceived had the artist not worked out his techniques so thoroughly."[1]

Concerning the portrayal of nudes, the painter himself wrote:

> *One day it occurred to me that Japan has produced only a small number of nudes. I happened to realize that [the woodblock print artists] Harunobu and Utamaro only exposed part of a leg or knee in order to convey the real feel of skin. It was then that I decided to attempt to convey the real feeling of skin*

> *as my own beautiful* matière, *and so I turned again to the painting of nudes after an interval of eight years. . . . I began to reproduce the softness and smoothness of skin, inventing a canvas surface whose very texture has the appearance of skin.*[2]

This process led Fujita to the cultivation of his personal style, visible in *Two Female Nudes*.

One of the features of this style is the enclosure of a shallow space, often with walls or similar planar motifs. Cloth and skin are also often juxtaposed and combined. The touch of cloth is made to seem congenial to the skin, and the sight of the cloth stimulates the spectator's tactile response. Fujita had a continuing penchant for the subject of nude women, having painted a great number of female couples, clothed and unclothed, from his early years to the end of his life.

In *Two Female Nudes*, one figure, awake with her eyes open, balances herself by crossing her legs. The other, in contrast, possibly asleep and with her eyes closed, reveals her body and her limbs, innocent and self-indulgent. Fujita is said to have enjoyed the frolics of the artists he knew in Paris, yet he never took any alcohol and sequestered himself in his studio for several hours every day. He possessed a serious, ascetic side to his personality that represented quite another aspect of his life. Thus he was adroit in separating the exterior from the interior, the bright side from the dark. *Two Female Nudes* seems to hint at the day and the night of women.

Emiko Yamanashi

Notes:

1. Kimura Shōhachi, "Teiten," *Atelier*, November 1929, pp. 118-19.
2. Fujita Tsuguji, *Bura ippon* (Tokyo: Kōdansha, 1984), p. 115.

FUJITA TSUGUJI
Two Female Nudes 1930

FUJITA TSUGUJI
Llama and Four Women 1933
Watercolor on paper, 155 x 95 cm/61 x 37⅜ in
Mie Prefectural Art Museum, Tsu

The four people depicted in this scene are shown wearing the type of dress traditional to the area around Lake Titicaca in Bolivia. The trip during which Fujita met this group was an especially moving one that left a deep and lasting impression on the artist. In his book entitled *Swimming the Land*, Fujita included a section called "Observations of South America." There we find the following statement.

> *During my long years of living overseas, I might even say among all the unrepeatable experiences of my entire life, if someone were to ask me what lake I liked the best, I would say more than any other one I have ever seen I love Lake Titicaca on the border between Bolivia and Peru, in South America.*[1]

It was in August of 1932 that Fujita put the Bolivian capital of La Paz behind him and headed toward Peru, a trip that took him past Lake Titicaca. The view from the window of the train as it climbed into the Andes was described by Fujita in this way:

> *Dozens of hairy alpacas, llama, and other camel-like animals were scattered across the scene. Occasionally a man or woman could be seen sitting alone in the wilderness, their backs loaded down with heavy looking burdens, their heads protruding from the centers of serape cloaks colored in phenomenal shades of red and blue.*[2]

Fujita constantly tried to capture the hard work and good faith of the local people who lived in an area almost totally unaffected by modern industrial civilization. The artist saw these people as hemmed in by "a soft wave of grass that swayed over the less colored plateau—a single, unbroken plane from which not a single tree protruded." Ironically, these people were the heirs to the great empire of the Incas, and Fujita's visits to the ruins of that culture convinced him that the durability and power of Inca artifacts were above those of Egypt and India.

In *Llama and Four Women*, the artist captured the self-possessed composure, the spiritual qualities of a people that recalled the deep rooted permanence of Incan culture. Arranging the squatting figures in a semicircular form gives this work a strong impression of having been constructed in the studio, based on sketches made at the scene. The distinctive white background and line drawing, so characteristic of Fujita, are not present in his South American works, such as this one. Instead, richly colored planes are used to form images without the aid of outlines. In this particular work, Fujita displays a much more abundant use of color than was typical of his pieces during the previous decade. Nonetheless, there remains something of the painting style of his earlier period when he made use of line drawings and pale coloration.

Looking back over Fujita's painting career as a whole, it is clear that the mid-1930s formed one of his major turning points. Although this particular painting was not among them, twenty-seven other pieces, including works executed in Central and South America, were shown at a special Tokyo show in 1934, arranged to evaluate Fujita's suitability for inclusion in the exclusive *Nikakai* artists' group. A panel of critics discussing the entire exhibition made this comment on Fujita's paintings. "His recent works, as well as those painted from materials gathered together in Mexico, display such a sense of sadness and gloom that we find it impossible to relate to them with any intimacy." There was a feeling that, "this is an artist whose time has passed."[3] The fact that this opinion was held by some gives us an indication of Fujita's ambiguous reputation in Japan during the following years.

Emiko Yamanashi

Notes:

1. Fujita Tsuguji, *Chi-o oyogu* (Tokyo: Kōdansha, 1984), p. 177, reprinted from the original 1942 edition published by Shomotsu tenbōsha.
2. *Ibid.*, p. 148.
3. *Atelier*, October 1934, p. 19.

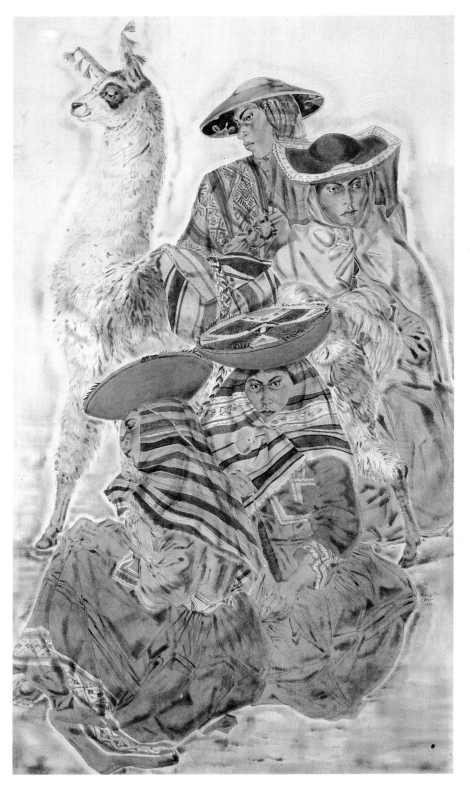

FUJITA TSUGUJI
Llama and Four Women 1933

FUJITA TSUGUJI
Madeleine in Mexico 1934
Oil on canvas, 90.8 x 72.8 cm/35¾ x 28⅝ in
The National Museum of Modern Art, Kyoto

—

Madeleine Lequeux, who posed for this painting, was a dancer at the Casino de Paris. Because of the blazing red color of her hair, she was often called "the female panther." At that time she was under the patronage of an American industrialist who was feared like a gangster in Montparnasse, but she escaped from him and ran off to South America with Fujita, taking with her the gold and diamonds which she had received from her American patron.

The pair stayed in Brazil for four months, then moved on to Argentina, Bolivia, and Peru. In November 1932 they arrived in Mexico, where they spent the next seven months. The following year, they took an indirect route back to Japan, passing through New Mexico, Arizona and other parts of the United States, to arrive in Tokyo during November 1933. Once there, Madeleine helped Fujita construct a Mexican-style studio, where they lived together. While the artist painted, Madeleine worked as a *chanson* singer and gained fame as an authentic French star direct from Paris. She later made one visit to her native land, came back to Japan and never saw France again before her sudden death at Fujita's home in 1936. She was known to have been dependent on alcohol and morphine. Still, she was charming, and it was said that despite her being selfish and so willful that she could never be controlled, her simplicity and naiveté were such that no one could dislike her. Fujita made many sketches and paintings of Madeleine, the majority of them nudes, which is not surprising since there is testimony to the fact that while at Fujita's house the woman virtually lived unclothed.[1]

Fujita was a prolific writer as well as a painter, publishing a number of essays including *One Arm, Swimming the Land* and *Parisian Days and Nights.* However, although he left a considerable number of writings about women, he always wrote in generalities, avoiding anything deeply personal. In reference to their departure from Europe for South America, Fujita sounded almost uninterested.

In 1931, the atmosphere in Europe had become oppressive for me and for some reason I had a great desire to brighten my spirits by inhaling to the fullest the free air of South America. So, on October 30th, I set sail from Cherbourg for Brazil on the English steamship Armanzola.[2]

Still, an artist does not speak in words only, for what he captures in his paintings can also testify for him. Fujita's sketches of Madeleine, dated and with their locale recorded on each of them, clearly tell a story of his travelling around South America with his companion.

The woman portrayed in Fujita's paintings does not impress us as carrying some great burden or suffering from complex human relationships. Her character, most clearly revealed by the way she moved, seems to have been brought to a standstill, hidden in the act of painting, arranged and ordered as a phenomenon existing only in color and form. Fujita always maintained a distance in his portrayals of his subjects, and it seems he did so even when painting Madeleine.

This piece was one of the twenty-seven paintings shown at the special exhibition held by the *Nikakai* in 1934.

Emiko Yamanashi

Notes:

1. Tanaka Jyo, *Foujita Tsuguharu,* (Tokyo: Shinchōsha, 1969). p. 169
2. Fujita Tsuguji, *Chi-o oyogu* (Tokyo: Kōdansha, 1984), p. 136.

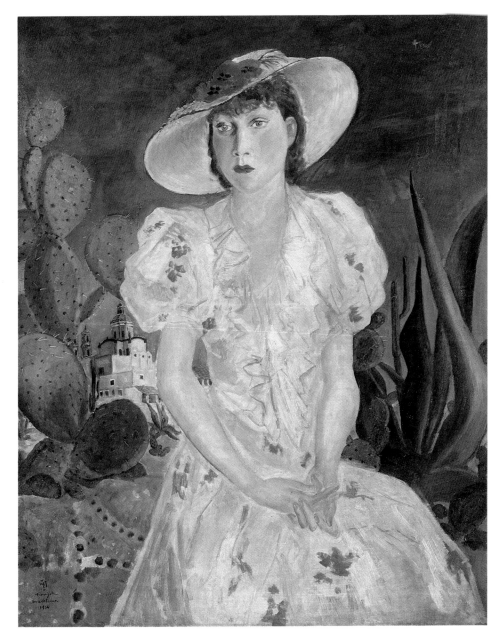

FUJITA TSUGUJI
Madeleine in Mexico 1934

FUJITA TSUGUJI
Chindon Performer and Serving Maid 1934
Watercolor on paper, 91 x 73 cm/35⅞ x 28¾ in
The Museum of Modern Art, Kamakura

This work is thought to be the painting with the same title shown in a special exhibition of the painter's work mounted in Tokyo in 1934. The painter's handwritten text "Tsuguji Fujita Tokyo Juillet 1934 Chindonya" can be found together with a square stamp reading "Fujita" above the left ankle of the maid.

Chindonya, or *chindon* performers, put on gaudy costumes and makeup and walked the streets banging gongs, drums and other instruments in order to advertise special events, shops, and so forth. The term *chindon* is derived from the sounds made by their instruments. Such forms of Japanese advertising have virtually disappeared with the advent of mass media, and of television in particular, but Fujita on his return from Europe was still able to see such groups, and he may well have been attracted to those who earned their livelihood with such rueful noisemaking. At his special exhibition, Fujita presented three works on this subject. The other two were entitled, *A Trio of Chindon Performers* and *A Student Band of Chindon Performers and a Girl*.

Critical response to these and similar works was by no means favorable. In a review in *Atelier*, October 1934, the author remarked that "Fujita is handling such realistic subjects as *chindonya* and fishmongers, but what he expresses is not realistic at all." The writer continued with the following comment:

> *Fujita's art is never realistic. His works in the present exhibition, particularly those dealing with Japanese customs, are his own* ukiyo-e *intended to create an effect akin to printing. He looks back with nostalgia at some old dream of Japan. All the subjects he has chosen—a* sumo *wrestler, a fishmonger's servant boy, a geisha on a back street— are purely Japanese, but he does not portray the major aspects of modern society. Such works may please foreigners but not his Japanese viewers.*

This kind of criticism is of interest as it reveals the distance on one side between a painter groping for direction in Paris, the base he has chosen for his activities, and, on the other side, the attitudes expressed in Western painting circles in Japan. One critic went so far as to say that "in the end, Fujita's art is exotic and nostalgic. These qualities represent the essential nature of his accomplishment." It may indeed be correct to characterize Fujita's style as "exotic and nostalgic," for he never did picture "the major aspects of modern society," no matter what country he visited. The paintings of the *chindon* performers were produced from the same viewpoint that produced portraits of his mistress in Tokyo or the laborers he found in South America.

The charges leveled against Fujita by the Tokyo critics were based on an examination of works created by a painter striving to be exotic in Paris through the use of elements of Japanese techniques who, back in Japan, applied the same techniques to old Japanese customs. His critics, however implicitly, disparaged the older traditions and favored a new, and Western, modernity. Thus Fujita's works, and their reception, help indicate what kinds of subjects and techniques were sought in Western-style painting in modern Japan, and suggest as well the difficulties of determining precisely what modernism in fact represented.

•

Emiko Yamanashi

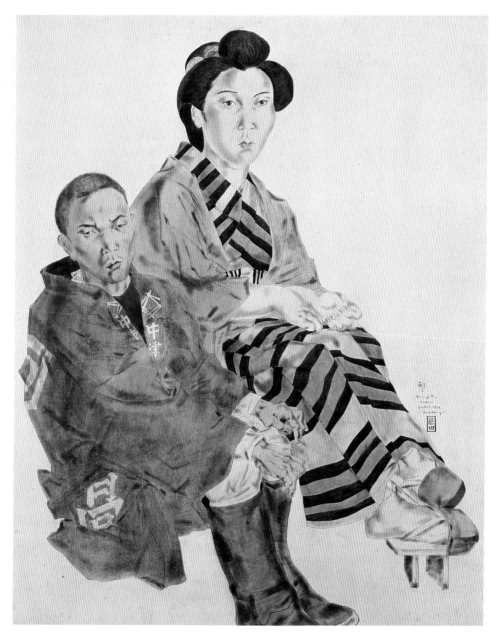

FUJITA TSUGUJI
Chindon Performer and Serving Maid 1934

KANAYAMA HEIZŌ
Place Pigalle in the Rain 1915
Oil on canvas, 60.1 x 72.1 cm/23⅝ x 28⅜ in
Hyogo Prefectural Museum of Modern Art, Kobe

During the middle of March 1915, Kanayama Heizō sojourned at the Marquis Hotel at 2 rue Duperré, Place Pigalle 13, in the ninth arrondissement of Paris. This work was completed during his stay at this establishment which faces directly onto the Place Pigalle.

Kanayama had been studying at the Western Painting Section of the Tokyo School of Fine Arts, but left in 1911. The following year he took what money he had and paid his way to France, returning to his own country in November 1915. We have his diary entry from the day of his arrival in the French capital—March 7th, 1912. Titling the entry "My First Twelve Hours in Paris," it is a precious document that conveys with life and energy what it was like to be a Japanese artist in Paris at that time:

> *I joined the ranks of artists eight years ago, and since that time my heart has never been far from the Luxembourg Museum . . . I rushed directly there . . . with two others. Because I had to keep up with them, I was unable to savor each step, but still I was able to see the Impressionist paintings hung in the Paintings Section. . . . The works were so different from what I had imagined. I wept tears of sheer joy. I was so happy that I couldn't stop.*

We have another impression of the Luxembourg Museum that was written down by novelist Shimazaki Tōson. Tōson's stay in France, from 1913 to 1916, nearly overlapped with the period that Kanayama spent there. He visited the Luxembourg perhaps one year after Kanayama and wrote the following about his experience:

> *By and by, I set foot into the room which is dedicated exclusively to the French Impressionists. I hardly had a moment to relax, so busy was I greeting the works that were hung on either side. For the first time I stood before Degas, in front of Renoir, and with Pissarro. Ah! Doesn't that one look like it's been influenced by the paintings of Spain or some place near there? Is that a Manet? Oh, up at the top of that wall! It looks like that picture called* The Sea *which I have become so familiar with through reproductions. So this is Monet! Thoughts like these made me feel the same sense of intimacy I would have had if I had been surrounded by a group*

> *of my oldest friends. And hanging at the very top of a high wall, the quiet scenery of Cézanne was also there.*[1]

Shimazaki Tōson associated with Kanayama while they were in France. In the same work, Tōson wrote these words about his artistic friend: "the traveler of travelers—Kanayama's sunburned face." It is a fact that Kanayama never took any particular painter as his master. Up to 1913, he spent most of his time away from Paris, journeying to every part of Europe. For this reason, landscapes comprise the overwhelming proportion of the works he produced on the Continent. Very few paintings deal with human subjects. The greater part of these landscapes are views of rural villages, or harbor towns on the sea. Thus, *Place Pigalle in the Rain* must be considered particularly exceptional in that it is a direct depiction of the city of Paris. Nevertheless, the viewer is struck by the the fact that, even in depicting a great city, Kanayama conveys almost nothing of the noisy bustle and uproar we normally associate with a metropolis. Rather, he spiritually communes with Pissarro in quiet and mutual contemplation. Thus we already see in this work some indications of the landscape specialist, a role that would become basic to Kanayama after his return to Japan. At home again in late 1915, he continued to utilize this masterful control of the oil medium to produce scenes of almost every area of his native land.

Tsutomu Mizusawa

Notes:

1. Shimazaki Tōson, *Étranger* (Tokyo: Shunyōdo, 1922).

146

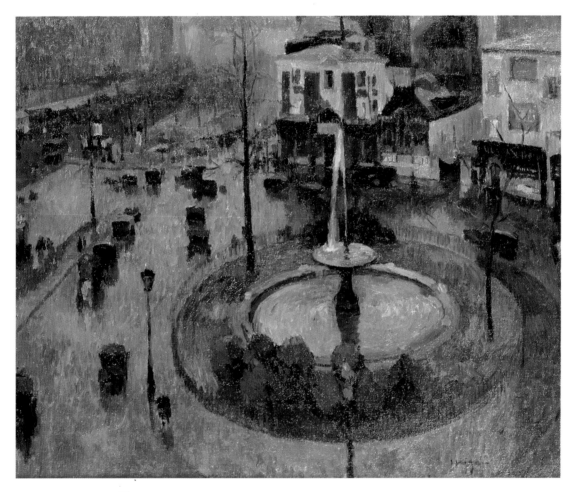

KANAYAMA HEIZŌ
Place Pigalle in the Rain 1915

KANOKOGI TAKESHIRŌ
Portrait of a Woman 1901–1903
Oil on canvas, 73 x 54 cm/28¾ x 21¼ in
Kyoto Institute of Technology, Kyoto

In order to study painting Kanokogi Takeshirō went to France three times in his life. On all of these occasions he was a student of Jean-Paul Laurens at the Académie Julian in Paris. He made the first journey to France via America together with MITSUTANI KUNISHIRŌ and others and studied in Paris from 1900 to 1904, under considerable financial hardship. His second visit, from 1906 to 1908, was sponsored by Baron Sumitomo and the third visit from 1915 to 1918 by Matsukaze Yoshisada, an entrepreneur in Kyoto. A year after returning from France in 1908, he succeeded ASAI CHŪ as president of the painting school that ASAI had established in the Kyoto/Osaka area. What Kanokogi learned abroad can be characterized as the typical French academicism. Kanokogi felt it his mission to instruct younger painters. He established ateliers called Academy Kanokogi in both Kyoto and Osaka in 1928. Comparing the guidance given at Kanokogi's studios with the kind of instruction provided by KURODA SEIKI, Professor of the Tokyo School of Fine Arts, it is interesting to note that, although he was outside the mainstream of the Western painting circles of the capital, Kanokogi's method was closer than KURODA's to the practice which was then being taught at the École des Beaux-Arts in Paris. Still, reading KURODA's diary and Kanokogi's reports on his overseas experience, it is clear that the two masters were aware of their mission to guide Japan's development of Western painting skills, techniques for which artists were still groping at the end of the Meiji period. Kanokogi's account of the organization, management, instruction and various examinations of Académie Julian at the beginning of the twentieth century is a valuable document. Giving warning in one of his reports, Kanokogi writes as follows:

I think what is most required of Japanese artists is the study of anatomy. Most Japanese painters studying in France have not attended any beneficial lectures of anatomy until now. A student who tried to attend one of these lectures is said to have been shocked by the strange odor and have fled away. This is lamentable. As I said before, nudes lie at the basis of European art. Those who take entrance examinations here must submit nudes, and those who seek to obtain a scholarship for study in Rome have to produce nudes in competition. It is anatomy that is essential for the completion of nudes. To study this science deeply, you must have such courage that you can dare kissing the dead. At that school, a teacher will treat a cadaver with the joyous face of a gardener who is caressing a beautiful flower. At first, nauseated by stinking corpses, we vomited once, but later we became accustomed to the smell in the dissection room and even felt it pleasant.

What I want to tell you most is that I think Japan's Western-style paintings are based on weak foundations. Do those who are presently called great masters of such painting in our country have the skill at sketching and knowledge of anatomy necessary for this development? Such are the requirements of French and other European painters. A few of us may perhaps have acquired them. But some of those who consider themselves to be such great masters are insisting that the knowledge of anatomy and the art of sketching are not worth much scrutiny. They say, "This color is bad, that must not be used," or criticize younger painters by discussing, say, their imagination or the dignity of their works. This is very dangerous. Paintings produced to conform with the fancies of these teachers are, as it were, houses built on unsolid ground. They look beautiful at a glance but do not endure long. If you say the style of these paintings threatens to dominate young artists, I will be very anxious about the future of Western painting of our country.[1]

This portrait of a woman was finished in Europe. Kanokogi's accurate sketching technique allowed him to grasp his object securely. The work testifies that the painter did, indeed, fully acquire the art of Western portrayal based on his study of anatomy.

Toru Arayashiki

Notes:

1. *Bijutsu shinpō*, September 1904, pp. 3–12.

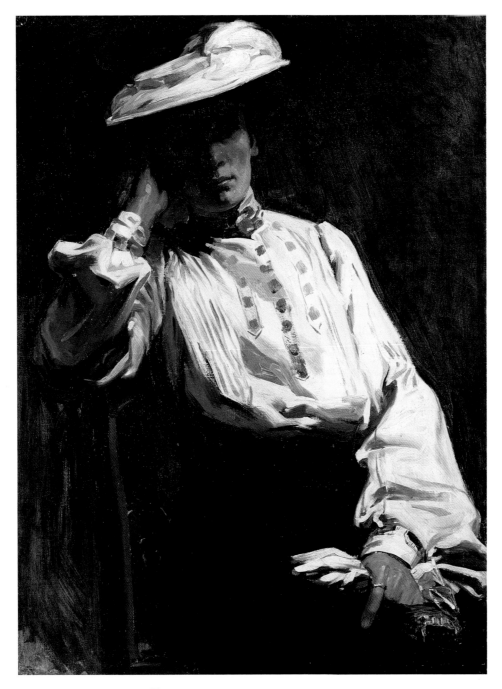

KANOKOGI TAKESHIRŌ
Portrait of a Woman 1901–1903

KANOKOGI TAKESHIRŌ
A Torrent of the Yamato Yoshino River 1933
Oil on canvas, 89.4 x 130.3 cm/35¼ x 51¼ in
Mie Prefectural Art Museum, Tsu

In 1904, shortly after returning from France, Kanokogi Takeshirō read a report on his overseas experience at a meeting which was held in Tokyo by a Western painting society to which he belonged. In this report he mostly gave his impressions of cities he had visited in Europe. The summary of the report which appeared in the art journal *Bijutsu shinpō* provides an important clue to Kanokogi's achievements after his return from abroad. In particular, Italian cities such as Milan, Venice, Florence and Rome seem to have been implanted in his memory. He delivered his impressions of these cities and expressed his opinion on the kinds of stylistic beauty common to pictures which could be seen in European museums. For example, after giving his view on the Old Masters of the Venetian School, he says, ". . . here I would like to direct your attention to the fact that Venice is a land abundant in blends of colors. The heroes of painting begotten by this land have succeeded in the art of coloration."[1] He describes in concrete detail the schools of painting which arose in those Italian cities from the Renaissance to the Baroque period, ascribing their successes to the following reasons. "I have aimed to verify the fact that the character of each school is congruent with the tastes of a land which generated the painters belonging to it. In other words, I want to say that these painters worked in accordance with the energy of nature."[2] Meanwhile, Kanokogi criticized Japanese painters, saying:

When I saw your pictures, my first reaction was a suspicion that you had painted something going against the energy of nature. . . . Some people in the art schools are using purple profusely. Perhaps they are following the French Impressionists, but if you think their manner is the latest international style, you will make a great mistake. Impressionism, which was created in France, did not come from any desire to amaze the spectator by the lavish use of purple. In France, because of its climate, all things sometimes take on a purple tinge. The Impressionists wanted to reproduce this natural color and never went so far as to ignore the energy of nature. In this regard, Monet was the most outstanding, but the painters who appeared after Monet mostly imitated nothing but his style and did not inherit his spirit.[3]

Indeed, the painters of the White Horse Society, an art society centering around KURODA SEIKI who had returned from France in 1893, were painting many pictures on the basis of such purple tones. Kanokogi reproved them severely for this simplistic imitation of Impressionism. What Kanokogi learned above all in France was Western realism. He insisted that inasmuch as it was Japanese who held paint brushes, their works, whether portraits or landscapes, should be finished in a Japanese style.

To produce oil paintings is not to mimic Westerners. We only intend to produce true pictures with Westerners' tools. Nonetheless if our works are praised on account of Western-style composition and coloration, our future will be really hopeless. This is what I mean by 'going against the energy of nature.' The air, trees, buildings and the balance of these things are entirely different in Japan and in the West. If we were going to picture Japanese subject matter in Western style, how could we comply with the energy of nature? . . . We Japanese have to produce pictures which can inevitably show the unique characteristics of our nationality anywhere in the world.[4]

Kanokogi created some pictures using Japanese history for subject matter. Those attempts may or may not be successful, dealing as they do with myths, legends and historical events. In landscape painting, he pictured a number of scenic spots in Japan. Most of these landscapes, as is visible in *A Torrent of the Yamato Yoshino River*, utilize the techniques of realism that he acquired in Europe. We can notice in particular that his ability is fully demonstrated in the linear expression of trees and rocks that he adopted.

Tōru Arayashiki

Notes:

1–4. All citations taken from Kanokogi lecture reproduced in *Bijutsu shinpō*, June 1904.

150

KANOKOGI TAKESHIRŌ
A Torrent of the Yamato Yoshino River 1933

KISHIDA RYŪSEI
Portrait of Bernard Leach 1913
Oil on canvas, 61.5 x 46 cm/25¼ x 18⅛ in
The National Museum of Modern Art, Tokyo

This portrait was first exhibited with the title *Portrait of B.L.: I*, in October 1913, soon after the disbandment of the *Fusainkai*. The major turning point in Kishida's artistic life began when he first encountered Post-Impressionist art in 1912, and as he befriended Mushanokōji Saneatsu (1885–1976) and others at the literary magazine *Shirakaba*. It was his "second birth" as he called it, and he was profoundly moved by these experiences. He later wrote:

It was an extremely emotional period in my life. I would look at the paintings and I would be gasping with excitement. I was so overwrought there would be tears in my eyes. My paintings then, were not merely influenced by the Post-Impressionists, they were more like copies. I would unabashedly paint in the manner of van Gogh.[1]

However, by the end of the second *Fusainkai* exhibition, Kishida was beginning to abandon his Post-Impressionist influences. During this period, around 1913, the artist was gradually outgrowing the superficially imitative and grossly subjective in his means of expression, and was seeking a "fusion with Nature." While keeping his Post-Impressionist perspective, Kishida was trying to return to simpler sketching methods. As Kishida struggled to change, his most important motifs were self portraits and portraits. His obsession for using the human face for a subject is thought to confirm his own existence as he vacillated between moods of self-assertion and loneliness. He writes of these feelings in a letter to his friend the painter Kimura Shōhachi:

The reason why I often find the most powerful attraction, before all else, to the human face is that I yearn for others—live human beings—in my life. Through love, I have learned to savor the depth of the human heart. Through the love I feel, I believe I am becoming more and more a live human being. This feeling does not consciously drive me to paint human faces. Yet, there is no gap between my spirit that yearns for human beings, and my want and interest in painting human beings. Painting portraits is a natural thing for me right now.[2]

As he continued to paint portraits, Kishida eventually left behind him the primary colors of the Post-Impressionists and the bold strokes suggesting his own subjective expression. In their place, he gradually developed his detailed Realist style, using a brown palette. *Portrait of Bernard Leach* is a product of this transitional period.

The model for this portrait, Bernard Leach (1887–1979), was a famous British ceramicist. He was born in Hong Kong and after spending his childhood in Japan, he studied in England at the Slade Art School and the London Art School. In 1909, he returned to Japan and remained there until 1920. He studied ceramic art under Ogata Kenzan VI, and befriended fellow artists Tomimoto Kenkichi (1886–1963) and Hamada Shōji (1894–1978), as well as the writers of *Shirakaba* magazine. Returning to England in 1920 he continued his work as a ceramicist in St. Ives. Kishida first met Leach in November 1911 at an art exhibition sponsored by the *Shirakaba* group. Thereafter, their friendship developed. The Japanese painter visited Leach's studio to help paint ceramic ware, while Leach taught Kishida etching techniques. In the April 11, 1913 entry for his diary, Kishida wrote, "I promised Leach I would paint a large portrait of him. Leach said he would try etching my portrait."[3] The date on the portrait is probably accurate. Yet, as Kishida remembers it, "I painted two oil portraits sometime around 1913. One, I've painted over, and the other I've kept. It isn't a very good resemblance but it serves as a good memento for myself."[4]

Atsushi Tanaka

Notes:

1. Kishida Ryūsei, "Omoide," *Shirakaba*, vol. 10, #4, reprinted in *Kishida Ryūsei zenshū* (Tokyo: Iwanami shoten, 1979–80), vol. 2.
2. Kimura Shōhachi, "Sōdosha," *Bijutsu*, vol. 3, reprinted in *Kishida Ryūsei zenshū*, vol. 1.
3. Kishida Ryūsei, "Nikki," *Kishida Ryūsei zenshū*, vol. 5.
4. _____, article on Bernard Leach, *Shirakaba*, reprinted in *Kishida Ryūsei zenshū*, vol. 2.

KISHIDA RYŪSEI
Portrait of Bernard Leach 1913

KISHIDA RYŪSEI
Self Portrait 1914
Oil on canvas, 44.5 x 37.2 cm/17½ x 14⅝ in
Fukushima Prefectural Museum of Art, Fukushima

Kishida contributed eight pieces to the exhibition held in November 1913 by former members of the *Fusainkai* group. Kishida felt there was a gap between his style and those of the rest of the group. Soon after, he wrote:

These days I am beginning to feel more and more strongly that I am not what is called a Contemporary Man. And I am realizing increasingly that I have graduated from the seductions of the so-called Contemporary. The thought has been trying for me. I was very much confused until I finally found my solitary path. I have not been confused in such a way as to waver from my basic desires, but I was confused as to which path I ought to take. Now I take it for granted that this was inevitable. But I have always seen Nature in my basic desire. I believe that this was the only reason why I was able to grow to what I am now.[1]

Thus Kishida believed that the best thing to do was to follow his instincts and portray nature as accurately as he could. For Kishida, the "Contemporary" was represented by the Post-Impressionists, and from them, he learned to liberate his senses and to assert himself in his own expression. However, while contemporary European art left behind Post-Impressionism in the pursuit of the equally formal style of Fauvism, Kishida sought his own path in Realism. If contemporary art was an expression that sought the total liberation and freedom of the individual, then the direction that Kishida took in Realism suggested a control over the expansion of the Self, a movement then opposed to the currents of contemporary art. Yet, at the same time, as Kishida rooted himself in his "instinctual nature"—his spirit, senses and his natural temperament—in order to discern his subject through his own eyes, he too manifested a contemporary attitude towards art.

The next year, in March 1914, Kishida and his wife moved to Yoyogi on the outskirts of Tokyo. The following two years, in what is now known as his Yoyogi Period, became an important phase in Kishida's artistic career. There he worked energetically, gradually perfecting his distinctive style of Realism. In fact, he held three solo exhibits that year, in March, October and November. *Self Portrait* of 1914 was displayed at his October exhibit. Appraising this exhibit, the artist Ishii Hakutei (1882–1958) pointed out that it represented a "restart" rather than "progress" for Kishida. Yet Ishii found an interesting tendency in the six self portraits included:

From the beginning, Kishida has been a self portrait artist. I wonder how many self portraits he has painted thus far? It has most likely reached some astonishing number by now. . . . Rembrandt is also known to have left a large number of self portraits, but in his case, he had changed poses and costumes on each of them. I found it strange that there was little difference in the pose, size, color, or facial expression of a number of Kishida's bust self portraits exhibited this fall. And I also found it strange that these portraits looked much older and sterner than Kishida himself, as though he were already an old man. . . . It may be said that Kishida's self portraits are more serious than the paintings of any other contemporary Japanese artist. His self portraits throw a sense of bitterness at those that wallow in the pleasures of mere painted art.[3]

Ishii compared Kishida with Rembrandt. Kishida's Realist works from this period, including this self portrait, are painted in emulation of the Old Masters. Kishida had learned much from classical European art. As he later wrote, "I was first influenced by Rembrandt, Rubens, Goya and the like, then I was influenced by Dürer, Mantegna and van Eyck. I admired Dürer most of all."[4] In explaining why Kishida had turned towards the European Old Masters as examples for his Realism, it must be noted that all the while he had within himself an impulse towards religious fulfillment, a strong will to seek a complete world within himself. Thus it was only natural that he was drawn most to the religiously oriented art of Dürer and other Old Masters.

Atsushi Tanaka

Notes:

1. Kishida Ryūsei, "Fusainkaiten," *Yomiuri shinbun*, December, 1913.
2. *Ibid.*
3. Ishii Hakutei, "Kimura, Kishida," *Takujō*, vol. 5, Dec. 1914.
4. Kishida Ryūsei, "Jibun no funde kita michi," *Kishida Ryūsei zenshū* (Tokyo: Iwanami shoten, 1979–80), vol. 2.

KISHIDA RYŪSEI
Self Portrait 1914

KISHIDA RYŪSEI
Reiko with a Woolen Shawl 1920
Oil on canvas, 45.5 x 38 cm/18 x 15 in
Fujii Gallery, Tokyo

The model for this portrait is Kishida's seven-year-old daughter Reiko. The earliest of Kishida's many Reiko portraits, *Reiko at the Age of Five* (The Museum of Modern Art, Tokyo) was painted in 1918. In his later years, the painter wrote how the series of Reiko portraits he had produced over the years held a greater significance in his artistic development than that of other, ordinary portraits. The Reiko portraits had provided Kishida the opportunity to move away from "material beauty" towards a "spiritual beauty." As Kishida explained it in another way, these changes represented his moves away from the "Classicist influences" of Dürer and other Northern Renaissance artists towards finding his "inner beauty" as spiritual fulfillment in his own type of Realism. The Reiko of these portraits is seen both through the loving eyes of a father as well as through the detached eyes of an artist seeking profound beauty within the untainted life force. Just as he had produced a large number of self portraits between 1913 and 1914, Kishida sustained until around 1924 a series of Reiko portraits in oil and produced numerous sketches and watercolors of his daughter. Furthermore, it should be noted that during the period in which he produced the vast number of Reiko pieces, he also painted many portraits of Reiko's playmate, Omatsu. It is clear that Kishida more or less saw this girl with the same kind of emotions and with the same regard he had for Reiko.

On the back of the piece shown here is the date, "10 November 1920" and a note indicating that it took eighteen days to finish. A compositional sketch also accompanies this portrait. We may retrace these eighteen days from Kishida's diary. On October 15, 1920, he wrote, "I started a new oil portrait of Reiko around 11 o'clock. It has been so long since I last painted an oil that my heart is dancing. I cut some new canvas and fastened it to a frame."[1] Except for a week-long intermission, he painted daily. But around the 27th, Reiko became ill with a cold and Kishida had to make a few adjustments in order to continue his work, as he explained in the following passage:

She is catching a cold and she might have a fever, so I had her stop modeling and let her go to bed. It seems that there is nothing serious, but all the same—just in case. I have rolled up a mattress, put Reiko's clothes on it, and draped a shawl over it. I place that on the modeling platform. This works well. The dummy doesn't move and doesn't have to take any breaks. I think I will finish the shawl with this model.[2]

The detailed rendering of the shawl was finished by the 31st, and Reiko, now recovered, was brought back to the platform. That day he wrote, "I've finished the shawl, so I called Reiko. I put the dummy Reiko away and draped the real Reiko with the shawl. I painted a little bit of the kimono. Tomorrow I can start once again on the face and other features."[3] Finally on November 10, the portrait was completed, and in his diary, he wrote of his satisfactions and discontents:

I started working on Reiko's portrait after breakfast. I intended to finish it today by all means. I think it is practically finished, but the face isn't sufficiently good enough. Lack of sleep troubles me. . . . Around four o'clock, I finished Reiko. I think I will put my brush away now. It took me eighteen days this time. That is pretty fast. I think this is the best portrait that I have painted. But there is more to be asked. I thought I would be able to bring out a more lively flavor to it, and that is a bit regretful. I'll make up for it with the next one.[4]

Atsushi Tanaka

Notes:

1–4. Kishida Ryūsei "Nikki," *Kishida Ryūsei zenshū,* vol. 5.

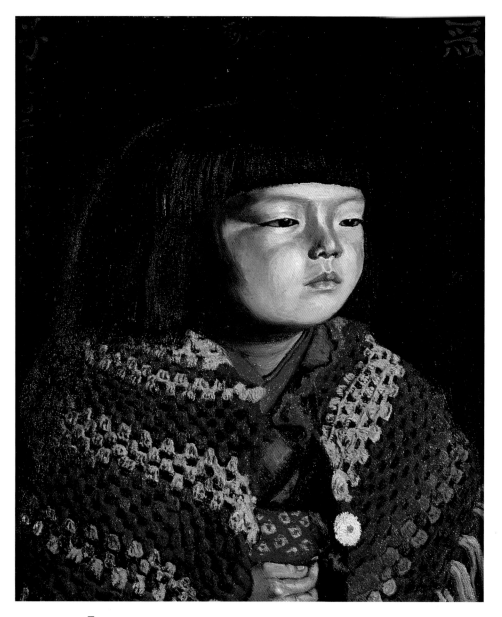

KISHIDA RYŪSEI
Reiko with a Woolen Shawl 1920

KISHIDA RYŪSEI
Still Life (Three Red Apples, Cup, Can, Spoon)
1920
Oil on canvas, 36.5 x 44 cm/14⅜ x 17⅜ in
Ohara Museum of Art, Kurashiki

Early in Kishida's career still lifes did not represent a very important motif. The artist felt that he could not "put as much energy into them as with portraits and landscapes." He reasoned that this was because he saw still lifes as something he painted "only when it was raining, as work to be done in diversion." However, one day, around 1916, he began a painting using an urn for its motif. He wrote, "I gradually began to get the hang of it as I went along. When I was done, I was content with myself, having gained the confidence that I, too, could paint still lifes."

Besides the confidence that he gained from painting that urn, there was another reason that drove Kishida to paint still lifes during this period. That summer, Kishida was diagnosed as having tuberculosis and had to move to the pastoral Komazawa Village on the outskirts of Tokyo in order to recuperate. As his health improved, in February 1916, he moved on to Kugenuma in Kanagawa Prefecture. Thus, during this period, he was unable to paint outdoors, and since still lifes could be painted indoors, such subjects naturally became Kishida's primary concern. And as still lifes brought about a major turning point in the development of Kishida's style of realism, they remained important for the rest of his career. In reference to a still life featuring two apples (painted in 1915; now lost), calling it "the first artistic still life fruit that I painted," Kishida wrote:

I came to a turning point as I painted this piece. I was able to tread one step farther ahead as a Realist. I was confident that I had succeeded in bringing out even more clearly a sense of inner beauty. I felt that I was that much closer to the supreme beauty within me. At that moment, I knew that I was able to be myself even more. I knew that the two apples, the mystical in the concrete, sitting still before me, were at the same time sad, strong, and profound. There was a poem behind this painting. It sang of the destiny of two children sitting on the beach. There, clearly for the first time, I saw this sort of beauty.[1]

As this passage indicates, Kishida had stepped beyond the realm of mere detailed realism. By superimposing the image of "two children sitting on the beach" over that of the two apples, Kishida learned to imbue his art with symbolic significance. In what Kishida calls a pursuit of his own "inner beauty" or

as the "mystical in the concrete," and in a state of mind similar to that of a solemn prayer, he tried to project the depth of his emotions into his art. He did so by creating within his realist expressions a communion, rather than a confrontation, between himself and the subject. He had already experienced this sort of aesthetic revelation and deepening of emotions in his portraits and landscapes; now, significantly, he felt them strongly in his still lifes.

Still Life, shown here, has been acclaimed as a masterpiece of refinement. Kishida's diary reveals the detailed developmental process through which this work was completed. The work was first mentioned in his entry for December 12, 1919 at about the time when he acquired a print of Jan van Eyck's *Giovanni Arnolfini and His Wife* (1434):

It is a portrait of a Dutch merchant and his wife, and features a round mirror. It has a profound grandeur, refinement and beauty. Every day I get new stimulation from this painting. It stimulates my creative urge. I have put it in a temporary frame, and have it hung above the organ. Its beauty is truly enchanting and refined. What I seek now is the kind of beauty of light red and the profound simplicity of the ancient Egyptian murals (I have in mind the picture of the woman at the grinding stone). . . .

I am now at work on a still life similar to the one I finished recently. I started it yesterday. It is a deep-toned piece with colors that include a sober-toned vermilion, all crimson and silver. I have in mind a sober toned and warm beauty; a quiet and uncomplicated simplicity; a flavor of the mystical. What I seek is the sense of simple mysticism that is only present in primitive or primal (or ethnic) art.[2]

Atsushi Tanaka

Notes:

1. Kishida Ryūsei, "Jibun no funde kita michi," *Kishida Ryūsei zenshū* (Tokyo: Iwanami shoten, 1979–80), vol. 2.
2. ———, "Nikki," *Kishida Ryūsei zenshū*, vol. 5.

158

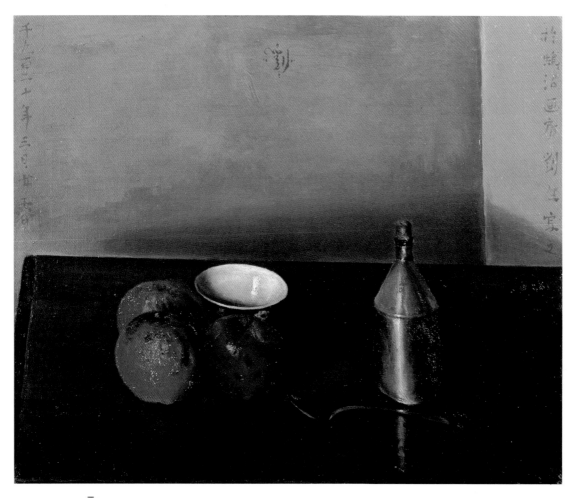

KISHIDA RYŪSEI
Still Life (Three Red Apples, Cup, Can, Spoon) 1920

KISHIDA RYŪSEI
Country Girl 1922
Oil on canvas, 64 x 52 cm/25¼ x 20½ in
Private collection, on deposit at The Museum
 of Modern Art, Kamakura

Looking at this painting, one finds something greatly different from any previous work by the artist. Up to this point Kishida had unswervingly pursued a style of Realism in which he sought a profound spirituality. Yet here, in a style he termed "Realist Mysticism," a surreal quality permeates, creating an impression that borders on the grotesque. This signifies that Kishida's aesthetics had begun moving in a direction away from Realism, towards something quite different. As though to announce this change of course, Kishida noted on the lower left corner of the picture, "Learning from the Han-Shan Painting of Yen Hui." In his diary, Kishida indicated in greater detail the process through which this piece was conceived and completed. In the March 23, 1922 entry he wrote:

About the motif that has been on my mind for the last few days, the one that the grotesque quality of Yen Hui's painting inspired in me. Yesterday, I was looking at it with [the novelist] Nagayo Yoshirō [1888–1961], and others. We talked about it and the idea kept growing, and I finally started feeling that I'd rather do this after all. There was a perfect size canvas available so I offered to start on it immediately. I brought a photographic plate of Yen Hui's painting to my side, and I started drawing, half copying the composition.[1]

Yen Hui, whose ink painting inspired Kishida, was a painter of late Sung Dynasty and early Yuan Dynasty China (latter 13th century), who painted Buddhist and Taoist art in an expressionistic style characterized by psychological distortions and extreme variations of fine lines and thick strokes. Han-Shan and Shin-Te, the subjects depicted in Yen Hui's painting, were two hermits who are said to have lived around the end of the T'ang Dynasty. Used as motifs in countless Chinese and Japanese Zen Buddhist paintings, they are customarily portrayed with tattered rags and long unruly hair. Yen Hui's celebrated painting of the two ascetics is now at the Tokyo National Museum.

As is obvious from considering the Chinese masterpiece that inspired this piece, Kishida was moving away from classical European art towards Eastern art. The turn apparently occurred between 1919 and 1920. During this period Kishida made three trips to the Kansai area, encountering the ancient art of Kyoto and Nara. The influence of his friend Bernard Leach, who had just returned from China, was also instrumental. Kishida wrote:

Leach, having just come back from China, brought home a lot of stories to tell. I'd like to note that this also has been instrumental in arousing my own interest in Oriental aesthetics. Leach loved the East. Just as we Japanese have adored the West, he appreciates the East with an intimate sensibility.[2]

When *Country Girl* was first exhibited in 1922, Kishida wrote an article expressing his current aesthetics and tastes:

I find a path in front of me that I would not have been able to set foot on if it were not for Realism. This is neither the path of Goya, nor the path of Delacroix. This is my path. Standing there, I see Goya, I see ancient China. I see ukiyo-e. And what there is to be learned, I shall learn, and what there is to be emulated, I shall emulate; these will make my path all that much more sophisticated. These days, I feel myself drawn even more towards the art of ancient China . . . and I am drawn to ukiyo-e, especially to the sense of line developed by Matabei the First. There is a robust sort of mystique to it which attracts me. Furthermore, these days, I see and appreciate a lot of Japanese classical theater. In my fervor, my trips to the theater have become extremely frequent. The savor of artistic gravity, the various sophistications, a sort of Oriental grotesque, the sort of beauty that the color red conjures; so much has been valuable in the development of my new aesthetics.[3]

Atsushi Tanaka

Notes:

1. Kishida Ryūsei, "Nikki," *Kishida Ryūsei zenshū* (Tokyo: Iwanami Shoten, 1979–80), vol. 7.
2. _____, article on Bernard Leach, *Shirakaba*, reprinted in *Kishida Ryūsei zenshū*, vol. 2.
3. _____, *Shirakaba* May 1922, reprinted in *Kishida Ryūsei zenshū*, vol. 3.

160

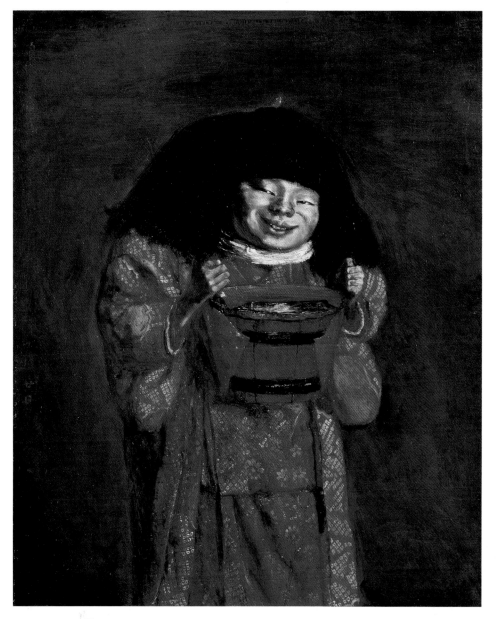

KISHIDA RYŪSEI
Country Girl 1922

KISHIDA RYŪSEI
Portrait of Dr. Kondō 1925
Oil on canvas, 44.5 x 36.5 cm/17½ x 14⅜ in
The Museum of Modern Art, Kamakura

In the great Tokyo earthquake of September 1, 1923, half of Kishida's home was destroyed. He and his family left Kugenuma, where they had made a comfortable home since 1917, and moved to Kyoto. In what is known as his Kyoto Period, which lasted until February 1926, Kishida led a somewhat decadent life. It was not a very productive period.

From the latter part of his Kugenuma Period, Kishida was being rapidly drawn towards the attraction of Oriental beauty. Now financially well off, he began collecting antique artwork, especially Sung Dynasty Chinese art and early hand-painted *ukiyo-e*. He frequented the theater, and began drinking, which he had rarely done before. Calling himself the "Kaitai Sensei" (Master Buymore), he would buy whatever antique art pieces he wanted, even if he had no idea how he could afford them. Artistically, he made bold attempts at using oil as a medium for creating Oriental expressions. More often, freeing himself from the limitations of the Western medium, he worked to create Japanese-style paintings. In fact, Kishida left only a handful of oil paintings during this period, including a number of "Reiko" pieces and vegetable still lifes. Otherwise, there are only a few portraits commissioned by private patrons, of which this is one.

The model for this portrait, Kondō Tsugushige (1865–1944), was the father of a member of the *Shirakaba* group, Kondō Kei'ichi (1897–unknown), and a professor of surgery at the Tokyo University's Medical Department. This was actually the second portrait Kishida painted of Dr. Kondō; the first was lost in the earthquake. Hearing that the original piece had been lost, Kishida, who was then at his Kyoto residence, set out to paint a new portrait, travelling to Tokyo for that purpose. He finished the piece on March 20th.

Kishida's taste as a collector and admirer of hand-painted *ukiyo-e* seems to permeate the portrait. The expression on the model's face is rawly exaggerated; the proportion of the head is much larger than the rest of the body, while the hands are drawn smaller in contrast.

The year after he finished this portrait, Kishida wrote a book on early hand-painted *ukiyo-e*, which he termed his "record of appreciation." In the introduction, he summarizes the nature of its beauty in sensitive and touching words,

> *I wonder how long I have been entranced by early hand-painted* ukiyo-e *art. Perhaps it has been six, seven or eight years now. Naturally at first, I was just gazing at the work of Iwasa Matabei without much thought. But then, I began to notice how the strangely raw flesh looks on the faces of both the males and females. There is a primitive sort of beauty to it, a mystic attitude that seems to capture the deeply realistic. There is even an eerie feeling to the bland, characteristically Oriental faces. It has the flavor of what I would call a* derori *[meaning slurping, drooling] beauty.*[1]

Using an adjective *derori* that he coined himself, Kishida describes the nature of hand-painted *ukiyo-e* art with his artist's perceptiveness. And, the word *derori* seems to be a fitting adjective for this portrait. Kishida has the model hold a flower. But this is not the same flower that he portrayed his young daughter Reiko with, in a prayer to the innocent and untainted life force. Rather, it is intended to provide a humorous contrast to the harshness of the model's exaggerated features. The portrait might even be viewed as a caricature of the stern doctor.

Apparently Kishida had also learned the use of such witticism from *ukiyo-e* art. One finds such playfulness in this portrait. Or rather, it might be that Kishida saw himself as an *ukiyo-e* artist as he painted this piece. In any case, this portrait demonstrates the expressive techniques and aesthetics of *ukiyo-e* art as they were absorbed by Kishida.

Atsushi Tanaka

Notes:

 1. Kishida Ryūsei, *Zenshū*, vol. 4.

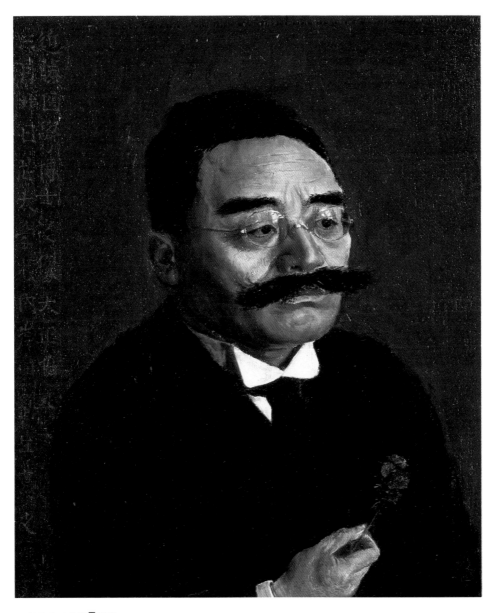

KISHIDA RYŪSEI
Portrait of Dr. Kondō 1925

KOIDE NARASHIGE
Portrait of Mrs. N 1918
Oil on canvas, 91 x 80.2 cm/35⅞ x 31⅝ in
Aichi Art Gallery, Nagoya

Koide painted the *Portrait of Mrs. N* in 1918 at the age of thirty-one, three years after he graduated from the Tokyo School of Fine Arts. He had returned to Osaka, his home town, and had married. Koide's works were repeatedly rejected at the government-sponsored *Bunten* exhibition and, deprived of recognition as a painter, he struggled to develop his skills. He first achieved success at the age of thirty-two in 1919 when he won an award for *The Family of N* at an exhibition sponsored by the *Nikakai*, a private art organization willing to exhibit works by young painters. Thus it was relatively late in his life that he gained public recognition.

"Mrs. N" was Koide's wife, whom he married in Osaka in 1917. His works, from this portrait to *The Family of N*, a group portrait of his family, faithfully reflect his personal life.

The *Portrait of Mrs. N* is characterized by an elaborate realism produced through Koide's effort to fix the image of the object by gazing at it and slowly reproducing what he saw with his brush. In this case, Koide's realism can be said to represent his adhesion to the object by means of such intensive visual study of his wife. The background being closed with a heavy curtain, the small space portrayed in the painting is filled with the figure of his wife, almost uncomfortably so. Because of the dimensional compression, the light streaming obliquely from the right creates no spatial effect. Dense oppressive air seems to remain stagnated in space. The naive, reproductive realism employed by Koide was not pursued by him as an explicit principle of painting. This made the artistic aims of the picture somewhat vague. In that sense, the portrait might be seen as an early work from his formative period.

In *The Family of N* (see McCallum, Fig. 55), Koide's wife is depicted as a trustworthy, thoughtful person in a very individual manner. She is also portrayed as possessing the character of a typical Japanese housewife of the period. Its composition, beautifully calculated, is extremely "Japanesque" in its motif, as it deals with a family of the middle class of Taishō-era Japan. Thereafter, Koide continued to work with scenes of contemporary Japanese life.

The Family of N was produced in 1919, the year after the *Portrait of Mrs. N.* Although that interval was a short one, the later picture was created with the consciousness and skill of a painter expanding his vision of the nature of his subjects by careful observation.

Hikaru Harada

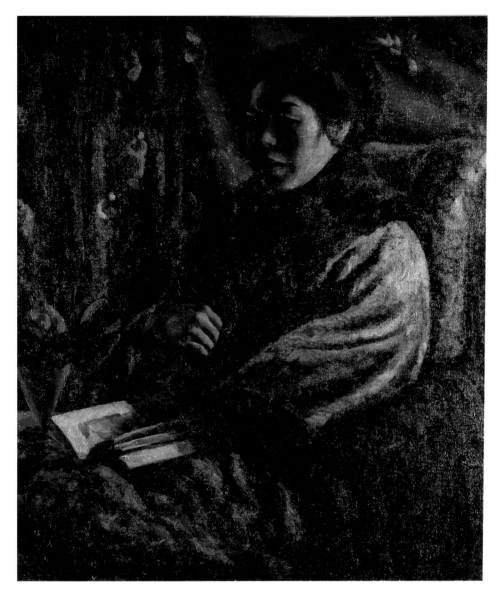

KOIDE NARASHIGE
Portrait of Mrs. N 1918

KOIDE NARASHIGE
The Window 1922
Oil on canvas, 51.5 x 44.5 cm/20¼ x 17½ in
Mie Prefectural Art Museum, Tsu

Koide Narashige visited France and Germany for half a year from August 1921 to February 1922. As he was by this time a mature painter, we may reasonably suppose that the purpose of this visit was not to study oil painting but rather to observe the latest conditions of European art. Koide mainly stayed in Paris, and French art appeared to his eyes as follows. "I saw so many worthless pictures that I became disgusted with painting itself and felt disposed to abandon it. I quit [the *Salon d'automne*] in half an hour. There are a lot of trifling pictures in Paris, just as I had imagined before I left Japan."

With this impression, he quickly returned home. But this seemingly slight regard for French art cannot be accepted at face value. Rather, we should read into his response an implicit criticism of those Japanese painters who preceded him, who had been single-mindedly bent on imitating the succession of avant-garde movements in French art. Koide was determined not to follow suit. Clearly, Koide was conscious of his own talent in painting and of his status as a Japanese painter, and he observed French art with the eye of the painter who had already established himself. Grasping with sensitivity the differences in aesthetic experience between Japan and France, Koide thought of his position, one that was impossible to maintain by merely admiring French art.

Accordingly, this short trip to Europe was very significant for Koide. On this occasion, calmly facing Europe as the opposite of his culture, he was more clearly aware of the direction that he was to take. The trip brought about a change in his style. Many works typical of Koide's early style exemplify his realistic adherence to detail, using thickly overlaid oil colors, which create a gloomy, oppressive atmosphere. Such stylistic features were effaced during his overseas travel, after which his works were marked with the new style of his later period, a free and facile way of expression through repeatedly deposited thin layers of oil colors, and a refined and unconventional sense of composition. In Paris, Koide did not copy French art but discovered himself and his own nature.

As it was for the purpose of observation that he visited Europe, Koide produced only a few works there, and most of these were small in size. In Paris he boarded at a house at 17, rue du Sommerard. This picture depicts a winter prospect of the city viewed from a window of the house. Somewhat speedy strokes relate the work to Fauvist brush technique, a direct influence of French painting. As a work attempted in the course of his self-discovery, it is one of his very few experiments in a thoroughly Western style. Nevertheless, Koide's preference for vigorous lines and decorative curves and his power to create dynamic, tense compositions, as found here, later were to govern the development of his mature period.

Hikaru Harada

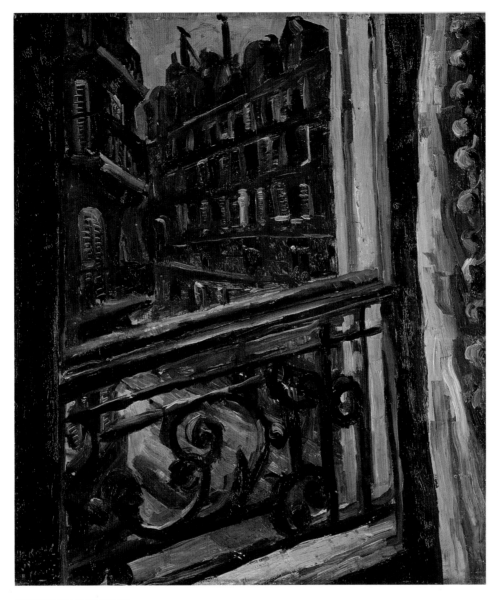

KOIDE NARASHIGE
The Window 1922

KOIDE NARASHIGE
Standing Child 1923
Oil on canvas, 89 x 64 cm/35 x 25¼ in
Yamatane Museum of Art, Tokyo

Koide created three oil paintings depicting his son. One of them, *The Family of N* (see McCallum, Fig. 55) is a work typical of his early style. There the boy, one year old, is flanked by the painter and his wife. This work was created before the painter left for Europe. Two years after his return from abroad, Koide completed two more paintings of his son. In these, the boy, now five years old, stands alone, wearing a reddish-brown sweater with an ultramarine jumper brought back from Paris by his father as a souvenir.

Standing Child, the second painting of his son, indicates how much Koide's style had evolved since his European trip. The composition is intricate. The small space is filled with various articles, such as the large cane chair at the right, with a vertically-striped kimono laid over its back, as well as a table in the background, with a tablecloth and pitcher. The depth of the picture is too shallow to suggest the spacial relationships of these various objects; the result is a closed, even stifling conception of space. In this respect, the picture resembles the earlier *The Family of N* in its elaborate, perhaps even ostentatious composition. The number of objects packed into the composition creates an unsettling sense of oppression.

Nevertheless, a comparison of the face of the child as depicted in the two pictures shows a very different means of expression. In the first, short detailed strokes emphasize the contrast between light and shade. In this regard, Koide's style shows considerable influence from KISHIDA RYŪSEI. *Standing Child*, however, avoids excessive detail and, with its long animated strokes, gives preference to a more direct pictorial effect. This change suggests not only technical progress but the substance of what Koide was able to learn in Europe.

The third picture of the artist's son, produced in the same year, *Boy with a Bugle*, shows the boy facing the spectator, framed in a background painted a single color of blue. The extremely simplified composition, rid of all superfluous elements, results in a work of great refinement. Such a work could only be achieved through the kind of bold experiments undertaken by Koide after his return from Europe; by the time he created *Boy with a Bugle*, the oppressive mood peculiar to his early works had dissipated completely. Instead, pictorial elements, the effects of contrasted colors, and rough rhythmical brushwork came to the fore of the artist's expressive technique.

These three portraits can thus be seen as a shifting index of Koide's stylistic evolution.

Hikaru Harada

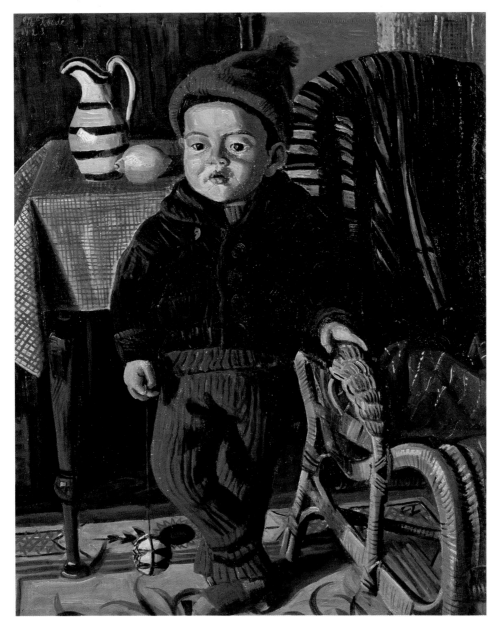

KOIDE NARASHIGE
Standing Child 1923

KOIDE NARASHIGE
Still Life with Globe 1925
Oil on canvas, 47.2 x 68.3 cm/18⅝ x 26⅞ in
Hiroshima Museum of Art, Hiroshima

Following Koide's return from Europe in 1921, his earnest attempts to develop his own style found their first fruit in a series of still lifes. Produced one after another, they formed a major part of his oeuvre that continued on nearly until his death. Those still lifes created shortly after his return home manifested a sense of form absent in his former works. Koide insisted, rather self-consciously, that his visit to Europe had no significance for his artistic development but rather allowed him to become aware of just how Japanese he was. Nevertheless there is no denying that his European trip was a turning point in his artistic development. Thereafter, strong formations, based on simple geometrical principles, began to appear in his work. This trend is particularly clear in the *Still Life with Globe* of 1925.

On a table are miscellaneous objects: bottles, a glass, pears, a saw, a glass cutter, a globe, and a sketchbook. At first glance the picture seems to represent random objects that might be found in some shopcase. A closer look, however, reveals that, in terms of the design employed, the large bottle with the glass stopper on the left corresponds to the globe on the right. Two oblique lines run from them respectively to the foreground, one from the large bottle through the glass and the pears to the glass cutter, the other from the globe through the glass to the small bottle. The compositional force that integrates these various objects into a unified whole thus constitutes one of the most important aspects of the picture. The individual objects that make up the framework of the design are visually captured in straight lines or simple curves that enhance the beauty of their forms, each complete in itself. The arrangement of the red and green fruits in the composition, unified by a basic tone of dark bluish grey, produces a harmony of colors. A painter friend of Koide, Kuroda Jūtarō, recorded that during this period, Koide made heavy use of turpentine in thinning his pigments, "as if he were guzzling it." It is perhaps because of this that the tones of the picture appear soft and spreading. The painter's sensitivity to the pictorial functions of composition, color, and form is especially apparent in the still lifes, such as *Still Life with Globe*, produced in the years following Koide's homecoming.

Creating still lifes requires a consciousness of composition. As objects are placed in an artificial order they are deprived of their usual individual pictorial value and must be treated as elements in a larger expressive design. We might say that Koide painted a large number of still lifes precisely in order to sharpen his sense of construction.

Sometimes Koide was attracted to old, trivial, even petty and useless objects. When he included such objects in his paintings, they often provided a strong decorative element. As time went on, he came to exploit this decorative tendency more openly. *Still Life with Globe*, however, conveys the artist's peculiarly ornamental and stylized manner of self expression, while demonstrating his rigorous exploration of compositional possibilities.

Hikaru Harada

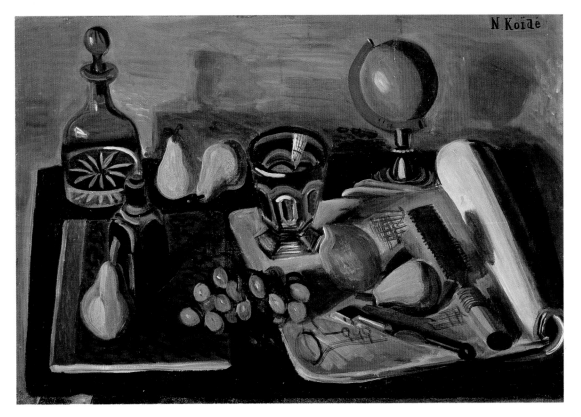

KOIDE NARASHIGE
Still Life with Globe 1925

KOIDE NARASHIGE
Vegetables on a Table 1927
Oil on canvas, 106 x 54 cm/41¾ x 21¼ in
Kitakyushu Municipal Museum of Art, Kitakyushu

From 1922 to 1931, that is to say, after his return from abroad until his death, Koide devoted himself mainly to pictures of indoor objects such as nudes and still lifes. One reason that he sought such indoor motifs may be that he no longer had enough physical strength to paint landscapes outdoors for lengthy periods. In any event, Koide spent more effort than other Taishō painters scrutinizing objects to be depicted and devising the compositions of his canvases. For nudes and still lifes he eventually was able to tackle a broad range of figure poses and compositional arrangements. Therefore his adherence to indoor subjects was well-suited to his natural disposition. He explained this as follows.

Still lifes are not natural; rather, they are artificial. To produce a landscape, you cannot put trees in arbitrary order or move a mountain to obtain an ideal composition. Before anything, you copy things as they are; then you move a little, until you settle in a suitable position. When you produce a still life— say, a picture of vegetables and fruits on a table— you can freely exchange and arrange them the way you like. But because you are so free, on the other hand, it is sometimes all the more difficult to find the right composition. Satisfied with no schemes, you risk inventing too many tricks in spite of yourself, and at last you produce a strange, ostentatious, unnatural mess. You can choose among an ample variety of compositions, but as far as subjects are concerned, you have to be content with a narrow range of choice. You do not meet nature in the way you do when you picture a landscape. Here, you do not deal with nature as an inexhaustible source of subject matter. In other words, you work mostly inside a room. Occasionally you have nothing but things daily at hand. For example, if you are living in a four-and-a-half-mat room on the second floor of a boarding house, all you have is a brown wall, a tea table, a brazier and a bookcase. Even Matisse would sigh at this sight.[1]

In 1922 Koide painted at least four pictures of flowers, plants and vegetables heaped on a long-legged, hexagonal table. Deeply attached to this hexagonal table, which was made in China or Korea, he often used it in the background of his paintings of nudes. Having many curves, it is almost excessively decorative, and the painter seems to have studied it obsessively, almost as if it were a fetish. In the composition of *Vegetables on a Table*, Koide, taking advantage of the table's verticality, made its interesting shape stand out and calculated the effect of colors to vividly bring out the vegetables on the black table from the dark blue background he employed. Adherence to objects, calculations as to their arrangement, and the introduction of striking contrasts in their bright colors make up one feature of Koide's still lifes. Interesting shapes and intense contrasts of colors bring forth an exotic Oriental atmosphere, and in this respect the Japanese taste inherent in Koide's personality is most manifest in his still lifes. *Vegetables on a Table* is not a realist work delineating the outer appearance of things but rather a decorative painting with a novel, unconventional composition.

The museum in Beppu, Ōita Prefecture, houses his *Flowers on a Table*. Although the objects on the table are different, this painting is almost identical in terms of canvas size and color tone to *Vegetables on a Table*. The two pictures probably constitute a pair. Ordered by a patron who was about to build a Western-style dwelling, they were produced as adornment for the walls. If the pair is seen together, the composition of *Vegetables on a Table* will be seen as all the more forceful.

Hikaru Harada

Notes:

1. *Atelier*, February 1927.

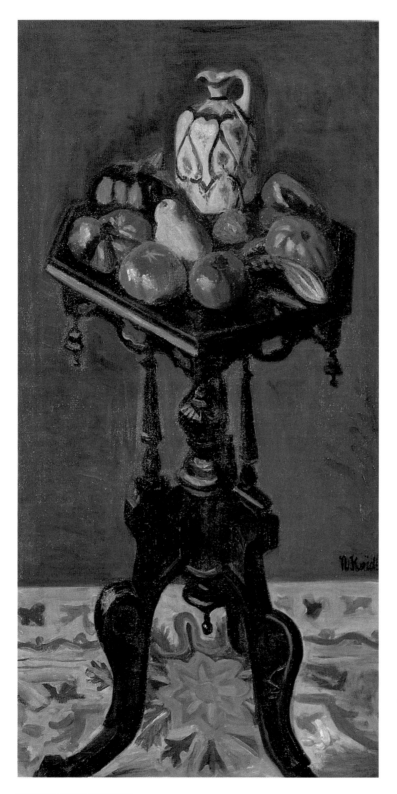

KOIDE NARASHIGE
Vegetables on a Table 1927

KOIDE NARASHIGE
Reclining Nude 1928
Oil on canvas, 41 x 56 cm/16⅛ x 22 in
The National Museum of Modern Art, Kyoto

As indicated in the annotation for *Vegetables on a Table*, Koide produced primarily nudes and still lifes during the ten years from 1922 to his death. His nudes strike various poses, including standing, sitting, lying with their backs turned toward the viewer, and lying with the face turned outwards. Sometimes such poses are viewed from overhead, or from the side.

Concerning women's bodies, Koide remarked:

I often hear that Japanese women are rather shapeless and that nudes other than those of Western women are worthless. Those who say so want to make fun of shapes of women depicted in Japanese oil paintings. I do not know whether theirs is indeed the right form of the human body, but if a French beauty with thin hair about her lips comes at a distance of one foot from me, then, before being struck with her grace, I will be overwhelmed by her strangely exaggerated nose, her deep-set piercing eyes and each pore of her rough skin, and I will possibly begin weeping. Some people despise short legs in view of a certain sort of idealism. In a streetcar I often see fat young women sitting, their stocky legs not reaching the floor, but I can regard them as quite charming.

Women depicted by Koide were those who had a long trunk, short legs and a small face, those he called "Japanese women." He found in such Japanese women's bodies a standard of beauty. Perhaps he thought that the happiness of being a painter lay in his ability to discern beautiful elements in the form of such bodies, nurtured by the traditional custom of living inside tatami-floored rooms, often sitting uncomfortably, courteously. In other words, Koide believed that when he, as a Japanese painter, dared to use oil paint as a medium, a way of expression introduced from Europe, he could bring out the beauty of elements heretofore hidden in Japanese culture.

This *Reclining Nude* emphasizes the volume of the thigh by bending the legs, the thickness of the hip by twisting the waist, and the length of the trunk by concealing one hand. While a skillfully composed expression of the human body, the painting also represents reality as caught by the artist's keen eyes. *Reclining Nude* combines pictorial composition with the realistic depiction of the human body in an au-

thentic manner. Here we may get a glimpse of his interest in European art, as it can be compared with, say, Matisse's famous nudes such as the *Blue Nude, a Reminiscence of Biskra*, 1907, now in Baltimore.

The space surrounding the naked woman is filled with the same hexagonal table with long legs that often appeared in Koide's still lifes, a cloth in red and white stripes which was bought in France, flowers in a vase, a carpet, and a bedcover. These decorative elements show Koide's predilection for ornamental pattern—another point in common with Matisse. Arranged with deliberate calculation in order to enhance the expression of a nude woman of great volume, their decorative elements contribute to a stunning painting in which Koide celebrates the unique beauty of "Japanese women."

Hikaru Harada

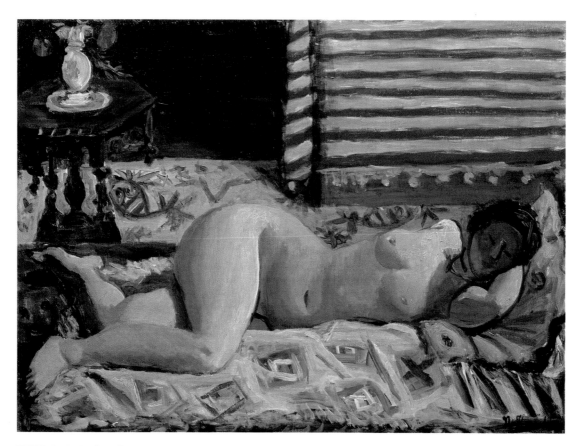

KOIDE NARASHIGE
Reclining Nude 1928

KOJIMA TORAJIRŌ
Begonia Field 1910
Oil on canvas, 91 x 118 cm/35¾ x 46½ in
Ohara Museum of Art, Kurashiki

Kojima Torajirō studied in Europe for five years from 1908 through 1912, primarily in France and Belgium. His stay in Europe was financed by Ōhara Magosaburō (1880–1943), owner of the Kurashiki Spinning Mills, who had supported Kojima's work since the artist had been a student in the Western Painting Section of the Tokyo School of Fine Arts. Ōhara was also known for his social work, founding the Kurashiki Central Hospital, the Ōhara Agricultural Research Institute, and the Ōhara Social Problems Research Institute. Yet Ōhara is even better known for his art collection, which formed the basis of the Ohara Museum of Fine Arts, Japan's first Western art museum, founded in Kurashiki City, Okayama Prefecture, in 1930.

Ōhara started his collection at the urging of Kojima, who was then a student in Europe. Some of the earlier pieces in the collection are the work of Kojima's French mentor, Edmond Aman-Jean. Later, with Kojima's second trip to Europe, during 1919 and 1920, and his third trip of 1922 and 1923, Ōhara's collection came to include such masterpieces as El Greco's *Annunciation*, Toulouse-Lautrec's *Portrait of Madame Marthe X*, and Giovanni Segantini's *High Noon in the Alps*. Also in the Ōhara collection are works by Léon Frédéric and George Desvallières, as well as the work of Jean Delvin, Emile Claus and others from the Belgian symbolist school under whom Kojima had studied. Kojima recounted his trip from Paris to Belgium in the summer of 1909 as follows:

> On my trip to Belgium, when I visited Ghent, [Jean Delvin] the head of the school where Ota Kijirō is studying, invited me to come see the school once. I told him of my dislike of schools and that since I would be returning to Paris after a week or so, I would not want to oblige him. Yet he said that this was of no matter and that I should come see the school for a day. And so I went. When I went there, it was very much different from any other school I have seen. Delvin, especially, was a very good natured man, kind and devoted to his work. Drawn by his educational philosophy, his devotion, his character and kindness, I finally decided to stay in Ghent and enroll in the school.

Despite Kojima's interest in certain Belgian symbolists, we find in the *Begonia Field* the influence of the French plein-air school. Here, Kojima uses many of their theatrical clichés, featuring women and children, picturesque props such as the wooden clogs and shovels in the foreground, and a patch of begonias blooming in a garden in the background. Still, Kojima's distinctive artistry can be seen in the delicate combination of hues in the backlit silhouette of the branches that frame the subject and in the subtly nuanced light filtering through the trees. A glimpse of Kojima's later style can be seen in his treatment of the matte red *matière* adding counterpoint to the field of begonias in the background.

The art historian Yashiro Yukio points out that Kojima's creative genius had developed because of the time he was given to perfect his own art.

The Ōhara family supported Kojima for his entire life, sponsoring three tours to Europe and building him a studio in Sakazu, near Kurashiki. Throughout his career, Kojima has never had to sell any of his work, and was left free to continue painting without any worries. He led the most fortunate life possible for a painter.[2]

Tōru Arayashiki

Notes:

1. Kojima Torajirō, "Europe," *Bijutsu gahō*, June 1913, p. 12.
2. Yashiro Yukio, *Geijutsu no patoron* (Tokyo: Shinchōsa, 1958), p. 206.

KOJIMA TORAJIRŌ
Begonia Field 1910

KUME KEIICHIRŌ
Gathering Apples 1891
Oil on canvas, 115.2 x 87.8 cm/45⅜ x 34½ in
Kume Museum of Art, Tokyo

In August 1891, Kume returned to Europe to spend the year on Bréhat Island off the northern tip of Brittany. It was the second time he went to the island that he so loved, where the ocean currents were such that it was unexpectedly warm despite its northern location.

According to the artist's memoirs, the population of the island at that time was a mere 300 or 400 people who counted only about 100 houses between them. He wrote of Bréhat, "This is certainly not the kind of island that the usual person would choose to visit. Even the merchants stay only long enough to have lunch and then leave again." In another entry he wrote,

The majority of the men are sailors, while the women, for the most part, stay home taking care of the fields, herding the sheep and tending to other domestic tasks. The land is made over to fields but in fact little can be induced to grow here. Potatoes are about as much as can be had but the flavor of these is very delicious indeed. Other than that, there are the apples, and every house has a large number of apple trees. Pears and other fruits are also produced in great numbers.[1]

Thus, *Gathering Apples* presents Bréhat about the time of year that the apples were reaching perfect ripeness. The women of the island wore a type of dress unique to that locale:

The type of dress usually thought of as typical for the woman of Brittany was much like the habits of the nun whom we see in church on Sunday, with the bodice decorated in velvet. They also use layers of white linen which were folded into various patterns and worn on the head as a hood or wimple. On the peninsula such attire is often to be seen, but here on the island very few of the ladies cut such a fine figure. They wear nothing but a very thin cloth on their heads.[2]

Despite such acute observations of the local people, Kume's forte was landscape rather than portrait or figure painting, and he produced a large number of poetically sentimental works that successfully captured the seasons, showing the subtle play of light on a scene. His technique of overlaying delicate layers of paint is suggestive of Impressionism, but his colors are much more sedate. Kume himself stated that there were no landscape artists whom he particularly copied but did say that he highly appraised the skills of Camille Corot, Jean François Millet, Théodore Rousseau and the other artists of the Barbizon School. As for Impressionism, he commented:

Setting aside any discussion of what the movement stood for, there are few of their actual works that I admire to any degree. When I went to see a special exhibition given by Claude Monet on the rue de Sèze, I thought that it was all wildly foolish. It struck me that perhaps Sisley and Pissarro were doing more in the line of serious and earnest research.[3]

Gathering Apples was one painting which Kume would never let out of his possession. It is believed that the first time it was publicly displayed was during the "Special Retrospective Showing of the Works of the Late Kume Keiichirō," February 11 to 27, 1935. Watercolor artist Miyake Katsumi (1874–1954), who commented on this posthumous exhibit, mentioned that there were many works that he had already seen before. Thus it appears that this work was already familiar to Kume's circle of painter friends.

Emiko Yamanashi

Notes:

1. Hakubakai, ed., *Kōfū*, part I, section 4, May 1905.
2. *Ibid.*
3. Kume Keiichirō, "Fūkeiga ni tsuite," *Bijutsu shinpō*, Aug. 1913.
4. Minami Kunzō, "Kume Keiichirō," *Bijutsu*, March 1935.

KUME KEIICHIRŌ
Gathering Apples 1891

KUME KEIICHIRŌ
Kiyomizu Temple, Kyoto 1893
Oil on canvas, 60.8 x 73 cm/24 x 28¾ in
Kume Museum of Art, Tokyo

Kume returned to Japan in 1893 after eight years of study in France. That same year he visited Kyoto with his close friend KURODA SEIKI, who had been with him during most of his stay in Europe. For both it was the first visit to Japan's ancient capital, and the two painters toured the many famous sights, vigorously sketching everything they saw.

The Buddhist temple Kiyomizu-dera was one of the most famous places they visited. Built in the eighth century and reconstructed in 1634, its main hall sits on a large stage, supported by a massive, scaffold-like structure. From there one has a commanding view of the entire city of Kyoto. Of all the many temples in Kyoto, Kume loved to paint Kiyomizu more than any other.

This particular painting of Kiyomizu remained in the Kume family during the artist's lifetime as it has since his death. It became known to the general public only after the Kume retrospective held in 1935. The watercolor artist Miyake Katsumi (1874–1954) expressed some interesting comments on the show. Seeing the landscape paintings which Kume had made in Europe, as well as those of the beloved temple, Miyake wrote:

When I first beheld the painting of Kiyomizu in Kyoto which Kume painted immediately after his return to Japan, what struck me most was that the colors were simply too beautiful. I had the distinct feeling that his depiction was somehow estranged from reality. This made me wonder if his renditions of the French countryside were idealized in the same Kume style, and to the same degree as I felt his Kiyomizu painting to be.[1]

Later, when Miyake traveled to France for his own studies, he discovered that the French landscape was every bit as beautiful as Kume had painted it. Miyake then wrote, "I recognized that Kume's paintings, far from being idealized portrayals, were accurate and objective pictures of reality." When Miyake questioned Kume about whether or not he approached painting in France with a different attitude than he did in Japan, Kume replied:

Just looking at the landscape of Europe is enough to stimulate my sense of beauty. I felt that I wanted to paint what I saw as it really was. On the other hand, the colors in Japanese scenery are somehow difficult to render for the artist and one must make painstaking efforts to capture a scene. It isn't at all enjoyable. I am afraid that my degree of interest in the natural scenes of the two countries is simply different.

Furthermore, Miyake stated that Kume had expressed great admiration for the landscapes of North America and England, and that there were many places in those countries that Kume wished he could paint. "To his very depths, Kume is a man moved by the beauty of nature, and I believe we can say that he is a painter who depicts nature as it is. He is a portrayer of objective representations of reality." In Miyake's view, this helped explain why Kume eventually quit painting after his return to Japan. "When he was confronted with the unenjoyable scenery of Japan, his inspiration ceased and, naturally, so did his production of paintings." For Miyake, "it was the attitude of a pure artist, and I rather sympathize with Kume, to say the least." At that time, Kume's works had an equally great influence on Western painting in Japan. There is no doubt that Kume himself recognized that this was the case. He thus began to dedicate his time to using the spoken word to promote artistic development in Japan while leaving the actual production of art works to his colleague KURODA. The two men seemed to have set up a sort of division of labor based on a mutual agreement as to the directions of Western art in Japan they sought. Their own broad-ranging observations on the future of Japanese culture were quite similar. They undoubtedly discussed issues such as what in the Western artistic tradition should be conveyed to Japan, and what elements were still missing in Japanese Western-style painting.

Emiko Yamanashi

Notes:

1. Miyake Katsumi, "Kume Keiichirō," *Mizue*, April 1935.
2. Kuroda Seiki, *Kuroda Seiki nikki* (Tokyo: Chūō kōron bijutsu shuppansha, 1966–68), vol. 1, p. 59.

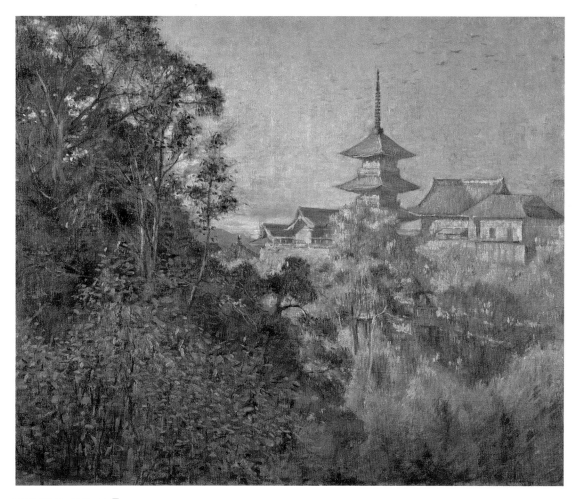

KUME KEIICHIRŌ
Kiyomizu Temple, Kyoto 1893

KURODA SEIKI
Woman with a Mandolin 1891
Oil on canvas, 80.2 x 64.3 cm/31½ x 25¼ in
Tokyo National Museum, Tokyo

After abandoning his law studies and concentrating on his training in painting in Paris, Kuroda began work in February 1890 on *Woman with a Mandolin*, the first painting he intended to enter in the Salon. Apparently he and his friend KUME KEIICHIRŌ hired the same model, as a similar drawing appears in KUME's sketchbook.

Kuroda was not able to meet the entry deadline. In a March 13 letter to his father he noted, "I am still working on the painting, but am far from finished. Tomorrow being the deadline, I cannot enter this year's exhibit. Moreover, my instructor is on an extended trip, so I cannot ask for his advice. As rushing to finish the work would not lead to any beneficial results, I will put off entering it in the show until next year. I believe I can finish it in a week or so." He wrote that the subject of the work was a "woman who seems to be deep in thought after having put down her mandolin."

While working on the picture he asked his mentor, Raphaël Collin, his views, and in a letter to his father dated April 3, Kuroda wrote, "I recently asked M. Collin to evaluate my painting for me. I am pleased to say that he praised it highly." In September Kuroda made some additions to the work, and entered it, together with *Reading*, which he had begun in June, in the 1891 Salon of the So-ciété des Artistes Français. *Reading* was accepted, but *Woman with a Mandolin* was rejected.

Woman with a Mandolin was, nonetheless, an important work and serves as an indication of his rapid progress in the short, two- to three-year period of his initial training. The coloring shows a gradual move away from his early use of browns and pinks to blues and purples. The highly evocative pose of the woman leaning back against the cushion is coupled with the suggestion of an auditory element potentially emitted from the mandolin. As a result, the picture expresses a broad range of sensory appeals, a tradition of Western painting that Kuroda greatly admired.

Regarding his signature in Chinese characters in the upper left corner of the work, Kuroda noted that his teacher suggested that it would be clear that a Japanese painter had done the work if it were signed in *kanji* characters. He signed it "by Seiki Minamoto Meiji 24." It is said that all samurai family lines can be traced back either to the ancient Minamoto or Taira families. Kuroda used this namesake, as his family line was thought to derive from the Genji clan.

Before his return to Japan, the only one of KURODA's works to be exhibited in Japan was *Reading*. After his return, his study of a nude, *Morning Toilette* (see Rimer, Fig. 33), which had been shown at the exhibition of the Société Nationale des Beaux-Arts in 1893, was exhibited in Japan, only to be condemned as immoral. This was the start of the famous "nude controversy." Kuroda did not diverge from his opinion that the study of nudes was imperative for the development of Japanese art, and refused to give permission to have his work removed from the exhibit. When he became an instructor at the newly formed Western Painting Section of the Tokyo School of Fine Arts, he had his students sketch nudes as part of the curriculum, causing the same kind of difficulties faced by Thomas Eakins at the Pennsylvania Academy of the Fine Arts, who was forced to resign in 1886 over such teaching methods. Both Japanese and American societies had prudish attitudes concerning the use of nude models. It is interesting to speculate what the reaction in Japan would have been had the half-nude *Woman with a Mandolin* been exhibited with *Reading*.

Emiko Yamanashi

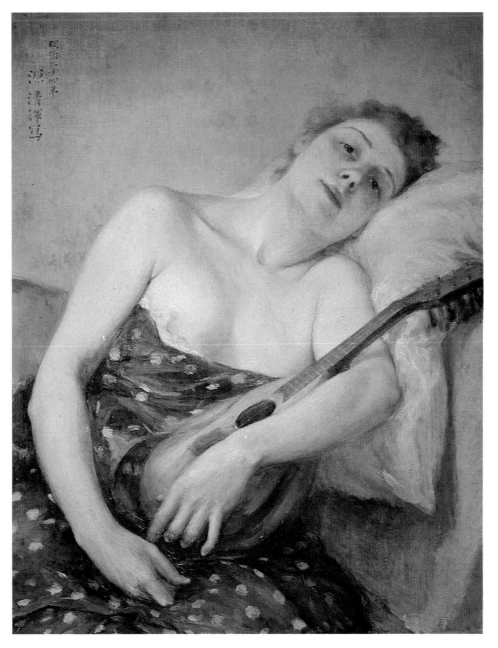

KURODA SEIKI
Woman with a Mandolin 1891

KURODA SEIKI
Study for Telling an Ancient Romance:
 A Man and a Maiko 1896
Oil on canvas, 78 x 51.5 cm/30¾ x 20¼ in
Tokyo National Research Institute
 of Cultural Properties

Kuroda noted in his diary that the model for the *maiko* (young *geisha*) in this sketch was named Tamaha, and the male model was a paper merchant named Shōjirō. Of the studies done for the six characters, the sketch of the male was drawn last, and as a result, consists of only the barest outlines. Kuroda's detailed charcoal sketches of the two main characters included two of the *maiko*'s face, two of their joined hands, one each of the nude man and the clothed male bust, and sketches of the man's legs.

Kuroda was attempting through this work to introduce into Japan a revolutionary new genre which he termed "idea painting." "Idea paintings" were intended to manifest the visual realm perceived in the mind of the artist precisely as if it existed in reality. They reflected, in essence, the historical and conceptual works that were considered the pinnacle of the painting hierarchy traditionally transmitted in Western art academies.

In their initial exposure to Western painting, the Japanese were profoundly struck by its nearly photographic realism. Consequently the main current of Western painting in Japan took realism as its goal and Japanese artists became engrossed in attempts to reproduce their subject matter as naturalistically as possible. Kuroda, however, felt this kind of painting was no more than a preparatory stage for "idea paintings." He asserted that the true realm of Western painting lay in taking realistic paintings a step further, to a point where the artist's conceptual ideology and ideal visual world could be expressed in grandiose compositions. *Telling an Ancient Romance* was Kuroda's first attempt at this new genre.

The reviews of the finished oil painting (see Takashina, Fig. 3), exhibited at the third White Horse Society exhibition in 1898, were not particularly favorable. The *Yomiuri shinbun* quoted Kuroda as saying "From my deep devotion to this massive work, which I hoped to make a total success, I have experienced only repeated failure and disappointment." The artist accounted for the painting's failure as stemming from the lack of appropriate coloring and perspective, and the fact that he "strove so assiduously to depict the thin air that ultimately the work portrayed a void in which temporal and spatial dimensions were obscured." While his compositional arrangement was praised, he was criticized for leaving the viewer with a "vaguely unpleasant sensation." The *Bijutsu hyōron* magazine noted, "the reason for the de-emphasis of perspective is because of the decorative nature of the work," and continued, "it is regrettable that the artist shows traces of his struggle to make use of realism."

It was felt that Kuroda's artistic goal, his technical style, and his artistic aptitude did not unite in this work. The painting was judged less persuasive than his works based on actual scenes, which revealed both technical skill and persuasive sentiments.

Kuroda's only other "idea painting" to be publicly displayed was *Wisdom, Impression, and Sentiment,* a set of three symbolically posed nudes on gold-leafed canvases (see Takashina, Fig. 4). After being exhibited at the White Horse Society exhibition, the three were shown at the 1900 Paris Exposition Universelle, where they won a silver medal. Nonetheless, the work was poorly received when later exhibited in Japan, where viewers could not understand the association between the title and poses, or what the nude figures symbolized.

The failure of Kuroda's "idea paintings" was not due solely to his artistic capabilities. Western painters in Japan were not mature enough to understand Kuroda's intentions. In France his concepts and ideals might have gained more prominence, and perhaps there would have been a larger, more comprehending audience for his work.

Ironically, although Kuroda sought to introduce "idea paintings" into Japan, the realism of *Telling an Ancient Romance* inspired many "genre paintings" around 1900, works in which Japanese artists depicted scenes of daily life and people, such as farmers returning from the fields, a solitary old woman walking along a river bank at dusk, and other comparable scenes.

Emiko Yamanashi

184

KURODA SEIKI
Study for Telling an Ancient Romance:
 A Man and a Maiko 1896

KURODA SEIKI
Study for Telling an Ancient Romance:
A Serving Maid 1896
Oil on canvas, 93.8 x 47.7 cm/37 x 18⅝ in
Tokyo National Research Institute
of Cultural Properties

In the autumn after his return from France in 1893, Kuroda visited Kyoto with his friend, KUME KEIICHIRŌ. Kuroda, who had not been to Kyoto before going to France, wrote that "for the first time I felt as though I was in a different country outside the realm of Japan." It is interesting that Kuroda, who spent his formative years (between the ages of seventeen and twenty-seven) in France, felt Japan's ancient capital, Kyoto, resembled a foreign country. His sensibilities reflect a thorough Westernization.

His first impression of *maiko* (young *geisha*) was that they were "beautiful birds," and he sketched them as well as the scenery around Kyoto. One day he stopped by Seikan Temple, located near the famous Kiyomizu Temple, and asked the priest about the temple's history. The priest related the story of Kogō, one incident in the tragedy of the rise and fall of the Heike clan, made famous in the celebrated medieval chronicle *Tales of the Heike*.

Taira Kiyomori, the warrior who wrested power from the aristocracy in the twelfth century, had established himself as undisputed autocrat while strengthening his ties with the aristocracy and imperial family through a series of marriages into his clan. One such arrangement was the betrothal of his daughter Tokuko to Emperor Takakura. Kogō, a lady in waiting whose favor the Emperor courted, feared retribution from Kiyomori and fled the court to the Saga plain, outside Kyoto, where she hid herself in a lonely hut. Emperor Takakura, however, could not forget his true love, and sent Minamoto Nakakuni to search for her. While riding around the Saga plain in the clear moonlight, Nakakuni gradually perceived the sound of Kogō's *koto*, the traditional Japanese stringed instrument. She was playing her favorite song, a piece full of longing. Nakakuni took Kogō back to the court. Later she bore the Emperor a baby girl. Kiyomori's resentment over the Emperor's growing affection for Kogō boiled over, and he forced Kogō to become a nun. It is said that he cut off her ears and nose and banished her to the Seikan temple. Later generations took pity on her plight and placed a statue of her in the temple.

Upon hearing this story, Kuroda wrote that he felt as though he had witnessed the events at first hand, and was determined to take up the tale as a motif. There is evidence of a conception for such a work in one of his sketchbooks.

That year Kuroda was able to achieve only a vague conception for the work, and in the following year, 1894, he was conscripted into the army at the time of the Russo-Japanese war. Upon his return he was commissioned to do a painting by Marquis Saionji, and began work in earnest under the patronage of the Sumitomo family. From mid-January to mid-April, 1896, he prepared charcoal sketches and study oils. He lodged in a corner of a photographer's studio located in central Kyoto, hired models, and commenced the final work. Kuroda, an eccentric artist fresh from Paris, drew stares with his unusual appearance. Moreover, the comings and goings of his unconventional artist friends and *maiko* models led the neighbors to call his lodgings "a crazy house." Oei, the *maiko* who acted as the model for *A Serving Maid*, was quite cooperative in the production process, recruiting other models as well.

The twenty-one charcoal and eleven oil sketches for *Telling an Ancient Romance* were put on exhibit at the first White Horse Society exhibition held in October 1896. The newspapers and magazines focused attention on the drawn and painted sketches and raised expectations for the completed work. In exhibiting his preliminary studies Kuroda was attempting to introduce Western academic working methods into Japan.

After being exhibited at the 1898 Society exhibition, the completed work was preserved in the Sumitomo collection (see Takashina, Fig. 3). Unfortunately, however, the painting was destroyed during an air raid in 1945. Today, the only remaining traces of the work are the preparatory drawings and oil sketches and a black and white photo of the final painting.

Emiko Yamanashi

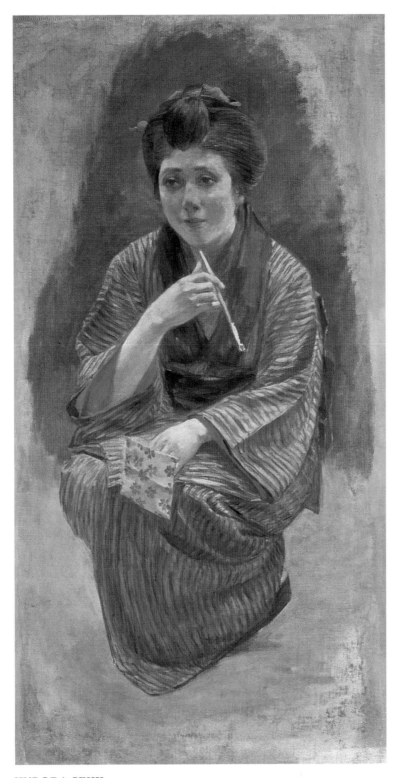

KURODA SEIKI
Study for Telling an Ancient Romance:
A Serving Maid 1896

KURODA SEIKI
Flowering Field 1907
Oil on canvas, 126 x 181 cm/49⅝ x 71¼ in
Tokyo National Research Institute
 of Cultural Properties

Flowering Field is puzzling in many respects and seems to be either unfinished or a study piece. The women's hands and legs, and the fur laid out in the center of the work, are all roughly sketched, and the work is unsigned. According to Kuroda's diary, work on this piece commenced in 1907; the last diary reference to it is September 6, 1915. Two explanations for the incomplete nature of this work are possible. Either Kuroda felt that he had gone as far as he could with the painting, despite the fact that it was incomplete, or he intended to add more to it, but circumstances prevented him from doing so.

Another puzzle concerning this work is why the artist should have undertaken this type of subject at this time in his career. Of all his works, this is the closest to the style of his mentor, Raphaël Collin. In fact, it is highly evocative of Collin's *Three Women in a Green Field* of 1895 (see Takashina, Fig. 5), which was bought by the Maeda family in 1908, through Kuroda's influence.

A review of Kuroda's style shows that throughout his career few of his works resembled those of Collin. Early in his career he studied Belgian and Dutch painting, and from the 1890s he created primarily portraits and landscapes. After returning to Japan, the artist embarked on the development of his own individual style, and the works Kuroda exhibited in the 1900 Paris Exposition Universelle reveal a conscious incorporation of Japanese elements.

Collin's major motifs were nude or clothed women as symbols of intangible elements such as "Time." Kuroda originally concentrated on nudes and portraits of women, but his style differed markedly from Collin's in terms of form and color preferences and in that he strove for an ideal world in his painting.

The study for *Summer*, which was shown in the 1897 Salon in Paris, resembled Collin's style in terms of theme and concept. However, Kuroda could not bring the work together, and it was not completed. Regrettably the work is no longer extant.

One theory concerning Kuroda's motivation in creating *Flowering Field* was that he was attempting to impart artistic direction to the *Bunten* exhibition, newly established in 1907, which was to become the Salon of Japan, by having his "idea painting" shown. Nonetheless, while Kuroda may have learned from other artists, he certainly would have conceived a design that reflected his own style were he intent on influencing the direction of the exhibition. Another hypothesis is that Kuroda was induced by outside forces (a government commission, for example) to undertake a monumental work such as *Flowering Field*.

In 1916 Kuroda criticized the *Bunten,* condemning his countrymen as lacking the talent to create "idea paintings," and censured himself as having not yet created a true "idea picture." He finally realized from his repeated failures that his artistic character was not adapted for "idea paintings." Kuroda was well aware that "Salon paintings" were on the decline in the West. He was also cognizant of his own influence on the development of Western painting in Japan. These factors may also provide an explanation for Kuroda's having created a work that he himself realized was behind the times. Evidence of Kuroda's earnest attitude toward his art and his consciousness of his influence on the direction of oil painting in Japan can be seen in the fact that he kept this unfinished work in his studio for eight years.

Emiko Yamanashi

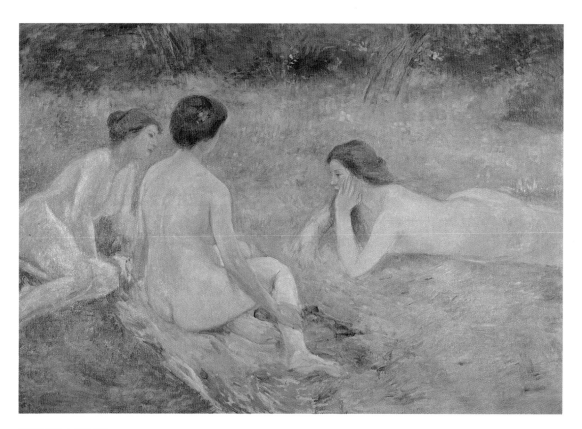

KURODA SEIKI
Flowering Field 1907

MAETA KANJI
Family of a Master Carpenter 1928
Oil on canvas, 130.7 x 162.5 cm/51½ x 64 in
Tottori Prefectural Museum, Tottori

During his studies at the Tokyo School of Fine Arts, Maeta was deeply moved by a series of lectures given by the Christian philosopher, Uchimura Kanzō (1861–1930), who was such a powerful influence on the thinking of his time. Until his departure for France in 1922, Maeta devoted himself totally to the ideas espoused in Uchimura's lectures. In particular, he developed a deep interest in the Christian notion of confession.

When Maeta met the socialist thinker and old friend Fukumoto Kazuo, just back in Paris from studying Marxism in Berlin, the painter's beliefs began to shift. The paintings he did in Paris clearly reveal this change, showing an increased dedication to realism and the clear inspiration of Courbet.

When Maeta returned to Japan in 1925, he lived in Tottori, then spent a rather unproductive period in Kyoto. By 1926 he began to contribute essays on art criticism to various publications. Because of the artist's continued association with Fukumoto, now one of the intellectual leaders of the Japanese Communist Party, Maeta himself was chosen for observation by the Special Police and his home was under constant surveillance. By 1928, when the artists active in the proletarian movement attacked Maeta as "opportunistic" and too "bourgeois" in his approach to aesthetics, he gradually moved away from any direct Marxist inspiration.

Family of a Master Carpenter was shown in 1929 at the fourth exhibition of the *1930 kai* (1930 Society). Like many of the portraits of workers Maeta created while in France, this work shows his interest in the kind of subject matter deemed appropriate to politically progressive art of the period. Maeta's technique, on the other hand, shows little of the kind of realistic aesthetic demanded by orthodox Marxism. Indeed most realistic art created in Japan during this period shares an idealistic atmosphere reflective of Japanese culture at that time.

In an article he wrote for the art magazine *Bi no kuni* in 1927, Maeta remarked that creating groups of people on canvas is more difficult than it appears, for a "group" is not simply a gathering of people. Each person must show some correlation, some unity with the others, yet must also represent some individual realm as well. To express a group adequately, he noted, it is necessary to incorporate vertical penetration of individual figures with an intuition to maintain a horizontal sense of harmony.

Nishigaki Takeo, a student of Maeta, has offered an interesting comment on the artist's compositional style during the period when *Family of a Master Carpenter* was created. According to Nishigaki, Maeta would draw out a sketch on scraps of graph paper or lined manuscript paper, then build up his idea by applying pigments with his fingers. The painter only began to work on the canvas after he had completed such a preliminary model. Then on the canvas he first would fill in vertical lines with charcoal in order to recreate the sketch in full dimensions before applying the colors. Maeta evidently worked very quickly, particularly in the final application of color.

In *Family of a Master Carpenter*, the placement of the figures and the directions in which they face have been carefully planned and composed. At the same time, the color shows a striking economy with his use of reddish browns and greens. The painting clearly reveals the exacting techniques of a young painter who was to pass away only two years later, in his early thirties.

Tōru Arayashiki

190

MAETA KANJI
Family of a Master Carpenter 1928

MAETA KANJI
The Red Hat 1928
Oil on canvas, 116.7 x 90.9 cm/46 x 35¾
Mie Prefectural Art Museum, Tsu

In his essay entitled "The Essence of Realistic Technique," published in 1929, Maeta expressed his thoughts on representation in terms of the following three principles. First, objects should not be "explained" to the viewer by the artist but presented in terms of tactile impressions. Secondly, the artist should create pictorial space by placing in consonance the directions of the linear elements of the design with the color planes, a technique much preferable, the artist insisted, to a simple reliance on the rules of linear perspective. Thirdly, the artist should strive to establish the actuality of objects by stressing the unity of the whole composition. For example, he wrote, in the case of clothing, whatever patterns of decoration may be involved, the artist must first grasp clearly the tactility of the fabric and its capacity to envelop the body; questions of pattern, for example, should be left until last. If a face is bright, he concluded, the garment can be dark, and the background intermediate in color. In that manner, a true harmony can be created.

The Red Hat is one of a series the artist created of women wearing hats, in which the techniques outlined above were rigorously carried out. Those familiar with the entire series may recall different background objects, such as a window, a curtain, a desk, or other comparable structures. In this painting the sitter's chair is treated as an abstract pattern of stripes and spots, while the background is composed of several color planes in an arrangement suggesting movement. The subject's right hand is not shown, which enhances the presence of the clenched left hand. Her eyes are symbolized by two touches on the forehead in shadow from the brim of the hat, while her hair shows the scratches of the palette knife. The painting is an example of the techniques suggested in Maeta's essay that, he assures his readers, will allow the temperament of the artist to emerge.

Women wearing hats seem to have assumed a special role among Maeta's motifs after his years in France, when he began to choose such subjects as laborers and nude women. One painting, entitled *A Red Hat*, painted in 1925, now in the collection of the Hiroshima Museum of Art, conveys a kind of religious atmosphere through the tranquil expression of the sitter. The sitter's black garment, red hat, and red collar suggest a monk's habit; indeed her peaceful countenance and folded hands, one on top of the other, hint at a symbolic significance. In such a work, asserts the art historian Hijikata Teiichi, may be perceived the inspiration Maeta derived from his contact with Uchimura Kanzō, the great Christian religious leader. Indeed, the impact of Uchimura's lectures on Maeta, which he attended while a student at the Tokyo School of Fine Arts, seems to have constituted a profound and permanent influence.

Tōru Arayashiki

MAETA KANJI
The Red Hat 1928

MITSUTANI KUNISHIRŌ
Nude Leaning on a Chair 1912
Oil on canvas, 79.5 x 64 cm/31¼ x 25¼ in
The National Museum of Modern Art, Tokyo

Mitsutani Kunishirō held exhibitions in February and March of 1914 to present works produced during his second visit to Europe from 1911 to 1913. At that time, the following critique appeared in the art journal *Bijutsu shinpō*:

At Mr. Mitsutani's two exhibitions, we took notice of a quite new feature he added to his works. He seems to have somewhat adopted the Post-Impressionist technique. Of course one can recognize in the coloration and method of these paintings his peculiarities which have remained the same as before his departure for Europe. Since his debut his paintings have been characterized by flat representation and dull colors. We think that his conversion in Europe has brought on something very natural and interesting.[1]

In 1900, Mitsutani went to Europe for the first time, by way of America. He was accompanied by his friends, KANOKOGI TAKESHIRŌ and Maruyama Banka, both painters. In Paris he attended Jean-Paul Laurens's classes at the Académie Julian. Mitsutani's second visit to France was realized in 1911 with the aid of Ōhara Magosaburō, who is also known as the patron of KOJIMA TORAJIRŌ. On this occasion Mitsutani called on Renoir and asked him to produce a painting for the Ōhara collection. The influence of the French master can be seen in Mitsutani's *Nude Leaning on a Chair*. In the course of his second sojourn in France, the painter strived to acquaint himself with then current trends of art, about which it was impossible to learn at the Académie Julian:

I went to Paris once before. As it was my first overseas experience, I tried to see a wide range of things, and consequently I was so busily moving about for, say, sightseeing, that I could not concentrate on my work. On my second visit I intended to pursue my study more deeply and so wanted to rent an atelier where I could work intensively and freely. At first I worked for some time under the tutorship of M. Laurens at the Académie Julian and listened to his rigorous criticism, which I found instructive because I had been rather idle until then. As I had expected, his criticism was thoroughgoing. He quite convinced me of his point of view. Still, I gradually came to feel uncomfortable. Most people at this studio, I perceived, were excessively concerned about outward forms. They directed their efforts at winning paint-

ing contests. Thus I became more and more reluctant to attend that school. . . . After three months I left and began to work in an atelier, where I engaged in my own artistic work. . . . Notwithstanding this change of circumstances, my old habits often hampered me from doing what I wished.[2]

A comparison between *Nude Leaning on a Chair* and works produced just after Mitsutani's first visit to France indicates a conspicuous change in his technique of painting. In those works, he often used the method of "expression by external light," a technique still prevalent in the pictures adorning the Salons of Paris at the time when Mitsutani first visited France. In this later painting of a seated nude, by contrast, the intention to depict the nude in a sculptural fashion, using light and shadow, is not strong; instead, the nude form is softly modeled by a subtle range of hues and the back of the chair is treated as a decorative, rather than a structural, factor. This change in Mitsutani's way of expression immediately caused controversy in Japan. In answering these criticisms, he explained himself as follows:

Any painter must sooner or later undergo some changes in his style. It is impossible to remain the same from the beginning to the end. Even if there is something fixed in my art, I do not necessarily consider that quality to represent my personal identity. The works created prior to my recent journey to Europe do not represent my whole personality. If you think they show my individuality, you are mistaken. As I was dissatisfied with my attitude, I attempted to seek a new course. I am hereafter going to make various attempts and commit my works one by one to the judgment of the public. Meanwhile my true individuality has yet to be found. . . .[3]

Tōru Arayashiki

Notes:

1. *Bijutsu shinpō*, April 1914.
2. *Ibid.*, March 1914.
3. *Ibid.*, November 1915.

194

MITSUTANI KUNISHIRŌ
Nude Leaning on a Chair 1912

MITSUTANI KUNISHIRŌ
Scarlet Rug 1932
Oil on canvas, 113 x 154 cm/44½ x 60⅝ in
Ohara Museum of Art, Kurashiki

In his study *Western Paintings in the Meiji and Taishō
Periods*, Moriguchi Tari, after describing the stylistic
changes seen in successive nudes produced by Mitsu-
tani Kunishirō, concluded that the artist's final attain-
ment in this genre was the *Scarlet Rug.*

> *On a scarlet rug Mitsutani placed only two naked
> women, a Pekinese and flowers of a kodemari
> [a low decorative garden plant of the rose family],
> and covered the large space with those colors which
> gave it a flat appearance. Tempering the scarlet of
> the rug with an opaque sober tone, the artist has em-
> phasized above all a harmony between this Oriental
> tone and the soft yellow tinge of the naked women.
> The whole picture is controlled by refined simplicity
> and a plain lightness. In order to produce nudes
> which fully characterize Japanese women, he sought
> specifically the appropriate softness, contours, poses,
> and color schemes.*[1]

The objects in the picture are viewed slightly
from above so that the scarlet expanse of the rug can
appear as large as possible, about two-thirds of the
entire picture's surface. The naked women fix their
eyes on the small pet who assumes a charming pose
at the right. Thus the women's postures suggest a
movement from the upper left to the lower right of
the canvas. This flow of movement corresponds
with the blooming branches of the *kodemari.*
(*Kodemari* literally means "small handball." The plant
bears this name because small white five-petaled
flowers gather like handballs on each branch in
spring.) The women diagonally divide the composi-
tion in two. The cushion and book beside one
woman are conventional trappings of Western art,
but the *kodemari*, a decorative plant that has long
been familiar to the Japanese, and the Pekinese, a
dog of the type brought from China in the Nara pe-
riod and bred enthusiastically as a small pet in the
Edo Period, contribute to the Oriental atmosphere
of the picture.
Mitsutani produced several works dealing with
similar themes. Yashiro Yukio discussed this series
of works as follows:

> *A series of works called* Scarlet Rug, *which he
> painted after returning from abroad, is truly splen-
> did. These probably count among his masterpieces
> produced after the change of his style because of*

*his European experience. Housed by the Ohara
Museum of Art, most of them are unfamiliar to the
public in the metropolitan region. Mitsutani's*
Scarlet Rug *series may well deserve a high reputa-
tion. The most famous among the series is the pic-
ture of two women lying on the rug with a dog be-
side them and a white blooming* kodemari *on the
background. My favorite shows a nude woman lying
wearily against a background of morning glories.
Here we can find not Renoir's sensitivity but a truly
ornamental treatment of the softness, allure, and
melancholy of the female body. A room adorned
with a picture like this is filled with a sense of hap-
piness. In this respect it is not impossible to say that
the picture is a sort of descendant from those of
Renoir.*[2]

Tōru Arayashiki

Notes:

1. Moriguchi Tari, *Meiji Taishō no yōga*, Tokyo: Tōkyōdo, 1941.
2. Yashiro Yukio, *Kindai gakagun*, Tokyo: Shinchōsha, 1955.

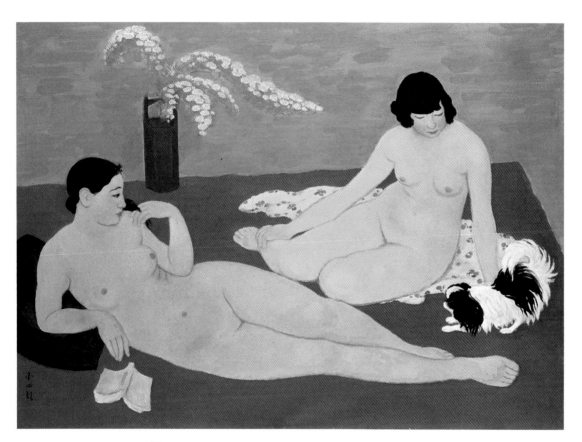

MITSUTANI KUNISHIRŌ
Scarlet Rug 1932

MORITA TSUNETOMO
French Landscape 1914–1915
Oil on canvas, 50 x 61 cm/19¾ x 24 in
The Museum of Modern Art, Saitama

By a stroke of misfortune Morita Tsunetomo's visit to France in 1914 coincided with the outbreak of World War I. He was able to stay in Paris for only a short time and was forced to take temporary refuge in London, subsequently touring the French provinces with sketchbook in hand. In November 1914 he stayed for a month in Aix-en-Provence, the home of Cézanne, with his friend the painter Hasegawa Noboru.

Almost all of the oil paintings that Morita executed in the course of his two-year stay in Europe were essentially attempts to digest the artistic vocabulary of Cézanne. The color palette, featuring mainly brown with restrained additions of green and blue, the disposition of mainly diagonal strokes of the brush, and the flat treatment of the distant blue sea is clearly a conscious attempt to imitate the style of Cézanne's middle period. This strategy results in the creation of a solid pictorial composition, as if the whole of the picture surface had uniformly crystallized. It can be said that in this work Morita's rational approach enabled him to come within a hair's breadth of Cézanne; indeed he comes even closer to the master than YASUI SŌTARŌ, the first painter in Japan to work under the influence of the French master.

However, the formative principle which lies at the foundation of Cézanne's art is the distortion of perspective through multiple visual points that transforms the composition of the picture surface as a whole into something dense and compact. Morita, however, only applied this principle, and even then only loosely, in his depiction of the small house which has no effect on the overall composition of the painting. This does not reflect the shallowness of Morita's understanding of Cézanne so much as the character of Morita as an artist. The watercolors and drawings which Morita executed during his stay in Europe are spontaneous and improvisational, with no trace of Cézanne's logically thought-out approach to his art. Before travelling to Europe, Morita had acquired a background in traditional Oriental ink painting with the *Nihonga* painters Ogawa Usen and Hirafuku Hyakusui. While in Europe Morita was particularly drawn not only to Cézanne but also to the caricatures of Daumier and Goya. After returning to Japan, he wrote an essay in letter form, published in the March 3, 1918 *Yomiuri shinbun*, in which he classified the appeal of art into "the extraordinary power of human qualities" and "the extraordinary power of artistic qualities." As an example of the former he cited Daumier and the thirteenth-century Japanese painter-monk Toba Sōjō, famed for his caricatures of birds and beasts; as an example of the latter he gave the name Renoir. Morita had stopped producing oil paintings modeled after Cézanne by the time he wrote this essay, and the focus of his creative work had moved to sketching, using India ink or dark crayons. Then, during the 1920s he suddenly moved in the direction of traditional painting in a style based on the expression of "the extraordinary power of human qualities." These contradictory elements were already present in the works which he executed during his stay in Europe.

On the basis of evidence provided by the artist's family, this work is currently thought to have been painted around 1915 and to depict a landscape in Brittany. Although geographical investigation is necessary before the location can be affirmed, Morita once noted that "I went again to Brittany that summer. Bréhat Island is a rocky island and a very interesting place," thus indicating that the area around Bréhat Island probably served as the basis for this painting.

Tsutomu Mizusawa

198

MORITA TSUNETOMO
French Landscape 1914–1915

MURAYAMA KAITA
Self Portrait 1916
Oil on canvas, 60.5 x 50 cm/23⅞ x 19¾ in
Mie Prefectural Art Museum, Tsu

In his short lifetime of twenty-three years, Murayama Kaita created a number of self portraits. Among them, the character of this piece is especially direct, showing Expressionist influences at their most powerful. On the back of the canvas, probably in another person's handwriting, is written "Self Portrait/Murayama Kaita/1916/9." However, a close look at the background to the right reveals segments of scenery, and in the center there is a portion of a human head indicating that Murayama painted over a previously finished picture. Since full X-ray examinations have not been conducted as of this writing, it cannot be determined whether the earlier painting was another self portrait. Neither can it be said for sure if the date on the back is that of the earlier or of the present painting. However, since the date was marked by someone other than the artist at a later date, it probably refers to the later work.

This self portrait was probably painted immediately after Murayama's trip to Oshima Island in the summer of 1916. Just as the young German artists of the Brücke group visited Dangast Island during the summer and lived together, modern Japanese artists sought refuge from the cities and searched for new motifs on Oshima Island. Compared to two other paintings that are thought to have been finished by Murayama on the island that summer, the style and the techniques used for this self portrait are very different. The light from the lower left provides an orange-yellow highlight on the collarbones, chin and facial features, coloring the face like *kabuki* make-up. The portrait was executed quickly with bold, decisive lines over the previous painting with little in the way of prior preparation.

In spring of 1916, Murayama fell in love with a model named Tama, who soon rejected him. He returned to Okazaki in Aichi Prefecture, where he applied for a military draft examination. About the same time, he is known to have wandered around the Hida region, apparently to overcome his emotional confusion. The stay in Oshima, which lasted from July to the end of August, might have been one stage in these meanderings. Up to now, except for three paintings, no other work from this period has been located. Murayama possibly lost much of his inspiration during this period, but meeting his

friend Yamazaki Shōzō on Oshima rekindled some of Murayama's creativity.

Soon after his return from Oshima in September, Murayama entered a large painting entitled *The Monkey and the Woman*, (current whereabouts unknown) in a Tokyo art exhibition. He placed a ridiculously high price on this major work, which was rejected from the show. Unfortunately, not even a photograph remains of *The Monkey and the Woman*. Yet from the use of a woman and a monkey for motifs, it may be surmised that this piece was among a series of storytelling pictures that he painted, along with a charcoal sketch entitled *Nude Hugging a Monkey*, drawn in the same year, and an oil entitled *The Pauper and the Woman* (current whereabouts unknown). It is probably in these three pieces that the theatrical, self-conscious character of the young poet-artist is most apparent. The poet and painter Kosugi Hōan described *The Monkey and the Woman* as a painting in which Murayama "so bravely exposed his personality that the flaws showed." The *Self Portrait* of 1916 reflects this phase of creative enlightenment in the artist's career. Painted with an explosion of creative genius, where Murayama "so bravely exposed his personality" without so much as bothering to completely erase an earlier painting, this self portrait has come to be appreciated as a masterpiece of the second decade of this century.

Tsutomu Mizusawa

MURAYAMA KAITA
Self Portrait 1916

NAKAMURA TSUNE

Self Portrait with a Straw Hat 1911
Oil on canvas, 41.5 x 32 cm/16⅜ x 12⅝ in
Nakamura-ya, Tokyo

This light-filled self portrait was probably executed in a single sitting by Nakamura Tsune on May 15, 1911. The overall touch is free to the point of being wild, and the bold white highlights seen on the brim of the hat, tip of the nose, the jaw, and parts of his shirt, overflow with confidence. Works displaying a relaxed brush and sense of improvisation so richly evident in the finish of this painting are extremely rare in Nakamura's oeuvre, and we might well assume that the artist himself was rather satisfied with what he had accomplished. In the lower right hand corner we find the date and artist's name carefully inscribed in French: "le 15 Mai/T. Nakamura."

When we compare this work with the earlier series of self portraits which Nakamura made between the years of 1909 and 1910, it is clear that some major developments in his abilities occured during the interim. In *Self Portrait with a Straw Hat* he attempted to fill the canvas with the effects of sunlight flooding in from above. At the very opposite extreme are the self portraits done between 1909 and 1910 which were executed in dark and somber hues reminiscent of Rembrandt's style. Nakahara Teijirō, a sculptor and close friend of Nakamura, recalled the enthusiasm that Nakamura felt toward Rembrandt during those earlier years.

> *I think it must have been in about 1910. Nakamura had found a book of Rembrandt reproductions on the shelves of the Maruzen Book Store. The Nakamura of those days virtually seemed to glow with joy at having this book. With real persistence he was determined to glean every available piece of information about Rembrandt that his book of photographs could possibly offer. Over and over again he went through it until the pages were literally black from the turning.*[1]

At this time Nakamura Tsune was evidently dissatisfied with the familiar French academicism of Nakamura Fusetsu, his mentor and teacher. Likewise, Nakamura harbored similarly unsettled feelings toward the sensual plein-air style of the White Horse Society centered around KURODA SEIKI, by then the leader of the Japanese art world. For Nakamura Tsune, baptized a Christian during May of 1907, creating art had taken on the aura of a religious activity. It is possible that this conviction made him believe he could approach Rembrandt's forms of expression by communing with the very being of the long-dead Old Master. In any event, Nakamura placed himself squarely in the camp of those opposed to realism, perhaps without any conscious choice on his part. However, Nakamura concerned himself only with the early Rembrandt who painted himself in exotic, theatrical poses. Even though the earnest self-examinations of the young Nakamura—already suffering from lung disease—lent a pathetic seriousness to his self portraits of these years, his works never transcended imitation.

At the fourth *Bunten* exhibition, held in October 1910, Nakamura displayed a stereotypical Rembrandt-style picture of himself called *Portrait*, along with a landscape entitled *A Seaside Village* (or *House with White Walls*). This latter work displays an Impressionistic flavor in its brushwork and use of color. Then in 1911 he produced what is considered the representative work of his early years, *Woman*. This work overflows with the sensuous charms of a half-nude figure painted with such a soft touch that it has generally been appraised as "in the manner of Renoir." In the development of the artist's works, *Self Portrait with a Straw Hat* thus stands midway between *A Seaside Village* and *Woman*.

Nakamura never directly experienced Europe. For him, Rembrandt, the Impressionists, Renoir, and other artists assumed equal status in his mind and he found himself presented with a grand selection of styles from which he felt he could pick and choose at will. Nonetheless, the successful execution of such freedom of choice must rest on a firm mastery of the physical qualities of oil as an artistic medium. Small as it is, then, *Self Portrait with a Straw Hat* speaks eloquently of Nakamura Tsune's personal artistic achievements.

Tsutomu Mizusawa

Notes:

1. *Chūōbijutsu*, November 1920.

NAKAMURA TSUNE
Self Portrait with a Straw Hat 1911

NAKAMURA TSUNE
Nude Girl 1914
Oil on canvas, 80.3 x 65.2 cm/31⅝ x 25⅝ in
Aichi Art Gallery, Nagoya

In 1914, from March until July, a large-scale general art show called the Tokyo Taishō Exposition was held in the Japanese capital. *Nude Girl* was exhibited there, along with another by the same artist. The second painting, *A Still Life* (1911, location unknown) was awarded the Bronze Prize.

The model for *Nude Girl* was a girl named Toshiko, the eldest daughter of the Souma family, who occupied the building directly behind the one that housed Nakamura's studio. The family received various kinds of help from the artist over the years. Toshiko's parents operated the Nakamura-ya Bakery in the Shinjuku district, a popular place among artists. So well liked was the spot that around it there developed what might well be called the "Nakamura Salon." The bakery represented the most outstanding example of a European-style intellectual atmosphere to appear in Japan during the early Taishō period. Relationships that developed among those who frequented this "salon" exerted a great influence on Nakamura's spiritual and psychological formation.

Nakamura's entries in the Taishō Exposition evoked differing opinions. One critic wrote that "Nakamura's *Nude Girl* is saturated with blood and crimson. And while one might admit that the joys of youthful flesh are well depicted, it is regrettable that the softness of the body is lost in the dazzling intensity of his colors." Another expert commented, "In viewing Nakamura's *Nude Girl,* an image of a Renoir female came immediately to my mind." Evidently the critics assumed that the artist's intention was to use the body of this young girl to express a feeling of sensual vitality that could evoke memories of Renoir, a strategy not considered by those writers to be worthy of special critical acclaim.

In his depiction of the nude body, Nakamura hesitated during the creative process, a fact seen in a number of heavily painted-over details such as the left nipple, right elbow, and the back. If the calm and leisurely expression of the body achieved by the aged Renoir was indeed the goal of the painter, then this work surely does not reveal it. In addition, the contrast between the stolid, greatly simplified expression given to the hands, and the great detail lavished on the sofa in the background cannot be described as particularly effective.

More than the other elements in the composition, it is the head that draws our attention, in particular the model's vivid facial expression. The eyes and brows convey the feeling of a strong-willed intelligence that will not be denied. The nose and blushing cheeks preserve a childlike character, the full lips a healthy sensuality. Surely it was in the face that the artist worked hardest to express the individual character of his model. Nakamura was attempting to capture that part of the human form that is most indispensable, and the most uniquely individual. This is not simply an anonymous, unclothed model but is a portrait that expresses a real personality.

There is a related episode concerning this picture that is worthy of mention. According to various accounts, the principal of the Christian mission school that Toshiko was attending happened to go to the exhibition. Looking over the works displayed, she was greatly surprised to find one of her own students pictured, almost totally nude. She subsequently asked that Nakamura's painting be withdrawn. Of course, what made Toshiko capable of behaving in what, at the time, must have been an extremely bold manner, was not the young woman's own lack of decorum. It was rather the atmosphere in which she found herself at the "Nakamura Salon" where art, above all else, was judged important. It is thought that about this time a budding romance blossomed between the artist and his model Toshiko, though it was doomed to end in catastrophe.

Tsutomu Mizusawa

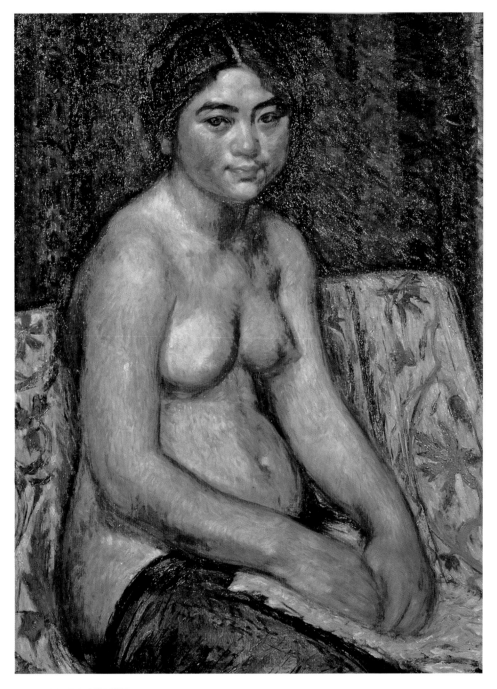

NAKAMURA TSUNE
Nude Girl 1914

NAKAMURA TSUNE
Seashore at Hiraiso 1919
Oil on panel, 23.5 x 33 cm/9¼ x 13 in
Tamagawa Museum of Modern Art, Ehime

When discussing Nakamura Tsune we can not ignore the fact that he was long confined to bed with consumption. For twenty years, from the occurence of the disease at age seventeen to his death at thirty-seven, he kept on striving to accommodate himself to this menacing disease. Shortly after the first attack he went to the seaside in Hōjōminato, Chiba Prefecture, for recuperation. *A Rock* and *A Seaside Village*, two paintings he presented to the public at age twenty-four, were produced while he sojourned in Chiba and Ibaraki Prefectures, seeking fresh air away from the city. Several later paintings, in which he gave vent with violent brushwork to the agony of a love frustrated on account of the disease, were created during his visit to the volcanic Oshima Island.

Nakamura remained in Hiraiso, Ibaraki Prefecture from July to September 1919. There his simple routine of walking, reading, and sketching was often disturbed by a high fever and hemoptysis. This trip was his last attempt to recover his health in a rural environment. Thereafter, he remained at home, virtually unable to leave his bedroom and atelier. Thus these landscapes, including *Seashore at Hiraiso*, are inseparably connected with his restless travels seeking respite from his tuberculosis.

Due to his health Nakamura could not extend his creative activities or his circle of friends, nor could he travel to Europe to study painting. Yet in the midst of his quiet life he endeavored to understand European conceptions of painting all the more deeply. He most respected Rembrandt, Cézanne and Renoir, and he sought in their works a sustenance which could nourish his own ideas of painting.

For *Seashore at Hiraiso* the painter studied the calm sea on a summer afternoon from the garden of his hillside lodging. The picture is not one of his most finished works; it remains a sort of sketch, in which he tried to allay his restlessness during these days in which he sought quiet. Nevertheless, Nakamura exposed his intractable melancholy in the manner he rendered the grass and tall trees in the foreground in violent strokes. Nakamura rarely overlaid a canvas with short strokes like these in *Seashore at Hiraiso*, in order to catch the entire scene at once as in van Gogh's style. In only one other picture, in which he also depicted a view of Hiraiso, can similar characteristics be found. Standing before the peaceful prospect of the fishing village, the painter could not find himself in harmony with this scene; and I believe *Seashore at Hiraiso* therefore conveys how disheartened the artist felt in his forced solitude in rural Japan.

Hikaru Harada

206

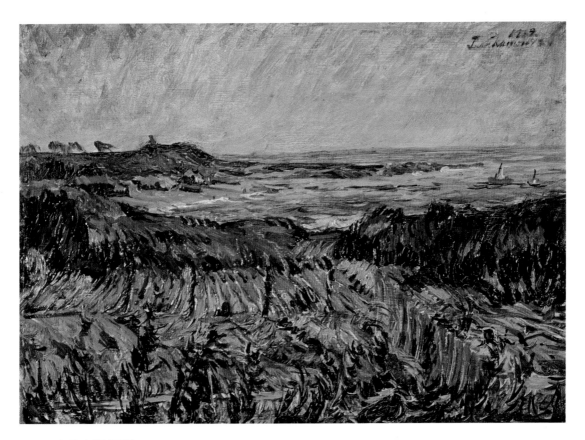

NAKAMURA TSUNE
Seashore at Hiraiso 1919

NAKAMURA TSUNE
Still Life with Wrapping Paper from a Bottle
of Calpis 1923
Oil on canvas, 60.7 x 50.2 cm/23⅞ x 19¾ in
The Ibaragi Prefectural Museum of Art, Mito

This picture was produced in 1923, one year before Nakamura Tsune died. His tuberculosis advancing, he was mostly confined to bed, but as far as possible he still managed to go to his atelier, producing fine works one after another during his last two years. Still lifes and portraits of himself and the people around him were the only possibilities that the sick artist could now choose as subject matter.

Nakamura produced several successive still lifes from the summer to the autumn of 1923. Calpis, which figures prominently in this painting, is a fermented milk drink that first appeared in 1919 and quickly won extensive popularity. As it was thought to be effective against tuberculosis, we may suppose that the painter took it habitually. When sold, it was wrapped in polka dot paper, which, in this picture, lies unfolded on the table.

Of his life of this period he wrote,

My physical condition was relatively good and, somewhat carried away with my own happiness, I was able to paint two or three still lifes, one after the other. This effort may have affected my health. Since I caught high fever, I have not been able to get up. I was convalescing for several days, but then the fever recurred, probably because I had cut a board and painted it with a design, intending it as the background for a new composition.[1]

The board that he "cut as the background for a new composition" has a shape something like a church spire, and it can be seen behind flowers in the *Still Life with Wrapping Paper from a Bottle of Calpis*. Introducing this unusual object into his painting he "hoped to express that solemn mystery and feeling of infinity which one experiences inside Gothic churches," as he wrote in a letter to his friend. Many simple and speedily drawn lines establish a vertical thrust toward the upper edge of the picture. This movement is the expression of his moral desire, and as can be seen from the niche carved in one side of the wall behind, this spiritual motivation expressed his religious, Christian longing for Heaven. Therefore this still life can be understood as a religious work meant to represent a sort of prayer by the sick painter. The design is composed of simple forms in a manner he seems to have acquired from Cézanne, but any direct influence from the French painter was now completely assimilated into Nakamura's own style. Thus Nakamura created a spiritual world visualized through powerful lines and intense forms.

On September 1, 1923, just before the picture was completed, the region around Tokyo was hit by a devastating earthquake. The death toll exceeded 90,000. Although Nakamura did not directly suffer any loss, he wrote to a friend, "this earthquake brought home to me that, except for my painting, I have no means to procure absolute security in my own mind and so to overcome death." Witnessing the unexpected death of so many others, he understood that he could never avoid his own death, now so imminent. As it was unavoidable, he decided to imbue his life with significance through his painting. In Nakamura's case, the act of painting became that of praying. As a youth, he attended church and received baptism. Now having contracted an incurable disease, compelled to lead a solitary life, he regarded with intensity his personal reality and thereby fostered in himself a profound moral sense. The very act of painting, and the content of his pictures, can thus be seen as an expression of the sincere, serious mind of a man confronting death.

Hikaru Harada

Notes:

1. Nakamura Tsune, *Geijutsu no mugenkan* (Tokyo: Chūōkōron bijutsu shuppansha, 1977).

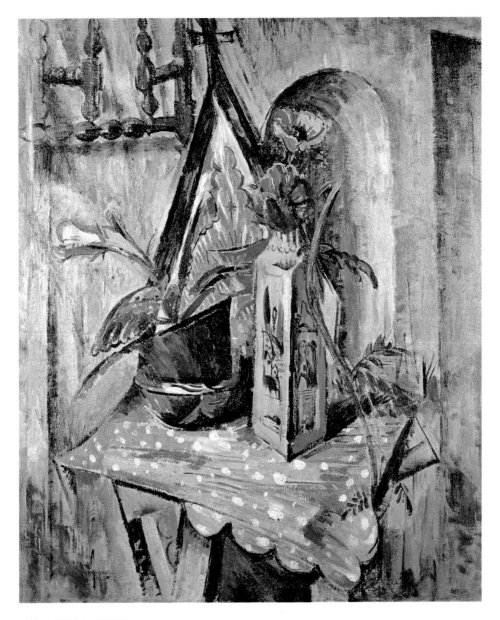

NAKAMURA TSUNE
Still Life with Wrapping Paper from a Bottle of Calpis 1923

OKADA SABURŌSUKE
Hagi 1908
Oil on canvas, 119.9 x 78.9 cm/47¼ x 31 in
Hyogo Prefectural Museum of Modern Art, Kobe

This work was submitted together with two others to the second *Bunten* exhibition in 1908. The model is thought to have been the younger sister of the artist's wife Yachiyo (who was in turn the younger sister of the dramatist Osanai Kaoru), whom he married in 1906. The picture takes its title from the *hagi*, a plant native to Japan, also known as Japanese bush clover. Traditionally thought of as the harbinger of autumn, *hagi* is one of the country's best-loved plants. That the title of this painting, *Hagi,* does not identify it as a figure painting, or name the sitter, is perhaps a manifestation of the tendency to emphasize literary sentiment referred to as "Meiji Romanticism," which came to the fore during the first decade of this century.

Having already assimilated the principles of plein-air painting introduced into Japan by KURODA SEIKI and KUME KEIICHIRŌ, Okada studied in France between 1897 and 1902, receiving guidance principally from Raphaël Collin, who had also taught KURODA and KUME. In the present work Okada, whose natural style as a painter was closer to that of Collin than were the styles of his distinguished Japanese predecessors, placed the figure in an outdoor setting and introduced a somewhat cloying lyricism that discloses eclectic techniques he acquired from Collin. KURODA offered the following appraisal of Okada's work:

Okada's style has gradually changed over the years, but the feature which remains constant throughout is the supremacy of color over form . . . Okada seems never to grow weary. He takes the greatest trouble over the most minute detail. This is why it is difficult to discover the real virtues in Okada's work, unless attention is paid to the finest points of detail. Works of his which do not take such care with detail are by no means among his best.[1]

The artist's brush is here concerned with painting his subject matter in "the most minute detail." There is no trace of any Impressionistic division of brush strokes. The artist is intent rather upon painting an idealized portrait in a mildly plein-air manner. We see here the academic, idealized aspect of Collin's work applied to Japanese motifs.

Okada's personality as an artist is revealed by the way in which these Japanese motifs are painted on the canvas after being subjected to the most minute examination. The girl's hair style is by no means a traditional one, but is a chignon in the Western style. She holds in her hands a Western-style umbrella, and the large butterfly pattern to be seen on her Japanese-style clothing is not a pattern which would have been seen in traditional Edo dress. Modernity is thus combined effortlessly with traditionally represented motifs. The detailed depiction of the shape and texture of each motif adds the atmosphere of realistic genre painting to this portrait. Balancing detail with the character of the model, this work is one which illustrates the virtues of this painter at a time before Okada veered towards a rather vulgar form of lyrical expression.

Tsutomu Mizusawa

Notes:

1. Sakai Saisui, "Okada Saburōsuke," *Bijutsu shinpō*, April 1911.

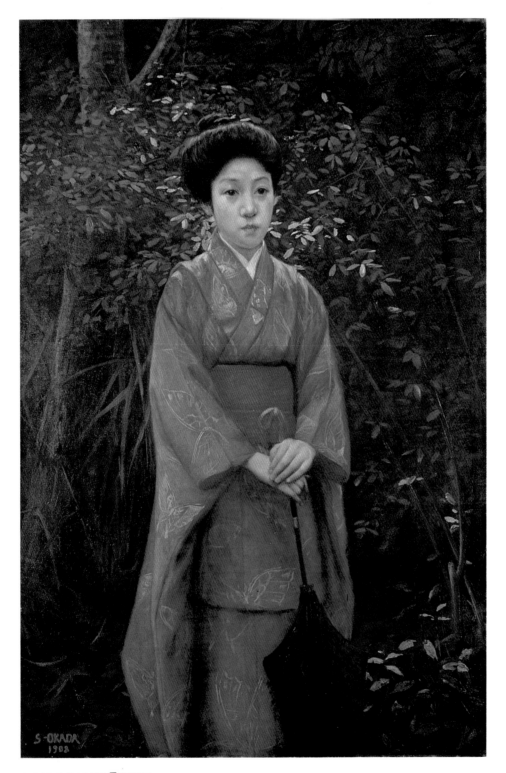

OKADA SABURŌSUKE
Hagi 1908

SAEKI YŪZŌ
Snowy Landscape 1927
Oil on canvas, 61 x 72.5 cm/24 x 28½ in
The National Museum of Modern Art, Tokyo

"It was after Saeki's first visit to Europe that his canvases began to show a real combustion of artistic energy. His works prior to that voyage may be called an extention of his studies begun in school," wrote MAETA KANJI, who was studying at the same time in Paris. "At first he did not move beyond the knowledge of any other art student in terms of how to produce this color of the human body, or that of ground. It was in France that, enraptured by his contact with a number of masterpieces, he came to be driven by the desire for true creation."[1] Probably no one would deny that the authentic life of Saeki as a painter started in Paris.

Accompanied by his wife and daughter, Saeki left Kobe in November 1923 and arrived in Paris, the place he had so ardently yearned to see, in January 1924. Early works produced during this first stay in Paris, such as *A Distant View of Notre Dame* or *A Distant View of Paris*, reveal a considerable influence from Cézanne. To break the fetters of this conventionalism, to obtain his own identity, it was necessary for him to encounter Maurice de Vlaminck. This took place in 1924; yet even though Saeki was enlightened by this meeting, he never wholeheartedly dedicated himself to following that painter. Maurice Utrillo eventually came to serve as a more important mentor.

Snowy Landscape serves as a useful illustration in this regard. In particular, Saeki's many paintings of snow-covered landscapes recall those of Vlaminck's own wintry landscapes, one of his most characteristic motifs. Two snowscapes of Paris, for example, both produced about 1925, show a treatment that closely resembles Vlaminck's. Yet four oils, each titled *Snowscape*, finished in 1926 after Saeki's return to Japan, look quite different both in composition and brushwork from those produced in Paris. One of them creates an atmosphere redolent of the Southern School of Chinese painting, and is reminiscent of certain works of the Japanese literati painter Yosa Buson (1716–1783), himself much influenced by the Chinese example. The painting shown here was originally titled *A Snowball Fight*, rather than *Snowy Landscape*. As the original title suggests, the painting, although basically a landscape, does stress as well the movement of a group, a subject seldom taken up by Saeki. The choice of this subject matter alone signi-

fies an important difference between Saeki and Vlaminck.

The painting is said to represent a wintry scene near an elementary school in Shimo-ochiai, the district in Tokyo where Saeki set up his atelier. The art critic Imaizumi Atsuo describes the work as "a picture beautiful in its harmony of white and brown." He points out the painter's dexterity in coloration and finds the work one of the superior pieces in the relatively unproductive period after Saeki's homecoming.

Shunrō Higashi

Notes:

1. Maeta Kanji, "Saeki Yūzō," *Bi no kuni*, vol. 5, no. 2, February 1929

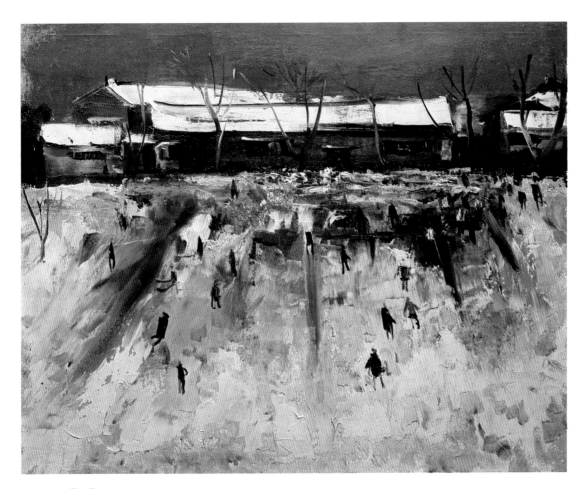

SAEKI YŪZŌ
Snowy Landscape 1927

SAEKI YŪZŌ
Newspaper Stand 1927
Oil on canvas, 80 x 73.5 cm/31½ x 28⅞ in
The Asahi Shinbun, Tokyo

In an article written by Saeki's wife Yoneko, published in the September issue of the magazine *Shufu no tomo*, she related the following incident concerning her husband.

Saeki had always studied diligently, but after he went to Paris for the second time, he began to paint with such vigor that it almost seemed as though he were possessed. It was probably about this time that he developed his characteristic style of painting. With swift brush strokes, he would complete two or three paintings a day. The fact that these works, painted so hastily, would later be called masterpieces is beyond anything I could have imagined. He used a minimum of brushstrokes yet devoted the utmost care to the composition of each work, from edge to edge. Such a style, however, grew from his strenuous labor, his daily practice. His brush movements were as quick as the breaths he drew. Those who watched him were amazed.

It is said that the time Saeki needed to complete a work was drastically shortened after his traumatic meeting with Maurice de Vlaminck during his first visit to Paris. Determined not to allow his inspirations to escape him, Saeki constructed his canvases himself and used a special ground. As a result, he sacrificed the durability of the canvas. He was more driven by the urgency to create a picture as soon as possible than by the desire to preserve his work for posterity. In a well-known letter to his friend the painter Satomi Katsuzō, Saeki wrote that in the few months since arriving for the second time in Paris in August 1927, he had painted 107 works in September and another 145 in October.

Another artist resident in Paris at the time, Nakayama Takashi, confirmed Saeki's abnormal absorption in painting.

When he began to exert himself he would simply continue to paint one piece after another. As long as it was not raining heavily, he would spend all morning and afternoon in his usual dirty clothing and oversized shoes in the middle of some grey road, or in front of some country cafe. At times, he would produce three or four paintings a day. Winter was approaching Paris. Yet except for the fact that he wore gloves, there appeared no change in his atti-

tude. Indeed, he could stand at the edge of some frozen road for hours on end, painting. . . .[1]

A painting named *Newspaper Stand* was entered and chosen for the Paris *Salon d'automne* in 1927. It is quite likely that the present painting is that work, and it can be considered typical of those produced early after Saeki's return to Paris. The newspaper lettering that decorates both sides of the building, for example, creates a relatively simple effect and does not yet possess the coloring and skill of composition mastered in his last works.

His friend MAETA KANJI wrote of Saeki:

When his natural inspiration began to possess him, he would go into a literal frenzy. There was no single trace of personal intent, effort, or formative development in these works; he would capture the instantaneous changes in nature, like the drifting light, and could imprint each second with his own fleeting sensibilities. These pictures serve as symbols of his strong impulsiveness.[2]

As MAETA noted in his essay, the final stage of Saeki's art, in which this impulsiveness in turn dissolves, would come still later. Yet even in some of the pictures created during these months there are already subtle signs of Saeki's loneliness.

Shunrō Higashi

Notes:

1. From an essay published in 1929 by the *1930 kai.*
2. Macta Kanji, "Sacki Yūzō," *Bi no kuni*, vol. 5, no. 2, February 1929.

SAEKI YŪZŌ
Newspaper Stand 1927

SAEKI YŪZŌ
Posters and the Terrace of a Cafe 1927
Oil on canvas, 53.5 x 65 cm/21 x 25⅜ in
Bridgestone Museum of Art, Tokyo

In 1925, Saeki was still in Paris, where he had gone to perfect his art. In November, he wrote a letter to one of his former fellow students at the Tokyo School of Fine Arts. In it, he described his own situation at the time. "Right now, I cannot say that I am a disciple of Vlaminck. In terms of my own material, I have not actually moved away from the things I have learned from Vlaminck. Still, what I paint is not Vlaminck—I would say it is closer to Utrillo. I hope that I can bring the old city of Paris back to my native Japan." In another, he wrote, "I have been trying hard to find out just where I am, and I think that I have succeeded for the most part."

These statements were made at the end of the painter's first visit to Paris. The European artists who had the most profound influence on Saeki during his initial stay in Europe were Maurice de Vlaminck and Maurice Utrillo. The incident of Saeki's meeting with Vlaminck is discussed elsewhere in the catalogue. Another event, equally pivotal for Saeki's development, was an Utrillo exhibition in May 1925 held at the Galerie Bernheim-Jeune. Fascinated by the work of the French master, Saeki first adopted the French artist's method of grasping, then depicting a Parisian city scene in a large and sweeping way. Then he moved in closer to his subject, filling his canvases with the play of light on the store fronts.

Eventually, Saeki was able to free himself from the Paris of Utrillo and paint his own vision of the city. At that point, his preferences moved to expressions of the beautifully textured quality of the soiled and aged walls of the buildings he encountered. Parallel to that interest was his fascination with lettering and posters, which became an important element in his compositional style.

The paintings that Saeki created during his year-and-a-half back in Japan in the mid-1920s did not possess any of the features so characteristic of his first European period. Rather, in retrospect, they suggest a discontinuity or interruption in his stylistic development.

On his return to Paris in 1927, Saeki, like a man possessed, resumed painting the withered face of the city. His second Parisian period was a brief one; by March 1928 he had been hospitalized.

Among these bursts of activity were a group of paintings sometimes referred to as the "advertisement" series, which show qualities quite different from those created during his earlier sojourn. In those first works, his fascination with posters and lettering might be said to be limited to the painted letters themselves; now he created calligraphy. These flowing and vibrant shapes, and not the buildings, here become the focus of attention.

We know from an inscription in the upper right hand corner that the present painting was done on November 27, 1927. By this time, the new calligraphic style has been applied not only to the lettering but to the chairs, the tables, even to the figures that inhabit his scenes. In this respect, Saeki reveals a consonance of spirit with the great calligraphic masters of the past, with links going back through Japan to the great Chinese masters of the T'ang Dynasty.

Kenichirō Makino

216

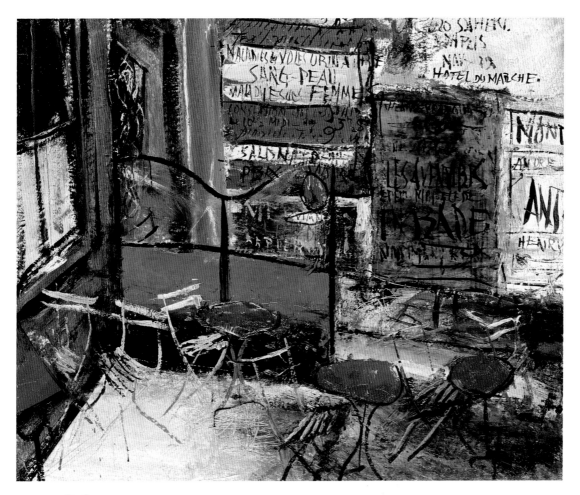

SAEKI YŪZŌ
Posters and the Terrace of a Cafe 1927

217

SAEKI YŪZŌ
Restaurant 1927
Oil on canvas, 59.3 x 72 cm/23⅜ x 28⅜ in
Yamatane Museum of Art, Tokyo

Restaurant was a work produced during the early days of Saeki's second stay in Paris. The artist returned to the French capital in August 1927, after a journey on the Siberian railway, accompanied by his wife and child, as on his first visit. After spending a few nights in a hotel, they moved to a newly-built atelier, with the walls still damp, which Saeki had located at 162, Boulevard du Montparnasse. His wife Yoneko later recollected that, "after returning to Japan, my husband, it seems to me, was constantly thinking he could only accomplish the task remaining to him during his life by going back to Paris in order to paint the soiled walls and loosely-fixed posters he found on the back streets." Thus it seems when Saeki made this second voyage to France, he was prepared for a final creative effort prior to what he must have felt was his imminent death.

Yoneko wrote as well that her husband "painted pictures around Montparnasse. Yet as there were in the neighborhood an observatory and the Luxembourg gardens, the district showed the kind of beauty that comes from orderliness. He felt this too well trimmed, too far removed from what he was actually seeking. So he resorted to the back streets, with his canvas under his arm." MAETA KANJI, a friend who truly understood the essence of Saeki's art, described the same phenomenon as follows:

> What could not be called 'unclean' among his motifs? His subjects are houses, rubbish pasted over with advertising bills, sheds, shoe stores, garages, even public lavatories, outdoor cafes in crowded suburban areas, all kinds of soiled and faded things we witness every day. And the more he occupies himself with these things, the more forcefully his works impress us.[1]

The novelist Yokomitsu Riichi, who lived for some time in France himself, declared that Saeki's pictures may express "the surprise of a Japanese in Paris," in the sense that he discovered scenes in the back streets that Parisian painters seldom if ever attempted to depict. On the other hand, Saeki did not merely look at Paris with the eyes of a foreigner. Rather, archetypal scenes dormant within the innermost recesses of his mind were activated and materialized by the actuality of Paris. Saeki did not set out to comprehend Paris intellectually; his soul found his own dreams there. For that reason, the scenes that he encountered were never unclean in his sight. When he wrote that he found the old houses of Paris interesting and the smokestacks and advertising bills beautiful, he was telling the truth. He aimed at a means of artistic expression in which both the clean and the unclean could coexist.

The restaurant that is the subject of the Yamatane Museum of Art canvas is expressed as part of a flat wall, without the perspective needed to show its thickness and bulk. We are shown walls covered with posters in a disorderly way. The artist's sensitive coloration of color planes, not depth in space, conveys his response to the motif. Saeki never acquired a three-dimensional vision. SAKAMOTO HANJIRŌ, the painter who knew Saeki's work well, noted Saeki's disinclination to create depth in his work, which made his treatment of human figures unsatisfactory, since, as SAKAMOTO put it, "human figures cannot be treated like landscapes." He observed that, rather, Saeki depicted objects flatly so that he could bring out distances freely, with ease and without obstructions, in the manner of the Southern School of traditional Chinese painting.

Shunrō Higashi

Notes:

1. Maeta Kanji, "Saeki Yūzō,"*Bi no kuni*, vol. 5, no. 2, February 1929.

218

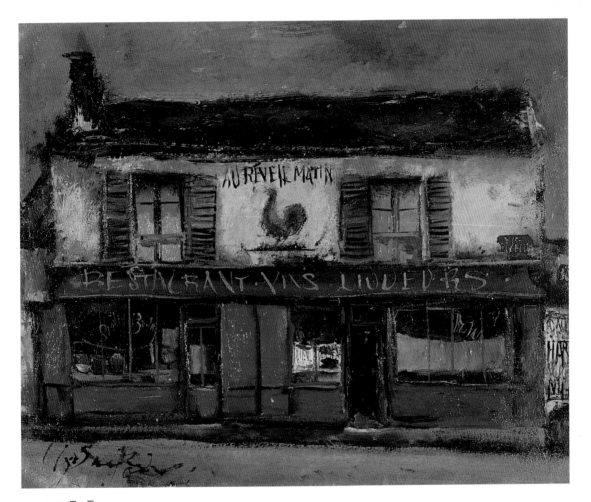

SAEKI YŪZŌ
Restaurant 1927

SAEKI YŪZŌ
Church of St. Anne 1928
Oil on canvas, 72.5 x 59.7 cm/28½ x 23½ in
Mie Prefectural Art Museum, Tsu

When Saeki's friends and colleagues published a first
overview of his work in 1929, this picture was la-
beled "Sacré Coeur," and until 1970 it was known
by that name. The art historian Asahi Akira, who
much admired Saeki's work, then identified the sub-
ject as St. Anne de la Maison Blanche, located in the
thirteenth arrondissement. Asai's research seems to
indicate the relatively late date of 1928, during the
artist's second Paris visit.

The calligraphic lettering that covers the surface
of so many of Saeki's "advertisement" and "cafe-
restaurant" paintings is entirely missing here. A
portion of the buildings facing onto the back streets
behind the church are done in a brick red tone. Other-
wise, the entire canvas is a monochromatic black and
white, bathed in a bluish light that provides unity to
the scene. In the background, the way in which the
artist has depicted the dome of the church with its
two small towers trailing smoke gives the effect of a
Japanese ink painting. All in all, this work serves as a
remarkable contrast to the violent play of line and
letter, the psychological dramas and tensions of Sae-
ki's "advertisement" and "cafe-restaurant" paintings.

Prior to Saeki's return to Japan in 1926, he told
Serizawa Kōjirō, the noted Japanese novelist then liv-
ing in Paris, "I don't really want to return to Japan,
but I have the feeling that if I go back and look at
our traditional styles of Japanese paintings, things
like landscapes and sacred images, I may be able to
better perfect my own paintings. That's why I've re-
signed myself to making the long trip back." When
he arrived back in Paris, in November 1927, he told
his painter friend Kinoshita Shōjirō that "when I re-
turned to Japan, I was greatly impressed by Oriental
art." Saeki's unconscious Orientalism, on the other
hand, seen for example in the manifestation of line in
the "advertisement" series, is quite different from the
calculated synthesis of Eastern and Western aesthetics
achieved by FUJITA. *Church of St. Anne* shows
Saeki's proclivities in quite another way. In this
painting the artist has deliberately adopted an Asian
form of expression taken from the techniques em-
ployed in ink painting. Here Saeki is moving from
an unconscious regression to the East to a conscious
return to things Oriental.

Kenichirō Makino

220

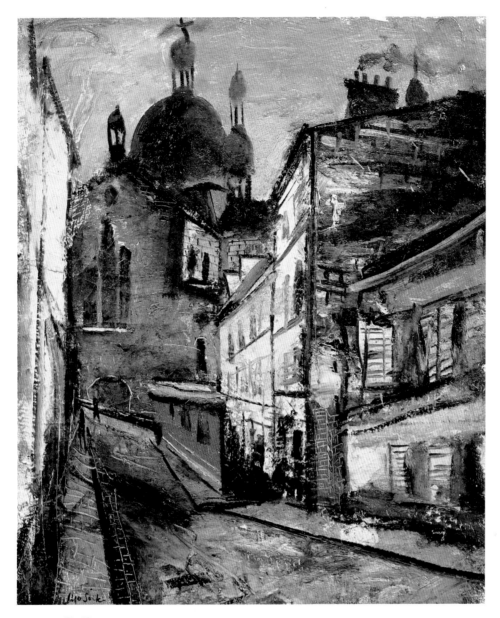

SAEKI YŪZŌ
Church of St. Anne 1928

SAITŌ YORI
Self Portrait 1929
Oil on canvas, 53 x 45.5 cm/20⅞ x 18 in
Kasama Nichido Museum of Art, Kasama

Painters who returned home from France in 1909 and 1910 began to assert new principles for painting distinct from the aesthetic ideas of those who studied in Europe before them, such as KURODA SEIKI and KANOKOGI TAKESHIRŌ. Saitō Yori, who returned home in September 1909, participated in the movement to promote new ideas. Although he accompanied KANOKOGI to Paris, Saitō was not content with Jean-Paul Laurens's instruction at the Académie Julian and so sought to assimilate the techniques of such masters as Puvis de Chavannes, Gauguin, and the "Nabis" as well as other Post-Impressionists.

After returning to Japan, Saitō led a campaign of revolt against the *Bunten* exhibitions, which had been established by the Ministry of Education in 1907. He organized the *Société du Fusain* together with Takamura Kōtarō and KISHIDA RYŪSEI, and he joined those who created the literary journal *Shirakaba*, which was then introducing Impressionism and Post-Impressionism into Japan. The first exhibition of the *Société du Fusain* was held in 1912. Saitō's works presented at this time show a certain influence of Gauguin. Nevertheless it seems that he modeled his methods more closely on those of Puvis de Chavannes, whom he so much admired. Puvis exerted immense influence on those Japanese artists who studied in Paris, particularly those painters and sculptors arriving in France prior to World War I, most of whom landed at Marseilles. These Japanese, it seems, customarily sought out Puvis's canvases in the Musée de Marseilles and his frescoes in various monuments there. The August 1916 issue of *Bijutsu shinpō*, an important art journal, was a special number devoted to Puvis de Chavannes. It contains many interesting articles written not only by figures of the new generation such as Takamura Kōtarō and ARISHIMA IKUMA but also teachers at the Tokyo School of Fine Arts such as KURODA SEIKI, KUME KEIICHIRŌ and OKADA SABURŌSUKE. Saitō Yori also contributed a monograph entitled "The Art of Puvis de Chavannes," in which he wrote:

We esteem classic art. But we are disinclined to follow the theory and practice of the classic artists. This unwillingness, I think, is natural. We can only say that even though our manners are different from theirs, we finish our art by overcoming this difference in thought. . . .

After declaring his artistic standpoint, Saitō explained his specific interest in Puvis:

As Puvis's works, unlike Cézanne's, are classical in their motifs, they are easily confused with common mythological fabrications. But when we understand this fact, and penetrate the reality of his work, we realize that none of his creations are frivolous products, artificial fabrications or mere ornaments. Rather, his style is a vessel for his thought and his taste. . . .

Saitō identified Puvis "as an idealist, outside the world of the Impressionists" and described, in his analysis of the atmosphere peculiar to the French painter's works, the fact that the art of Puvis sought not passion but tranquility, "presenting the solemnity of nature." Saitō concluded that the originality of Puvis's art, in contrast with Impressionism, which directly deals with modern civilization in terms of themes and techniques, lies in "its attitude of opposing modern civilization," which is an important element that guided Puvis in the composition of his pictures:

His works present an objective beauty and are even religious. They bear on a world which is different from modern civilization as treated by the current generation of impulsive artists. While these impulsive artists reproduce objects before their eyes in their own subjective manner, Puvis de Chavannes deals with the objective world which appears in his meditation. . . .

Saitō's *Self Portrait* is thus both a record of his commitment to a style and a memento of an artist responsible for the diffusion of new concepts of painting in Japan prior to World War I.

Tōru Arayashiki

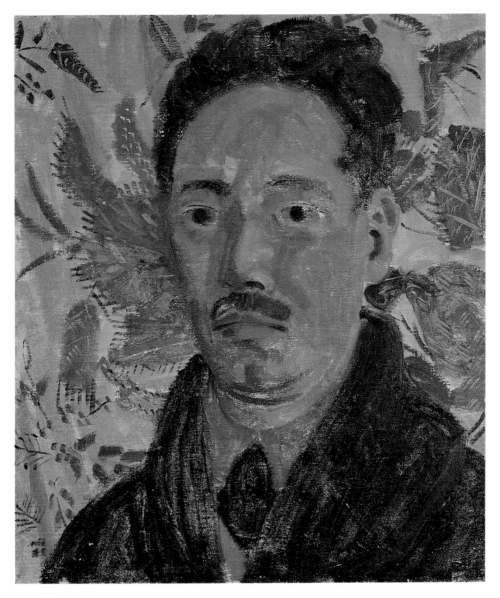

SAITŌ YORI
Self Portrait 1929

SAKAMOTO HANJIRŌ
Scene at Oshima Island 1907
Oil on canvas, 116.3 x 73 cm/45¾ x 28¾ in
Fukuoka Art Museum, Fukuoka

In his memoirs, Sakamoto commented on his re-
action to paintings by his childhood friend AOKI
SHIGERU, who in some ways was considered his
artistic rival.

> *It was from literature that Aoki obtained his ideas
> for his pictures. And by avoiding a real confronta-
> tion with nature, either intentionally or unintention-
> ally, and by substituting his subjective imagination
> for realistic representation, I believe he weakened his
> art. In pictures like* A Good Catch *or* Palace
> Under the Sea *[Cat. 2], Aoki's use of his imagi-
> nation in the construction of his works was exces-
> sive. Fantasy as such is good, but when you pursue
> such themes, with only dreams to guide you, you
> will in the end find yourself at a loss with the con-
> tradictions in your thinking. In Aoki's case, it is all
> the more regrettable, for I have never encountered
> such a sensibility to color or such a power of
> representation.*[1]

No doubt a peculiarly vague style, created to
overcome those "contradictions in thinking," re-
mains a hallmark of Sakamoto's own late manner,
which admits of nothing literary. Nevertheless the
early works created in his mid-twenties, such as the
present work, reveal an expression of melancholy
that surely has something in common with literature.

Scene at Oshima Island was first shown in 1907,
the year after he spent the summer with his friend,
the painter MORITA TSUNETOMO, on Oshima Is-
land. Sakamoto later published an account of this
trip in the art journal *Hōsun*. There he described the
bucolic life of the people he saw living on that vol-
canic island: "When I saw a group of women draw-
ing water, crouching, then resting on a bank, I felt
the kind of animation that might be found in a pic-
ture by Burne-Jones." This phrase bears a relation-
ship to the narrative character of his works of this
period, paintings that are somewhat out of tune with
the social realities of Meiji Japan and which convey a
certain ennui that reflects the sensibility of the painter.

In 1905, Sakamoto made a copy of a graduation
thesis written by Umeno Mitsuo, a friend from
Kurume, the artist's home town, entitled "Dante
Gabriel Rossetti as a Pre-Raphaelite Painter." Umeno
was a friend as well of AOKI SHIGERU, and, through
him, of the well-known poet Kanbara Ariake, who

did much to make AOKI'S work known. Given this
circle of kindred spirits, Sakamoto could scarcely
have been indifferent to the romantic and spiritual
atmosphere they created in their own works.
Sakamoto was not to establish his own artistic indi-
viduality until 1912, in a work entitled *Dim Daylight*,
in which he created a vision that could transcend the
facts observed by the the artist's eye.

Shunrō Higashi

Notes:

1. Sakamoto Hanjirō, *Watashi no e watashi no kokoro*, (Tokyo:
Nihon keizai shinbunsha, 1970), p. 43.

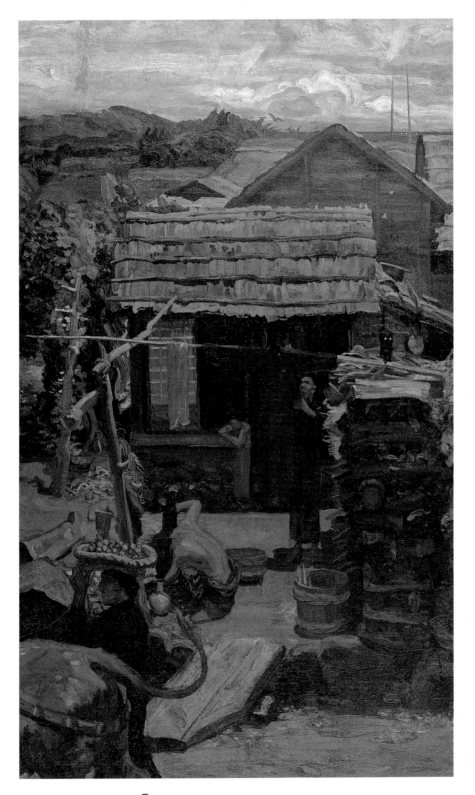

SAKAMOTO HANJIRŌ
Scene at Oshima Island 1907

SAKAMOTO HANJIRŌ
Villa Grenais in a Suburb of Paris 1922
Oil on canvas, 33.3 x 41.1 cm/13 x 16⅛ in
Hiroshima Museum of Art, Hiroshima

Compared with other painters, Sakamoto was less willing to go to France. He believed that he had established his method of creation with *A Cow*, a picture he presented at the seventh *Nikakai* exposition in 1920. But as he later wrote, when a friend insisted, "in that case, Europe is all the more worth your seeing," he was not able to resist the temptation to go abroad.

Determined to stay in France for three years, Sakamoto embarked at Yokohama on July 31, 1921, after he had secured resources for his foreign sojourn by selling paintings and receiving gifts from his patrons. Incidentally, among his fellow-passengers on the ship were the Western-style painters KOIDE NARASHIGE, Hazama Inosuke (b. 1895) and Hayashi Shizue (1895–1945). Landing at Marseilles on September 17, Sakamoto arrived in Paris the following day. He settled in a dwelling with an atelier that Saitō Toyosaku (1880–1951), an oil painter who was already living in Paris, had found at 18 rue Ernest Cresson, in the 14th arrondissement. KOJIMA TORAJIRŌ had previously resided at this house near Montparnasse, and when Sakamoto moved in, the painters Masamune Tokusaburō (1883–1964) and Koyama Keizō (b. 1897) were also lodging there. In October Sakamoto entered the Académie Colarossi through the introduction of Saitō Toyosaku. At this school, on rue de la Grande Chaumière, which counted among its alumni Gauguin, Rodin and Whistler, Sakamoto attended the classes for half a year of Charles Guérin, one of the leading figures of the Société des Artistes Français. Soon after, seeking new motifs, he wandered the streets and outskirts of Paris, and visited museums and galleries until July 1924, when he returned to Japan. Sailing from Marseilles, he arrived at Kobe on the first of September.

In a letter sent to the *Asahi shinbun* from Paris, Sakamoto wrote, "When we see the works of such great masters as Cézanne, Renoir, Monet and Manet, we do not really feel that we can entertain a hope any longer." He and KOIDE NARASHIGE were in this regard free from illusion in comparison to many Japanese painters, most of whom, valuing the French art created after Impressionism, were bent on imitating the forms of Cubism and Fauvism. Both Sakamoto and KOIDE, however, understood the gap between Japan and the West, especially with France, and they were clearly aware of their own positions on art from the outset. From his standpoint, Sakamoto's concern was to express on canvas "human beings," a goal that had been lost after the advent of Cézanne. His discovery of Corot as a pioneer who had carried out this task doubtless achieved the objective of Sakamoto's overseas study. From that period to his final years Sakamoto repeatedly talked about Corot, for whom his esteem never waned.

But this discovery does not account for the whole gain resulting from his stay in France. We can say that Sakamoto's manner of showing objects by going beyond their external forms to give a more profound existence, using simplified color tones, was in a real sense fully developed by the stimuli he received and trials he had undergone in France. Above all, Sakamoto came to express clearly his sensibility and to combine simplicity with brightness. Here we find a charm absent from his previous works. In a review of his paintings created in Europe, which were presented at the twelfth *Nikakai* exhibition in 1924, the year of his return, the painter Yamamoto Kanae wrote:

> As everyone says, his paintings are spiritual. Still they are nothing but pictures. They do not imply anything literary. Mr. Sakamoto painted only what he saw with his eyes. . . . However, "seeing" is of immense significance, and lies therein a reality that has been depicted by Mr. Sakamoto for the first time.[1]

Villa Grenais in a Suburb of Paris, which was not displayed at this exhibition, is a work produced in the early days of his stay in France. Not seen for many years, it was first placed on view in the Sakamoto retrospective of 1982, when it offered fresh evidence of the evolution of Sakamoto's sensibilities while he was in France.

Shunrō Higashi

Notes:

1. *Atelier*, October 1925.

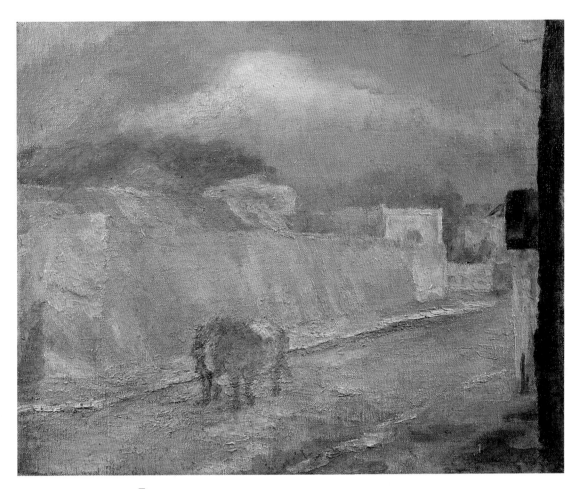

SAKAMOTO HANJIRŌ
Villa Grenais in a Suburb of Paris 1922

SAKAMOTO HANJIRŌ
Horse Coming Out of Water 1937
Oil on canvas, 80 x 116.5 cm/31½ x 45⅞ in
The National Museum of Modern Art, Tokyo

After returning from France in 1924, Sakamoto left Tokyo, the center of Western art, for his home town, Kurume, in Fukuoka Prefecture. In this period, when he was the most vigorous both mentally and physically, it was the subject of horses that Sakamoto tackled exclusively. His temperament proved similar to that of van Gogh's; he could not paint an object unless he saw it before him. In Kyushu, there were then many horses used in farming, and horse fairs were a common occurrence where, it is said, Sakamoto was often seen seeking horses whose arrangement of mane and physique pleased him. He especially loved the horses he found in the pastures around Mount Aso:

What an easy, serene, free, calm and delightful life horses lead! Here, compared with them, human beings appear miserable indeed. What a splendid form they assume when running abreast on green grass, a brawny flow from muscle to muscle. Further, to modulate and accent these movements, their manes and tails are shining, as if bursting with splendor.[1]

Before long, Sakamoto won an unenviable notoriety as a painter "picturing nothing but horses." In apology he wrote,

As I am painting only horses, it has been said that my production is merely repetitive. If I am laughed at for this, I am not hurt at all, but if the meaning of such criticism is that the essence of my pictures remains somehow merely conservative, I will be dismayed indeed. I do not care if I repeat the same subject. If this repetition can endlessly improve the content of my art, then, as a painter, I am, rather, proud. I do not necessarily disregard the opinion that painters, as members of society, should take up social problems as motifs, but what matters after all is the intrinsic nature of their work. Even if a painter pictures one stone, his work, depending on his attitude, may act on contemporary society.[2]

The following recollection illuminates Sakamoto's attitudes even more clearly.

In the old days, a lot of horses were working in fields around here, and in due course, interested in them, I often painted them. My love for them occasioned my pictures, but my purpose was to present

horses and me, in other words, to express my world formed in my mind through the medium of horses. To tell the truth, if I had been interested in, say, rice bowls or nō masks instead of horses, it would not matter at all. The principal constitution of my pictures is not accounted for by objects which are painted, but I myself who paint them.[3]

Horse Coming Out of Water, produced in 1937, was presented at the twenty-fourth *Nikakai* exhibition. Sakamoto stated his feelings about the picture as follows:

Although I have pursued the subject of horses over a considerable period, I have never thoroughly brought out what should be depicted. In this respect, perhaps my work represents a succession of failures. Still I think, however little progress I make, if I persevere in this course I will certainly be able sometime to conquer a small part of the universe of art.[4]

This picture is closely related to a watercolor produced in 1935, which depicts the moment that two horses, a parent and foal, emerge from the water. Again in 1953, Sakamoto turned to this motif and did two oil paintings, which show almost the same composition. The oil paintings, lacking the freshness and liveliness of the sketch-like watercolor, are simple and intense in form and color. In his attempt at an organic integration of the whole, what Sakamoto called "the feel of objects," he created an atmosphere which allows the spectator to envision the slow motion of a cloud, devoid of outlines. This work is neither a product of fantasy, nor is it adulterated by literary elements. Rather, it is a work in the domain of pure painting, one that transcends distinctions between figurative and abstract art.

Shunrō Higashi

Notes:

1. *Atelier,* October 1928
2. *Atelier,* September 1933
3. Sakamoto Hanjirō, *Watashi no e watashi no kokoro* (Tokyo: Nihon keizai shinbunsha, 1969)
4. *Mizue,* October 1937

228

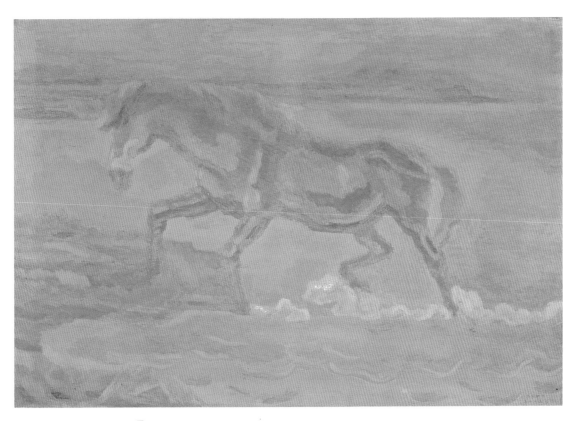

SAKAMOTO HANJIRŌ
Horse Coming Out of Water 1937

SEKINE SHŌJI
Portrait of Inoue Iku 1917
Oil on canvas, 65 x 53 cm/25⅝ x 20⅞ in
Private collection, on deposit to Fukushima
 Prefectural Museum of Art, Fukushima

This work, which was only recently discovered and restored, was displayed for the first time at an exhibition entitled "Sekine Shōji and his Age," held during the autumn of 1986 at the Mie and Fukushima Prefectural Museums.

Inoue Iku (1840–1929), the model for this painting, was the mother of Inoue Okio (1874–1953), who ran a dairy farm in the Fukagawa area of Tokyo, where the Sekine family was living. Entries in Sekine's diary, immediately after completion of *Portrait of Inoue Iku*, are of great interest in that they give an indication of the mixed feelings of despair and self-confidence that he experienced deep within himself. Take, for example, the following entry for July 4:

Here I am at the age of nineteen—what have I done for this world? What does personality mean? Nothing. How important is art? It's insignificant. I'm not going to die, I can't die before I can create something of greater force! Having been born into this world, I don't want to leave it before I've achieved something of significance.[1]

Sekine was almost entirely self-taught as a painter, but an important influence on his work was exerted by the artist Kōno Michisei (1895–1950), a resident of Nagano Prefecture, whom Sekine first met on his travels in 1915. Kōno was a painter who later participated in the *Sōdosha* group organized by KISHIDA RYŪSEI; he provided Sekine with much stimulation by showing him reproductions of paintings by classical artists such as Albrecht Dürer and Leonardo da Vinci. Sekine thereafter changed to painting realistic sketches in the classical manner with firm, sharp lines. Itō Shinsui (1898–1972), a Japanese-style painter one year older than Sekine and a friend since their childhood days, recalled the resulting changes in the style of his lifelong friend:

Sekine initially wanted to paint only in dark shades and showed no evidence of a feeling for color. He used to insist that paintings could be executed entirely in black and white. However, he was most impressed by the paintings of Yasui Sōtarō which this artist exhibited at the Nikakai *after returning to Japan, and the influence which they exerted on him led him to treat color in a highly extravagant manner. . . .*

For some time after this Sekine painted in the style of Cézanne, but gradually he came to acquire his own style. It was a great shame that he died so suddenly, just when he had acquired the ability to execute works of great force.

The reference to "the style of Cézanne" appears to refer especially to works such as the present portrait, in which a sense of volume is created by piling up small fields of color. It was later that Sekine's talent came into full blossom. However, at the end of 1918, Sekine caught a cold that led to pneumonia, which in turn brought on the pulmonary tuberculosis that caused his death in June of the following year. Among the obituaries which appeared at that time, the painter ARISHIMA IKUMA, who had recognized Sekine's talent, described the essence of Sekine's still incomplete art as follows:

Sekine was forever attempting, to a greater extent than any other painter, to express directly what he felt in his spirit without relying exclusively on the visual merits of what he created. The fantasies which he saw inside himself seem to have been different from the experiences of other artists. Sekine was thus an unusual painter who proved able in the course of his brief life to express himself in his own individual manner.

ARISHIMA was indeed correct to point out that Sekine's world was one of fantasy expressed in terms of vivid coloring. However, it is also a fact that, although technically immature, the *Portrait of Inoue Iku*, as well as all of Sekine's paintings up until the time when he discovered his own individual style, are imbued with the artist's youthful spirit and so retain their freshness to this day.

Atsushi Tanaka

Notes:

1. Sekine, "Nikki," in Sakai Tadayasu, ed., *Sekine Shōji ikō, tsuisō* (Tokyo: Chūōkōron bijutsu shuppansha, 1985).

230

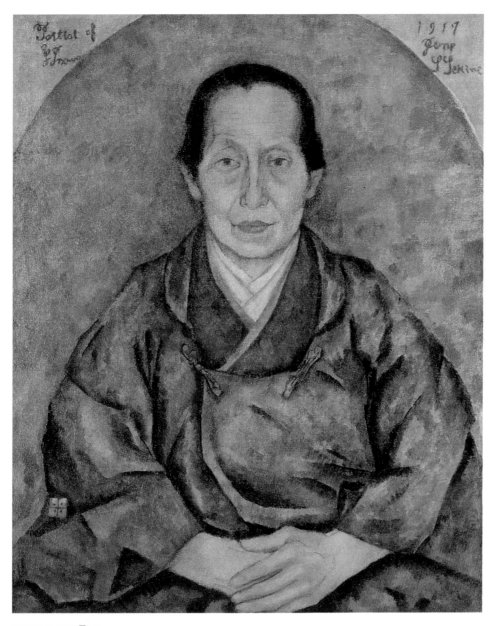

SEKINE SHŌJI
Portrait of Inoue Iku 1917

UMEHARA RYŪZABURŌ
Self Portrait 1911
Oil on canvas, 72.7 x 60.7 cm/28⅝ x 23⅞ in
The National Museum of Modern Art, Tokyo
Exhibited only in St. Louis and New York

On the back of this small piece, Umehara later added the note, "Self portrait, 1911, in Paris," indicating that it was painted during his years of study in Paris, after he visited in Spain. Any discussion of Umehara's Paris years, from 1908 through 1913, would be incomplete without mentioning his encounter with Renoir and the influence the old master had on the young artist.

Truly overwhelmed by Renoir's work, a selection of which he had seen at the Musée du Luxembourg, in February 1909 Umehara hesitantly called on the master in his studio in Cagnes-sur-Mer. Umehara was deeply moved by this meeting. Henceforth, the Japanese painter received advice on his own work, accompanied the master on sketching tours, and learned much about the French art world from Renoir. As a matter of fact, Renoir's strong influence is apparent in most of Umehara's work from this period, indicating the significance of the old master in the early development of the artist.

But this self portrait, although its colorful expression still shows the abiding influence of Renoir, also contains elements pointing to Umehara's future development. It was painted in 1911, after the artist visited Toledo and came in contact with many paintings by El Greco.

Later, around 1912, visiting Naples on one of his many tours around Europe, Umehara came to a major turning point in his own thinking. "In all of Europe, I know of no other city that is freer from the dreary and suffocating presence of Christianity. Encountering ancient Greek and ancient Roman art is as refreshing as encountering flora and fauna in the wild."[1] Umehara was greatly enriched as an artist by his encounter with ancient art, when, for example, the artifacts excavated from Pompeii began to enter his field of vision, which until then had been totally concentrated on Renoir. Just as he was drawn to Renoir's world of colors, Umehara's artistic creativity was stimulated by the beauty of the sights he saw amidst the sun and the blue sea of southern Europe. Thus while still showing definite influences of Renoir, his works seem liberated from an earlier rigidity and are characterized by a greater sense of freedom.

In June 1913, Umehara returned to Japan. In October of that year, the results of his European studies, including this self portrait, were introduced to the world in an exhibit sponsored by the *Shirakaba* magazine. Although the 110 pieces that he brought home from Europe were highly regarded by some of those who knew the artist personally, the general reaction was not positive. As the novelist Nagayo Yoshirō (1888–1961), a member of the *Shirakaba* group, remarked:

> The impression one received from the exhibit was all Renoir. What is more, Renoir's work itself does not necessarily suit my taste. Surely there was grace in Umehara's colors, where he cuts Renoir's grander scale down to size, and can indulge in soft, sensuous beauty. However, those works merely seemed bloated and effete in my eyes. The truth is that from my own temperament at that time, I was unable to find anything in his work to which I could relate.[2]

While Nagayo later became a fervent admirer of Umehara's art, his immediate reaction as recounted here represented the opinion of most who attended the exhibit. In fact, only one piece sold at that time.

Atsushi Tanaka

Notes:

1. *Bijutsu shinpō*, vol. 13, no. 2, February 1924.
2. Nagayo Yoshirō, "Umehara Ryūzaburō" in *Umehara Ryūzaburō* (Tokyo: Kyūryūdo, 1958), vol. 1.

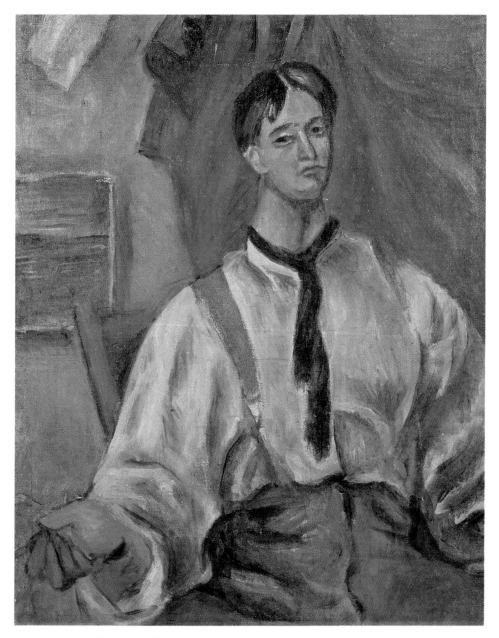

UMEHARA RYŪZABURŌ
Self Portrait 1911

UMEHARA RYŪZABURŌ
Camellias 1915
Oil on canvas, 53.5 x 44.5 cm/21 x 17½ in
The Museum of Modern Art, Kamakura

Presenting work from his European studies in a one-man show shortly after his return to Japan, Umehara established himself as a new talent within the artistic community. It was an age when there was a growing discontent with the rigid academicism of the *Bunten* exhibitions sponsored by the Ministry of Education. Eventually a group of young artists pursuing Impressionist and more recent artistic movements formed their own group, the *Nikakai*, in 1914. Joining this group, Umehara contributed as a member until 1918. Thus he launched his career in Japan as an iconoclast of the avant-garde. Yet there were still major obstacles that Umehara had to overcome.

One need for Umehara was to outgrow the influence of his beloved master Renoir. Demonstrating originality was no easy matter for Umehara, since Renoir represented for him an absolute. Later he reflected on the internal struggle that tormented him at the time:

> Certainly, I have gained much from my frequent contacts with Renoir, and from knowing the life of such a great artist. On the other hand, I think that perhaps my artistic freedom may have been impeded because of it. I feel that were it not for that meeting, I would have been able to develop more freely, more bravely.[1]

Umehara also was forced to overcome the differences between European and Japanese culture, a difficulty that all artists who studied in Europe inevitably experienced. In Paris, Umehara had learned to confront his technical and artistic problems directly and naturally from working inside the European artistic tradition. Thus he was greatly confused when he returned to a totally different world in Japan. YASUI SŌTARŌ, a painter of the same generation, faced the identical problem when he returned from Europe the following year.

Through this struggle, Umehara was able to produce only one piece for his first joint exhibit. Lost in a fire, this was the first version of the painting under consideration, also entitled *Tsubaki* (Camellias). Among the various critiques of this piece was the following commentary by the painter and printmaker Yamamoto Kanae (1882–1946):

> Umehara's piece was outstanding at the exhibit in terms of the incomparable beauty of his use of color.

> In particular, the values of the red and the yellow seem irresistibly charming. Red seems to be an intimate friend of Umehara's. If there were not any more red paint, he might even stop painting altogether! I gazed enchanted by this painting of the camellia. But then, it occurred to me that if one took away the elegant colors of this painting, what would be left of it? Probably the role of the camellia and the vase are there in the end to support the artist's color scheme.[2]

In reply, Umehara published the following:

> I wish to comment on the piece that you discussed. (I am afraid that certain unbecoming aspects of the picture have met with your disapproval. I myself have had hesitations about bringing this piece out for the exhibition.) As you point out, there is no denying that the color harmony of this picture is red. However, I do not fear that nothing would be left of my picture after you take away its colors. There will be plenty left, namely the harmony and the strength of the lines.[3]

Considering that Umehara rarely retorted to criticism in writing, it may be surmised that it was his own self-conflicts that led Umehara to take up his pen. In mentioning the "harmony and the strength of the lines" supporting the facade of beautiful colors he had created, Umehara verified that he sought a strong definition of form. The *Camellias* shown here was painted two years later. Now, along with the brilliant red of the camellias, one finds an even bolder structure. Thus it may be said that Umehara demonstrated a resolution of his inner conflicts and found a clearer assertion of composition and form in the *Camellias* of 1915.

Atsushi Tanaka

Notes:

1. Nagayo Yoshirō, "Umehara Ryūzaburō," in *Umehara Ryūzaburō* (Tokyo: Kyūryūdo, 1958), vol. 1.
2. Yamamoto Kanae, "Nikakai ten," *Jiji shinpō*, 15 September, 1917.
3. Umehara Ryūzaburō, *Jiji shinpō*, 20 September, 1917.

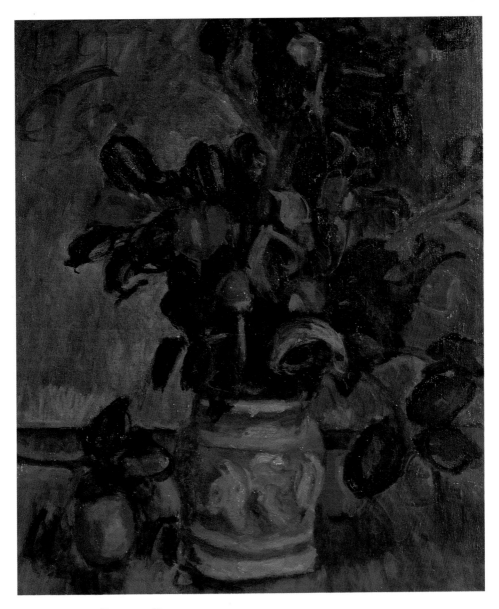

UMEHARA RYŪZABURŌ
Camellias 1915

UMEHARA RYŪZABURŌ
Nude 1921
Oil on canvas, 65.5 x 50 cm/25¾ x 19¾ in
The National Museum of Modern Art, Tokyo

In December 1919 Umehara learned of Renoir's death and experienced a tremendous shock. Umehara had been planning another visit to Europe as a means of overcoming the creative block he was facing. The news of Renoir's passing gave him another good reason for this journey, and he left for Paris in October 1920. In Paris, Renoir's memorial exhibition was underway at the *Salon d'automne*. After seeing this exhibit in January 1921, Umehara visited Renoir's home in Cagnes-sur-Mer and paid his condolences to the master's family. He then headed for his favorite Naples, returning to Paris in April. Back in Paris, he rented an atelier and painted until he set off for Japan in July 1921.

Although this second journey to Europe occupied less than a year, the visit was crucial for Umehara in overcoming his creative block and bringing back the former liveliness and luster of his work. It was as though the artist had been revitalized by the beautiful scenery and bright sun of Naples, Cannes, and southern Europe.

As seen in the *Nude* of 1921 (believed to have been finished in Paris) the brilliant colors, simplified forms and carefree brushstrokes that distinguish Umehara's work from this second European tour established his later style. It was nearly two years later, in May 1923, that these European pieces were publically exhibited in Tokyo at the first exhibition of the *Shun'yōkai*, a group Umehara joined after his return home. At the time, Ogawa Senyō (1882–1971), a fellow Western-style painter, gave an appraisal of Umehara's *Nude* in comparison with another piece at the exhibit, *A Nude Figure* by YOROZU TETSUGORŌ:

Yorozu's painting uses a woman's nude figure to portray the world as a kind of tea. It is a bitter, dark brown tea, and not one of those bland teas that is easily available. It is as though white eyes are being reflected in that tea. Umehara Ryūzaburō's variegated beauty, however, is literally beauty in essence. While Yorozu's nude speaks with its immobile lines, Umehara's nude figure bursts forth from his colors.[1]

Although Ogawa's comparison of these two nudes is based entirely on his subjective emotional impressions, his remarks bring out the contrast between the two artists' very different temperaments.

YOROZU's introduction of subjective distortions has made his work a slightly abstract and rather abstruse piece. In Umehara's *Nude*, on the other hand, sensuality and freedom are heightened and glorified by a brilliant play of colors. A comparison of these two pieces would suggest YOROZU as the more introverted personality, submerged deep into the self, while Umehara appears the extrovert. Umehara's extroverted brightness stood out not only in contrast with YOROZU's interiority, but far outshone all others at the *Shun'yōkai* exhibit as, on the whole, neutral colors dominated in the works placed on display.

Kuroda Seiki was supposed to have imported the light and the colors of the Impressionists into Japan. But in front of Umehara's art, all the rest seem to darken. . . . All along, my eyes have been set on the dark realism practiced by Kishida Ryūsei. After looking at that real-to-life world, it is of little wonder that I saw the art of a king in Umehara's work.[2]

Umehara returned from his second European journey with a renewed, grand vision. In the *Shun'yōkai* exhibition he established for himself a solid place within the artistic community with this masterpiece.

Atsushi Tanaka

Notes:

1. Ogawa Senyō, "Shun'yōkai," *Mizue*, vol. 220, June 1923.
2. Nakagawa Kazumasa, "Umehara Ryūzaburō," *Chikaku no kao* (Tokyo: Chūōkōronsha, 1967).

236

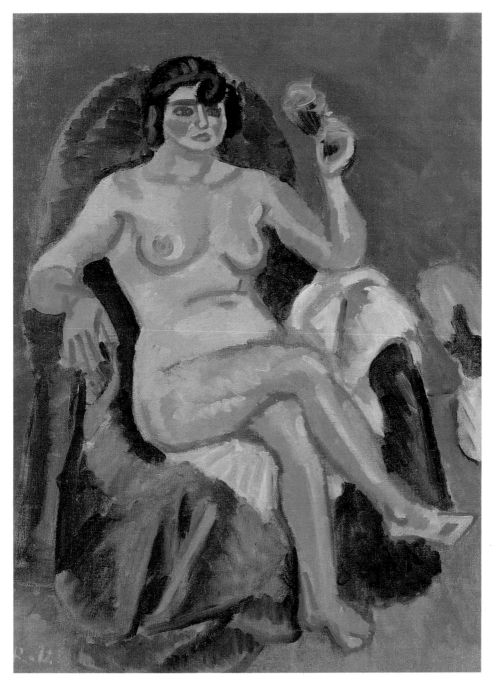

UMEHARA RYŪZABURŌ
Nude 1921

UMEHARA RYŪZABURŌ
Nojima Villa in Atami 1933
Oil on canvas, 53.5 x 65.3 cm/21 x 25¾ in
The Museum of Modern Art, Kamakura

Comparing the work of KISHIDA RYŪSEI and Umehara Ryūzaburō, the philosopher Tanigawa Tetsuzō (b. 1895) gave the following description of the latter's art:

> Umehara's artistic world is a world of perpetual brightness. This brightness comes partially from the beauty of the colors and the artist's technique, but mainly from the nature of the subjects which he chooses. These subjects stand as a reflection of Umehara'a own spiritual world.[1]

Tanigawa went on to pinpoint the aesthetic character of the work of these two artists:

> Kishida's is a cold and mystical world. This is true both of his landscapes and his still lifes. Apples and tea bowls are placed quietly in infinite space, in an eternal silence. In his landscapes the blue sky is always far, far away . . . Umehara's is a warm world full of bright light. Even in his winter landscapes, his paintings above all communicate the warmth of the sun. . . . They are imbued with an authentic vitality, which always abounds in Umehara's paintings.[2]

This comparison seems to define accurately the essence of the work of these two contrasting artists. As Tanigawa points out, both the rich sense of volume of Umehara's nude women and the light and colors which pervade his landscapes are symbols of an "authentic vitality." In the present painting, *Nojima Villa at Atami*, which depicts the corner of a garden reflected in the bright, warm light of the sun, perhaps what Umehara most wished to portray was the "authentic vitality" of the green of the trees and the light of the sun.

The villa portrayed in this picture was situated in Atami and belonged to the artist's friend Nojima Yasuzō. Umehara took a particular liking to this area when he first visited it in the summer of 1931, and thereafter he frequently borrowed the villa during summers to indulge himself in creative sprees. His liking for this part of the Izu peninsula was stimulated by the similarity of its climate to the bright and warm climate of southern Europe, to which he felt particularly attracted. It was from this richly foliated garden that Umehara painted numerous views of the sea. He occasionally invited models to the villa; it was here that he painted, in 1935, *Bamboo Window Nude*, now in the collection of the Ohara Museum of Art in Kurashiki.

Nojima Yasuzō (1889–1964), the owner of the villa, was not only Umehara's friend but also served as a kind of patron both to Umehara and to other Western-style painters. He was the son of the president of the Nakai Bank, and in 1919 he opened the Kabutoya Gado Gallery where exhibitions were held of paintings by such artists as MURAYAMA KAITA and the deceased SEKINE SHŌJI. He also opened his Tokyo residence for one-man shows by artists such as KISHIDA RYŪSEI, YOROZU TETSUGORŌ, and Umehara. While associating on the one hand with artists, he also took an early interest in photography. During the 1920s and 1930s he produced many brilliantly conceived artistic photographs which, in their display of a highly individual sensibility toward realism, established him as a major force in the history of modern Japanese photography.

Atsushi Tanaka

Notes:

1. *Bijutsu*, vol. 13, no. 6, July 1938.
2. *Ibid.*

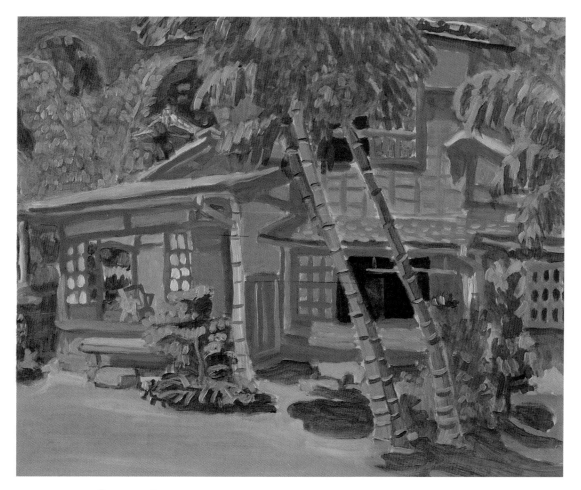

UMEHARA RYŪZABURŌ
Nojima Villa in Atami 1933

UMEHARA RYŪZABURŌ
Nude with Fans 1938
Oil on canvas, 81 x 61 cm/31⅞ x 24 in
Ohara Museum of Art, Kurashiki

According to Umehara, he worked on numerous sketches for a year until he finally began painting the final version of *Nude with Fans* in oil in June 1938. The piece was finished on August 8 and entered in the *Bunten* exhibit held in October.

By this time Umehara was leading his own independent art group. However, in 1935, for the purpose of imposing the prevailing nationalist policy of unity upon the artistic community, the Ministry of Education reorganized the Imperial Art Institute. Umehara, along with other independent art group leaders, was required to join the national institute. As a result he was appointed a judge for that year's *Bunten* exhibit.

Among the critiques of the exhibit, many voiced reservations about the nude's contorted expression. For example, Uno Kōji (1891–1961), a novelist and admirer of the work of KOIDE NARASHIGE, wrote:

Umehara Ryūzaburō's Nude with Fans *is obviously outstanding. However, while the screen in the background is excellent, the strangeness around the limbs and the hips of the nude itself constitutes a flaw. With recent images of this artist's excellent landscapes still fresh in my mind, I have been slightly disappointed by this piece.*[1]

As the young artist Mukai Junkichi (b. 1901) put it:

Umehara's positioning and coloration have the majesty of a mural. It is as though a network of thick nerves runs through it all. There is a demonical sharpness to his insatiable pursuit of his vision. The proper depth and sobriety of the paint could only be achieved at the hands of Umehara. However, I have slight doubts about the repetition of emerald green on the nude's left hip.[2]

Thus, Umehara's stylistic distortion of the nude was widely questioned. Yet the nude itself is not the sole focus of attention in this picture. Rather, it is the total harmony of the nude and the screen in the background that gives this painting its interest. Although the artist has not left any detailed commentary on this work, it is apparent that he created a typically Japanese setting for the picture with the Oriental screen.

It might be imagined that when he chose the magnificent gold screen with red and silver fans for the background, Umehara had in mind the kind of glamorous ornamentation that can be seen, for example, on medieval Momoyama Period decorative screens. Umehara's interest in the traditional arts, evidenced in this piece, was also encouraged by several other factors. For one thing, he had sought to separate himself from his earlier European influences and constantly strived to develop his own style of art. The incorporation of traditional elements into his work signified a certain maturation of this pursuit. Then, too, nationalist sentiments were growing rapidly in prewar Japan. In an interview, Umehara revealed some of the thoughts that lay behind his increasingly Oriental tastes:

Q. Seeing your newer works, they seem to be becoming increasingly more Oriental. What are your thoughts concerning this?
A. I'm not satisfied with merely imitating the West. But not any Oriental influences would do; they would be better if they were something that came to the surface in a natural manner. I am not consciously seeking the Oriental in my art, but I could say that I do not like merely imitating the West.
Q. We hear a lot about the Eastern Spirit, or the Japanese Spirit. What do you think of such trends?
A. The spirit is not something that should be thought of in any limited perspective. Thus far, Western-style artists have not found much affinity with Oriental art. It's just that these days, people are starting to look backwards toward the traditional and discover what they find refreshing.[3]

As an outstanding work from the period, the *Nude with Fans* may be seen as the piece in which Umehara revealed a change in his artistic direction.

Atsushi Tanaka

Notes:

1. Uno Kōji, "Bunten," *Bi no kuni*, vol. 14, no. 11, November 1938.
2. Mukai Junkichi, "Iyasaka Jugo Ueno-jin," *Bi no kuni*, vol. 14, no. 11, November 1938.
3. *Atelier*, vol. 12, no. 2, February 1935.

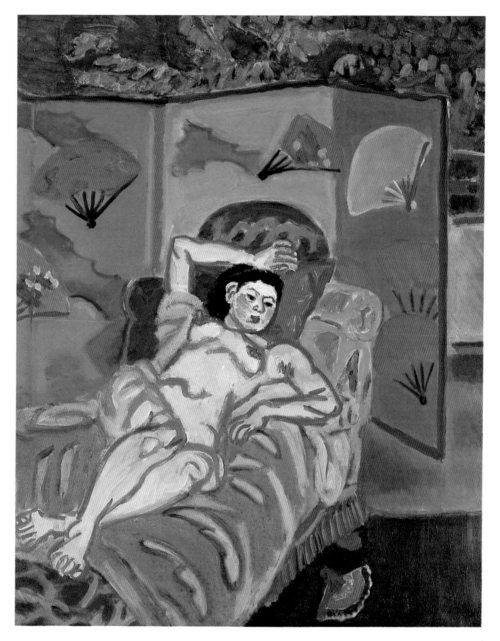

UMEHARA RYŪZABURŌ
Nude with Fans 1938

UMEHARA RYŪZABURŌ
Changan Streets, Peking 1940
Oil on canvas, 72.7 x 90.9 cm/28⅝ x 35¾ in
The National Museum of Modern Art, Tokyo
Exhibited only in St. Louis and New York

At a time when Japan had already begun to invade China and was heading fast towards World War II, Umehara, ironically, found himself enchanted by Peking, China's ancient capital. The artist worked for several months in Peking each year from July 1939 until 1942, just as the war was escalating. In "Peking Impressions," an article he wrote after returning from his first visit in 1939, he described the charms of the great capital:

> I cannot put all that is Peking into a few words. First, I was impressed by the fact that I always found more to experience than I imagined before my visit. I had been told that there are a lot of trees in Peking, but I could not have imagined that there were actually so many.
>
> Looking at the great clusters of architecture, the beauty of their mass and the gorgeous beauty of their colors are beyond any comparison. Close up, it was a little disappointing that they looked rather crude, but looking at entire structures, I was overwhelmed by the beauty of their powerful solidity.[1]

The Forbidden City that dominates the center of the old city of Peking and sights such as those around the Heavenly Altar where ceremonies for the Emperor were conducted provided ideal motifs for Umehara, who was spellbound by their majestic scale and elegant colors. Yet Umehara's fascination with Peking lay not merely in the beauty of these sights. In Peking he enjoyed a life much different from that of Japan—in the food, the theaters and the beauty of the women. In "Peking Impressions" he wrote, "The whole of Peking is filled with a peacefully relaxed grandeur. In it, I myself began feeling tranquilly composed. At one time, such was my serenity that I was reprimanded by the occupying Japanese soldiers and was left ashamed of myself. But that is the greatness of Peking." In ancient Peking, far removed from the growing strife of the war and free from the tensions of a tumultuous age, Umehara found opportunity for reflection and contentment.

Changan Streets, Peking was painted during his second visit, from May through September, 1940. As during his first visit, he stayed in a room on the fourth floor of the Peking-Hanten Hotel from where he painted views, including this one, of the Forbid-den City. After his second visit, the artist reported his impressions in an article entitled "Return to Peking," from which the following passage is taken. Although his painting techniques are not explicitly described, he does offer a glimpse of his ideals in regard to color:

> The Japanese sense of color lies in the beauty of subtle tonalities. But the Chinese sense of color is in the beauty of the combination of primary colors. Both worlds are beautiful of course, but I have a yearning to paint in the world of such strong colors. In the Japanese sense of color, the contrast with nature is weak. If you look at Japanese architecture, you only see the sparse contrasts of the white walls within an overwhelming field of gray. There is little stimulation in such weak contrast, and I feel little power or fullness in it.[2]

The "power and fullness" that Umehara felt in the "world of strong colors" was beautifully expressed in *Changan Streets, Peking* in terms of contrasts, such as that of the green trees against the red walls of the imperial palace. In this feeling, comparable to his attraction to the bright, sunfilled sights of southern Europe, originates the sense of color that is basic to the aesthetics of Umehara.

Atsushi Tanaka

Notes:

1. *Tōei*, vol. 15, no. 11, November 1939.
2. *Tōei*, vol. 16, no. 12, December 1940.

242

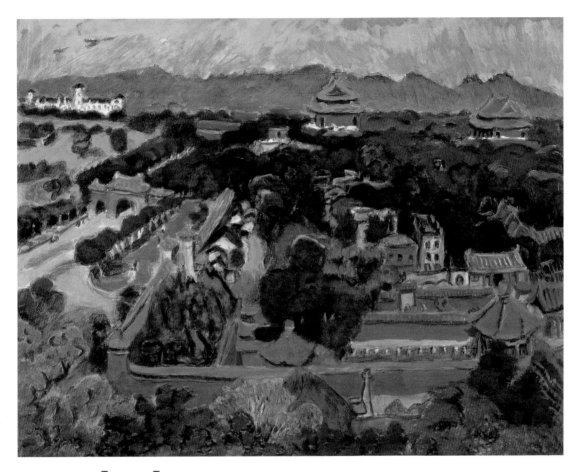

UMEHARA RYŪZABURŌ
Changan Streets, Peking 1940

YAMASHITA SHINTARŌ
Woman Reading 1908
Oil on canvas, 92 x 73 cm/36¼ x 28¾ in
Bridgestone Museum of Art, Tokyo

Yamashita Shintarō painted three views of a woman reading a book during his student years in Paris (1905–1910). All three were selected for awards in the Paris Salon. One of these, *On the Balcony*, was painted in 1908, shortly after Yamashita's return to Paris from a trip to Spain the previous year. The artist described the piece as follows:

> This painting is from my first Paris tour and represents a rendering of a Bulgarian woman painter by the name of Aneta Holzinger. First, I was the model and she painted, then I painted with her as a model. Her facial features were not very interesting, so that I had to paint her from the back.[1]

In the autumn of 1908, Yamashita was at work painting possible entries for the following year's Salon. He rented a pension near the Sorbonne, and from that room, which looked down on a small park, he painted *Woman Reading* and *After Reading*.

The painter Saitō Toyosaku, a friend of Yamashita's from their Paris days, later recounted how Yamashita was heavily influenced by Velazquez during his first years in Paris, and pointed out evidence of the Spanish master's influences as well as those of the nineteenth-century academic painter Paul Albert Besnard (1849–1934). Indeed, the delicate, almost sugary qualities that characterize Yamashita's early work reflect many of the prevalent aesthetic values of the Salon of turn-of-the-century Paris.

After his return to Japan, Yamashita wrote in detail of his artistic motives in the fine arts magazine *Bijutsu shinpō*:

> *After Reading* is a study of contre-jour. In other words, the entire face is darkened by a strong backlight, the sunlight behind the subject. With contre-jour, varied light reflections color certain areas of a subject with strange hues. This piece is simply a study of this effect. Having finished a book, the woman sits in thought. She has a cashmere shawl over her shoulder and is seated on an Empire-style chair. Since the dominant color is blue, the picture could easily give off a cold feeling. However this tonality is balanced by the rays of strong light beaming in from the background.
>
> In *Woman Reading* I have used a human subject to express the brilliant colors of autumn. An ac-

quaintance of mine in Paris, a colonel's daughter, was a very beautiful woman, and since I liked the dresses that she wore, I once asked her to be my model. However, since she was not able to oblige my request, I had to settle for an ordinary model and had her dress in the kinds of colors that my acquaintance had worn. She draped casually around herself a green-colored, light shawl a couple of yards in length. Actually, the shawl was also in contre-jour, but that fact was not as noticeable because of the white reflection from the book's pages on the model's face. Here, the dominant colors are green and yellow from the yellowing leaves outside, which blend with the model's rosy complexion. There is a flower vase placed on the balcony in the background. The flowers are roses. When I showed Raphaël Collin this flower vase, he suggested that rather than using an ornately beautiful French vase, I should use a delicately elegant Japanese vase. I supposed that a Japanese vase would have been more appealing in M. Collin's eyes, but I didn't have any on hand that would serve the purpose, nor did I want to use a blackish vase, since that would have been too distracting. One problem that I had in finishing this piece was that the room was so small that my line of vision fell on the model's face so that I was looking down on her.[2]

Incidentally, the "colonel's daughter" that Yamashita writes of was the younger sister of the painter Pierre Victor Robiquet, his classmate at the École des Beaux-Arts.

Tōru Arayashiki

Notes:

1. Quoted in Bridgestone of Museum of Art, ed., *Yamashita Shintarō*, Tokyo: Bijutsu shuppansha, 1956.
2. *Bijutsu shinpō*, vol. 10, no. 1, November 1910, pp. 10-11.

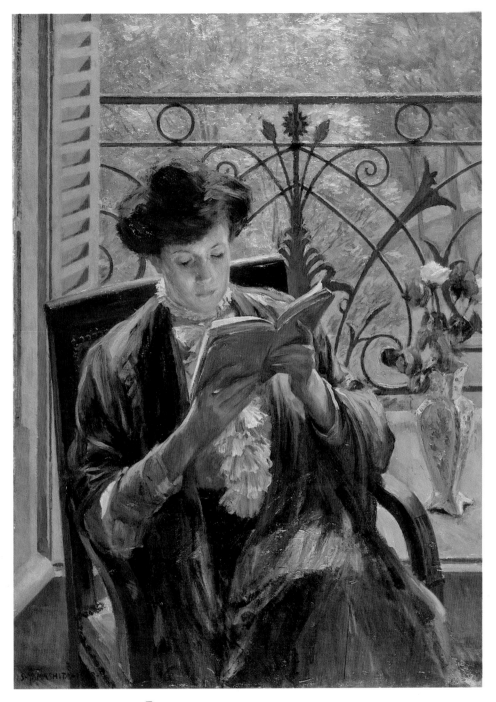

YAMASHITA SHINTARŌ
Woman Reading 1908

YAMASHITA SHINTARŌ
Offering 1915
Oil on canvas, 55 x 45.7 cm/21⅝ x 18 in
Bridgestone Museum of Art, Tokyo

The model in this piece is Yamashita's wife, Johanna, to whom Yamashita was married in 1910. "Soon after my return from Paris, through the introduction of ARISHIMA IKUMA, I was engaged to be married to Johanna Yamasaki, eldest daughter of a former official in the Imperial Household Ministry and his Prussian wife Laura Drehbess," Yamashita wrote in the notes for a book on his collected work, published late in his life.[1]

The title, *Offering*, refers to the offerings that are made at shrines and temples. In the essay cited above, Yamashita explained that Johanna was depicted offering a pomegranate to Kishibojin, the Buddhist goddess of fertility. Kishibojin, who served Buddha, holds a holy fruit—a pomegranate—in her hand, so Yamashita's piece is a symbolic expression of faith in the goddess.

Upon his return from France, Yamashita entered the works he had finished in Europe in the *Bunten* exhibition, and embarked on a successful career as one of the new generation of European-educated painters. Using his own family as subjects, Yamashita symbolically celebrated elements of Japanese tradition in paintings such as *Offering* and *Boy's Festival*, where we see the *ayame* (blue flag iris), and flying carp banners that are used to celebrate the occasion.

Among Yamashita's work, *Offering* represents an important turning point, a move away from the Salon-style portraits that characterized his work from the Paris years. In contrast, the painting reveals the great influence of Renoir, whom the young painter admired from his student years in Paris. Yamashita wrote of his meeting with Renoir:

I met Renoir ten years ago, in the summer of 1909. Umehara Ryūzaburō, Arishima Ikuma, and I visited Renoir at his studio in Montmartre where Umehara introduced us to the Master.

The old Master was at work when we arrived, and we were left waiting for some time after we were shown into the studio. There, for the first time in my life, I saw a great painter actually at work with his brush. His eyes were fixed on the model, and he was brushing on the paint with such force that the brush was making squeaking noises with each stroke. One would have thought that he might tear the canvas with his sheer power. It is a sight that I would not forget for the rest of my life.

Painting is power itself. I was awed to think that even the old Master's more graceful work had been brought about from such tremendous energy. Eventually, the old Master put down his brush, and began talking about a great many things in his quiet but clear way. . . .[2]

Tōru Arayashiki

Notes

1. Bridgestone Museum of Art, ed., *Yamashita Shintarō* (Tokyo: Bijutsu shuppansha, 1956), p. 8.
2. Yamashita Shintarō, "Renoir," *Chūō bijutsu* vol. 6, no. 1, January 1920, p. 65.

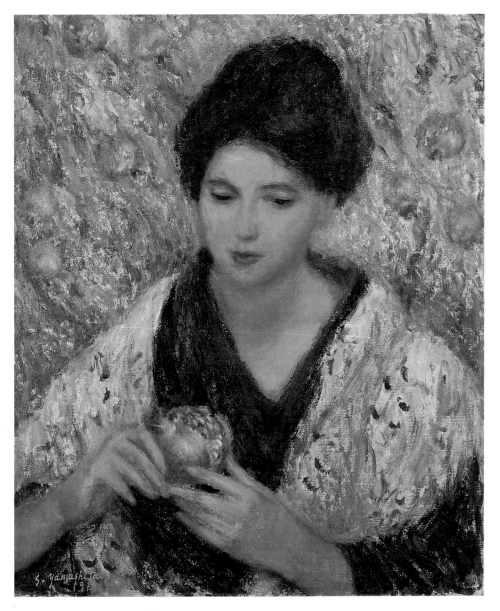

YAMASHITA SHINTARŌ
Offering 1915

YASUI SŌTARŌ
Self Portrait 1913
Oil on canvas, 45.5 x 38 cm/18 x 15 in
Kasama Nichido Museum of Art, Kasama

Yasui Sōtarō painted very few self portraits during his lifetime. As he destroyed most of his early work before leaving for Europe in 1907, little is known of his early attempts in this genre other than two small self portraits painted in oils he gave to his two painter friends UMEHARA RYŪZABURŌ and Tanaka Zennosuke. Apart from a much later group portrait with his family, now in the collections of the Hiroshima Museum of Art, the work displayed here and one other study, discussed briefly below, are the only self portraits known to exist.

In this painting, Yasui appears dressed rather formally in the European style, in contrast to the others mentioned above, which show the artist in more casual attire. The artist is obviously setting out to create the kind of formal atmosphere he felt appropriate. The picture is not dated, but the present owners believe that it was finished in 1913, an appropriate date in terms of the development of the artist's technique. It is possible that Yasui painted this work toward the end of his stay in Europe. The tonality chosen by the artist, and the touch he has employed, suggest his successful assimilation of certain techniques employed by Cézanne, the painter he so much admired.

Yasui evidently saw the self portrait as an altogether personal form of expression. He did not regard such paintings as suitable for public exhibition, and he chose not to exhibit this work in his 1915 homecoming show. Indeed, during his years in Europe, Yasui had concentrated mainly on landscapes, still lifes, and genre painting. Only two portraits were included in the exhibition.

Yasui's attitude concerning the painting of portraits at that stage in his career stands in strong contrast with his later enthusiasm. He often recalled that between the time of his return from Paris in 1914 until the end of the 1920s he felt himself frustrated as he continued to search for authentic personal and artistic goals. The search, and the frustration, were typical of many other gifted painters at the time. Yasui spoke of himself as working "in the style of Derain," and such styles, although important in France, seemed somehow inappropriate for Japanese painters of Yasui's generation. Doubtless Yasui himself became aware of this fact in the 1930s, when he began to discover that, once he had secured his mature style, his greatest talent actually lay in portrait painting. His transition to this genre secured Yasui an important position in the Tokyo art world. That success in turn allowed Yasui to realize that, during the previous decade, he had accomplished little.

In the study executed at about the same time as this portrait, Yasui used watercolor to sketch a pose quite similar to the finished work, except for the fact that the artist is without his jacket. The expressions are quite similar; in both, the artist appears to be gazing at the observer with slightly upturned eyes. Although the expression is softened in the completed work, it is apparent in the watercolor version that Yasui has attempted to portray his emotions with precision. The eyes are asymmetrical, the bottom lip tense, creating a moody atmosphere. Such manipulations were undoubtedly unintentional and resulted from a scrupulous self-observation. Such moodiness may well have been typical of those artists working to master new techniques in an alien environment. In the 1930s, when Yasui was to discover how to use such effects consciously, he was able to begin a new and effective phase of his development as a portrait artist.

Tsutomu Mizusawa

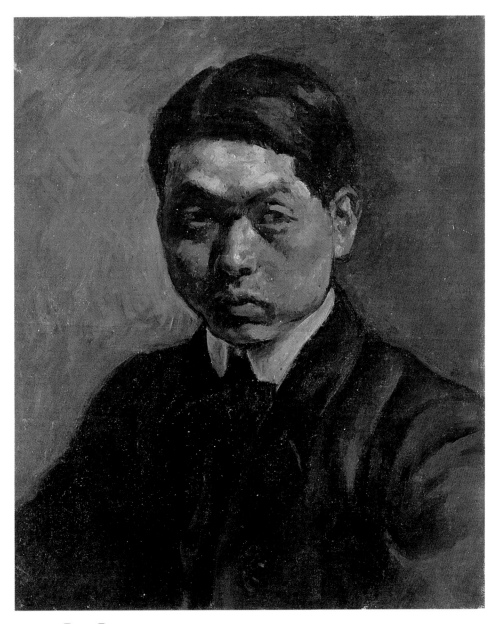

YASUI SŌTARŌ
Self Portrait 1913

YASUI SŌTARŌ
Woman Washing Her Feet 1913
Oil on canvas, 116.8 x 80.3 cm/46 x 31⅝ in
Gunma Prefectural Museum of Modern Art,
 Takasaki

Woman Washing Her Feet is a painting representative of Yasui's work during his Paris years (1907–1914). Of this piece, Yasui later recalled:

> *At the Académie Julian I worked primarily with this size of painting because that format was required for the school's contests.* Woman Washing Her Feet *was the first painting of that size I created after I left school. Psychologically, it was as though I were still continuing my work at the school, and so I worked very hard on this piece. I had already been drawn to Cézanne's work, so that the painting is naturally influenced by his style. However, I remember that I also tried to bring in a few elements from Daumier. During my stay in Europe I later painted two other pieces on a similar scale,* Girl With Black Hair *and finally,* Sparrow and the Girl.

In Europe, Yasui first studied at the Académie Julian under the guidance of Jean-Paul Laurens, but he left the school in March 1910. Thereafter, he set up his own studio, and travelling throughout Europe to encounter a wide variety of art, he began to develop a personal style. After seeing Yasui's work at the second *Nikakai* exhibition held in 1915, his friend and fellow student at the Académie Julian, MITSUITANI KUNISHIRŌ, commented,

> *Although Yasui's styles and thoughts may alter in the future, in keeping with his surroundings, I am heartened to see that for now there is an almost desperate steadfastness in his work. Actually, in some respects, Yasui's style already has been changed greatly. . . . As Laurens's student, he started out in imitation of his teacher's distinctive style, but Yasui's thinking gradually changed, which worried Laurens very much. . . . It is probably inevitable that the thinking of the younger generation must change. Yasui was very much liked by Laurens, and among our classmates, he was marked in both skill and in originality. Laurens is probably very much saddened by all this.*[1]

The "Laurens style" that MITSUTANI referred to is obvious in Yasui's charcoal drawings now at the Tokyo University of Fine Arts. The prevalent approach found in these pieces represents a conventional, academic style of rendering the human form.

MITSUTANI's article further tells how this style gained a new expressiveness as found in the deformations and gloomy colors that characterize *Woman Washing Her Feet*. The strong influences of Cézanne noted by Yasui can be recognized in the rendering of the water pitcher, basin, and chair. Further, the expression of the human body, particularly the exaggerated left shin and right breast, show debts to Cézanne's reconstructive style, and we can feel Yasui's zeal in a deliberate attempt to transcend the bounds of traditional artistic conventions. As to Yasui's claimed incorporation of "a few elements from Daumier," it is difficult to determine what exactly the artist had in mind. Perhaps he was referring to a similar use of dark hues and his choice of the quotidian motif of the bathing woman. Although Yasui left no mention of other inspirations, the expressions found in this painting rather bring to mind the style of El Greco, whose work had greatly moved him during his visit to Spain the preceding year. This influence is most obvious in the depiction of the cloth that the model is holding in her right hand. However, it should be noted that this style had not yet been subsumed into Yasui's own style, and so it cannot be said to be characteristic of his work at this period. At the same time, a year prior to Yasui's 1913 journey to Spain, the French novelist Maurice Barrès made El Greco a familiar name in Europe with the publication of his influential essay on that great artist, "El Greco, or the Secret of Toledo." Therefore, Yasui's interest in the Spanish master may reflect a growing fascination shared throughout his artistic milieu. In any event, the artist, who had just left his French mentor, apparently had entered a period of trial and experiment. *Woman Washing Her Feet* can thus be seen as one of Yasui's ambitious attempts to develop a new, individual style.

Tsutomu Mizusawa

Notes:

 1. *Bijutsu shinpō*, November 1915.

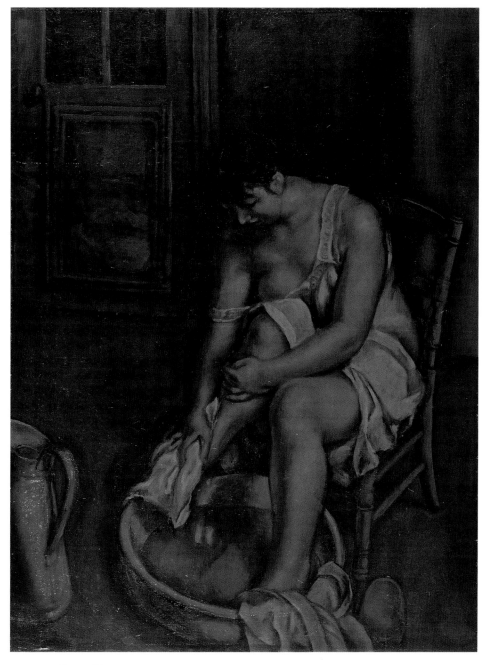

YASUI SŌTARŌ
Woman Washing Her Feet 1913

YASUI SŌTARŌ
Portrait of a Woman 1930
Oil on canvas, 115.5 x 87.5 cm/45½ x 34⅜ in
The National Museum of Modern Art, Kyoto

Along with another rendering of the same model created the previous year, this masterpiece marked the beginning of the famed "Yasui style" of the 1930s. In a memoir written in 1952, the artist commented on the piece:

The model was a young lady who occasionally brought paintings to my house. She was the eldest daughter of [the great Meiji] General Nogi's niece. . . . I finished the Seated Figure, *and I painted this* Portrait of a Woman *next. This was the first time that I painted a work of this size using a kimono-clad figure. The model was excellent, and I remember being very much engrossed and energetic in finishing this piece. Besides these, I also painted a smaller portrait of her.*

In the article "Yasui's Portraits," from *Collected Portraits of Yasui Sōtarō* (1940), Kojima Kikuo, a pioneer in Western art history studies, recounted his first impressions of *Portrait of a Woman* upon seeing the work on exhibition:

Yasui's painting was probably the best in all shown that autumn. It is the portrait of an eye-openingly beautiful young lady. She is dressed in a striped kimono of alternate pale rose and pale purple colors, with streaks of rosy-gray. Her obi sash is fastened by a belt of pale yellow and red color. The obi itself is splattered with an assortment of colors including brown, green, red and blue. The bright red of her undergarment shows here and there, providing a strong accent to the pale overall color combination. Her white socked feet are set firmly in the black leather slippers. The curved surface of the chair and the folds in the fabric about her knees are drawn with acute perceptiveness. There is youth abounding across the brow of this black haired, rosy-complexioned girl. Even the exaggerated plumpness of her fingers is not inappropriate. There is probably no other artist that has so successfully expressed the youthful and magnificent beauty of a modern young woman. . . . I was absolutely overwhelmed by the splendor of this new style of art; a style that is neither specifically Western, nor Japanese.

In creating a style neither Western nor Japanese, Yasui carefully chose his motifs. The black line in the background suggests a Japanese style sliding door; however, contrary to Japanese tradition, the floor is probably carpeted in Western fashion. Although placed indoors, the model is wearing a pair of outdoors slippers and is seated on a Western-style chair. Dressed in traditional Japanese kimono, the model's hair is cut short in the fashion of the 1920s, and her Western-style make-up complements her hair style. Her compact face and long, sleek limbs are features very different from the classical Japanese image. The pose that she takes, with her arms folded, elbows out, and her feet spread apart, counters what would be expected of a Japanese woman wearing a kimono. Thus, it is not only the style but the unconventional props and pose that defy characterization as Japanese or Western.

While the piece is painted in an extremely flat manner activated by a spontaneous linear expression suggesting the work of Dufy and Matisse from the 1920s, Yasui's colors evoke traditional Japanese tones, such as the pale pink that Kojima Kikuo described. And, although Yasui applied Cézanne's technique of using multiple perspectives that distort the image in such a way as to represent the subject with greater pictorial realism, the minimal depth of field results in a dimensionally flat image somehow closer to traditional Japanese painting.

Thus, while absorbing contemporary European artistic ideas, particularly those of Paris, Yasui also drew from distinctly Japanese sources. In so doing he created a visual expression of the cross-currents in a Japan undergoing the changes of rapid modernization. Subsequently, during the 1930s Yasui produced, one after another, a large number of character sketches and finished paintings in the new "Yasui style" that established him as a portrait artist of rare talent.

Tsutomu Mizusawa

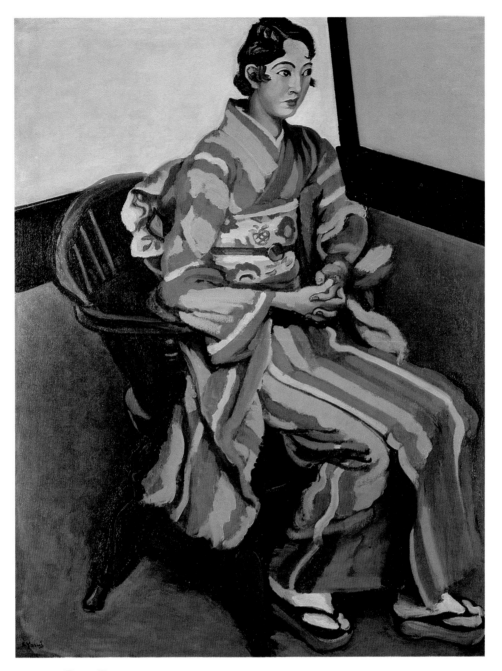

YASUI SŌTARŌ
Portrait of a Woman 1930

YASUI SŌTARŌ
Roses 1932
Oil on canvas, 63 x 52 cm/24¾ x 20½ in
Bridgestone Museum of Art, Tokyo

Though small in dimension, this monumental paint-
ing lucidly represents the artist's work of the 1930s.
As *Roses* was the only work that Yasui entered in the
nineteenth annual *Nikakai* exhibition, the artist was
apparently quite satisfied with this work. In 1952,
twenty years later, the artist commented:

> *I like flowers that have clearly defined forms. They
> are easier to draw, and I have most often drawn
> roses, chrysanthemums, dahlias and such. Some time
> back, the wife of Professor Minobe Tatsukichi [the
> famous legal expert and political philosopher] had
> been cultivating roses. Each year she would bring
> me a large bouquet of her roses. I was always de-
> lighted by these flowers, and I would sketch them
> immediately. The roses in this painting are also
> those that Mrs. Minobe brought me. I couldn't re-
> member now whether the background had been black
> from the beginning, or if I had painted it black mid-
> way through the work. The vase is inexpensive
> Imari ware.*

Here we see the combination of roses, which are
typically European, and the Imari ware, an ordinary,
everyday object in Japan. The delicate rose and hard
vase are placed on a creased, white table cloth with
rich textural nuances juxtaposed against an absolutely
expressionless black background so smooth that it
almost gives the impression of lacquer. As with the
Portrait of a Woman (Cat. 69) Yasui skillfully manipu-
lates a combination of Japanese and Western ele-
ments, resulting here in an evocative display of
contrasting shapes and textures.

The spontaneity of Yasui's choice of motifs may
be surmised from the artist's attitude towards an-
tiques. Choosing a simple, everyday Imari ware, the
artist did not allow himself to be led astray in the
vain quest for authenticity that so often afflicts an-
tique connoisseurs. The Japanese elements in Yasui's
art are pronouncedly direct and realistic and reflective
of his personal choices. For another rose picture of
about the same period, Yasui used a slightly off-
white vase that his wife found in the scorched rubble
left after the great Tokyo earthquake of 1923. Rather
than using a vase that might be considered culturally
valuable, the artist reacted more readily to the color
and the texture of the scorched vase.

In *Roses* we may perceive something rooted in
the natural and the everyday rather than a false Ori-
entalism. As with *Portrait of a Woman*, Yasui applied
techniques of distortion so that the result is not real-
istic in a strictly photographic sense. However,
because of his choice of everyday motifs and the
natural harmony of the elements he presents in his
paintings, Yasui has gained high acclaim as a
Japanese modern realist.

Tsutomu Mizusawa

254

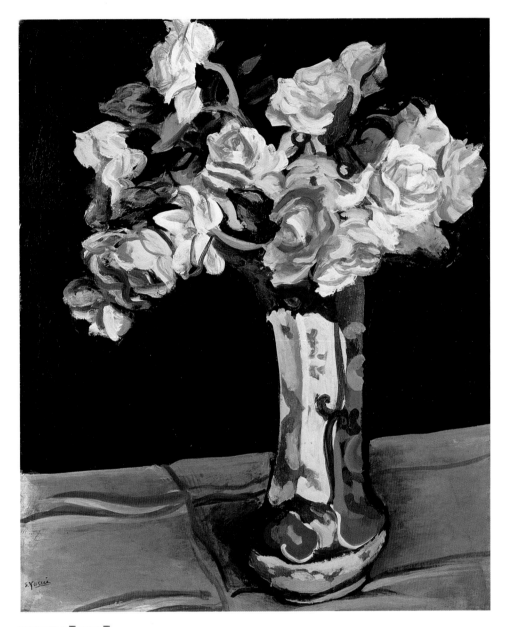

YASUI SŌTARŌ
Roses 1932

YASUI SŌTARŌ
Portrait of Mrs. F. 1939
Oil on panel, 78 x 63 cm/30¾ x 24⅞ in
Private collection

The sitter was married to Fukushima Shigetarō (1895–1960), a businessman and art critic. Fukushima had assembled an excellent collection of modern French art during and after his lengthy stay in Paris, from 1921 to 1933. His experiences there, and those of his wife Keiko (1900–1983), helped provide her with the material for a collection of essays which she published in 1950 under the title of *Parii no geijutsuka-tachi* (The Artists of Paris), thus beginning her own career as an essayist in the postwar period.

In this painting, Yasui used a certain amount of simplification and exaggeration in portraying this woman, a lady of intellectual standing who was on friendly terms with Matisse. She is dressed in a polished fashion, looking her most beautiful. The hat, corsage, rings, and other accessories are so carefully recorded that the painting seems to constitute a rendering of the manners and customs of the particular age in which it was created. Nevertheless, Yasui has been careful to capture the special personal characteristics of his model. In this regard, he achieves a sharp juxtaposition of fashion and feeling.

It is possible that such overstatement on the part of the artist may contain an element of sarcasm. Reaction to the painting was by no means altogether favorable when it was first shown in 1939. The critic Kojima Kikuo, for example, had this to say on viewing the work:

> *Although the public reception of* Portrait of Mrs. F. *has not been particularly generous, I disagree with such opinions. I feel sure that Madame Fukushima would not have been dissatisfied with it, if only for the tremendous sense of freshness that one gets from looking at the painting. Still, I can't help feeling that the deformations undertaken by the artist may be a bit overdone, and I found the coloration employed in the background rather uninteresting.*[1]

The "coloration" that Kojima found "uninteresting" is indeed rather subdued in tone, consisting as it does of a pattern in moss green and white, scattered over a mustard-colored field. Nevertheless, this pattern provides a very clear feeling of something traditionally Japanese. The colors, too, are traditional in tonality.

In an essay in the same volume mentioned above, Yasui remarked that "inasmuch as the human subject in a portrait is brought to life by the background, the creation of that element in the picture can be rather more difficult to handle." Such a remark suggests that the artist could hardly have selected his background colors in any careless way. He wished to make precise the atmosphere that he set out to create. As in so many of the works created in this time, Yasui rejected any excess.

Tsutomu Mizusawa

Notes:

1. Kojima Kikuo, "Yasui Sōtarō no shōzō," *Yasui Sōtarō shōzō gashū*, Zōkei geijutsusha, 1940.

256

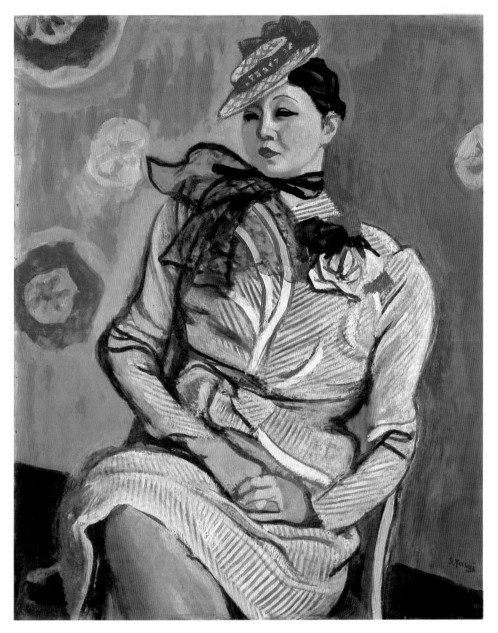

YASUI SŌTARŌ
Portrait of Mrs. F. 1939

YASUI SŌTARŌ
Portrait of Abe Yoshishige 1944
Oil on panel, 111.5 x 71.3 cm/43⅞ x 28⅛ in
The National Museum of Modern Art, Tokyo

Yasui created two portraits of this prominent intellectual, the first in 1944, the second in 1955. The earlier picture, included in the present exhibition, shows a full-length figure, seated in the artist's atelier. The later work is a half-length seated image, viewed from the side. The 1944 painting, finished during the war, was first shown in 1946. These works can be said to represent the final stage in portraiture reached by Yasui, who died of a lingering disease of the lungs in 1955, the same year that the second portrait of Abe was begun.

Abe Yoshishige (1883–1966) was well-known and highly respected in academic and intellectual circles in Japan. It was he who made the names of Spinoza and Kant familiar in Japan through his studies and translations in the field of philosophy. While still a student, Abe became a disciple of the novelist Natsume Sōseki, mentioned elsewhere in this catalogue as an important intellectual force during his time. Abe went on to uphold and champion liberal ideas throughout his career. Along with his writings, he served in a number of important educational posts, and, after World War II, he acted briefly as Minister of Education in 1946. Abe was, then, an important subject for Yasui to paint, and one with whose ideals the artist found himself in accord.

The two portraits the artist created suggest two opposing qualities of the philosopher, on one side his gentleness and on the other a firm commitment to his principles, suggesting an unyielding element in Abe's character. In particular, the 1944 portrait shows a monumental quality much like other works of Yasui, done in the 1930s, that helped establish him as a portrait painter of the first rank. The model sits imposingly, his arms folded, yet there is no false grandiloquence suggested in the modest means chosen by the artist to represent the figure. Behind the figure, the boundary between the wall and floor is shown on a slant, creating a line that leads to a portion of some object, probably the leg of an easel. The structure gives vigor to the painting. The critic Hijikata Teiichi, remarking on Yasui's late style, said that ". . . as an artist, he made the most sincere efforts to achieve a simplification of the elements presented in his picture, and I am sure that he took pleasure in creating such movement in his composition."[1] Yasui used concepts of space rather than any psychological treatment of his subject to invigorate his design, a technique that would come to full fruition in his postwar work.

The later 1955 portrait, which remained unfinished at the artist's death, lacks the monumentality of the 1944 effort, and although dexterous in its representation of the model, is far less ambitious in conception.

Tsutomu Mizusawa

Notes:

1. Hijikata Teiichi, "Yasui Sōtarō," *Bijutsu techō*, December 1949.

258

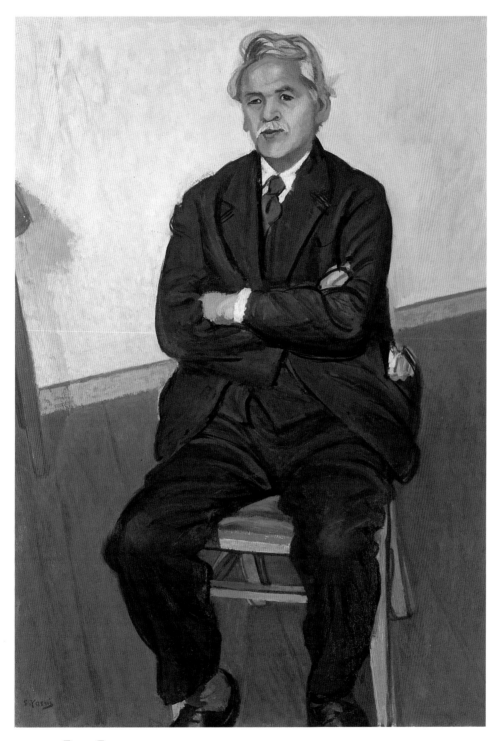

YASUI SŌTARŌ
Portrait of Abe Yoshishige 1944

YOROZU TETSUGORŌ
Rural Landscape c. 1912
Oil on canvas, 33 x 42 cm/13 x 16½ in
The Museum of Modern Art, Kamakura

In the painter's extant notebook, now in a private collection in Iwate Prefecture, a sketch of this picture is found on a page facing that of a sketch for *Landscape with a Smokestack*, the painting which was presented at the first exhibition of the *Société du Fusain*. From this fact we can date the picture around 1912, the year *Landscape with a Smokestack* was produced.[1] The painter also left an etching based on the same sketch. Great exuberant trees painted with sinuous brushwork and fields pictured in contrasting short parallel brush strokes remind us of the landscapes that van Gogh produced in his last years, specifically, his rural landscapes of Auvers.

After the first exhibition of the *Société du Fusain*, Yorozu wrote an essay on painting for a newspaper in Iwate Prefecture. Titled "A Letter Answering Criticism by My Friends," the essay, Yorozu's first published writing, was written as an answer to criticism of *Landscape with a Smokestack*, which was introduced to the public by the November 1912 issue of *Bijutsu shinpō*.[2] This letter articulates Yorozu's views of the art of painting and the influence of Post-Impressionism at the time when he produced the *Rural Landscape* and *Landscape with a Smokestack*. The artist described his impulse to create in the following manner:

I am often seized by a violent impulse which impels me irresistibly to reproduce my own impressions. Some say this is instinct. It may be so. . . . Now I betake myself to painting by carrying a canvas with me to embody symbolically my own mental impressions. Such is my sole pleasure and the only way I have to truly acquaint myself with life.

Yorozu began by painting "the things which impress him most," but he was dissatisfied with scenes that were balanced in color and form because "the effect of such scenes is dull."

If I was most interested in and impressed with the smokestack, which is one of the points disparaged by you, I would enlarge its form and intensify its color, although another strategy might be possible as well. Now, my canvas gets stained and confused. In an extreme of fatigue, I concentrate all my efforts and continue to paint on endlessly. I never stop painting until I obtain the expression which leaves no gap between the canvas and my mind. The results may seem to differ from external forms in reality, but I believe my work expresses the mark or impression on my mind, namely the true nature of what I see, in a bare, straightforward condition.

Yorozu's specific working process as described here can be said to have much in common with that of van Gogh and Gauguin, at least in terms of the intense self-consciousness found in their pictures. However, by asserting "I do not think there exist in this world any rules of painting, or definitions of art, or anything beneficial like that," Yorozu responded as well to the charge that he may have been imbued with Post-Impressionism.

I did not acquire much from the style which was brought by Mr. Kuroda and others. Others worried over this as well. . . . My senior, whom I respect, is said to have observed that Post-Impressionism was originally inspired by Japanese painting and so did not bring back anything new or rare to us. Yet, inasmuch as we all live in common on the earth as mankind, I do not wish to draw a sharp distinction between the East and West in discussing painting.

His "senior" was probably SAITŌ YORI, who took the initiative in organizing the *Société du Fusain*.

Yorozu attained a level of thought that transcends the differences between the East and West. Only Yorozu, who reached a standpoint where he could explore his own contemporary relation to European art, was able boldly to attempt to assimilate in Japan the essence of the new movements that emerged after Post-Impressionism.

Atsushi Tanaka

Notes:

1. See the article by Kagesato Tetsurō in *Bijutsu kenkyū*, no. 258, July 1986.
2. The letter is reproduced in Yorozu Tetsugorō, *Tetsujin garon* (Tokyo: Chūōkōron bijutsu shuppansha, 1968; revised edition 1985).

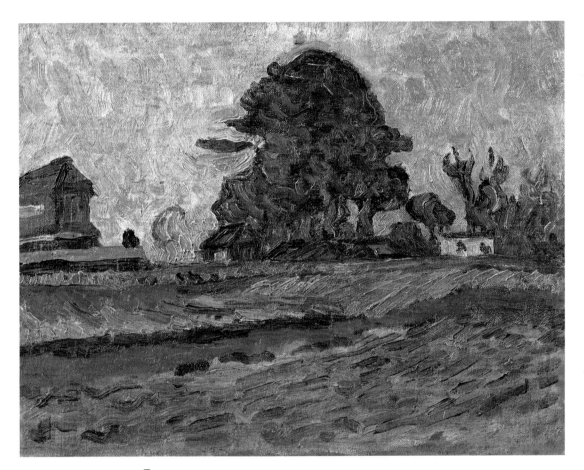

YOROZU TETSUGORŌ
Rural Landscape c. 1912

YOROZU TETSUGORŌ
Self Portrait with Red Eyes 1912
Oil on canvas, 60.7 x 45.5 cm/23⅞ x 18 in
Iwate Prefectural Museum, Morioka

Based on stylistic evidence it seems probable that this work must have been painted sometime during the period of Yorozu's involvement in the *Société du Fusain,* around 1912. At this time, an inclination toward the European avant-garde began to manifest itself as a sharply felt reaction to the influence in Japan of Post-Impressionist art. In this self portrait, Yorozu was clearly working beyond the realm of Post-Impressionism in more contemporary stylistic currents. Moreover, the boldness with which the artist attempted to grasp and absorb new modes of painting further supports dating *Self Portrait with Red Eyes* during this period.

After 1912 a virtual deluge of information on the newest currents in painting began to flood into Japan from every part of Europe. Movements like Cubism and Futurism, and names of groups like the "Blaue Reiter" became familiar through art magazines and newspapers. In retrospect it is clear that not all of the information disseminated was accurate, and that confusions arose. The appearance in print of rather unclear photographs of contemporary European art was enough to send an entire generation of young painters rushing into a new style they had only vaguely seen. For these reasons, Yorozu's works from this period take on a complex aspect, for they are at once experiments in diverse styles and a clear revelation of his commitment to participate in avant-garde movements.

Research indicates that Yorozu displayed his *Nude Beauty* and a number of other works for the first time in 1912. The display drew much critical acclaim, and some references were made concerning his Cubist tendencies. Taking into account the situation prevailing around 1912, however, the term "Futurist" seems a more fitting evaluation than "Cubist," because little information about the Cubist movement was available to Japanese artists at that time.

It is probable, however, that Yorozu's work shown in 1912 reflected his familiarity with Futurism. In particular, the October 1912 issue of *Gendai no yōga* (Modern Western-Style Painting) carried reproductions of Futurist paintings: some ten works by Umberto Boccioni, Carlo Carra, and Gino Severini were thus introduced to Japan. A close friend of Yorozu from the *Société du Fusain,* Kimura Shōhachi (1893–1958), participated in editing the magazine. (The same issue also carried comments by SAITŌ

YORI and KISHIDA RYŪSEI that were critical of Futurism.) It is also possible that Uriu Yōjirō, a member of the *Société du Fusain,* may have corresponded directly with Filippo Marinetti, the flamboyant theorist for Futurism, and as a result French and Italian publications on the movement were received in Japan.

What sort of Futurist paintings could have had a direct influence on Yorozu's *Self Portrait with Red Eyes*? As Yorozu may not have been able to grasp the full implications of a particular style, we might do better to direct our interest to the feelings invoked by the Futurist works available to him, keeping in mind that these paintings in turn had absorbed much from Cubism and other contemporary European artistic trends.

In his self portrait Yorozu took his own form and broke it down into sharp angular segments, filled in with primary colors, and he extended his analysis of pictorial space into the background of the picture. It is thus possible to suggest that Yorozu learned certain things from seeing the reproductions of the portraits by Carra and Boccioni, two painters who had taken on Cubist-like forms of expression.

During this period Yorozu painted a number of self portraits. All of these show him directly face on with hollow cheeks and eyes askance. Each is unique. One filters his expression through the style of van Gogh and makes free use of pointillism; another brings to mind German Expressionism. Others show a variety of divergent approaches. Surveying these works, it becomes apparent that more than any other motif, Yorozu used his self portrait as a vehicle for experiments in new styles.

We may suppose that when Yorozu felt inspired by a new mode of expression, he would attempt to draw that mode into himself in an effort propelled by his strong artistic consciousness. This internal impetus was doubtless channeled into the artist's self portraits. Thus the precipitous stylistic leaps made by Yorozu's self portraits during the period beginning with *Self Portrait with Red Eyes* may represent the artist's direct, graphic reflection of the chaotic conditions then prevailing in Japan in reaction to the torrential influx of European art styles.

Atsushi Tanaka

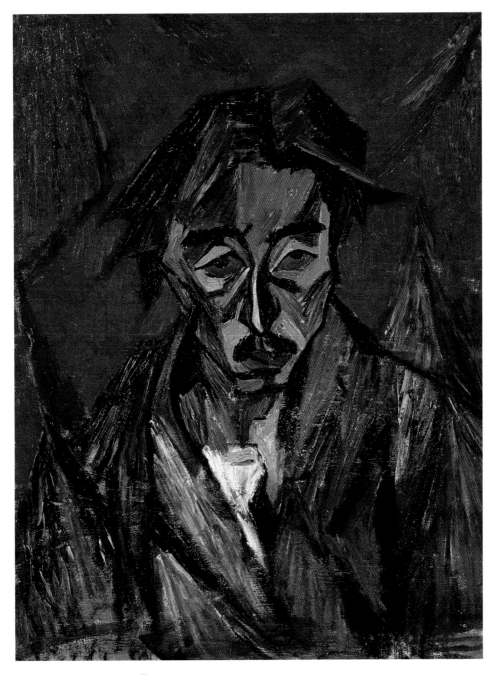

YOROZU TETSUGORŌ
Self Portrait with Red Eyes 1912

YOROZU TETSUGORŌ
Woman with a Boa 1912
Oil on canvas, 80.3 x 65.2 cm/31⅝ x 25⅝ in
Iwate Prefectural Museum, Morioka

In March of 1912 Yorozu graduated from the Western Painting Section of the Tokyo School of Fine Arts. His *Nude Beauty*, executed as a graduation project, is presently in the collection of The National Museum of Modern Art in Tokyo (see McCallum, Fig. 51). Today, this piece is valued as the country's earliest example of Post-Impressionist art and is said to represent Japan's acceptance of that style. At the same time, for the painter it meant his clear separation from KURODA SEIKI's plein-air academic style, and Yorozu's start as an independent artist.

In the paintings of the Post-Impressionists other young Japanese artists also felt the first movements of a subjective spirit of individual assertiveness, and the expansion and liberation of self. The following account of Yorozu's production of *Nude Beauty*, recorded by fellow student Kobayashi Tokusaburō (1884–1949), is helpful in attaining an even clearer understanding of the situation:

In those days we never dreamed that any real French pictures would ever actually be brought to Japan. At best we were able to see a few tiny reproductions of new pictures in the illustrated pages of magazines. Printed photographs of the paintings had not yet reached these shores.

Our key resource at that time was C. Lewis Hind's The Post Impressionists, *which had just become available. Young people were very excitedly competing to see who could stare at its pages the longest. The book contained critiques of Gauguin, van Gogh, Matisse and Cézanne, as well as a few photos of some of their paintings. I very much doubt that Yorozu could have had any broader knowledge of the Post-Impressionists than was contained in the pages of that book, but his astonishing brain was able to penetrate to the very essence of Post-Impressionism.*

Kobayashi gives us some idea of the great difficulties which Yorozu and his contemporaries experienced as they attempted to study the works of the Post-Impressionists, using reproductions so unclear as to be totally unacceptable by today's standards. *Woman with a Boa* was created under these circumstances. Yorozu's wife Yoshiko, whom he had married in 1909 and affectionately called Yoshi, served as his model. Structurally, we find a woman sitting in a chair, boldly depicted directly from the front. The form of the subject is strongly expressed using wide, short brush strokes of bright contrasting colors. The whole gives the distinct impression of having been directly influenced by van Gogh's 1887 *Portrait of Père Tanguy*, which appeared in the Hind book. Furthermore, from the way that the face has been portrayed, with the nose and eyes treated very simply, a resemblance can be seen with the *Girl with Green Eyes*, a Matisse of 1908 also reproduced in Hind.

Woman with a Boa was unveiled in 1912 at the first exhibition of the *Société du Fusain*. The Society did not so much support a cohesive policy or stylistic direction as it attempted to represent the aspirations of many young artists who, weary with the academicism of the *Bunten*, felt a spiritual resonance with Post-Impressionist painting.

Thirty-three artists participated in this first exhibition and 168 pieces were displayed. Yorozu himself submitted seven paintings, including *Woman with a Boa*. While we find no criticism of his contributions, the following overall evaluation of the Society's exhibit conveys the general situation of the artist at that moment: "The greater part of the pieces exhibited by the *Société du Fusain* are little more than imitations of Matisse and Gauguin. There is almost nothing that can be considered as truly manifesting the inner selves of the participating artists."

Certainly in relation to *Woman with a Boa* there are lingering doubts about just how much Yorozu understood the formal problems which made the works of van Gogh, Matisse and others so pregnant with meaning. The situation of the *Société du Fusain* members may have been very much like that of the writers in the contemporary *Shirakaba* group who studied the paintings of van Gogh in order to develop an emotional sympathy for the sufferings of his troubled and creative life. Yorozu and his colleagues were essentially striving toward expanding their inner lives by searching the paintings of the Post-Impressionists for an expressive mode that could allow them to manifest their individual selves. In that sense, their bold willingness to copy represented their commitment to the challenge of modern art in their times.

Atsushi Tanaka

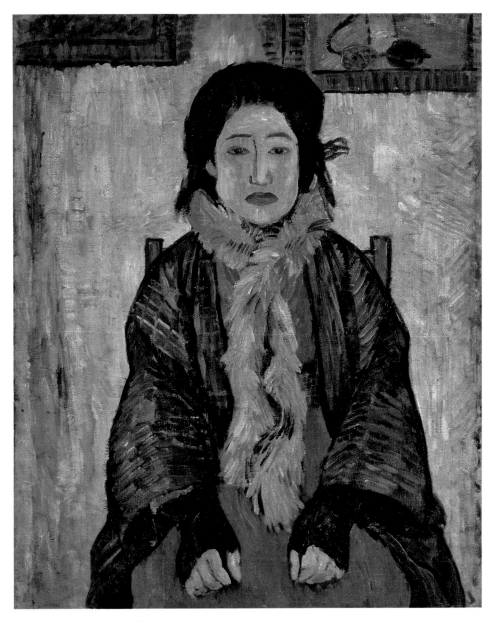

YOROZU TETSUGORŌ
Woman with a Boa 1912

YOROZU TETSUGORŌ
Nude with a Parasol 1913
Oil on canvas, 77.5 x 50 cm/30½ x 19¾ in
The Museum of Modern Art, Kamakura

This picture was presented at the second exhibition of the *Société du Fusain* in 1913 under the title *Étude*. As the title indicates, this work was begun as a study during the painter's school days; it was improved subsequent to his graduation in 1912, and is signed and dated "1913, Yorozu." That it was a study is attested by the painter Nabei Katsuyuki (1888–1969), who was Yorozu's junior by two years at the Tokyo School of Fine Arts. Nabei recollected the following:

When we were working together . . . at the art school, Yorozu did not hesitate to demand what he desired. To determine the postures of models, we all consulted together; but whenever he confidently proposed an idea, it was carried out immediately. The pose which was then much talked about both inside and outside the school was that of a nude holding a parasol. I also went to see the model being used in a senior class workshop. Indeed a naked woman was sitting there, putting up her parasol! At first I was struck with the feeling of strangeness, but I gradually recognized something pleasant in the pose that almost made me smile. This pose had been proposed by Yorozu and adopted by his classmates. The decision of course brought honor to the work of he who proposed it. Yorozu said it was interesting how the red light passing through the parasol affected the body beneath. This idea, which is commonplace today, was certainly leading the fashion thirty years ago.[1]

Of course Monet and other Impressionists often pictured women holding parasols under the sunshine, and Yorozu may have known these paintings. In fact, one of his extant sketchbooks (owned by the Iwate Prefectural Museum) contains a copy of Renoir's *Les Parapluies (The Umbrellas, 1881–85, National Gallery, London)* as well as a sketch of female students under parasols coming and going on a street. These drawings may suggest the source of his idea for the pose that stunned his fellow students.

When the picture was presented at the exhibition of the *Société du Fusain*, Ishii Hakutei (1882–1958), an oil painter and art critic, wrote the following:

I think the essence of Mr. Yorozu's Étude *lies in the fact that he has faithfully reproduced the ill-shaped naked body of a Japanese woman. Without choosing any fitting colors or scheme of design, he has simply made the woman hold the parasol, as if*

he wished to trifle with some sort of eccentricity. I cannot approve of the results.

The combination of the "ill-shaped naked body" with motifs inclined toward "eccentricity" characterizes many of Yorozu's paintings, especially his nudes. *Nude with a Parasol* exposes the somewhat Impressionist eye of the painter, because the use of the parasol itself derived from Impressionist painting. Nevertheless, this work is more subjective in expression than the nudes the artist produced while a student. Yorozu reformed his student works, like this nude, using processes of deformation and reapportionment of form, which allowed him to deny the academic style he had been taught. Of Yorozu's later nudes, Nabei Katsuyuki wrote in the memoir cited above, "I am about to smile at them; but just then something solemn keeps me from doing so. Such is the emotion they arouse in me." This comment can also be applied to *Nude with a Parasol*.

Atsushi Tanaka

Notes:

1. Nabei Katsuyuki, "Yorozu Tetsugorō," in *Kanchū bōjin* (Tokyo: Asahi shinbunsha, 1953).

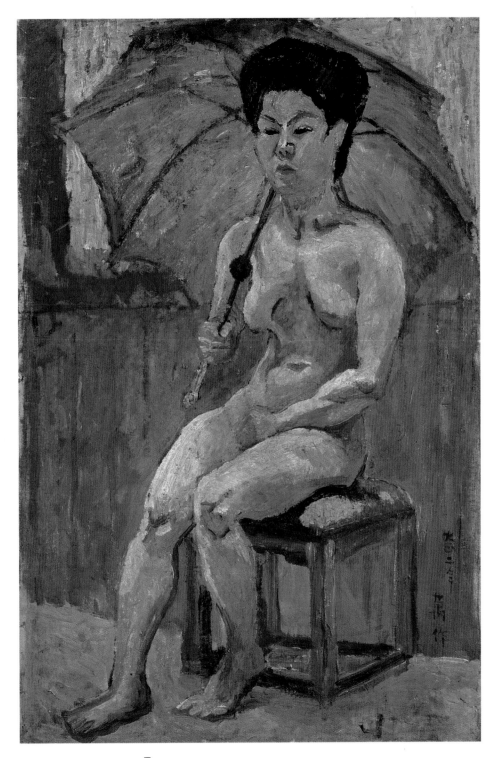

YOROZU TETSUGORŌ
Nude with a Parasol 1913

YOROZU TETSUGORŌ
Reclining Nude 1923
Oil on canvas, 79 x 115.5 cm/31⅛ x 45½ in
Kitakyushu Municipal Museum of Art, Kitakyushu

Reclining Nude was one of four works exhibited in the *Shun'yōkai*'s first exhibition, held in 1923. At that time Yorozu composed an essay entitled *On My Reclining Nude*, in which he made the following comments:

> *I never have second thoughts about how others may see what I paint. Instead, I am a person who puts into the painting only that which comes directly out of my own self. For example, I suppose there are many cases where I might well be asked just why I painted a human being some certain color. Needless to say, I don't see people in unusual colors. Still, when working, if I were not to paint the figure that color, I would never be able to really achieve my own pace or find my true form. What else can I do? In other words, that particular color was the one that had always been lurking there inside of me, in my own inner life. Thus, I take advantage of the chance offered by the painting to verify my own humanity with my own hands. I think this is the one and only means I have of doing so.[1]*

Yorozu's cool, detached self-examination speaks in a concrete fashion about the problems of artistic strategy. Rather than depicting the actual appearance of the object as it meets the eye, the artist chooses instead to cultivate a deeper insight into the most private recesses of his personality by expressing what he referred to as "my own inner life," creating a "science" of his "personal self." This conviction also attests to the existence of a tenacious psychological commitment to stay true to the artist's own, individual self.

During the production of his earlier paintings the artist's attitudes underwent a considerable development, in which he turned away from his earlier avant-garde aspirations, eventually arriving at what might be called a sort of "spiritualism" or "individualism." Yorozu himself called this viewpoint "Orientalism." It is by no mere chance that subsequently he devoted himself to experimenting with *nanga*, Japanese ink painting inspired by the "southern style" of classical Chinese painting. The year before he completed *Reclining Nude*, Yorozu made the following statement in reference to the world when depicted in *nanga* paintings:

> *What the viewer feels is a single rhythm, a rhythm of the brush, a rhythm of the ink. And of course it is a human rhythm. Somehow I think this feeling is very close to the way we experience things in our modern styles of artistic expression.[2]*

Further, Yorozu commented about the works of Tanomura Chikuden (1777–1835), an Edo period *nanga* painter, as follows:

> *Above all, I think what distinguishes his works is the way that he painted the meandering branches of trees. I intuitively feel something in common with works by Kandinsky and other modern European artists. There are certain points of confluence, I am convinced. In fact, some things here may well be even deeper than Kandinsky. . . .[3]*

Yorozu went on to state that the question was not one of locating mere superficial stylistic similarities. Rather, he felt it to be locating a sympathetic resonance between the fundamental spiritual worlds which formed the background of the paintings themselves.

Are we to assume that the admiration which Yorozu directed toward traditional arts such as *nanga* represents a retreat from the daring avant-garde tendencies that he had earlier displayed? To cultivate an emphasis on his own individuality and an awakening of the self, Yorozu had to continually question his own being; at first, he seemed to have found that he could explore his own existence only by assimilating avant-garde painting from Europe. It also appears that each style which he assumed left him with a feeling that some part of his true self remained unexpressed. This explains his constant demand for something new and different. When he finally came full circle to his "Orientalism," it is likely that for the first time he was able to establish a reciprocal relationship with European painting which allowed him to attain personal artistic freedom.

Atsushi Tanaka

Notes:

1. *Mizue*, June 1923.
2. *Junsei bijutsu*, July 1922.
3. *Ibid.*
Both essays are presently reprinted and available in Yorozu Tetsugorō, *Tetsujin garon* (Tokyo: Chūōkōron bijutsu shuppan, 1985)

268

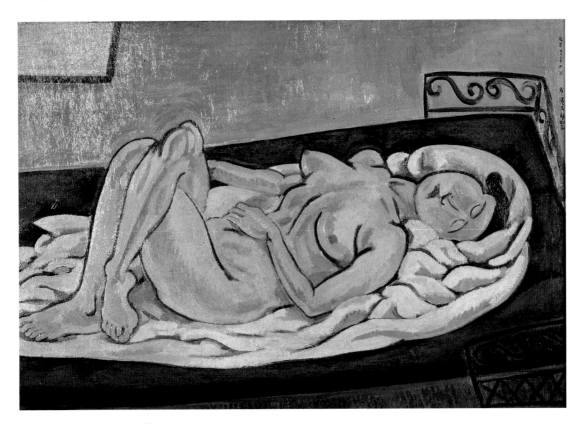

YOROZU TETSUGORŌ
Reclining Nude 1923

Fig. 61. KUME KEIICHIRŌ and his fellow artists with their Parisian model.

DOCUMENTS

Selected and translated by J. Thomas Rimer and Emiko Yamanashi

In the quest to create a genuinely contemporary Japanese art, painters, writers, and intellectuals created a revealing and often eloquent testimony to their search. The following materials have been chosen to indicate how a number of the artists represented in this exhibition viewed themselves, their work, and the value of their own experiences. Their writings have been arranged, insofar as possible, in chronological order of composition. They are divided into four general categories: responses by the artists to their French experience; accounts of their sometimes problematic relationships with their perceived ideals of Western art; statements concerning their personal artistic intentions; and, finally, their views on the nature of art in general.

I. Memories of France

UMEHARA RYŪZABURŌ (1888–1986), already well-trained in Tokyo by his teacher ASAI CHŪ, arrived in Paris in 1908 when he was just twenty. Fascinated by modern French art, he divided his time between galleries and private collections in order to study the newest paintings and deepen his understanding of contemporary art, so different from the academic style he had mastered in Japan. Umehara developed an intense love for Renoir's work, examined in detail all the paintings he could locate, and eventually travelled to the south of France in order to attempt a meeting with the Master himself. Their encounter was a happy one. Umehara became Renoir's student and eventually a close friend of the family. Umehara's memoir of Renoir contains a number of touching incidents concerning the French painter who, already sixty-seven years old when the two met, was able to continue painting, despite his increasingly frail health, until his death in 1919. No other Japanese painter of the period was able to work so closely with a French artist of Renoir's enduring stature.

MY FIRST MEETING WITH RENOIR (1917)

The house was surrounded by what seemed a copious olive grove, planted inside a fence that ran around the property. The entrance through the fence could be surveyed from a second-story window; and indeed, a rather stout older woman now looked out and seemed rather surprised to see me. When I knocked, a large-boned, black-haired woman, wearing a kind of bodice with white dots on a red ground, so familiar from Renoir's paintings, opened the latch in a careless fashion. Then, with some hesitation, she pulled open the gate, which I had taken to be the kitchen entrance.

"I have come from Japan to see Monsieur Renoir," I blurted out. Startled, she led me inside. I detested the need to make such a self-serving introduction, but on this occasion there was no help for it. In fact, had I not said what I did, I might never have found the occasion to meet him. I was ushered into a large room, in the middle of which stood a table naked of any decoration. On the chimney were two small bronzes by Maillol. I had never seen such a spare, neat sitting room in Europe, and I was quite surprised.

I had evidently passed muster with Mme. Renoir, who had indeed been observing me from the second-story window. I was evidently admitted because I myself was a painter, because I admired the Master's work so much, and because I had come from such a distant country. "So, you would like to see my husband then," she said as she disappeared. I waited, alone, with a fluttering heart.

From something that I had read, I knew about Renoir's rheumatism. Still, I had no inkling that he would appear in such rough clothing, and supported on two canes. Yet coming forth from those threadbare clothes was his majestic neck; and above all, I saw his strong, splendid eyes. I found myself, for some reason or other, filled all the more with respect for this man who, on the surface, seemed to make such a wretched appearance. I would not have felt it peculiar had I knelt at the base of his cane. I felt a mysterious transformation inside me which I can in no way try to describe when, with fear and trembling, I touched the hand he held out to me. I found

myself startled, filled with a profound sense of thanks and gratitude.

I will always remember the way the Master looked at that moment. Seeing this bizarre guest, for whom he was altogether unprepared, he could not even imagine in what language he was to be addressed. Since then I have never again seen anyone quite so startled. As I remember, I was so anxious to express my profound admiration for his art, and my thanks to him, that I quite forgot about my broken French and managed to address him, it now seems to me, in a relatively natural manner. I told him how I had learned of his name through books and had studied his paintings through printed illustrations of his work long before I left Japan. I told him how all the Japanese admired the Impressionists, and that there were many who were trying to study these new techniques. As I stopped and started my meandering remarks, he listened to me. We climbed up and down the corridors, Renoir manipulating his canes as he went along, so that he could show me his atelier. I realized from his beaming face that in some fashion or other my visit had brought some pleasure to this remarkable old man. I was profoundly happy.

His atelier was not particularly large. The door and the wainscotting were painted yellow and the walls a light blue. There was a small boy there, familiar from some of the paintings, and Mme. Renoir explained that he was their third son Claude, then nine years old. Renoir had done a series of canvases showing this boy and a woman with a red dress, writing at a desk. This woman was Mme. Renoir's niece, Gabrielle. I later learned that for fifteen years she had not only served as his model but had helped in every way, from cleaning his brushes and palette to aiding the awkward old man when he stood or walked. She was a peerless maidservant and companion.

Renoir had me sit in one of the chairs beside him and so gave me the opportunity to observe how he could create that world of harmony I so much admired. He took up a thin brush between his index and middle fingers, squeezed it dry with his thumb, and then, while holding with some difficulty in his arthritic left hand his palette, on which he had neatly arranged his colors—white, red, blue, green, black, and so on, all in order—he studied his model while, stroke after stroke, he piled up the thin layers of paint on the canvas. By watching him I thus discovered that the richest color harmonies were achieved by the juxtaposition of strong contrasts between relatively weak colors. His efforts now seemed to have reached their climax. With his casque and a piece of cloth wrapped around his neck like a young laborer,

Renoir opened his white-bearded mouth and began to sing what I took to be a phrase of Wagner. I later read something of Octave Mirbeau in which he indicated how he could feel the force of nature in Renoir's joy as he created; and at this moment, I felt exactly the same thing myself. Mme. Renoir, standing behind me, said that there was no one else alive who could paint in that way, with that touch of the hand. "There is not, Madame," I said. I felt no need to add anything more.

—Umehara Ryūzaburō, *Runoāru no tsuioku* (Tokyo: Yōtokusha, 1944), pp. 11–13.

SAKAMOTŌ HANJIRŌ (1882–1969), unlike many other Japanese painters of his generation, went to France not as a young man but as a mature artist in his thirties, already possessing a fluent and established style. His response to modern French art was tempered by a strong sense of his own personal artistic identity, one somewhat at odds with French taste as he discerned it. By 1921, when Sakamoto arrived in Paris, the work of such painters as Cézanne and van Gogh, which had created such a sensation a decade or more earlier, was by now becoming absorbed into an expanding canon of modern art. Sakamoto could thus observe their work dispassionately, in a fashion quite different from those Japanese who discovered the potentialities of modern European art through such painters earlier in the century.

LOOKING AT SOME FRENCH PAINTINGS
(1922)

There is one thing that, until now, has seemed missing for me in France. That is the lack of a certain mystery. There is something dry in the charm of the countryside here, whatever the elements of nature, the ground, the trees, or the plants. Beauty here shows itself in sweetness, like some confection, or in its patterns. There is certainly no lack of good taste in France, but that "good taste" rarely startles. I have been told that, from the beginning, there has been no true philosophy created in this country. Perhaps that is so. It would seem that those who grow up here are basically cheerful. The French are said to be proud of the fact that they have harmonized art and science; this may be why beauty seems to unfold here on such logical principles. That logic is so coherent that I find myself smiling. . . .

The word *joli* is often used here, and it seems to me that this word might be considered representative of the French frame of mind itself. That word contains within it the sense of "beautiful," "good," and "refined." It is applied to the paintings of Millet as much as to the sculpture of Rodin. The French seem to look on art in the same way that they observe

beautiful women. What gives satisfaction is that element which most quickly attracts the eye. This word *joli*, then, and the national characteristics it represents, trouble me. It is here that the Asian and Western temperaments are most sharply divided. . . .

—from "Parii tsūshin," *Tokyo Asahi shinbun*, December 24–28, 1922.

SAEKI YŪZŌ (1898–1928) had a passionate love affair with Paris, which compelled him to undertake two extended visits there, both under difficult financial circumstances. These trips brought him pain as well as pleasure, as he found himself increasingly isolated in his search for an authentic style. Not as adept with words as some of his contemporaries, Saeki's written remarks on his Paris journeys barely suggest either the force of his inner turmoil or the brilliant visual success he achieved in his finest work. Still, his published accounts show something of his daily routine undertaken while he tried, sometimes slowly and with difficulty, to find himself.

LIFE IN PARIS (1926)

As I haven't been in Paris long [on this first visit], I am not yet very well informed. When I first arrived, I stayed in a room in the Hotel Sommerard that Mr. Satomi and the others arranged for me. Soon afterwards, I moved to the suburb of Clamart. I happened to find a room there next to that of Mr. Kojima.

During that time, Mr. Kojima had been feeling lonely, as he had been living in a solitary house in the midst of a wood. He was delighted that now my wife and I would be living nearby. Our friends Maeda and Satomi, among others, often came to visit, by train or by streetcar.

Two or three months after this, Mr. Satomi was kind enough to introduce me to Vlaminck. The painter told me that my first works were merely academic. He was then kind enough to tell me a number of interesting things, including stories about various artists and their paintings. Toward the end of the year, Mr. Satomi and I made a trip to the village at Nesles-la-Valée, where we painted a number of

landscapes. I stayed there for three months, Mr. Satomi for about four.

Nesles-la-Valée is a fine place. In our free time we picked apples and pears, lined them up by the window, then ate some every day. The neighboring village is a good one too, with lots of places that look like those you can see in the paintings of Vlaminck.

After that, I came back to Paris, where I was able to take over the atelier used by Okada Minoru, about four blocks behind the Montparnasse railway station. I gradually became interested in the idea of painting scenes within the city of Paris itself, and so I stopped going to the suburbs. I continued on in this fashion until my return to Japan. When my brother came to France for a visit, I went to meet him in Marseilles, and for a week or so we travelled to Arles and Avignon, the only places I was able to see outside of Paris.

Since I was living in the area where the fourteenth and fifteenth arrondissements of Paris converge, I set up my easel and painted virtually every spot in these areas. My successful works were few, but I had the chance to paint an enormous amount. I felt a bit lazy when I got up in the morning, but once I was at it, I really lost myself in my work.

I came to be intrigued with the old houses in Paris. I was particularly fascinated with the chimneys, and with the beautiful posters pasted up everywhere. When I took time off from my own painting, I tried to see as many new works of art as possible, rather than going to the Louvre. I was delighted to find so many wonderful exhibitions. Among them, I found myself most impressed with the colors of Chagall, the profundity of Modigliani, the charm of Utrillo, and with the painterly techniques employed by Vlaminck. Just about the time I returned to Japan, I was beginning to create an art of my own; yet I had to come home, and I departed in tears.

I left Paris on a snowy evening in January. My friends all came to see me off. I felt as though I had been banished to Siberia! How I long for a chance to go back again!

—*Mizue,* July 1926.

II. Japanese Attitudes on Western Painting

Many issues divided the responses of Japanese painters to the Western art they either saw at first hand or learned about through reading and studying reproductions. Perhaps the most difficult problem they faced was that of finding a means to maintain and develop an individual vision while at the same time facing the necessity to learn new and, for some, alien artistic techniques and viewpoints. The problem of establishing an appropriate set of relationships between, on one hand, the artist's individual conception, his technique, and

his subject matter, and, on the other, his need to grasp the significance of an increasing flood of information about European art, receives eloquent commentary in the writings of many of the artists of the period.

KURODA SEIKI (1866–1921) was the first truly gifted Japanese painter to return to Japan from Europe; he introduced the methods of the European art academies to Japan. As perhaps the premier teacher to the next generation through his important position at the Tokyo School of Fine Arts, Kuroda felt a responsibility to encourage his students to develop a genuine interior vision of their own. A fine craftsman himself, however, Kuroda insisted that craft and personal insight must go together in order to produce any genuine work of art.

GOING BEYOND THE SKETCH (1916)

To express my desire quite openly, I wish that we might go beyond the stage of the sketch and progress to the state of painting finished pictures. On the whole, we do not yet have the skills necessary to create real paintings. These days, when it is fashionable to speak ill of mere technique, my remark may seem a strange one. Yet I refer to skill in no deprecatory sense. I mean the sort of ability necessary to express one's artistic intentions. With this skill we can make a picture into a real work of art. I would like our skill to be just like that required to polish a diamond. After all, European paintings, including the classical ones as well, are never executed in a thoughtless manner. Any such attitude is useless; a European painter, whatever the "-ism" to which he subscribes, will paint with zeal and patience. In that context, all our Japanese paintings look rough. One glance at them will show just how crude and unfinished they are; it is not a question of whether or not the emotions they express can be conveyed to the viewer. They show no maturity, no sense of calm in their execution. Our artists must find a way to express themselves on the basis of their individual point of view, and they must learn to paint with more ardor, so that their vision can be adequately expressed. In stating my views, I am not reproving the others. I am criticizing myself. My pictures too are rough. I am deeply ashamed of them. And since I can see the same defect in the paintings of others as well, I feel I can express myself here: we must all find a means to break out of this "age of the sketch" in which we find ourselves. Until now, I myself have only produced sketches. Now, I want to create real pictures.

—*Bijutsu*, November 1916. ▨

MORITA TSUNETOMO (1881-1933), who visited France when in his early thirties, maintained a lifelong allegiance to the art and ideals of Cézanne. This allegiance gave him in turn a powerful understanding of the close relationship, so important for the French master, between the landscapes of Provence Cézanne knew so well and the visual principles developed in his art. For Morita, an understanding of these kinds of reciprocal relationships was crucial for the development of any painter's style. In that context, the development of a stylistic dialogue with imported innovations was, in his view, particularly problematic.

From THE LIFE OF THE PAINTER AND HIS HOMELAND (1921)

Those artists among us who go to Paris and return have certain demands placed upon us by the circumstances of contemporary Japan. Those demands, I believe, impress on returning artists a need to bring back to the art world in our own country some fresh impulses. It is somehow taken for granted that with each exhibition given by an artist just back from Europe, something fresh will appear. It is assumed as well that what is brought back *is* fresh. In one respect, it is not surprising that something new might be anticipated in the work of those who have been immersed in the latest developments, and that, indeed, there may be some artistic value in what those who have returned have managed to create. Nevertheless, this level of expectation places too heavy a demand on these young artists. I feel that such an expectation is merely frivolous. It does not touch on the real meaning of art.

The intimate connection between the growth of an artist and the land in which he has grown to adulthood is ignored. Japan herself is forgotten, and no necessary relationship is perceived between the excitement found in France and the real interior development of the artist. What is truly new in art can surely not be perceived in such superficial circumstances. It is a mistake to think that every artist who goes to Paris and returns can bring something of value back. . . .

I do not deny that, in order for art to flourish, some impetus and excitement are needed, but I truly believe that an artist's real development can, as a matter of course, take place only in his own environment. I agree with utmost enthusiasm that as many persons as possible should go to Europe, go to Paris in order to see as many great works of art as possi-

ble. Yet, at the same time, I want to say to each of them, "go, develop as much excitement, as much respect for what you see as possible. Then hurry home. For if you remain too long, your true life will suffer."

Whatever one's native country, wherever he was born, such is perforce the place to which a person's most intimate attachments have been developed. Those who are born in Japan thus have the closest feelings concerning their own surroundings. It is to those that they retain the greatest sense of nostalgia. There, they can feel the closest ties. A year ago, I myself finished spending twenty months in France, in a state of excitement and shock. After I returned home, I experienced a certain sense of calm. Even a certain dullness. A sense of being somehow forlorn. Yet, as the days pass, as far as I am concerned, I find these sensations the freshest, the most genuine of all. . . .

—*Waseda bungaku*, March 1921. 🔳

KANOKOGI TAKESHIRŌ (1874–1941) bears witness to the growing accessibility of the whole range of Western art to Japanese artists. They might now use the total heritage of visual forms and ideas as their point of reference. They were thus no longer limited to the ideals of modern French art. In Kanokogi's view, the officially sanctioned emphasis on the techniques first of Impressionism, then Post-Impressionism as taught at the Tokyo School of Fine Arts, risked limiting and rendering mechanical the artist's individual spirit.

LOOKING BACK AFTER FIFTY YEARS (1924)

As I reflect on my experiences studying abroad on three different occasions, I have come to realize that the kind of paintings that enjoy popularity in Europe today have developed on the basis of the worst trends in modern thought. I have come to despise the techniques employed by the painters now praised; at the same time, I have come to respect more and more the techniques employed by the old masters. I can feel no respect for those works painted after the work of Renoir became popular, particularly those created since the coming of the so-called "Cézanne style." On the other hand, I admire enormously the work of Michelangelo in Italy, Rembrandt in Holland, Gainsborough in England, Delacroix in France, and, among the modern painters, the work of my own teacher Jean-Paul Laurens. In terms of the future of my own country, what I most hope to achieve is a contribution to the world of art that shows truly Japanese characteristics. I want to paint oil paintings that are neither merely

fanciful nor exactly like Western paintings. I would like to lead the public according to this principle. I decry the fact that the so-called "leaders" of Western-style painting in our country have, in their bureaucratic positions, been able to support the one faction that, because of politicized views, continues to confuse those who love art. They do damage to the development of painting.

I am also sorry to see that our young painters always follow blindly the newest European fashions without any consideration for a wider vision. Under these circumstances, they cannot develop their own point of view but can only create works of transient interest.

—from "Kaiko gojūnen," pp. 11-12 🔳

Increased exposure to Western art brought a sharpened perception of the differences between the Japanese and Western traditions of conceptualizing and executing art works themselves and of the differing contexts and environments in which works of art were placed and enjoyed. In this regard, SAKAMOTO HANJIRŌ (1882–1969) was a particularly acute observer of these differences and the challenge they presented.

JAPANESE AND WESTERN ART (1925)

The spirit contained in works of art, whether large or small, created by Westerners reveals a spiritual base that is related in turn to a consciousness of people and of society. Japanese art, on the other hand, has concerned itself with a domestic, personal taste based no doubt on the customs of the past and our own intimate feelings concerning our daily life. The basis for the difference between our tastes and those of the Europeans lies in this distinction. Perhaps this is why Japanese paintings somehow look awkward when placed on exhibition. European paintings are created in a broadly rendered style for that purpose from the beginning.

Traditionally in Japan, paintings created for sliding doors and folding screens were considered to require a broadly rendered and public style, and even hanging scrolls were meant to show elements of that style as well. Yet most art was created on the basis of the artist's own sense of life, and such works were appreciated for their keenness, purity, and sense of melancholy. In this regard, possibly no other culture has been as merciless as Japan in judging works of art in terms of affectation or vulgarity. Seen from this perspective, there are probably few Western paintings that would satisfy. This is doubtless because we, on an unconscious level, have concealed within us the desire for some sort of religious con-

sciousness. If this desire on our part is not somehow visible in a work of art, it is hard for us to feel any real sense of admiration.

As I walked through the *Salon d'automne* with these personal thoughts, it became immediately apparent that there are many vulgar and distasteful works on display, paintings that are created with a wrong attitude from the start. There seem to be a large number of works that brazenly advertise themselves in some sort of contest for the survival of the fittest. They reveal not their principles but a desire to compete commercially. Yet, just as one might say that, even though the stream is muddy, there are large fish swimming in the water, so it must be admitted that in the art world of Paris today, there are far greater painters than in Japan. Even if various hints would suggest a certain spiritual paralysis in French art, the structure is still alive and functioning.

The world of Japanese art, when compared to that of Paris, is perhaps more pure, certainly far less brazen. A sense of ferment, of ardor, is still alive. There is an assumption that the future will bring a still higher level of accomplishment; yet now, there seems to be only small fish, in a small stream. I have no sense of a great talent developing among us. Our general level of success is rising; yet looking at the work of our individual painters, I can find only small movements that seem somehow forlorn.

I am convinced that nature as we know it in Japan holds many happy elements for the creation of art. The colors of nature in Japan are not striking and so may appear a little bland on the surface. Yet here in France, I do not find the kind of nature we know in Japan, which can produce that feeling of a flowing tenderness and graciousness.

—*Mizue*, October 1925. ▨

FUJITA TSUGUJI (1886–1968), who spent much of his active career in France, was determined to locate a personal style through his direct responses to the strategies of the European contemporary painters whose work he saw in Paris. Active after World War I, when individuality in personal expression was the paramount virtue sought in France, Fujita developed his own authenticity in terms of innovation from within the established boundaries of contemporary European painting.

SOME FRANK ADVICE TO THE YOUNG
(1936)

Why is it that our seniors did not try their utmost to compete with Western painters when they went to Paris? Why did they return to Japan, thinking of their own positions, rather than struggling on with their real opponents? I myself have decided that, whatever else might happen, I would enter the ring and throw myself wholeheartedly into the fray. I began by doing exactly the opposite of what my friends were doing. I hoped that the world would understand and forgive me until I had come to find some light on my way. I went through a difficult period, not even corresponding with my beloved father for a period of six years. I looked over the work of the painters I saw in Europe. The style of Dunoyer de Segonzac, which makes use of thick layers of paint, was much in fashion in those days; I thus tried to paint with the thinnest surfaces possible. Various artists like to use large brushes in the manner of Kees Van Dongen; I set out to use a very fine brush. Many tried to use complex and beautiful colors in the fashion of Matisse; I decided to try to create my paintings in black and white. All I did was the opposite of what the other painters attempted.

My teacher Kuroda, who was an Impressionist of the "purple school" and who used that color in his shading, urged me to remove black from my palette of colors. I found his suggestion quite ridiculous. Black was the color to which we Japanese and Chinese are most sensitive. Why shouldn't we use it in oil painting? I decided that I would use black in my paintings. I worked hard on my brush technique and on the use of materials. Others may have some interest in my methods. Ready-made paints such as those sold in stores may be convenient, but they lack interest for an artist. Good work can only be done when a painter goes through the process of preparing his paints and even making his brushes, just as during the period of the Italian primitives, when Fra Angelico was painting, or during the Tokugawa period in Japan. Anyone can paint if he merely goes and buys what is readily available in the store.

I began by studying how to make use of these various materials. I experimented with them in various ways. At first I was not able to achieve any good results. I was very poor at this time, and I must have burnt five hundred works, either for heat or in order to cook my food. I kept only fifteen or sixteen of them, thinking that they would represent my best work after my death. The rest I consigned to the flames. I was confident, though, that those fifteen or so could earn me my reputation. It was this feeling that allowed me, during this difficult period of poverty, to take comfort and, in the spirit of oriental philosophy to which I subscribed, to make myself ready to die at any time. Even though my name might not be known to the world while I was alive, I thought, I might become famous after my death. Then one morning, I suddenly realized that, according to Western conceptions, it is fine during your

own lifetime to eat good food, prolong your health, and travel around to broaden your perspective. Then too, one could keep lots of materials to use as reference and to create as many works as possible before disappearing from the face of the earth. I realized that I had been wrong. I decided to live as long as possible, and to leave thousands of works behind!

Among them, surely half would have some value. If even a tenth or twentieth of them were good, that would be enough; after all, masterpieces aren't so easy to create.

—*Bura ippon* (Tokyo: Kōdansha, 1984), pp. 123–4.

III. Artists on Their Own Work

The various tensions placed on artists who attempted Western-style painting during this period transformed many of them into articulate spokesmen for the ideals they sought in their own work. Defining their goals with eloquence, their honesty in revealing the sometimes problematic nature of their quest provides moving testimony to the complexities of their search.

AOKI SHIGERU (1882–1912), one of the most ardent spirits of his generation, was completely dedicated to his art. To master that craft was, for him, to work toward the high human ideals that Western art held up to him. An eloquent writer, Aoki's comments show both ardor and rigor. The painting he discusses below is Cat. 2 in the present exhibition.

From ABOUT MY PAINTING *PALACE UNDER THE SEA* (1907)

In my opinion, any truly subjective realization in the visual arts cannot lack three elements, which are often in conflict: (1) conception, (2) knowledge, and (3) technique. However clumsy a work of art may be, it will have significance if all three elements are involved in its creation. On the other hand, no matter how skillfully a painting may have been created, it will be incomplete if one of these elements is missing. Until now, my own works have not shown these qualities. In my painting *A Good Catch*, I concentrated on the conception, which I believe I have to some extent conveyed. The second element, knowledge, became the source of my efforts in creating *Palace under the Sea*, a work that caused me so many difficulties. As for the third, technique, I must now make an effort to see to what extent the realities of nature can be used as a basis for creating a work of art. Until now, I have not yet succeeded in fusing these three elements. When I do so, I believe that I will be able to work in a spirit of artistic calm appropriate to that of a real artist, who possesses both an aesthetic conscience and a true sense of the significance of human existence.

—Aoki Shigeru, *Kashō no sōzō* (Tokyo: Chūōkōron bijutsu shuppan, 1966), p. 24.

KISHIDA RYŪSEI (1891–1929) was an eloquent spokesman for the vocation of the artist, both in terms of skill and of motivation. His numerous writings, examined together, provide a spiritual chronicle of the period that reveals the problems faced by writers, artists, and intellectuals in all spheres of cultural activity. Mixing the practical and the mystical, Kishida succeeded to a remarkable degree in articulating the powers of Western art, and of Western-style art in Japan, as a means to bring into being a spiritual dimension within the context of modern life. In the two brief passages cited below, Kishida relates some of these larger concerns to his own work.

From THE SUBSTANCE OF BEAUTY (n.d.)

There are in general three ways in which "inner beauty" becomes the "outer beauty" that is expressed in art. In the first instance, art is born directly from within, without borrowing any forms from nature itself. Such is the art of line, shape, and color, that which might be termed the art of decoration. Next is that art created as it comes to be discovered within natural forms, where it is given birth, an art that might be called the art of realism. In the third instance, a form is imagined that draws on a memory of natural forms, of imagination or of some conception or psychological impulse that is then given form. Such form naturally and of itself comes into being and can command in turn the birth of an "inner beauty." Such is the beauty of the imagination. This third beauty is closely allied to the first and the second. All grasp nature in an enhanced and decorative way. So it is that, to a certain extent, the decorative aspects of beauty are manifested through this realism. . . .

My own method mixes these elements. On the whole, I make use of realism, yet I never forget the need for the decorative element. I hope to paint in

such a way that in each canvas, images of decoration and of realism may fuse together. On the basis of my own experience, I believe there lies in the depths of realism a powerful decorative potential. If one pursues a realistic image to the fullest, startling images will result. In this is the true "mystery." This feeling of mystery lies within the sense we have of our own existence. It is a beauty without form. It possesses a surprising decorative rhythm. I do not feel misrepresented if I am referred to as an artist who has entered into a realm of "mystery" by way of realism. Still, at the same time, I do not feel that I merely look at objects in a realistic fashion. I would like to make use of the beauty of realism through the free use of my imagination. I feel that I would like to create and blend those elements more harmoniously than anyone as yet has done. The great virtue of our own time lies in the fact that we are capable of grasping more of the beauties of virtue than did the men of any other age. I would like to make freer use of that knowledge than has ever been done before. Art that possesses such power lives in a world of freedom.

—Kishida Ryūsei, *Bi no hontai* (Tokyo: Kawade Shobō, 1941), p. 24; p. 31. ▨

From WHY I HAVE MOVED AWAY FROM MODERNISM (1915)

My early work, which first brought me recognition, was greatly influenced by the Post-Impressionists (especially van Gogh and Cézanne) and clearly reflects the strong impression their paintings made upon me. Since that time, I became engrossed in theory, in such problems as color, the regulation of shapes, and other questions, in order to achieve the essential. Still, inevitably, I was never able to find any satisfaction in this effort. The more I attempted to simplify, the more strongly I felt a desire for a fidelity to the realities of nature. During this period my work thus began to draw away from contemporary tendencies, a fact that made me uneasy. Still, I believed that it was necessary for me to follow my own imperatives. So it was that I began to comprehend certain things that I alone seemed able to feel. I then grew away from outside influences and arrived at a stage where I could create the kind of paintings that I do today.

However much my paintings may seem to draw away from contemporary styles as they move toward a classic style, I still deeply respect van Gogh and Cézanne. Indeed, I believe that I understand them better, and respect them more, than I did when I was directly under their influence. I still derive profound ideas from them.

I have been taught by them to see nature according to my own inner demands. It was because of them that I was first able to set out on the path that gave birth to my own individual consciousness, that path which is revealed in my art. From that point onwards, I slowly became my true self. This does not estrange me from them. My own actions permit me to admire them all the more profoundly. By learning to feel within me the desire for an eternal beauty, I have come to realize that the Post-Impressionists, too, were attempting to reveal that same verity.

The world that van Gogh managed to capture in his last years was certainly one that possessed an eternal beauty. In that sense, I believe that both Cézanne and van Gogh were profoundly classical. Cézanne said it quite clearly: "The ultimate to which art can attain is the classic." I savor deeply those words. I profoundly agree with and respect them.

—Kishida Ryūsei, *Bi no hontai*, pp. 175–7. ▨

YOROZU TETSUGORŌ (1885–1927), one of the most experimental of painters in his generation, felt the loneliness of working as an isolated figure, rather than as a member of a group whose adherence to a communal style often formed the context in which many of the greatest works in traditional Japanese art had been created. For Yorozu, such traditional group attitudes could still produce a certain level of beauty, but a really committed contemporary artist must rise to a higher level, to go beyond what was for him the "art of decoration." In the age of individualism, Yorozu felt, while artists could band together, their work must stand alone.

ON FORMING AN ASSOCIATION OF ARTISTS (1923)

When artists truly and honestly attempt to pursue their own path, they must absolutely be allowed to do so in an environment of perfect freedom. For an artist, no limitation can be placed on that freedom. I have said that the purpose of this manifesto is to attract sympathizers. Yet in terms of the actual problems confronting us, with what attitudes are we to conduct our lives? The one thing that we must do is to pursue our individual path. We must live by creating our own works, and with an absolute honesty, by allowing our real selves full reign. There is no other way. It is never possible for a true artist to create art merely by setting out to touch the hearts of others. We must live by our credo that we will discover no "sympathizers."

There are those who ask if we who assemble together intend to create a new art. If there are any

who think that a group of true artists can actually join together, select together some set of principles, and then create works of art on the basis of those principles, with good results, they would be fools indeed. The path of art is an utterly individual one. Art can only be born of inner necessity. It is impossible to live on only in order to decorate. To escape from that urge to decorate is not easy. Yet our emotions, our very lives, are sometimes clouded over because of such decoration. In order to live in purity, we must work to escape from such a spirit of decoration. Art that is strongly decorative is in fact a withered art. It exposes men as they truly are.

Today, Japanese art, viewed from world standards, is by no means inferior. Indeed, we are blessed with many uniquely good qualities. In terms of taste, the Japanese people are certainly favored with high standards. This has been true historically, and it remains true in the artistic sphere today. In the next hundred years we can surely expect a great flowering. In the end it is we, and those who do sympathize with us, who must bear the burden of creating this golden age.

—*Tokyo Asahi shinbun*, June 3–5, 1923.

FUJISHIMA TAKEJI (1867–1943), who studied in Europe with Fernand Cormon and Carolus-Duran, fell, like so many of his generation, under the spell of Cézanne. Later in his life, however, Fujishima came to explain the ideals of his own work in terms of the creative attitudes of those great figures in his own culture whose aesthetic ideals created the great Japanese traditions. The conception, articulated so well by Fujishima, of the artist losing himself in his subject matter can be traced in artistic and literary attitudes back to the thought of such seminal figures in the Japanese arts as the great haiku poet Matsuo Bashō

(1644–1694), and even to Zeami Motokiyo (1364–1433), the dramatist who articulated the beauties of the medieval poetic nō theatre.

From MY PAINTING (1932)

In terms of the creation of my own work, I have taken as my motto, "absolute nothingness." It is in such a context that I paint what I observe. I have no "principles" or "ideology" concerning the way in which I paint. It is as though I were a cloudless mirror, a transparent mind. After all, a perfectly polished mirror has in one sense no appearance in and of itself but serves as a means to reflect all things in the world around it. If that mirror is clouded over or shows irregularities, then it cannot reflect a true image. I believe the province of art surely lies in this kind of true vacuum. It has been my long felt desire to push into these regions. I have tried to reach such a stage for a long time. Unluckily, I have not attained that level, neither as a man or as an artist.

When I paint, I am of course concerned with the sizes of the brushes I am using, my choice of colors, and so forth. Which brush will I use, and in which way? How will I employ a particular shade? These sorts of questions are certainly not without their importance. Still, when I reflect on those works of mine that show a real cohesiveness, that manage to lack any awkwardness, I know that, on the whole, I created them without any concern for such small matters. They were made possible without such worries. When I study these works now, I seldom know what color I used there, what brush technique I employed here. Would that I could create all my works in such a frame of mind!

—*Bijutsu shinron*, February 1932.

IV. On the Aims of Painting

As the artists of this period came to know more and more about the history and function in European society of Western art, they combined their sympathy and knowledge with an often intuitive understanding of their own Asian heritage. Such reciprocal consciousness led some to remark on the aims of painting. Their statements show them to have been at once, in the words of novelist Natsume Sōseki, "modern, international, and Japanese."

NAKAMURA TSUNE (1887–1924) was never able to study in Europe. Much of his wisdom concerning the larger purposes of art was self-taught. Fascinated by what he knew of the developments of contemporary European painting, he came to write eloquently through his own experience of the nature of the various elements that, for him, enter into the creation of an artistic vision.

THE ESSENCE OF PAINTING (n.d.)

An arabesque of abstract lines, the relation of geometric volumes, and the very tones of colors themselves have the power to express our own inner mental life. Those who would call themselves artists must master those powerful forces and learn to use them. It might be said that these represent the paint-

er's plan, the vision he has within him, the wisdom he possesses, his own internal logic. Yet in order to realize those intentions, give them strength, precision, and richness, it is necessary that those mathematical elements ally themselves with the myriad material details that go into making up the visual universe. This necessary meeting should bring neither a sense of degradation nor of humiliation to the painter. To take an example from music, the mathematical relationships in melody must be joined to an expressive, physically emitted sound that produces an actual quantity of noise. In architecture, the mathematical relationships in volume must be joined to practical considerations of space and architectural materials. In that regard, those new artists who resist the Cubism of a Metzinger or the abstract style of a Kandinsky want to place some element of their vision directly onto their canvas so as to give depth to their conception, to create an intimate connection with human life. On first glance, the rules of abstract painting allow for the creation of works more free than those that have been created heretofore, but in fact these conceptions produce an uncouth sterility. Why should this be so? The painter cannot, with the materials available to him, impose his vision down to the last detail without some reference to the visual images that make up the universe in which we live. The great attraction of the art of painting, indeed its essence, depends on a unique ability, available to no other art, to combine external and internal images in mutual harmony. The painter can, within his own mind, combine objectivity and his own subjectivity in order to give the suggestion of a deeper reality he can glimpse by means of the image he creates.

Such is the proper road that artists have walked since the beginning, and such is the most enlightened means available to create a true art.

—Nakamura Tsune, *Geijutsu no mugenkan* (Tokyo: Chūōkōron bijutsushuppan, 1963), p. 139. ▩

MAETA KANJI (1896–1930), who reached his maturity as an artist in the 1920s, saw with great clarity the challenges presented to his generation amidst the shifting styles and rapid metamorphosis of ideals in modern art. Like KISHIDA, *Maeta found the solution in a quest not for newness for its own sake, but in the development of an inner spirit strong enough to serve both as a comment on and critique of the artist's epoch.*

From THE KEY TO TECHNIQUES OF REPRESENTATION (1927)

Beauty changes. That fact is true. When those in the coming generations admire what the artists of today

have accomplished they will find that what remains will merely consist of a record of how the period was colored in. Yet can we possibly be satisfied with the fact that the burning creative desires of our youth will only become a tinted record of their times? No, we cannot. Youth today must stake their very lives on the need to grasp the beauty of the on-coming age.

The content of beauty changes from one generation to the next. The individual assertion of life revealed in the work of Cézanne, van Gogh, and others possesses an eternal beauty redolent as well of our society at this time. What the youth of today must seek is that beauty which can express the new society in which we live. Yet such an effort is hard to reconcile with the nature of our society as it exists today. When artists begin to assert and express their passions, they will soon realize that they themselves are living at a time when they must be forced to take cognizance of the pain they feel, and to acknowledge as well the necessity of waging war against society. Those who lead, once they have grasped the nature of contemporary reality, must use their spiritual strength in order to express themselves without distortion, however much they may have to suffer. Should such an artist appear, he will be, like one who truly masters the art of his time, a new Rembrandt, a new Cézanne, a new van Gogh.

—Maeta Kanji, *Shajitsu no yōken* (Tokyo: Chūōkōron bijutsushuppan, 1960), pp. 80–81. ▩

MITSUTANI KUNISHIRŌ (1874–1936), who knew European art well and had himself experienced a long and successful career in Japan as a Western-style painter, was acutely aware of the vicissitudes in the fortunes of Japanese painters who, in attempting to make a living for themselves in Tokyo and elsewhere, often risked compromise and misunderstanding.

From QUESTIONS AND ANSWERS ON PAINTING (1931)

Q: What about style?
A: The question of style can be difficult. Some works of art are beautiful, some are ugly. We need not decide which one is better. Even in a work that sets out to be ugly, order must be established, and shapes and colors must be worked through. In the case of a beautiful work, all vulgar aspects must be discarded. We must think on the nature of beauty. There always remains the question of whether some elegance is always present in art; but leaving that aside, an artist who has been well trained for a long time will have beauty in his work, whether his painting is "ugly" or "pure." That choice involves

the intention of the artist. Does an artist paint for beauty? For ugliness?

If an artist trains himself for a considerable period, he will come to possess the skill that can allow him to express his own intentions. Should he get that far, then his position, his market value if you will, can be determined. If he can create five, better still ten first-class works, that will be enough.

Q: Can paintings be treated as merchandise?

A: Actually, works of art must not be created in terms of their sale value. Needless to say, however, highly individual works by younger painters can scarcely be expected to sell. To find buyers, these painters must compromise. If we create a work exactly in the way we wish, we may well have to resign ourselves to the fact that our work may sell for little if anything. Young painters really have to compromise. We may warn them not to do so, but the situation is difficult to remedy, I fear.

Q: If a good painting that will also sell can be created, then doesn't the problem disappear?

A: In principle, yes, but I don't think that such a situation is likely to arise. How could such works be good? There is no way to surmount this problem. Can good paintings only be made when you are poor and cannot eat? In any case, if you are a millionaire, I doubt that you can do it!

Q: Does the work of the artist match society's definition of a genuine occupation?

A: Perhaps it is best to think that it does not, I suppose. Still, human beings do have to eat. If we could earn money while painting as freely as we please, that would be fine. But as we must earn our livelihood, our work does become an occupation. As far as I am concerned, I think that may be just as well. In terms of my own principles, I would rather not earn money; and indeed when you resist such impulses, new artistic paths often open up for you. That is why I believe that even those of us who come back from Europe can well put up with a struggle for three years, even five years. Otherwise, our work can't be trusted.

Q: What about the imitation of new styles?

A: Of course one has to imitate. Even if we want to create works that are uniquely Japanese, we still need to look at Western paintings in order to supplement our own deficiencies. And I don't believe we have to set out to be "Oriental." If we simply express ourselves, the results will be sufficiently "Oriental," I am sure.

—*Bijutsu shinron*, September 1931

In the debate between timeliness and timelessness as ideals in the creation of art, FUJITA TSUGUJI'S (1886–1968) sense of the need to attempt to combine both elements reveals a fearlessness of purpose as well as a self-consciousness concerning the nature of the visual medium that makes him a thoroughly international artist.

From GENIUS (1936)

It is hard for us to express in one word just what art is all about, but works that are generally acknowledged to be of real significance never lose their value, however old they may be. They will preserve in themselves a fresh life throughout the coming generations. On the other hand, works that merely reveal new styles are not necessarily of value; there are many of these which are bad. They are dead even as they are born. Which of these works can truly be named as good? How can such works be brought into being? Such are the problems we artists face in our own lives.

The works we create must grow from our own unique ideas. They must not in any sense be imitations taken from the ideas of others. Such cowardly works never show the proper qualities. It is our duty to create works of art such as have never existed in the past, nor, without us, might ever exist in the future. It is just this kind of effort that makes life worth living. To steal the accomplishments of another merely in order to recreate them is an act without meaning. It is often said, for better or for worse, that we Japanese are gifted for imitating things, which we can improve upon, but that we are lacking in the innate power to create without a model from which to work. In the realm of art, we must create works of a new value, one of our own devising. This is very difficult to accomplish. Yet once such a work has been created, the universe of art will have been enlarged. The artists who can create such works can surely be called Masters. Perhaps only one such painter can appear in a hundred years. How I wish that one of them might be born in Japan!

—Fujita Tsuguji, *Bura ippon*, pp. 13-14.

SELECTED BIBLIOGRAPHY

I. Materials in Western Languages

This section of the bibliography contains materials either entirely in Western languages, or items published in Japan that contain substantive material in Western languages. Annotations call attention to entries of particular value. This section of the bibliography was compiled by Gerald D. Bolas and J. Thomas Rimer.

DICTIONARIES AND REFERENCE WORKS

Roberts, Laurance P. *A Dictionary of Japanese Artists*. Tokyo, New York: John Weatherhill, Inc., 1976. Useful entries on individual artists, with bibliographic citations.

————. *Robert's Guide to Japanese Museums*. Tokyo, New York, and San Francisco: Kodansha International Ltd., 1978. Individual entries often contain items of interest concerning modern Japanese art.

Tazawa Yutaka. *Biographical Dictionary of Japanese Art*. Tokyo, New York, and San Francisco: Kodansha International Ltd., 1981. Fewer artists are included than in the Roberts dictionary but entries are longer and provide more detail. Good bibliographic citations.

See also various entries in *Kodansha Encyclopedia of Japan*, published by Kodansha International Ltd., in 1984. The entry for "Modern Painting" (Vol. 6, pp.155–158) is particularly useful.

MONOGRAPHS AND ARTICLES

Baekeland, Frederick. *Imperial Japan: The Art of the Meiji Era (1868–1912)*. Ithaca, New York: Herbert F. Johnson Museum of Art, Cornell University, 1980.

Bridgestone Museum of Art. *L'Académie du Japon moderne et les peintres français*. Tokyo: Bridgestone Museum of Art, 1983. The exhibition focuses on several of the important French teachers of the Japanese, such as Jean-Paul Laurens, Fernand Cormon, Carolus-Duran, and Raphaël Collin, with three brief essays and a catalogue in French.

Centre Georges Pompidou, ed. *Japon des Avant Gardes, 1910–1970*. Paris: Centre George Pompidou, 1986. A highly useful catalogue, with excellent essays and illustrations, covering some of the historical periods treated in *Paris in Japan*, notably the work of Yorozu Tetsugorō.

Conant, Ellen P. "The French Connection: Emile Guimet's Mission to Japan, a Cultural Context for *Japonisme*." In Hilary Conroy, Sandra T. W. Davis, and Wayne Patterson, ed., *Japan in Transition, Thought and Action in the Meiji Era*. Rutherford, New Jersey: Fairleigh Dickinson University Press, 1984: 113–146. Fascinating background material on French and Japanese cultural relations during the period.

Fenollosa, Ernest. "Contemporary Japanese Art." *Century* 46 (1893): 577–581. An account of Japanese government actions to establish a policy of artistic self-development.

French, Calvin. *Through Closed Doors: Western Influence on Japanese Art 1639–1853*. Ann Arbor: University of Michigan Museum of Art, 1977.

Haga Tōru. "The Formation of Realism in Meiji Painting: The Artistic Career of Takahashi Yuichi." In Donald Shively, ed., *Tradition and Modernization in Japanese Culture*. Princeton, New Jersey: Princeton University Press, 1971: 221–56.

Harada Jirō. "Japanese Art and Artists of To-day. I. Painting." *Studio* 50 (1910): 98–123.

————. "The Modern Development of Oil Painting in Japan." *International Studio* 55 (1915): 270–278.

Harada Minoru. *Meiji Western Painting*. New York and Tokyo: Weatherhill/Shibundo, 1974. A survey that deals with the artists who serve largely as precursors for those treated in the present exhibition. Includes a bibliography, glossary, and 131 illustrations.

Kawakita Michiaki. *Modern Currents in Japanese Art*. New York and Tokyo: Weatherhill/Heibonsha, 1974. An overview, with good illustrations, of the entire period from 1868 to the present.

Kumamoto Kenjirō. "Contemporary Painting of

Western Style in Japan." *Bulletin of Eastern Art*, no. 12 (December 1940): 7–16. Includes illustrations of a number of painters in the present exhibition.

Miyagawa Torao. *Modern Japanese Painting*. Tokyo, New York, and San Francisco: Kodansha International, 1967. A general account of the entire period from 1868 to the present, with a few pages concerning the period under review. Excellent illustrations.

Munsterberg, Hugo. *The Art of Modern Japan*. New York: Hacker Art Books, 1978. The period covered by this exhibition is treated in a few brief remarks, pp. 56–61.

Okakura Kakuzō. "Notes on Contemporary Japanese Art." *International Studio* 16 (April 1902): 126–30. Okakura's views on the Tokyo School of Fine Arts.

Rosenfield, John. "Western-style Painting in the Early Meiji Period and Its Critics." In Donald Shively, ed., *Tradition and Modernization in Japanese Culture*. Princeton, New Jersey: Princeton University Press, 1971: 181–219.

Selz, Jean. *Foujita*. Naefels, Switzerland: Bonfini Press, 1981. An engrossing account, in English and French editions, of the artist's life and work.

Slater, Willard. "Why Japan Collects Western Art." *International Studio* 75 (April 1922): 151–153. Useful comments on the projected Matsukata museum.

Sullivan, Michael. *The Meeting of Eastern and Western Art*. Greenwich: New York Graphic Society, 1973. The book deals with China as well. The period under review is covered in a brief section, pp. 138–42.

Takashina Shūji. "Paris and the History of Modern Art." In *From Impressionism to École de Paris*. Saitama: The Museum of Modern Art, Saitama, 1982: 144–149. This catalogue includes two essays in English, numerous color and black and white illustrations, and a particularly interesting appendix of documentary photographs.

Uyeno Naoteru. *Japanese Arts and Crafts in the Meiji Era*. Tokyo: Toyo Bunko, 1958. A volume in the ten-volume series "Japanese Culture in the Meiji Era." A number of useful details are provided that are otherwise unavailable in English.

Yamada Chisaburoh, ed. *Dialogue in Art: Japan and the West*. Tokyo, New York, and San Francisco: Kodansha International Ltd., 1976. See especially Kawakita, "Western Influence on Japanese Painting and Sculpture," pp. 71–112. 🔲

II. *Materials in Japanese*

This section of the bibliography includes a variety of materials concerning modern Japanese art. Annotations are provided when the material is of particular interest. Many of the books listed contain excellent color illustrations. This section of the bibliography was compiled by Tadayasu Sakai and Emiko Yamanashi, with editorial assistance from Mrs. Fumi Norcia.

GENERAL STUDIES

Asahi shinbunsha, ed. *Genshoku Meiji hyakunen bijutsukan*. Tokyo: Asahi shinbunsha, 1967. The volume contains entries for over two hundred artists, with full bibliographic information. The book can function as a dictionary on the subject.

Haga Tōru. *Kaiga no ryōbun*. Tokyo: Asahi shinbunsha, 1984. A remarkable study, based on comparative principles, of art and literature movements in the Meiji period.

Harada Minoru. *Kindai yōga no seishun zō*. Tokyo: Tokyo bijutsu, 1968.

Hijikata Teiichi. *Nihon kindai no bijutsu*. Tokyo: Iwanami shoten, 1965. Modern Japanese art discussed in a world context. Highly regarded.

————. *Kindai Nihon no gaka-tachi*. Tokyo: Bijutsu shuppansha, 1959.

————. *Kindai Nihon yōga shi*. Tokyo: Hōunsha, 1947. The first study, originally issued in 1941, that treats the history of modern Japanese art in terms of aesthetic concepts.

————. *Taishō shōwa ki no gaka-tachi*. Tokyo: Mokujisha, 1971.

Imaizumi Atsuo. *Gendai gaka ron*. Bijutsu shuppan, 1958.

Isozaki Yasuhiko and Yoshida Chizuko. *Tokyo bijutsu gakkō no rekishi*. Osaka: Nihon bunkyō shuppan, 1977. A history of the Tokyo School of Fine Arts.

Kagesato Tetsurō. *Natsume Sōseki. Bijutsu hihyō*. Tokyo: Kōdansha, 1980. An analysis of important essays by the famous novelist.

Kawakita Michiaki. *Kindai Nihon bijutsu no kenkyū*. Tokyo: Shakai shisōsha, 1969.

―――. *Kindai Nihon kaiga no tabi*. Kyoto: Unsōdō, 1971.

―――. *Kindai Nihon no bijutsu*. Tokyo: Shakai shisōsha, 1964.

―――. *Kindai no yōgajin*. Tokyo: Chūōkōron bijutsu shuppan, 1959.

―――. *Meiji Taishō no gadan*. Tokyo: Nihon hōsō shuppan kyōkai, 1964.

―――. *Nihon no bijutsu—sono dentō to gendai*. Tokyo: Shakai shisō kenkyū shuppan-bu, 1958. A useful account of the history of Japanese aesthetics is employed in the treatment of the works discussed.

Kimura Shigeo. *Nihon kindai bijutsu shi*. Tokyo: Zōkei geijutsu kenkyū 1957.

Kumamoto Kenjirō. *Kindai Nihon bijutsu no kenkyū*. Tokyo: Ōkura-shō insatsu-kyoku, 1964. Excellent use of primary materials in discussing the development of modern Japanese art.

Miyagawa Torao. *Kindai bijutsu no kiseki*. Tokyo: Chūōkōronsha, 1972. The development of modern art is connected to larger concerns of modern intellectual history. A unique work.

Moriguchi Tari. *Bijutsu hachijūnen shi*. Tokyo: Bijutsu shuppan, 1954.

Nakamura Giichi. *Kindai Nihon bijutsu no sokumen*. Tokyo: Zōkeisha, 1976. Discusses the influence of the Pre-Raphaelites on Japanese romanticism.

―――. *Nihon kindai bijutsu ronsō shi*. 2 vols. Tokyo: Kyūryūdō, 1981–2. An account of various disputes that emerged in the development of modern Japanese art. A highly useful collection for understanding the issues of each period.

Nihon yōgashō kyōdō kumiai, ed. *Nihon yōgashō shi*. Tokyo: Bijutsu shuppan, 1985. A thorough study, with excellent illustrations, of how modern Japanese art was created, bought, and sold.

Ogura Tadao. *Kindai Nihon bijutsu no ayumi*. Tokyo: Shakai shisōsha, 1964.

Okada Takahiko. *Nihon no seikimatsu*. Tokyo: Ozawa shoten, 1976.

Sakai Tadayasu. *Kage no machi—egakareta kindai*. Tokyo: Ozawa shoten, 1983.

―――. *Seishun no gazō*. Tokyo: Bijutsukōronsha, 1982.

Sasaki Seiichi and Sakai Tadayasu. *Kindai Nihon bijutsu shi*. 2 vols. Tokyo: Yūhikaku, 1977. A general history of the arts from the middle of the Edo period through the postwar years. The term "modern" in connection with the arts forms the focus.

Sata Masaru. *Itan no gaka tachi*. Tokyo: Zōkeisha, 1968.

Takashina Shūji. *Kindai Nihon kaiga shi*. Tokyo: Chūōkōronsha, 1978.

―――. *Kindai no yōga* (Nihon no bijutsu, vol. 27). Tokyo: Kōdansha, 1972.

―――. *Nihon kindai bijutsu shiron*. Tokyo, Kōdansha, 1972. Essays on the accomplishments of artists in both the *yōga* and *Nihonga* styles.

―――. *Nihon kindai no biishiki*. Tokyo: Seidosha, 1978. An excellent treatment of the ideas on aesthetics held by various modern artists and writers, with an especially good treatment of the *Shirakaba* school.

Takeda Michitarō. *Nihon kindai bijutsu shi*. Tokyo: Kondō shuppansha, 1969.

Takumi Hideo. *Itan no gaka tachi*. Tokyo: Kyūryūdō, 1983.

―――. *Kindai Nihon no bijutsu to bungaku*. Tokyo: Mokujisha, 1979. Good information on various art journals and periodicals.

―――. *Kindai Nihon yōga no tenkai*. Tokyo: Shōshinsha, 1964. An excellent discussion of the historical significance of various modern art movements.

―――. *Taishō no kosei ha*. Tokyo: Yūhikaku, 1983.

―――, Harada Minoru, Sakai Tadayasu. *Meiji Taishō bijutsu*. Tokyo: Yūhikaku, 1981.

Terada Tōru. *Kaiga to sono shūhen*. Tokyo: Kōbundō, 1959. Relations between art and literature are stressed.

Tokyo National Museum of Modern Art, ed. *Gendai no me—kindai Nihon bijutsu kara*, 1974.

―――. *Kindai Nihon bijutsu no ayumi*. Tokyo: Tōto bunka kōeki kabushikigaisha, 1953.

―――. *Kindai Nihon bijutsushi ni okeru Pari to Nihon*, 1975.

―――. *Kindai Nihon no kaiga to chōkoku*, 1952.

Unno Hiroshi. *Nihon no aru nūvō*. Tokyo: Seidosha, 1978.

―――. *Toshi fūkei no hakken*. Tokyo: Kyūryūdō, 1982. Includes a discussion of the art-nouveau movement in Japan.

Urasaki Eishaku. *Nihon kindai bijutsu hattatsu shi*. Daichōkai shuppan-bu, 1961. Contains valuable information on the administrative aspects of the development of the arts during the Meiji period.

Yashiro Yukio. *Kindai gaka gun*. Tokyo: Shinchōsha, 1955. An important treatment of several modern Japanese and European painters.

COLLECTED WORKS, MULTIPLE SETS

Gendai Nihon bijutsu zenshū. Tokyo: Kadokawa shoten, 1954–6.

Gendai Nihon no bijutsu. 14 vols. Tokyo: Shūeisha, 1974–6.

Genshoku gendai Nihon no bijutsu. Tokyo: Shōgakukan, 1977–9. Several volumes deal with modern

Japanese art of the period.

Genshoku Nihon no bijutsu. Tokyo: Shōgakukan, 1970–71. 25 vols. Vol. 27, *Kindai no yōga*, by Takashina Shūji, is a particularly persuasive treatment of the subject.

Kawakita Michiaki, ed., *Sekai bijutsu zenshū.* Tokyo: Kadokawa shoten, 1964. Vol. 24, a supplementary volume on postwar movements, discusses modern art.

Kindai Nihon bijutsu zenshū. Tokyo: Tōto bunka kōeki, 1954. Vols. 3 and 4 cover modern oil painting.

Kindai no bijutsu. Tokyo: Shibundō. Issued serially, a number of these magazine-format volumes provide definitive information on a variety of aspects of modern Japanese painting, sculpture, crafts, architecture, etc.

Nihon gendai gaka sen. Tokyo: Bijutsu shuppansha, 1952–58. 21 volumes on modern Japanese artists.

Nihon no meiga. 50 vols. Tokyo: Kōdansha, 1972–4.

Nihon no meiga. 18 vols. Tokyo: Kōdansha, 1975–7.

Sekai bijutsu zenshū. Tokyo: Heibonsha, 1951–55. Total of 28 volumes. Japanse modern art is included in vols. 4 and 5.

Sekai meiga zenshū. Tokyo: Heibonsha, 1960–62. Japanese modern art is contained in vol. 23, contemporary art in a supplementary volume.

Tokyo geijutsu daigaku. *Zōhin zuroku*, 1954–63. A catalogue of works in the collections of the Tokyo School of Fine Arts.

Zauhō kankō kai. ed. *Gendai Nihon bijutsu zenshū.* Tokyo: Kadokawa shoten, 1954–56.

———. *Gendai sekai bijutsu zenshū.* Tokyo: Kawade shobō, 1954. Japanese modern art is featured in vol. 11.

EXHIBITION CATALOGUES

Bridgestone Museum, ed. *Nihon kindai yōga no kyoshō to Furansu*, 1983.

Fuji bijutsukan, ed. *Inshō-ha Parii to Nihon*, 1981.

Kanagawa kenritsu kindai bijutsukan, ed. *Kindai Nihon yōga no hyakugojūnen ten*, 1962.

———. *Kindai Nihon yōga no tenkai*, 1981.

———. *Nihon yōga o kizuita kyoshō ten*, 1977.

Kokuritsu kokusai bijutsukan, ed. *Kaiga no āru nūbō*, 1980.

Mie kenritsu bijutsukan, ed. *Nihon kindai no yōgakatachi*, 1982.

Nishinomiya-shi Ōtani kinen bijutsukan, ed. *Shirakaba no seiki ten*, 1981.

Saitama kenritsu kindai bijutsukan, ed. *Inshō-ha kara École de Paris*, 1982.

Tokyo kokuritsu kindai bijutsukan, ed. *Fontanesi Ragusa to Meiji zenki no bijutsu*, 1977.

Tokyo-to bijutsukan, ed. *Kindai Nihon bijutsu no ayumi ten*, 1979.

Yamaguchi kenritsu bijutsukan, ed. *Kindai no yōga no ningen zō*, 1980.

WORKS ON INDIVIDUAL ARTISTS

AOKI SHIGERU

Aoki Shigeru. *Kashō no sōzō.* Tokyo: Chūōkōron bijutsu shuppan, 1966.

Kawakita Michiaki. *Aoki Shigeru.* Tokyo: Nihon keizai shinbunsha, 1972.

———. *Higeki no shōgai to geijutsu.* Tokyo: Chūōkōron bijutsu shuppan, 1964.

ARISHIMA IKUMA

Arishima Ikuma. *Omoide no ware.* Tokyo: Chūōkōron bijutsu shuppan, 1976.

Kanagawa kenritsu kindai bijutsukan, ed. *Arishima Ikuma ten*, catalogue, 1977.

Takumi Hideo, ed. *Hitotsu no yogen, Arishima Ikuma geijutsuron shū.* Tokyo: Keisōsha, 1979.

ASAI CHŪ

Harada Heisaku. *Asai Chū gashū.* Kyoto: Kyoto shinbunsha, 1986.

Ikebe Gishō. *Mokugyo ikyō.* Kyoto: Unsōdō, 1907.

Ishii Hakutei. *Asai Chū.* Kyoto: Unsōdō, 1929.

Kumamoto Kenjirō. *Asai Chū.* Tokyo: Nihon keizai shinbunsha, 1970.

FUJISHIMA TAKEJI

Kumamoto Kenjirō. *Fujishima Takeji.* Tokyo: Nihon keizai shinbunsha, 1967.

Takumi Hideo. *Geijutsu no esupuri.* Tokyo: Chūōkōron bijutsu shuppan, 1982.

FUJITA TSUGUJI

Fujita Tsuguji. *Bura ippon.* Tokyo: Kōdansha, 1984.

———. *Chi-o oyogu.* Tokyo: Kōdansha, 1984.

———. *Fujita Tsuguji gashū.* Tokyo: Nichido shuppan-bu, 1978.

KANAYAMA HEIZŌ

Hyōgo kenritsu kindai bijutsukan, ed. *Seitan hyakunen Kanayama Heizō ten*, catalogue, 1978.

Kanayama Heizō gashū. Tokyo: Nichidō shuppan-bu, 1976.

Tobimatsu Minoru. *Kanayama Heizō.* Tokyo: Nichidō shuppan-bu, 1976.

KANOKOGI TAKESHIRŌ

Kanokogi Takeshirō gashū kankōkai, ed. *Kanokogi Takeshirō gashū*, 1920.

KISHIDA RYŪSEI

Hijikata Teiichi. *Kishida Ryūsei.* Tokyo: Nichidō shuppan-bu, 1971.

_____. *Kishida Ryūsei zenshū*. Tokyo: Iwanami shoten, 1979–80.
Kishida Ryūsei. *Bi no hontai*. Tokyo: Kōdansha, 1961.
Tokyo kokuritsu kindai bijutsukan, ed. *Botsugo gojūnen kinen Kishida Ryūsei ten*, catalogue, 1979.
Tomiyama Hideo. *Kishida Ryūsei*. Tokyo: Iwanami shoten, 1986.

KOIDE NARASHIGE

Koide Narashige. *Koide Narashige e nikki*. Tokyo: Kyūryūdō, 1968.
_____. *Taisetsu na fun'iki*. Tokyo: Shōshinsha, 1975.
Takumi Hideo. *Koide Narashige*. Tokyo: Nichidō shuppan-bu, 1975.
_____. *Koide Narashige—e no aru hagaki*. Tokyo: Kyūryūdō, 1976.

KOJIMA TORAJIRŌ

Kojima Torajirō denki henshū shitsu, ed. *Kojima Torajirō ryakuden*, 1967.
Okayama sōgō bunka sentā, ed. *Kojima Torajirō botsugo gojūnen ten*, catalogue.
_____. *Kojima Torajirō to sono shūshū seiyōga ten*, catalogue, 1980.

KUME KEIICHIRŌ

Kume bijutsukan, ed. *Kume Bijutsukan*, catalogue.
Miwa Hideo. *Hōgan bijutsu ron*. Tokyo: Chūōkōron bijutsu shuppan, 1984.

KURODA SEIKI

Kagesato Tetsurō. *Kaiga no shōrai*. Tokyo: Chūōkōron bijutsu shuppan, 1983.
Kumamoto Kenjirō. *Kuroda Seiki*. Tokyo: Nihon keizai shinbun-sha, 1966.
_____. *Kuroda Seiki nikki*. 4 vols. Tokyo: Chūōkōron bijutsu shuppan, 1966–68.
Mie kenritsu bijutsukan. *Seitan hyakunijūnen kinen Kuroda Seiki ten*, catalogue, 1986.

MAETA KANJI

Imaizumi Atsuo. *Botsugo gojūnen kinen Maeta Kanji ten*, catalogue, Nihon keizai shinbunsha, 1979.
_____. ed. *Maeta Kanji ron. Imaizumi chosaku shū*, vol. 2. Tokyo: Kyūryūdo, 1979.
Maeta Kanji. *Shajitsu no yōken*. Tokyo: Chūōkōron bijutsu shuppan, 1966.
Taki Teizō. *Maeta Kanji*. Tokyo: Nichidō shuppan-bu, 1977.

MITSUTANI KUNISHIRŌ

Kawakita Michiaki. *Kindai no yōgajin*. Tokyo: Chūōkōron shuppansha, 1959, pp. 138–59.
Yashiro Yukio. *Kindai gaka gun*. Tokyo: Shinchōsha, 1955, pp. 31–48.

MORITA TSUNETOMO

Morita Tsunetomo. *Ga seikatsu yori*. Tokyo: Kokon shoin, 1934.
_____. *Heiya zappitsu*. Tokyo: Kokon shoin, 1934.
_____. *Morita Tsunetomo gashū*. Tokyo: Kokon shoin, 1934.
_____. *Tsunetomo gadan*. Tokyo: Kokon shoin, 1934.
Saitama-ken bunka kaikan, ed. *Morita Tsunetomo isaku ten*, catalogue, 1968.

MURAYAMA KAITA

Kanagawa kenritsu kindai bijutsukan, ed. *Murayama Kaita no subete ten*, catalogue, 1982.
Kusano Shinpei. *Murayama Kaita*. Tokyo: Nichidō shuppan-bu, 1976.
Murayama Kaita zen gashū. Tokyo: Asahi shinbunsha, 1983.
Yamamoto Tarō, ed. *Murayama Kaita zenshū*. Tokyo: Yayoi shobō, 1963.

NAKAMURA TSUNE

Mie kenritsu bijutsukan, Kanagawa kenritsu kindai bijutsukan, ed. *Botsugo rokujūnen kinen Nakamura Tsune ten*, catalogue, 1984.
Nakamura Tsune. *Geijutsu no mugen kan*. Tokyo: Chūōkōron bijutsu shuppan, 1977.
Yonekura Mamoru. *Nakamura Tsune*. Tokyo: Nichidō shuppan-bu, 1984.

OKADA SABURŌSUKE

Nishinomiya-shi Ōtani kinen bijutsukan, ed. *Fujishima Takeji, Okada Saburōsuke ten*, catalogue, 1980.
Saga kenritsu hakubutsukan, ed. *Hyakutake, Kume, Okada sannin ten*, catalogue, 1974
Tamura Kazuo, ed. *Okada Saburōsuke sakuhin zuroku*. Kyoto: Benridō, 1978.

SAEKI YŪZŌ

Asahi Akira. *Saeki Yūzō*. NHK Sōsho, 1984.
Imaizumi Atsuo, others. *Saeki Yūzō gashū*. Tokyo: Bijutsu shuppansha, 1966.
Saeki Yūzō gashū kankō iinkai, ed. *Saeki Yūzō gashū*. Tokyo: Kōdansha, 1968.
Sakamoto Katsu. *Saeki Yūzō*. Tokyo: Nichidō shuppan-bu, 1970.

SAITŌ YORI

Saitama-ken bunka kaikan, ed. *Saitō Yori*. Tokyo: Bijutsu shuppansha, 1960.
Saitama kenritsu hakubutsukan, ed. *Tokubetsu ten Saitō Yori*, catalogue, 1975.

SAKAMOTO HANJIRŌ

Kawakita Michiaki, others. *Zōhan Sakamoto Hanjirō sakuhin zenshū*. Tokyo: Asahi shinbunsha, 1981.

Sakamoto Hanjirō. *Sakamoto Hanjirō bunshū*. Tokyo: Chūōkōronsha, 1970.

———. *Watashi no e watashi no kokoro*. Tokyo: Nihon keizai shinbunsha, 1969.

SEKINE SHŌJI

Mie kenritsu bijutsukan, ed. *Sekine Shōji to sono jidai ten*, catalogue, 1986.

Sakai Tadayasu. *Sekine Shōji ikō, tsuisō*. Tokyo: Chūōkōron bijutsu shuppan, 1985.

UMEHARA RYŪZABURŌ

Hijikata Teiichi. *Kindai Nihon no gaka ron*, in *Hijikata Teiichi chosakushū*, vol. 6. Tokyo: Heibonsha, 1971.

Imaizumi Atsuo. *Yōga ron—kindai Nihon*, in *Imaizumi Atsuo chosakushū*, vol. 2. Tokyo: Kyūryūdō, 1979.

Kawakita Michiaki. *Kindai hyakunen no sakka*, in *Kawakita Michiaki bijutsuronshū*, vol. 5. Tokyo: Kōdansha, 1978.

Seibu bijutsukan, ed. *Umehara Ryūzaburō ten*, catalogue, 1984.

Umehara Ryūzaburō. *Runoāru no tsuisō*. Tokyo: Mikasa shobō, 1952.

———. *Ten'i muhō*. Kyūryūdō, 1984.

———. *Umehara Ryūzaburō jisen gashū*. Tokyo: Yomiuri shinbunsha, 1960.

YAMASHITA SHINTARŌ

Bridgestone Museum, ed. *Seitan hyakunen Yamashita Shintarō ten*, catalogue, 1981.

———. *Yamashita Shintarō*. Tokyo: Bijutsu shuppansha, 1955.

YASUI SŌTARŌ

Kamon Yasuo. *Yasui Sōtarō*. Tokyo: Nihon keizai shinbunsha, 1979.

Yasui Sōtarō. *Gaka no me*. Tokyo: Zauhō kankōkai, 1956.

———. *Yasui Sōtarō ronshū*. Tokyo: Bijutsu shuppansha, 1956.

YOROZU TETSUGORŌ

Kanagawa kenritsu kindai bijutsukan, ed. *Seitan hyakunen kinen Yorozu Tetsugorō ten*, catalogue, 1985.

Moriguchi Tari, comp. *Yorozu Tetsugorō sakuhinshū*. Morioka: Iwate nippōsha, 1973.

Yorozu Tetsugorō. *Tetsujin garon*. Tokyo: Chūōkōron bijutsu shuppan, 1968.

Yorozu Tetsugorō gashū henshū iinkai, ed. *Yorozu Tetsugorō gashū*. Tokyo: Nichidō shuppan-bu, 1974. ▨